Art of the Modern Age

NEW FRENCH THOUGHT

SERIES EDITORS
Thomas Pavel and Mark Lilla

Jean-Marie Schaeffer

Art of the Modern Age

PHILOSOPHY OF ART FROM KANT TO HEIDEGGER

Translated by Steven Rendall

With a Foreword by Arthur C. Danto

 NEW FRENCH THOUGHT

PRINCETON UNIVERSITY PRESS · PRINCETON, NEW JERSEY

Translated from the French edition of Jean-Marie Schaeffer, *L'Art de l'âge moderne. L'Es-thetique et la philosophie de l'art du XVIIIe siècle à nous jours l'homme* (Paris: © Editions Gallimard, 1992)

Library of Congress Cataloging-in-Publication Data

Schaeffer, Jean-Marie.
[Art de l'âge moderne. English]
Art of the modern age : philosophy of art from Kant to Heidegger / Jean-Marie Schaeffer; translated by Steven Rendall with a foreword by Arthur C. Danto.
 p. cm. — (New French thought)
ISBN 0-691-01669-0 (cloth : alk. paper)
1. Aesthetics, Modern. 2. Art—Philosophy. I. Title. II. Series.

BH151.S33132000
111'.85'0903—dc21 99-038862

Published with the assistance of the French Ministry of Culture

This book has been composed in Adobe Bauer Bodoni

http://pupress.princeton.edu

Printed in the United States of America

10 9 8 7 6 5 4 3 2 1

In Kyoto for

Yasusuke and Motoko Oura
Takao and Kiko Saijo
Pierre Devaux
Shigeki and Keiko Tominaga
Naomi Fujimoto
Hiroko Maruyama
John and Christine Rose,
then, as well as for
Mai, Mika, Miyuki, Momoyo, Yu, Rei
and all the other enchantresses.

Contents

Foreword

The Speculative Philosophers of Art

BY ARTHUR C. DANTO

W HEN I WAS invited to write some introductory words to Jean-Marie Schaeffer's remarkable work, I thought it somewhat misleading that it was to be placed before an American readership in a series devoted to "New French Thought." For one thing, though its title is *Art of the Modern Age: Aesthetics and the Philosophy of Art from the Eighteenth Century to the Present*, French philosophers are bit players at best in the sweep of speculation the book surveys. The heroes—or the villains—of Schaeffer's story are Germans all, from Kant, through the Romanticists Novalis and Friedrich Schlegel, to Hegel, Schopenhauer, Nietzsche, and Heidegger. Schaeffer himself *is* of course a contemporary French thinker, and so his book qualifies, externally at least, as New French Thought. But it is scarcely representative of what we have come to regard as French thought since the late 1960s, as defined by the work of Derrida, Foucault, Baudrillard, and others, who have labored to expose, through deconstruction, the hidden pathogens of contemporary thought and culture. If those figures constitute what we assume to be French thought, then Schaeffer is a representative of a new wave with an animus against the germanophile generation before his. Anyway, I hope this book gets looked at by philosophers who would not ordinarily consider French thought as bearing on their concerns.

There is, it must be granted, a deconstructive tinge to Jean-Marie Schaeffer's undertaking, inasmuch as he identifies and seeks to disarm what he regards as a powerful distorting theory—the "speculative theory of art"—which lies beneath and behind the magisterial texts that define the canon of philosophical aesthetics. But Schaeffer himself writes far more in the grain of Anglo-American analytical philosophy than do any of his celebrated peers. His writing is governed by certain values the previous generation of French thinkers has at times cheerfully cast aside—the ideals of clarity and consequence, the ideas of logic, truth, and evidence—in favor of allowing signifiers to frolic in giddy verbal play, constrained only by the author's impish inventiveness. The true spirit of Deconstruction is to treat texts as so many disguises for the will-to-power of their conserva-

tive or subversive authors. By contrast, Schaeffer is so precise and unre-
lenting a philosophical critic that one wonders how some of the philoso-
phies he anatomizes here can possibly survive the operation. His several
chapters are diagnostic expositions of texts which have had a powerful
influence on the tenor of the previous generation of French thinkers—
what would these thinkers have been without Hegel, what would Derrida
have been like as a thinker without Nietzsche and Heidegger? The previ-
ous generation of French thinkers owes much of its style, its spirit, even its
content to what it took over and transformed from the same body of Ger-
man texts Schaeffer distances himself from through a sustained radical
skepticism. So by discussing the German metaphysicians, Schaeffer is
obliquely attacking the previous generation of French thinkers at the
roots. This, as I shall suggest, connects with the politics of art in France
today, but it has rather less connection with the situation in the United
States, where his arguments will mainly be for the benefit of philosophers,
who might perhaps find in them a justification for not engaging with what
we may simply call the Speculative Philosphers of Art.

With the guarded exception of Kant, the German thinkers taken up in
this book have had no impact to speak of on mainstream philosophical
thought in the United States. And they stand as so many distant Hima-
layas to the body of short argumentative texts through which the philoso-
phy of art has been addressed in America in recent years. This is so in part
because they express a set of attitudes toward art almost infinitely exalted
by contrast with the minimalist attitudes of American aestheticians, whose
paradigms have been Duchamp, Warhol, and Cage. Just now, there may
be a gnawing appetite for something grander than *Fountain*, *Brillo Box*,
and *4 Minutes*, *33 Seconds* can provide, and hence an uncertain longing
for the great redeeming visions of art the Germans struggled to articulate.
All the more reason to hope that Schaeffer's book quickly detaches itself
from its French context and stands on its own as a magnificent critique of
texts in the philosophy of art it would be of some considerable importance
for American philosophers to know about. They would find in Schaeffer
one of their own, so to speak, but fortified with a deep learning and a
particular understanding of his writers which only someone trained in
Continental traditions is likely to possess.

But what Americans may discover—putting the Speculative Theory of
Art to one side—is in fact a surprising congruence between the Romantic
philosophy of art as it developed in Germany in the nineteenth century,
and contemporary philosophy of art as it has been practiced in America
since the 1960s. Both, for example, have projected philosophies of the *end
of art*, and have constructed philosophical narratives of art history into
which the present, perhaps terminal state of art can be seen as an outcome.
The idea that the history of art is marked by a linked sequence of stages

was of course central in Hegel, but it has also become a topic of common interest among philosophers, historians, and artists themselves in America who have wondered whether the canon of minimal paradigms does not reflect a philosophical reduction that is one with the end of art? So much of Modern and Contemporary art could not have been imagined as art by Hegel, nor does it easily fit his proposed narrative of the stages of art history, from Symbolic through Classical to Romantic art. *Our* art, one might say, belongs on a level of intellectual self-consciousness that Hegel supposed was the mark of the end of art. In a way in which none of the art he would accept as such can be said to have done, contemporary art raises the question of what makes it art. It was precisely this through which Hegel defined the remaining interest of art in his own time—"Art invites us to intellectual consideration, and that not for the purpose of creating art again, but for knowing philosophically what art is." Hegel himself did not believe that the kind of art for which we may feel a certain nostalgia is any longer possible. But he might have found in the analytical philosophy of art a sustained investigation into "knowing philosophically what art is," made especially possible by the radically experimental art of the twentieth century.

The analytical philosophy of art has by and large concentrated on the ontology of the art work—on the basic difference between art works and what I have sometimes called "mere real things." Hegel has a metaphysical answer to this question, because in his view art works are expressions of spirit whereas real objects are merely real objects. But art had not evolved in his time to allow for the fact that externally speaking, we cannot easily distinguish art works from real things since they can look entirely alike.

The possible connection with Hegel is hardly likely to convince American philosophers that the Speculative Philosophers of Art are their kind of guys. They could, however, perhaps do worse than to follow the lead of Martin Heidegger, and take over from him the somewhat richer ontology he developed in *The Origins of the Art Work*. In his masterpiece, *Sein und Zeit*, Heidegger distinguished between two basic relationships in which we stand to the world—as a system of *objects*, which he terms *Vorhandenen* (which means the way they are before they have been modified by human touch or put to human purposes); and as a system of *uses*, which he terms *Zuhandenen* or "ready to hand." It is difficult to think of art works as belonging to either category. Art works are not natural objects, like trees or rocks, but neither do they seem made for use, like hammers and saws. An example of considerable interest to me has been Andy Warhol's *Brillo Box* of 1964, which so looks like the ordinary carton in which Brillo is shipped from warehouses to be unpacked in stockrooms, that the visual difference between them can be regarded as negligible. It is helpful to

think of *Brillo Box* as a *Werk*, and the ordinary Brillo carton as having a use, the question then being how work and object of use are to be distinguished philosophically from one another as well as from real objects. One of Heidegger's most interesting ideas concerns the way objects of use form complexes or wholes, which he designates *Zeugganzen*. The objects within a *Zeugganzes* refer to one another through their shapes—the hammer to the nail, the nail to the board, the board to the saw. Or the Brillo carton to the truck, to the economies of shipping and storing, and to the eye of the storekeeper, who finds it more attractive somehow than the cartons of Brillo's competitors. We all recognize that Warhol's *Brillo Box* has no place in the complex—the *Zeugganzes*—to which Brillo cartons themselves belong. Since it does not belong to the system of mere things either, we must subtract from the analysis of the art work anything that works have in common with things and with tools, and think of works as belonging in systems of works—an *art world*. Heidegger slips away from the powerful structure of objects, uses, and works, to take refuge in a moonily edifying characterization of *Werk* that he derives from the Speculative Theory of Art he inherited from his Romantic predecessors. Analytical philosophers would hardly follow him in this, and so have to find some more amenable way of effecting distinctions it is to his credit to have recognized. And having been spared the Speculative Theory of Art, they are in position to pursue Heidegger's distinction in directions he might have found insufficiently exalting to have merited his attention.

There is a third and somewhat surprising parallel. For the most part, none of the great German philosophers of art, at least after Kant, seems to have been particularly interested in the analysis of beauty or of taste, which one might have supposed would be the central topic of aesthetics. It is often advanced as a criticism of the analytical philosophy of art that it has allowed no room for what Marcel Duchamp described as "aesthetic delectation." Whatever happened to beauty? is heard today with increasing frequency, and it is perhaps of some value to be able to say that the great German philosophers of art did not themselves deal with that kind of question either—that it was their view indeed that art is of greater consequence than affording aesthetic gratification. They may, if Schaeffer is right, have given a flawed defense of this through The Speculative Theory of Art—but their intuitions were otherwise congruent with those of their recent American colleagues, who have had the benefit of art works that lie beyond the limits of their imagination. It was Duchamp most particularly who demonstrated that beauty is not part of the essence of art since something can be art without being beautiful. So beauty is something a work can possess or lack, with no implication for its status as art. This is something with which Hegel would certainly agree, and nothing more fundamentally divided Hegel from Kant than the fact that Kant could *not* have

agreed. That means that there is a greater gap by far between Kant and the Americans than between the latter and Romantics like Hegel.

Kant, indeed, was profoundly interested in beauty, but he hardly recognized a distinction between the beauty of art works and the beauty of natural objects—meadows, waterfalls, fields of flowers. In this he represents the characteristic attitudes of the Enlightenment. There is no fundamental distinction, so far as the anatomy of taste is concerned, between natural beauties in flowers and sunsets, or artistic beauty as found in gardens, palaces, or, for that matter, in works of art. The serpentine line—the "line of beauty" in Hogarth's *The Analysis of Beauty*—is invariant as to the difference between a sculpture of a beautiful woman, and the beautiful figure of the woman herself. In neither category of beautiful things could beauty, in Kant's view, be an objective property, so he had no choice but to subsume both modes of beauty as subjective, meaning, mainly, that beauty is what causes pleasure in the beholder. But, as in everything, Kant took his analysis into depths very few of his contemporaries could have anticipated.

For one thing, the experience of beauty gives a certain unexpected support to the metaphysical belief that the universe is not hostile to our most profound beliefs and hopes. In the *Critique of Pure Reason*, Kant wrote that "Metaphysics has as the proper objects of its enquiries, three ideas only: *God, freedom,* and *immortality*—so related that the second concept, when combined with the first, should lead to the third as a necessary conclusion." And in an earlier passage in the same work, he wrote, "The belief in a wise and great *Author of the world* is generated solely by the glorious order, beauty, and providential care everywhere displayed in nature." Beauty, in brief, was evidence not just of an author of nature—it was evidence that the world is not hostile to the belief that life has a purpose. The beauty of the world implies a purpose—hence *The Critique of Aesthetic Judgment* is but one part of *The Critique of Judgment*—the other being *The Critique of Teleological Judgment*, which is rarely discussed by aestheticians. Though the precise purpose which beauty intimates is not revealed, beauty at least assures us that we and the world are internally related, that the world is in ultimate harmony with our faith. This means that natural beauty was almost certainly more important to Kant's philosophy than artistic beauty could possibly have been. He famously defined beauty as *purposiveness without specific purpose*; but this means something a good bit deeper than feeling that a *work of art* has a purpose, though we cannot entirely make out what it is. Artistic purpose is disclosed through inquiry, but the purposiveness of nature is disclosed through a systematic metaphysical account, which his triad of critiques exemplifies. Kant's argument is intricate and systematic, but his effort is to establish a way of connecting the existence of beauty with a belief in the higher pur-

poses of creation, carries the analysis of beauty onto a scale of speculation so vastly disproportionate to the philosophy of art that it is scarcely any wonder that on the subject of art itself, Kant has so little to say. Connected as it is to the other two critiques, the *Critique of Judgment* is a speculative philosophy of beauty, but something less than a speculative philosophy of art.

In view of Kant's philosophical motives, it is something of an irony that "the *Third Critique*" should be the one text among those anatomized by Dr. Schaeffer which has recommended itself to American philosophers of art. Philosophical questions concerning art have been marginal to those through which mainstream philosophy in the United States is defined— but Kant is perceived to have written so deeply on the mainstream questions that the mere fact that he wrote about art at all is by and large the most reassuring thing to be said, in the mainstream mind, about the legitimacy of aesthetics. But Kant's towering reputation even among nonphilosophers has led to the belief that *The Critique of Aesthetic Judgment* must stand to the literature of aesthetics much as the *Critique of Pure Reason* stands to the traditional texts of epistemology. Though not a philosopher, the art critic Clement Greenberg claimed that if there were answers to aesthetic questions, they were to be found in *The Critique of Judgment*, and he often enough proclaimed it the greatest work on the subject ever written. Greenberg's view is widely echoed in art circles today. Only a few weeks ago, an artist told me he had been assured by a distinguished art historian—a *specialist!*—that Kant's was without question the greatest book written in the philosophy of art. But, the artist went on to say, he could make neither head nor tail of it. It is, however, not entirely a book to be read on its own. Kant was through and through architectonic, and one must see where beauty, and only incidentally art, fits in the whole grand design of his system. And the truth is that philosophers as well as artists may have a great deal more to learn from the philosophers after Kant, than from Kant himself.

The most compelling evidence that history had moved onto a novel plane in the period between Kant and Hegel is the fact that art is exalted by Hegel as close of kind to philosophy itself, whereas natural beauty is of no great philosophical consequence. "We at once exclude the beauty of nature," Hegel declares in the second paragraph of his immense work on aesthetics. "The beauty of art is *higher* than nature." The reason for this is that "The beauty of art is beauty *born of the spirit and born again*, and the higher the spirit and its productions stand above nature and its phenomena, the higher too is the beauty of art above that of nature." The Romantic exaltation of art speaks through every line in Hegel's book: "Art and works of art, by springing from and being created by the spirit, are themselves of a spiritual kind. In this respect art already lies closer to the

spirit and its thinking than purely external spiritless nature does." Hegel
has scant use for the concept of taste, or the concept of beauty in which the
discernments of taste find application: "So-called 'good taste' takes fright
at all the deeper effects of art," he writes. "For when great passions and
the movements of a profound soul are revealed, there is no longer any
question of the finer distinctions of taste and its pedantic preoccupation
with individual detail. For this reason the study of works of art has given
up keeping in view merely the education of taste." That means that artistic
beauty, for Hegel, insofar as it parallels natural beauty by awaking fine
feelings, has nothing to do with the deeper truths of art. Art, in what Hegel
terms "its highest vocation," forms, together with religion and philosophy,
Absolute Spirit. Art is philosophical thought expressed through sensuous
means.

References to Absolute Spirit are unlikely to go down smoothly with
analytical philosophers today. Still, however thundering his language,
Hegel has quite powerfully sundered the idea of art from having anything
essential to do with beauty. We respond to the sensuous dimension of art,
but only in the sense that we grasp what is being expressed in this mode.
And grasping this is like grasping a philosophical truth. Art is "one way of
bringing to our mind the deepest interests of mankind and the most com-
prehensive truths of the spirit." It is art that does this and not, as Kant
believed, Beauty. In art, spirit attains consciousness of its identity. In less
thundering terms, the philosophy of art replaces the philosophy of taste by
something close to art criticism. "Art invites us to intellectual considera-
tion, and that not for the purpose of creating art again, but for knowing
philosophically what art is." Hegel distinguishes two "moments" of such
knowledge: grasping the content of art—what a work of art is about—and
analyzing "the work of art's means of presentation." This is to treat art
works as embodied meanings. And that is what art criticism does. In No-
valis and in Schlegel, as Schaeffer shows, a powerful distinction is drawn
between being *ein Kritiker* and being *ein Richter*—being a critic and not a
judge. The critic addresses the work not in terms of criteria of taste but of
criteria of meaning and truth. And this must be especially appealing, I
would think, to analytical philosophers who not so long ago impugned any
effort to say what art is, suggesting that philosophers instead address
themselves to the language of criticism. But the fact that the philosophy of
art in Hegel is to be given over the philosophy of criticism is in itself a
mark that art is somehow a lesser thing than it had once been, when it was
the vehicle through which mankind's highest ideals were conveyed—when
it was the peer if not, as in the case of Schlegel, the superior of philosophy.

If Kant tells us less than we want to know about art, Hegel tells us
perhaps more than we can believe. The quarrel between Hegel and the
Jena Romanticists—the Schlegel brothers and Novalis—over the relative

significance between the Artist and the Philosopher is difficult to take seri-
ously at the end of a century of philosophy which has mainly consisted in
endeavoring to find out what after all philosophy is, and in which various
"final solutions" to the problem of philosophy itself have been pro-
pounded by—ironically—Germanic thinkers like Wittgenstein and the
Logical Positivists. If there are deep parallels between philosophy and art,
perhaps we can see the history of twentieth-century art itself as a kind of
philosophical examination into its own nature, with a tentative final solu-
tion in such twentieth-century views as that art can be anything and any-
thing can be art. And that, if true, leaves open the question of whether this
radical pluralism is consistent with the exalted view of art—of art as above
or below or alongside Philosophy—in which the Romanticists so unques-
tioningly believed. Least of all can we any longer believe that art promises
the kind of social salvation in which Nietzsche believed until he was disil-
lusioned at Bayreuth, and found that Wagner was a showman rather than
a shaman—a possibility not altogether inapplicable to the artist Joseph
Beuys, who so widened the possibilities for art that nothing could any
longer be excluded.

This returns us to Jean-Marie Schaeffer and New French Thought. For
the past some years, the expression *l'art contemporain* has carried a
charge of controversy in France that has no counterpart in American cul-
tural politics. In part this is due to the heavy state subsidies allocated to
artists and to art in France, which might be justified if art were as exalted
a pursuit as the Romantics believed it to be—and if we could possibly
think of *l'art contemporain* in those terms. If not, then the question arises
inevitably as to whether, in hard economic times, the program of arts sub-
sidization makes any sense at all. In the United States, state subsidy of the
arts is so minuscule that enemies of the National Endowment for the Arts
are right in saying that abolishing that institution would make virtually no
difference to the welfare of art in America. In compensation, the Congress
takes no interest in contemporary art. Its interest is provoked only when
the taxpayer's money is used to support art that conflicts with the pre-
sumed moral values of the taxpaying public. If artists like Robert Mapple-
thorpe and Andres Serrano want to produce their images, distasteful as
they may be to many, that is protected by the First Amendment. What the
First Amendment does not guarantee is that the people of the United
States should pay for such art. So the state is as indifferent to art's direc-
tion as to its existence. No one especially thinks it would be important for
art to return to something traditional in connection with which subsidiza-
tion *would* make the kind of sense it made to the Egyptians, prepared to
sacrifice money in great amounts that the pyramids be built, or to the
medievals, who were prepared to go to fiscal extremes in order that the
great cathedrals rise. It is of interest to reflect that when Hegel speaks of
the end of art, he means precisely this—"that art no longer affords that

satisfaction of spiritual needs which earlier ages and nations sought in it, and found in it alone." In the golden age, one might say, it was entirely thinkable that a community's entire resource would support artistic expression. When it is no longer felt necessary that *any* public resource be committed to art, that means that art alone does not satisfy the spiritual needs of the community in which that is true. In America there is in general no interest in going back to a golden age. If anything, the vector of artistic creation is forward, in the unrelenting pursuit of the new. But in France the tendency is to blame *l'art contemporain* for this felt situation. And the aim is indeed to return to an art which will satisfy needs of a kind the avant garde cannot possibly accommodate.

It is this tacit reference to current discussion in France that makes Schaeffer's book a contribution to New French Thought. And it is here that his critique of the Speculative Theory of Art takes on a quality of urgency. The urgency is unquestionably greater in the French context than the American. But since it belongs to the very texts to which one might return to discover the larger meaning of art in the satisfaction of human needs, it would be good for philosophers unhappy with the present situation in Anglo-American philosophy of art to work through Jean-Marie Schaeffer's indispensable book.

Underlying the dissatisfaction with *l'art contemporain* is a "nostalgia for an 'authentic' life that has not been desacralized and alienated," he writes. It is not a nostalgia for a certain kind of art so much as a nostalgia for an entire metaphysics of art, which really cannot be achieved without corresponding transformations in society as a whole. This is hardly to be achieved through a shift to realism or figuration. It cannot, in brief, be achieved through art alone. And while Schaeffer does not, so far as I can see, offer a knock-down argument against the Speculative Theory of Art, he has found sufficient problems in the main texts in which a metaphysical theory of art is advanced, to raise doubts as to whether it can or should any longer be entertained as ideal. Schaeffer would surely concede that much of contemporary art cannot easily be understood without reference to some piece of theory—but in general the theory will have played a role in the creation of the art. It does not and should not come from an external philosophy, which *prescribes* what can be art and what cannot. But each of Schaeffer's examples of the Speculative Theory of Art are, as he attempts to show, "persuasive definitions" of art—imperatives disguised as indicatives. Art as such does not require metaphysical legitimization. This leaves the questions of subsidy where they belong, in the realm of public debate over priorities. What remains to be said is that some better way of judging *l'art contemporain* must be found than that it is not the way art used to be.

Art of the Modern Age

Introduction

IN THE DOMAIN OF reflection on the arts in France there has been, over the past few years, a remarkable joint emergence of two apparently contradictory phenomena. The first is a singular aggravation of the legitimation—one might even say identity—crisis in contemporary art. In particular, this crisis is expressed in the ever-increasing multiplicity of essays and pamphlets attacking the present state of art and wondering "how we arrived at such a pass." The French replies to this question are diverse, but almost all of them involve challenging anew so-called "modernist" art, and many urge a return to classicism or sing the praises of a moderate eclecticism. Especially widespread in the domain of the visual arts, this reaction can also be observed in music, where disillusioned assessments of serialism are beginning to appear, or again in literature, where everywhere we hear appeals to return to "the great tradition" (or what passes for such). As we might expect, some of those who have suddenly adopted such traditional tastes were formerly the most enthusiastic incense-bearers for the "revolutionary" avant-gardes. More apocalyptic voices insist that the proposed remedies (classicism, eclecticism) are only placebos: the patient is moribund, and death—the end of art, so often proclaimed—must soon follow.

The second phenomenon, apparently in contradiction to this generalized peevishness, is a renewed French interest in aesthetics, or at least in Kantian aesthetics. Who could complain about that? Kantian aesthetics was only too long eclipsed by the various hermeneutics of art that have occupied the front of the stage since romanticism. But its renaissance often takes strange paths. Jean-François Lyotard, for instance, a postmodernist and yet a defender of the avant-gardes, focuses in particular on the theory of the sublime. Reinterpreted from a point of view that combines Adorno[1] (art as subversive) and Heidegger (art as *Ereignis*, as event or "occurrence"), it allows Lyotard to legitimate revolutionary art: "Avant-gardism is . . . present in embryonic form in the Kantian aesthetics of the sublime."[2] Nonetheless, in Kant's *Critique of Judgment* the theory of the sublime is a mere side issue that is not easy to integrate into aesthetic judgment as a whole;[3] moreover, as Lyotard himself concedes, Kant applies the predicate "sublime" not to works of art but to the subjects they represent: the sublime has to do with the aesthetics of nature and not with a theory of art.[4] If so, why should Lyotard seek an avant-gardist legitimation of art in Kant's works, unless it is because, emphasizing the failure of the evolu-

tionary model inspired by Hegel, he continues to think that art cannot get along without a philosophical justification? In fact, it is precisely this presupposition that needs to be examined.

As for the rereading of Kantian aesthetics proposed by Luc Ferry,[5] its aim is above all to develop a theory of political individuality and an ethics—in the name of which the avant-gardes are criticized; in this approach aesthetics and art are subordinated to social philosophy. To be sure, Kant himself conceives aesthetics from the perspective of a transcendental ideal of communication; but I shall try to show that this utopia of aesthetic transparency is not capable of providing the foundation for a theory of art, and especially not—unless we fall back on a transcendental angelism—a *social* theory of art, as Ferry seems to believe. It is moreover revealing—and this is too often forgotten—that for Kant the paradigm of the beautiful is natural beauty and not artificial beauty, that is, art.

The fact that the same text can be used to praise the avant-gardes and to criticize them is perhaps simply an indication that Kantian aesthetics cannot provide us with a theory of modern art. Its historical and contemporary importance does not reside in what it tells us about art—which is not very much—or in the "salvaging" of aesthetics by means of the ethics sketched out in the theory of the sublime, but rather in what it can teach us about the status of *discourse on art*. As for art itself, I am convinced that it will get along very well on its own.

The supposed crisis in the arts is in fact more than anything a crisis in the legitimation discourse on the arts, which is not at all the same thing. To see that there is a crisis in discourse, all one has to do is leaf through French art journals or literary supplements. It is in the domain of the visual arts, however, that the situation is most caricatural: abstruse, hollow gibberish and an absence of any coherent standard of evaluation are there the rule. This is the price we pay for the exorbitant privilege accorded to "deep interpretation" (symptomatic, psychoanalytic, deconstructionist, etc.)—irreproducible and self-legitimating—at the expense of "surface interpretation,"[6] that is, the analytic description of art works—which is reproducible and open to sincere intersubjective verification. Yet the reader is entitled to expect that an art critic will describe the work he is urging the reader to go to see, and that he will evaluate it, basing his judgment on explicit criteria (which readers, like the artist, may of course challenge); as for interpretation, if the work of art is to remain an experience, this should be above all a matter of individual reception.[7] Modern visual art is, to be sure, primarily a descriptive art (like classical Dutch art) rather than a narrative art (like Italian art).[8] Describing a descriptive picture is paradoxically easier than providing an *ekphrasis* of a narrative picture, and just as the art historian who is dealing with Dutch art falls back on an allegorical reading of the pictures, which would otherwise ap-

pear mute to him, the critic of contemporary art takes refuge in interpretation in order to escape the labor of formal description. But this reason of "convenience" is singularly reinforced by the general domination of the hermeneutic model in discourse on the arts.

In literary studies, the situation is no doubt just as catastrophic, but few critics are able to justify their appreciation of a book by analyzing its design, its construction, its language; most prefer to limit themselves to a vague summary and incantatory formulas about the mystery of writing or style (which they nonetheless studiously avoid describing). As often happens, the struggle against "positivist scientism" or "repressive ideology" has ended up producing contempt for analytic and descriptive work (and, hence, an ignorance of their tools), which are replaced by "deep interpretations" cobbled together from undigested philosophy.

We must not push angelism to the point of believing in an air-tight barrier between the fate of the arts and the discourses on them. Thus the historicist conception of artistic evolution that has dominated critical discourse accompanying modern art is partly responsible for the minimalist dead end at which several sectors of the visual arts have arrived. But the visual arts did not invent this discourse; at most, they adapted it to their needs. Hence it is an illusion to contrast a "good" modernity, which would be that of Baudelaire, for instance, to a "bad" one, which would be that of the avant-gardes;[9] beyond their differences (concerning for example the question of "progress"), both are based on the same conception of art. It would surely be wiser to recognize that art works cannot be reduced to plans, nor a fortiori to theories or to movements or schools. Here, as elsewhere, we must make allowances: just as Hölderlin's poetry survived the death of idealist philosophy, and Baudelaire's poetry survived the aesthetics of the "new," Kandinsky's painting will survive the avant-gardist mystique. A work of art can be judged on actual evidence; a judgment based on the theory or worldview it appeals to is never sufficient either to save it or to condemn it. To believe the contrary—to believe for instance that the value of a work of art can be determined in advance by its goal, or even by its position with regard to some postulated historical evolution, is to be a victim of a moribund discourse on the arts that has always overlooked—among other things—the irreducibility of the artistic act (but also of any act!) to the way it legitimates itself on social, philosophical, or other grounds.

What is this discourse? In a way, its constitutive illusion is illustrated by the question that it constantly asks: "What is Art?" For about the past two hundred years, this question, which was up to that point marginal in artistic and philosophical consciousness, as well as in human consciousness in general, has steadily grown in importance, to the point that in the domain

of the visual arts some people have come to think that the very goal of practicing these arts resides in the search for an answer to this question. Kandinsky thus says about modern art: "Its 'quiddity' will no longer be the material 'quiddity' oriented toward the object, as in the preceding period, but *an internal artistic element*, the soul of art . . ."[10] And in our own time, minimalism and conceptual art are no more than the extreme outcomes of this movement, whether in the form of a reduction of the work to a kernel presumed to be irreducible (minimalism), or to its evaporation into a theoretical construction obscurely evoked by the work of art (conceptual art). These two attitudes have occasionally made it possible to ask interesting questions about art—though they have not always given rise to interesting works. But fundamentally the essentialist quest makes no sense: art is not an object endowed with an internal essence;[11] like every intentional object it is (becomes) what people make of it—and they make the most diverse things of it. Its evolution does not lead us from the accessory toward the essential: all that ever happens is a change of grammar or ideal, and minimalism is a form of visual art that is neither more nor less essential than abstract expressionism and cubism, the art of icons and Japanese Buddhist sculpture—or any other style. The fact that not all forms of art, not all works of art, retain our attention to the same degree (what retains attention is eminently variable, however, according to the period, culture, country, social milieu, individuals, and the mood of the moment), and that we do not consider them as all having the same value, does not make some of them closer to the "essence" of art than others.

The search for the fundamental or ultimate constituents of art is nonetheless only one aspect—and one active especially in the visual arts—of the response to the question, "What is art?" In a more basic way its essence has been sought in a cognitive status that would not only be peculiar to it, but would make it simultaneously the fundamental knowledge and the knowledge of foundations:[12] we are told that art is an ecstatic knowledge, the revelation of ultimate truths inaccessible to profane cognitive activities; or that it is a transcendental experience that founds man's being-in-the-world, or again that it is the presentation of the unrepresentable, the event or occurrence of Being; and so on. The thesis, in all its forms and formulations, from the most profound to the most trivial, implies a sacralization of art, which is contrasted, as an ontological mode of knowledge, to other human activities, which are seen as alienated, deficient, or inauthentic. What some of its most enthusiastic current exponents do not know, or pretend not to know, is that this thesis also presupposes a theory of Being: if art is ecstatic knowledge, this is so because there are two kinds of reality, the apparent one to which we have access through our senses and reasoning intellect, and the hidden one that reveals itself only to art (and perhaps to philosophy). Finally, this thesis is accompanied by a spe-

cific conception of discourse on the arts: the latter's task is to provide a philosophical legitimation of the ontological cognitive function of art. What this amounts to is the claim that the arts and art works have to legitimate themselves philosophically.[13] They can do so, however, only when they are in conformity with their postulated philosophical "essence": whence precisely the necessity for artists to envisage their works as answers to the question, "What is art?"—understood as a question about its legitimacy. Thus the circle is completed: the search for the essence is in fact a search for philosophical legitimacy.

The speculative theory of Art—the name we propose to give this conception—thus combines an objectal claim ("Art . . . performs an ontological task")[14] with a methodological one (in order to study art, we have to bring to light its essence, that is, its ontological function). It is a *speculative* theory because in the diverse forms it assumes in the course of time, it is always deduced from a general metaphysics—whether systematic like Hegel's, genealogical like Nietzsche's, or existential like Heidegger's—that provides its legitimation. It goes without saying that the definitions of art thus proposed are not what they claim to be; they present themselves in a *descriptive* grammatical form, that of the definition of an essence; but since art has no essence (in the sense of a substantial identity) and is never anything but what people make of it, they are in fact *evaluative* definitions (the art works are identified *as* art works insofar as they conform to a specific artistic ideal—that of the alleged definition of essence). It is a theory of Art with a capital A because beyond works and genres, it projects a transcendent entity that is supposed to *found* the diversity of artistic practices and to have ontological priority over them. Only the postulated priority of the essence as a transcendent entity permits an apodictic discourse to say what art is "as such," that is, to pass off its evaluative definition as an analytic definition.

For almost two hundred years this speculative theory of Art has been the *doxa* of reflection on the arts. Thus we find it—already as a commonplace—in Hegel, according to whom art reveals "the *Divine*, the deepest interests of man, and the most comprehensive truths of the spirit."[15] When he formulated this thesis during the 1820s, he hardly felt obliged to legitimate it: in putting it forward, he knew that he was (already) in accord with most of his cultivated contemporaries. And when Martin Heidegger wrote in 1935: "Always, when that which is as a whole demands, as what is, itself, a grounding in openness, art attains to its historical nature as foundation. . . . Unconcealedness sets itself into work a setting which is accomplished by art,"[16] he was saying the same thing as Hegel had said a century earlier, with the exception of a few differences in vocabulary. He did not feel obliged to offer a detailed legitimation, either; he knew that his view was in accord not only with that of many of his contemporaries, but also

with that of prestigious predecessors: Hegel, of course, and also Hölderlin, Novalis, and the young Schelling, and later on, Schopenhauer and the young Nietzsche. These are all names of philosophers or philosopher-poets, because originally the thesis was part of a *philosophical* strategy—which later imposed itself, however, on the world of art. They are German names, too: that is because in its origin and in its most prestigious (and most influential) theoretical formulations, it belongs indeed to a German tradition—but one that very quickly spread throughout Europe.

The speculative theory of Art played a legitimating role for a whole period of Western art, the one generally designated by the term "modernism." The quality of some of the works produced within this framework will doubtless more than amply justify it in the eyes of our posterity. But for us it is different, because we have mired ourselves in it, often with delight, sometimes with uneasiness, rarely with lucidity—each generation believing that it was innovating when it was really only repeating the preceding generation with minor variations in vocabulary. Furthermore, the current crisis of discourse on the arts is a reliable sign that the speculative theory is threadbare. It is time to emerge from the confinement in which it has held discourse on the arts, and in order to succeed in doing so, it is important to understand first of all what it has committed us to and what it has led us to overlook.

The question is essentially that of the historical function of the sacralization of Art. Where and how was its historical destiny determined? To what need did it correspond—and what function does it continue to fulfill?

A few phrases from Paul Valéry will indicate our path. On 19 November 1937, he gave a lecture entitled "The Necessity of Poetry." In it he talked about his beginnings as a poet at the end of the nineteenth century:

> I lived in a milieu of young people for whom art and poetry were a kind of essential nourishment they could not do without; and even something more besides: a supernatural nutriment. At that time, we had . . . the immediate sensation that a sort of cult, a religion of a new kind, was very close to being born, and would give form to the almost mystical state of mind that was then dominant, and that was inspired in us or communicated to us through our very intense feeling of the universal value of the emotions of Art. When one thinks of the youth of that time, of that time more full of spirit than the present, and of the way in which we approached life and the knowledge of life, one sees that all the conditions of an almost religious training and creation were absolutely brought together. In fact, at that moment there reigned a sort of disenchantment with philosophical theories, a disdain for the promises of science, which had been very badly interpreted by our predecessors and elders, who were the realistic and naturalistic writers. Religions had been

subjected to the assaults of philological and philosophical criticism. Metaphysics seemed to have been exterminated by Kant's analyses.[17]

Valéry was describing the end of the nineteenth century, but his reference to Kant pointed toward the end of another century, the eighteenth. This is not an accident: like the avant-gardes later on, the symbolism of the last years of the nineteenth century, far from innovating, only played out once again a century-old drama, that of the romantic revolution and its reaction to Kantian philosophy. Valéry's description resonates like a tardy echo of the voice of Friedrich Schlegel or some other German romantic. There are the same protagonists (religion, philosophy, the sciences, Art—or its ideal paradigm, poetry), the same action (crisis in philosophical, and more generally, spiritual foundations), the same conclusion (Art—or poetry—as the result of the crisis).

It is in fact at the end of the eighteenth century that we must situate the birth of the speculative theory of Art. Its genesis, that is, the genesis of the "romantic revolution," is first and above all the response to a twofold spiritual crisis, one in the religious foundations of human reality and one in the transcendental foundations of philosophy. The two crises are connected with the Enlightenment and reach their—intellectual—apogee in Germany with Kantian critical philosophy. The term "revolution" must not lead us astray: the romantic revolution was fundamentally *conservative* because it consisted in essence of an attempt to reverse the movement of the Enlightenment toward a secularization of philosophical and cultural thought. To be sure, its birth results from the conjunction of many different social, political, and intellectual factors (among them the French revolution, certainly, but also the social emancipation of artists, that is, the increasing importance of the market as an institutional regulator). But at bottom the romantic syndrome is double: on one hand, the experience of a disorientation linked to the ever-greater differentiation of diverse spheres of social life, and on the other, an irrepressible nostalgia for a harmonious and organic (re)integration of all the aspects of the reality that were experienced as discordant and dispersed. The present world is a disenchanted world (Hegel, Lukács, and countless other thinkers will return to this topos), its Unity is not given; it must be (re)constructed. This is a profoundly *philosophical and theological* obsession—and it was primarily as such that it was experienced by Friedrich Schlegel, Novalis, Hölderlin, Schelling, and Hegel.

Kant's philosophy is the sore point in this crisis, since his criticism was held responsible for the dismantling of philosophical ontology and rational theology, which were henceforth subject to a speculative prohibition. To a certain extent the romantics accept the Kantian verdict: their central philosophical thesis asserts in fact that philosophical discursivity

can have no access to the Absolute. But they propose an alternate solution, which is none other than the speculative theory of Art: poetry—and more generally Art—will replace the failing philosophical discourse. It is clear: the sacralization of Art endows the arts with a *compensatory* function. We must note that its establishment as an ontological revelation does not emerge from a failure of philosophy as a metaphysical *impetus*, but rather from the incompatibility between its discursive form (deductive and apodictic) and its ontological content (or reference). The work of art will thus take over the metaphysical *impetus* and achieve the presentation of the content of philosophy. Novalis, for example, inspired largely by Neoplatonic theories, asserts that fundamental reality is accessible solely through the poetic ecstasy that escapes rational discursivity, which is incapable of transcending the duality between an enunciating subject and an object on which the enunciation bears: only the poet is at once subject and object, self and world, and thus he alone has access to the Absolute.

The sacralization of poetry—if not of Art—is assuredly not a romantic *invention*: the figure of the poet as interpreter of the mantic voice, as a prophet or *vates*, goes back to antiquity. It is moreover taken up by early Christianity in the form of an invocation to God, called upon to second the voice of the Christian poet. The thesis arises from time to time in the Middle Ages, and again in the Renaissance, but it always remains marginal. Above all, there is a fundamental difference between these earlier sacralizations of poetry and the romantic exaltation of poetry: the latter, confronted by the crisis in the traditional *Weltbild*, fulfills a compensatory function; this was not the case among the earlier defenders of the "divine" function of poetry.

The tradition of the speculative theory of Art cannot, however, be completely and simply identified with romanticism. The specificity of the latter with regard to subsequent philosophical developments of the theory resides in a twofold arrangement: not only is Art endowed with an ontological function, but it is moreover the *only* possible presentation of ontology, of speculative metaphysics. On this precise point, the *philosophers* who succeeded the romantics in general diverged from the inventors of the theory. Thus Schelling and Hegel, who in their youth shared the romantic conception of the transcendence of philosophy through Art, later reinstated the speculative rights of philosophy. In Hegel's *Aesthetics* Art is transcended by philosophy, the ultimate form of Spirit. But Art continues to be invested with the function of providing an ontological revelation; only its relation to philosophy is differently conceived. This idealist solution is later challenged in turn, notably by Schopenhauer, Nietzsche, and Heidegger, who put to new uses the problem of the hierarchical relation between Art and philosophy. The young Nietzsche, for instance, returns more or less to the romantic positions, that is, he reserves for Art (in its

dionysian form) the ultimate ontological revelation, whereas Heidegger postulates a dialogue between the two activities.

But if it is true that with objective idealism philosophy takes up the torch of the Absolute, so that Art no longer has to replace it, endoxical discourse (particularly scientific discourse) and common reality continue to stand for disenchantment and alienation. In other words, the deep motivation that gave rise to the speculative theory of Art—its compensatory function—continues to be active. Art is still supposed to counterbalance scientific knowledge's invasion of modern culture: objective idealism, Schopenhauer's gnoseological pessimism, the young Nietzsche's vitalism, and Heideggerian existentialism all explicitly oppose scientific discourse and try to devalorize it. And the compensation operates with regard to everyday, social, historical reality as well: while for Novalis poetry was supposed to "romanticize" life, Hegel maintains that Art achieves the sublation of empirical beingness into the ideal; for the young Nietzsche, a reader of Schopenhauer, dionysian art rends the veil of *maya* and frees us from the tyranny of the Will; for Heidegger, poetry pushes us beyond our inauthentic being-there toward listening to the "word" of being. It is clear that what unifies all these writers is the same nostalgia for an "authentic" life that has not been desacralized and alienated. And we shall have occasion to see in detail how Hegel, Schopenhauer, Nietzsche and Heidegger adapt the speculative theory of Art to their own ontology, how they try to harmonize the ecstatic nature of art with their claim, as philosophers, to be themselves depositories of an ecstatic knowledge, and how, finally, all of them need Art as a counterweight to a polemical view of common reality.

In contrast to the philosophers, artists—as Valéry's text testifies—obviously have a tendency to return to the romantic position, that is, to elevate art at the expense of philosophy, and thus to reactivate the "old quarrel" between philosophy and poetry to which Plato had already referred. Matthew Arnold, for example, wrote in "The Study of Poetry" (1880): "More and more mankind will discover that we have to turn to poetry to interpret life for us, to console us, to sustain us. Without poetry, our science will appear incomplete; and most of what now passes for religion and philosophy will be replaced by poetry. . . . [O]ur religion, . . . our philosophy, . . . what are they but the shadows and dreams and false shows of knowledge?"[18] And in our own time Joseph Kosuth, a conceptual artist, repeats the romantic thesis that incorporates philosophy into art: "Philosophical or theoretical language is a manner of speaking within art." However, in doing so he also inverts the Hegelian verdict on art: "The twentieth century has seen the birth of an epoch that could be called 'the end of philosophy and the beginning of art.' "[19] Kosuth's antiphilosophical polemic remains dominated, like that of the romantics, by a philosophical proble-

matics, in this case a reappropriation—abusive, in my view—of Wittgensteinian philosophy, interpreted in a mystical perspective.[20]

In more or less bastardized forms, the sacralization of poetry and Art has largely permeated most of modern artistic and literary life, and has constituted the Western art world's aesthetic horizon of expectations, as it were, for nearly two centuries. As a myth of the legitimation of the arts, it has accompanied—in the form of a denial—the social transformation of artistic practices: their slow and sometimes painful achievement of aesthetic autonomy, as well as their progressive integration into a market economy, that is, the replacement of relations of personal dependence between artist and patron by fluctuations in supply and demand[21] that are anonymous and aleatory—or so they seem. It is as if the loss of the traditional functional legitimations (religious, didactic, or ethical) had created a void into which philosophy fell, philosophy being itself in crisis as a result of the failure of rationalist theodicies and in search of a new legitimacy. Thus begins the long history of a reciprocal fascination, comforted by the rejection of a supposedly common enemy: prosaic reality in all its many hideous guises.

Any sacralization of a profane reality implies that the latter is distorted. The sacralization of Art is no exception to this rule. It distorts the component of prosaic life that must be part of the arts as well, even if it is only in their relations with the world of money, the creation and maintenance of a clientèle, coteries, and other realities that are all too human. We might console ourselves by noting that after all transfiguration is one of the functions of any myth. And we would doubtless be right to do so, had the speculative theory not produced other consequences. The latter were more damaging because they directly affected the quality of our relationship to art: through its speculative dogmatism, the speculative theory has blinded us to the actual logic—always precarious—of aesthetic and artistic experience.

Here we come back to Kant. If in his general philosophy he is the symbolic representative of this disenchantment with the world against which he will raise the protest of the sacralization of Art, at the same time he offers, through the analysis of aesthetic behavior proposed in *The Critique of Judgment*, an early critique of the logical foundations of the speculative theory of Art. In fact, he gives a definitive description of the specific character (not determining, and hence not apodictic) of aesthetic judgment, demonstrating at the same time the impossibility of any doctrine of the beautiful. Applied to the arts, this amounts to a declaration of the cognitive nullity of any philosophical doctrine founded on a definition of the essence of art, and a limitation of aesthetic discourse to the critical evaluation of art works and (I would add) to the study of their phenomenal

structures. Romanticism—and everything that follows from it—short-cir-
cuits the *Critique of Judgment* by reducing the Beautiful to the True, and
by identifying aesthetic experience with the presentative determination of
an ontological content. The domain of the arts thus ceases to be the one in
which we encounter art works; it becomes the manifestation of *Art* as it is
determined by speculative aesthetics. If Art reveals being, art works, on
the other hand, reveal Art, and are to be deciphered as such, that is, as
empirical realizations of the same ideal essence. Let us repeat: it is because
the works (and the arts) are reducible to Art that the latter can be an
ontological revelation; the definition of Art as presentation of onto-theol-
ogy implies the reduction of the works (and the arts) to the speculative
theory of Art.

Defining Art by its content of philosophical truth, the speculative theory
claims to describe its essence, whereas in reality it is only proposing one
ideal among others. For this reason it is always a discourse of exclusion, as
is shown in particular by Hegel's *Aesthetics*, which excludes or at least
marginalizes with a sweeping gesture all the artistic and literary genres
considered impure or inessential: instrumental music, the novel, pre-
Greek sculpture, Asian art, etc. More generally, it can be said that in the
speculative theory of Art a discourse of celebration usurps the place of an
analytic description of artistic facts, at the same time that aesthetic experi-
ence finds itself reified into apodictic judgment. It is not certain that phi-
losophy has gained through this, but it is certain that our relation to the
arts has been singularly impoverished as a result.

Through our addiction to the (philosophical) mirage of Art, we have
thus cut ourselves off from the multiple and changing reality of the arts
and art works; by claiming that Art was more important than this or that
work, here and now, we have weakened our aesthetic sensibility (and—
often—our critical sense); by reducing art works to metaphysical hiero-
glyphs, we have rarefied our paths to pleasure and denied the cognitive
diversity—and thus the richness—of the arts.

Nothing in this world, or in the other, ever replaces anything else. This
holds true for art: while it can be put in the service of religious revelation—
and it has often served it splendidly—it cannot replace it; if it can set forth,
illustrate, or defend metaphysical doctrines—and it has sometimes done
so with great elegance—it cannot replace their philosophical elaboration.
To think otherwise is to allow oneself to be deceived by mere words. This
in no way diminishes the arts; no one is required to do what is impossible.
And anyone who loves the arts has no reason to regret this fact, for the arts
are in themselves—even if they do not serve anything or anyone—such a
source of pleasure and understanding that one is hardly tempted to ex-
change them for a religion or philosophy acquired on the cheap.

What Is Philosophical Aesthetics?

Kantian Prolegomena to an Analytic Aesthetics

P HILOSOPHICAL REFLECTIONS on beauty and the fine arts can be found in every period of the history of philosophy. Today, however, hardly anyone doubts that it was in the eighteenth century, in the wake of Leibnitz, Wolff, and their followers, that a genuinely *philosophical* aesthetics was born.[1] It is generally acknowledged that Baumgarten made the crucial move when he linked the experience of the beautiful (and the fine arts) with the *facultas cognoscitiva inferior*, that is, with knowledge gained through the senses, and especially with knowledge gained through the imagination (*phantasia*) and the fiction-making capacity (*facultas fingendi*): "The science of knowledge and of sensuous representation is Aesthetics considered as the logic of the faculty of inferior knowledge, a philosophy of the Graces and Muses, an inferior gnoseology, an art of beautiful thought, an art of the analogy of reason."[2]

This birth of philosophical aesthetics can be interpreted in two very different ways. We can see in it a simple preparatory step toward the speculative theory of Art; in that case we will say that only the latter resolved the fundamental ambiguity of eighteenth-century aesthetics, which was caught between natural beauty and artificial beauty, between a theory of reception and a theory of the work of art. By means of an analysis of a few aspects of Kant's *Critique of Judgment*,[3] I would like to propose here a different interpretation. The philosophical aesthetics of the eighteenth century was basically pursuing a project different from that of the speculative theory of Art. The former's specific character is most clearly manifested in Kant: it seeks above all to be a meta-aesthetic contemplation, and more precisely an inquiry into the status and legitimacy of judgments of taste. This is not a trait peculiar to Kant. Alfred Baeumler has shown that taste is the essential notion of eighteenth-century aesthetics,[4] and this notion, which disappears in the speculative theory of Art, refers essentially to an activity of judgment. In Kant this discussion leads, moreover, to the idea of a specifically aesthetic Subject.[5] His aesthetics is thus not a theory of art but an anthropology of aesthetic experience and a transcendental analysis of the judgment that translates that experience into discourse.

But Baeumler goes further. According to him, the birth of aesthetics is in fact the dawning in philosophical consciousness of the problem of individuality and its irreducibility to conceptual determinations, since the experience of taste is par excellence an experience of feeling (*Gefühl*). The aesthetic sphere would thus be that of concrete, autonomous subjectivity: in artistic creation and in judgments of taste, the individual acts freely, without being subject to any heteronomy, whether theological, conceptual, or ethical. "Starting out from the question of taste, the third *Critique* discovers the concept of an object that is no longer subject to any doctrine, that is, to any abstract lawfulness that could be formulated a priori. As the end of the preface to the *Critique of Judgment* puts it, here 'Critique takes the place of Theory.' Instead of the pure concept, instead of a theory linked to the representation by a body of rules having absolute value, pure criticism appears. . . . The third *Critique* is solely critical, and no longer a critical preparation for a doctrine: there could not be a theory of its objects, in the sense in which there was still a theory of the objects of *The Critique of Pure Reason* or of *The Critique of Practical Reason*."[6] The idea that there could be no *doctrine* of Art—an idea in which Baeumler rightly sees the most important result of Kant's meta-aesthetic analysis—is in opposition, of course, to the very project of a speculative theory of Art. The romantics were perfectly aware of this and rejected the Kantian conclusion.

Baeumler's general thesis, which links the birth of aesthetics to the philosophical problematics of individuality, is very seductive. Among other things, it permits us to bring together in a synoptic perspective all the eighteenth-century attempts to provide descriptions of human aesthetic faculties, attempts whose most obvious characteristic is a rather disconcerting conceptual disparity: taste, feeling, perfection, imagination, wit (*Witz*), the soul (*Geist*), genius, etc., are all terms whose precise meaning is generally difficult to determine. By proposing to see in them the diverse and changing visages of a single fundamental problem, that of the status of the concrete individual (as opposed to questions that could be resolved by means of deductive rationality), Baeumler gives them a certain coherence. He is moreover supported on this point by Cassirer's interpretation, and at least in part by that of Philonenko. For the latter, the third *Critique*, and above all the part devoted to the critique of aesthetic judgment, is in fact a theory of interhuman communication and of individuality.[7]

I do not doubt that this interpretation reveals the strategic place occupied by aesthetics *in Kantian philosophy*: the *Critique of Judgment* tries to make use of aesthetic problematics for ends specific to the Kantian system. However, my point of view is different: I am interested less in the Kantian system than in the cognitive and historical status of Kant's reflection on aesthetics and the arts. Thus I would like to evaluate the *pertinence*

of the Kantian propositions as well as their specificity with regard to the later tradition. Instead of asking aesthetics to legitimate itself philosophically, I shall seek rather to evaluate it in relation to the object, the facts for which it claims to account.

I have said that the Kantian project is basically different from that of romantic aesthetics and more generally from the speculative theory of Art. We should not conclude, however, that there is no link between them. Thus the Kantian theory of genius is taken over by the romantics; it gives them a psychology of the artist in accord with their definition of Art as ecstatic knowledge. In the same way, the thesis of a finality without goal that is specific to the aesthetic object survives in the romantic thesis that the art work is autotelic and organic. That is because the fundamental disharmony between Kant and the speculative theory does not concern primarily the conception of the work of art, a conception that the author of the *Critique of Judgment* found in an artistic context that was *already* partly pre-romantic. Any analysis must obviously take into account this ambiguity of Kantian aesthetics and its exploitation by nascent romanticism.

<div align="center">

THE JUDGMENT OF TASTE AND FINALITY WITHOUT
REPRESENTATION OF A SPECIFIC END

</div>

We know that Kant accepts three fundamental human faculties: the faculty of knowledge, the faculty of desire, and the feeling of pleasure and displeasure. The faculty of knowledge and the faculty of desire each have a priori principles (the a priori forms of intuition and the categories, on one hand, the moral law on the other). One of the questions the *Critique of Judgment* proposes to answer is whether the feeling of pleasure and displeasure has its own peculiar a priori principle. Hence from the outset the aesthetic problematics is made part of an overall strategy. For the question as to whether or not there exists an a priori principle of the feeling of pleasure is linked to the philosophical problem of individuality and of direct communication. Cognitive communication is always mediated by universal concepts that treat singularity as just so many "cases." The same thing happens, although for different reasons, in moral communication: the human subject encounters others only as postulated ideal subjects in submission to the moral law. The importance Kant accords to aesthetics has to do with the fact that he thinks he can show that in contrast, aesthetic judgment, a singular judgment expressing directly an individual feeling, realizes a direct intersubjectivity.

The essential question he has to confront from this point of view is *how* the feeling of pleasure and displeasure can give rise to a judgment with intersubjective validity. Is it because the feeling of pleasure and displeas-

ure is not radically private? Can one still speak of judgment and inter-subjective validity in the absence of conceptual determination? The famous analysis of the four "moments" of aesthetic judgment seeks to answer these questions: it is supposed to guarantee both the universalizable character of aesthetic judgment *and* its autonomy.

Let us briefly recall these four moments:

a) *Quality*. The judgment of taste judges an object or a representation on the basis of a pleasure or displeasure, but without this feeling being determined by an interest in the object's existence. This *disinterested character* is the essential quality of any judgment of taste, or at least of any pure judgment of taste. And this is what distinguishes it from practical judgment: the latter, when it is empirical, *expresses* an interest (thus when I use the adjective "agreeable" to characterize an object, I am expressing the interest I have in the existence of this object); when it is pure, it *provokes* an interest (to the extent that the ethical law requires that sensuous reality be in accord with it, pure practical judgment provokes an interest in the realization of that accord). Disinterested, aesthetic judgment is thus free, and not only with regard to subjective preferences (hence with regard to what I find agreeable or disagreeable), but also with regard to the moral law (with regard to what is imposed on me as an obligation). Kant says that it is "self-legislative": it determines itself through its own reflective activity exerted on the form of sensuous representation. We see immediately why only the *formal* properties of the object are involved in the judgment of taste. If judgment dealt with matter, it would no longer be free, for confronted with matter the subject's sensation is always receptive, passive; in the domain of form, on the other hand, it is active, since form is imposed on matter by the human mind. The formalist nature of Kantian aesthetics (which explains in particular his ambiguous attitude toward music and color in painting[8]) thus derives directly from his theory of knowledge, and more precisely from his distinction between form and matter, between the spontaneity of the understanding and the receptivity of sensibility.

b) *Quantity*. The beautiful established by the judgment of taste pleases *universally*, but without concept. It pleases universally because it is based neither on a personal preference nor on a perceptual idiosyncrasy. So far as the latter is concerned, it is distinguished from naked sensation: the latter is also "without concept," but it is at the same time radically private and incommunicable; consequently a simple pleasure of sensation can never demand universal assent.[9] Of course, because the beautiful pleases without concept, the judgment of taste is also distinguished from cognitive judgment. In fact, if the beautiful could be conceptually determined, it would no longer express a subject's immediate feeling but would be subject to the rules of the understanding. And at the same time it would determine its object. For Kant the judgment of taste is not a judgment that

determines an object: it expresses the *relation* between a subject and an object. To be more precise: the judgment of taste does not enunciate any proposition concerning the conceptually determined properties of the object, but rather concerns the relation between the subject and the representation of the object. Thus when we refer aesthetic predicates to the objectal structure (*Beschaffenheit*), we are in reality making a projection that belongs to the domain of the "as if" (*als ob*).[10] Aesthetic predicates are *not* object predicates but relational predicates that connect the object with a specific mental state of the subject. Their universality is not due to some conceptual determination of the object, but to the fact that they claim that they can be shared by all subjects who judge; it is a matter of a "universality of voices," of a subjective and prescriptive universality. This logical determination of aesthetic predicates implies a radical distinction between aesthetic judgment, which is based on a feeling, and cognitive judgment, which is based on a conceptual mediation. Let us at once note that a single object can be approached from both angles: a formal or structural analysis of a work of art is *not* a judgment of taste but rather a cognitive judgment. At the same time, Kant thinks it is impossible to deduce or derive a cognitive judgment from a judgment of taste: "from concepts there is no transition to the feeling of pleasure or displeasure."[11] In other words, *no descriptive theory of the arts could ever be derived from an evaluative determination and vice versa.*

What then might be the precise relation between the feeling and the judgment of taste based on it? In § 9, Kant maintains that the judgment must *precede* the feeling, since only this priority of judgment can guarantee the feeling's universal communicability. He even goes so far as to maintain that the feeling of aesthetic pleasure is nothing other than the feeling of the communicability of the judgment. But at other points he seems to acknowledge that the judgment of taste, that is, evaluative judgment proper, would be more a sort of secondary activity superadded to the primary reflection on the form, this primary reflection giving rise to the feeling of the beautiful. In this perspective, the feeling of the beautiful and the demand for intersubjectivity would constitute two independent phases in aesthetic experience.[12] In general, Kant prefers the first thesis because of its links to the theme of intersubjectivity and communicability. But Paul Geyer has very pertinently objected that if we collapse the question of the beautiful and that of intersubjectivity into a single problematics, "we would arrive at the strange consequence that in circumstances in which the communicability of experience was not or could not be considered, that is, in circumstances of contingent isolation or necessary solipsism, not only would judgments of taste be out of place, but even aesthetic pleasure itself could not exist."[13] Kant defends the thesis of the priority of judgment over pleasure with such insistence because only in this way can the domain

of the practical and the theoretical find a bedrock foundation in the utopia of a direct, nonmediated communication.

c) *Relation*. According to paragraph eleven of the *Critique of Judgment*, the judgment of taste finds its foundation in "the form of finality of an object (or mode of representing it)"[14]—the form of a *finality exclusive of any end*. Unfortunately, Kant's developments of this thesis, on which his whole conceptual edifice is based, remain very abstract. Part of the difficulty undeniably results from the paradoxical character of this teleology, since it cannot give rise to the representation of a determinate end. Hence the expression "the form of this finality" (*Form der Zweckmässigkeit*): the beautiful object is not an object that a determining judgment recognizes as being in conformity with a (specific) end, but rather an object that, for a reflective judgment (aesthetic judgment), exhibits the form of finality as such (indefinite). Concretely: when a flower pleases me aesthetically, it is not because I recognize that the arrangement of its organs is in conformity with its reproductive end (a specific end), but rather because this arrangement is such that it arouses in me the idea that it could not be simply contingent but must be in conformity with some (indeterminate) purposeful intention.

In other words, aesthetic teleology does not refer to any objective goal of the object: in fact, the latter is always specific, that is, it presupposes principles of teleological connection that are *conceptually determined*. If the beautiful object pleases me by virtue of the representation of a determinate end (because it is agreeable, good, or perfect), it would no longer please me without a concept. From this it follows that the judgment of taste, although it is a *reflective* judgment, would not be a *cognitive* reflective judgment. In reality, cognitive reflective judgment always bears on a teleology that is postulated as *objective* (for example, an organic finality in the arrangement of an animal's organs); on the other hand, reflective *aesthetic judgment* bears solely on the *feeling* of an *unspecified* purposeful form, experienced as a state of harmony among the representative faculties.

The very notion of a finality without representation of a specific end remains largely obscure: Kant links it to the experience of a harmonious resonance of our cognitive faculties, or more precisely, he claims that it derives from this resonance. The thesis of the harmonious resonance of the cognitive faculties is clearly not paradoxical, like that of a finality without representation of a specific end. Let us return to our flower example: according to the first hypothesis, I find it beautiful because if I were to devote myself freely, that is, without any objectal constraint, to the "formative" activity of my productive imagination (in accord with the laws of the understanding) I would have a tendency spontaneously to project, among other things, a form of the same type as the one presented to me by the flower. Thus the form of the beautiful object is such that it spontaneously

accords with the generic requirements of my faculties of knowledge and puts them in a relationship of reciprocal harmony. This accord between the given and the spontaneity of our mental faculties is purely contingent, since the laws of nature do not in any way require it (if this were not so, *every* object perceived would be beautiful[15]). Hence—and here the second hypothesis comes into play—when there is an accord, we cannot avoid postulating a certain purposiveness in the representation in question, that is, a certain harmony between (phenomenal) nature and the supra-sensuous substrate that we postulate as its Idea.

Now it seems to me that this link between finality without representation of any end and the feeling of the harmony of our faculties is a nonanalytic postulate. It is not clear why the contingent character of the harmonious accord of our faculties *should* lead us to have the experience of a feeling of finality (without a specific end); and all the less since elsewhere—Kant often insists on this—our empirical relationship to the world *forbids* us to project any purposefulness into nature: why shouldn't we simply accept this accord as a fortunate circumstance not motivated transcendentally? Unless we approach natural beauty *in analogy* to artificial beauty (for which we postulate a *specific* finality): but this is an explanation Kant would reject because, as we shall see, he does not in any way consider natural beauty a form derived from artificial beauty; on the contrary, artificial beauty is only a secondary, impure form of the beautiful. In any case, the thesis of finality without representation of a specific end does not seem in any way analytically included within the experience of a harmony of the cognitive faculties. This means that one can accept the thesis of the experience of harmony without necessarily being obliged to follow Kant when he connects it with the postulate of a finality without representation of a specific end.

d) *Modality.* The judgment of taste postulates that the beautiful is the object of a *necessary* satisfaction, without this necessity being of a conceptual order. If satisfaction were not necessary, there would be no pure judgments of taste, but solely empirical judgments of taste, that is, ones determined by private sensations. For all that, the necessity accompanying the judgment of taste cannot be an objective, theoretical necessity giving rise to apodictic assertions, nor can it be a practical necessity, that is, the consequence of an ethical law given in an a priori manner. It is an *exemplary* necessity: each judgment of taste claims to be an example of a universal rule that could not be formulated conceptually. Thus even though the pure judgment of taste (by its generic character) is based on an a priori principle (a principle postulating the universal communicability of the pleasure felt in the disinterested experience of a harmony of our cognitive faculties), no judgment of taste (in its individuality) is *determined* by this principle (otherwise it would be a conceptual judgment).

The principle is purely regulative: the necessity connected with the verdict rendered by the judgment of taste resides in its universal communicability, which is postulated as the ideal horizon that is supposed to regulate my individual judging activity. For this reason, the obligation to acquiesce remains conditional: the judgment of taste is always problematic, for nothing assures me that the current case is correctly subsumed under the (nonformulatable) principle that is valid as a rule of assent. This is because the rule is never given as such, but solely in the form of one of its exemplary realizations. On one hand, the exemplary realization is exemplary only because it is in conformity with the rule; on the other, the rule could not be apprehended otherwise than *in* the exemplary realization. The rule is in a way the shadow that the judgment of taste projects in front of itself. This does not mean that it cannot be debated; although one cannot *dispute* a judgment of taste (it cannot be determined conceptually), one can nonetheless *discuss* it (because I can postulate in an a priori manner the possibility of universal assent, hence that of the universal communicability of aesthetic satisfaction[16]).

As the preceding analysis shows, Kant situates the judgment of taste between the radically private character of naked sensation and the strictly legal determination of the judgments rendered by the understanding. The crucial point is the feeling of the harmony of the cognitive faculties. Therefore we must try to determine more closely in what it consists.

Knowledge in its generic character always supposes the intervention of three faculties (if we set aside reason, which does not come into the feeling of the beautiful, but only into that of the sublime):

a) The intuition, which is the faculty that receives sensations.

b) The imagination, which synthesizes the sensations into a unified objectal field. It is intermediary between intuition and the understanding. On one hand it is linked to pure intuition by the fact that it imposes a priori a spatial and temporal structuration on the sensuous manifold. On the other hand, it relates the domain of the sensuous to the laws of the understanding. From this point of view its essential activity is schematization, that is, the sensuous presentation of the conceptual determinations that are provided to it by the understanding. In other words, it is the imagination that brings the sensuous manifold into contact with the organizational principles of the human mind. Whence its crucial importance, but also its difficult-to-explain status.[17]

c) The understanding, which determines the objectal field in the unity of consciousness in accord with a priori rules (categories) and empirical rules, through the intermediary of the imagination that "prepares" the sensuous givens so that the conceptual determinations can be applied to them.

Aesthetic representation brings the faculties of imagination and under-

standing into harmonious resonance, but without setting in motion a specific cognitive process. More precisely, this resonance remains indeterminate in the sense that the aesthetic object initiates neither an activity of specific conceptual determination on the part of the understanding, nor an activity of specific schematization on the part of the imagination. In other words, we experience the adequation of the aesthetic object to a *possible* harmonious activity of the imagination and the understanding, and thus we experience a *state* rather than an activity: the beautiful object is the one that brings about a "generic" equilibrium between the imagination and the understanding. To designate this indeterminate homeostasis, Kant employs the term "play": the free activity of the imagination and its harmony with the faculty of understanding are not subject to the requirements of a specific knowledge, but are simply related to the possibility of an (indeterminate) accord between the imagination and the faculty of knowledge.

The object on which aesthetic judgment bears is clearly never, we must remember, the materiality of a sensation, but rather only its form, and more precisely the unity of the sensuous manifold. In fact, the cognitive faculties are related only to the form of the objects (that is, to what can be universalized), to the formal unity of the sensuous manifold, and not to the material substrates of sensations, which themselves always remain private: "The being (*Wesen*) of the thing consists in the form . . . insofar as it can be known by reason."[18] Aesthetic reflection is reflection on a *Gestalt*.

But how are we to understand this term "form"? Following the usage established in the *Critique of Pure Reason*, the matter of a sensation is the manifold given a posteriori, whereas the form of intuition resides in the pure a priori time and space. Now these a priori forms of sensibility are coextensive with experience *as such*, since without them no experience is possible. As I said, if aesthetic form could be reduced to a priori forms, *everything* would be beautiful. Moreover, to the extent that these two forms belong to the very constitution of experience they cannot be perceived as such: "The simple form of intuition without substance is not an object in itself, but rather the simple formal condition of that object (as a phenomenon), since pure space and time, while they are something as forms of intuition, are not themselves the objects of intuition (*ens imaginarum*)."[19] Now, time and space are the *only* two forms of sensation that Kant acknowledges. And he explicitly opposes them to sensuous *qualities*, for example, taste (in the sense of a bodily organ) and colors: in the *Critique of Judgment* colors, or at least mixed colors, are excluded from the domain of true art because they are sensuous qualities, that is, they have to do with what is pleasant (with matter) rather than with the beautiful (with form). We see the difficulty: beauty cannot reside in a sensuous quality (sensuous qualities are private), but neither can it reside in the

pure a priori form of space and time, since it must always involve a concrete and *contingent* perceptual encounter, whereas these two forms are *necessarily* present in *any* objectal experience. The sole solution seems to be the one indicated by Roger Verneaux: " . . . the forms are space and time. The manifold contained in the forms is thus composed of parts of space and time. These parts do not exist before space and time have been divided, for they are contents. They come into existence in two ways: either because the understanding constructs figures and numbers in them, or because sensations take place in them and thereby distinguish places and moments within them. The first way is entirely a priori; it is the mental activity of mathematical science. The second is empirical in its origin, but the result is pure if we consider it in itself, that is, if we abstract, as aesthetics demands, from the sensations that fill the form, we are left with the empty places, as in the first case."[20] Formal beauty would thus indeed reside in the a priori forms of time and space, but not in their generic qualities: it would be linked to the specific combinations of "places" sketched out by objects that are always particular, combinations coinciding with the paths that the human mind in its freedom would construct in pure intuition. If that is the case, it is easy to understand why aesthetic pleasure is not a brute feeling, but always results from a complex activity of judging.

This analysis also shows to what extent Kantian aesthetics is an aesthetics of visual perception. The visual paradigm is never explicitly formulated, and yet it is clear that the notion of "the harmony of the faculties" is determined within this framework. This fact, of course, is in agreement with the priority Kant accords to natural beauty over artistic beauty.

For Kant, the harmonious resonance of sensibility and understanding brought about by the beautiful object provides not only a foundation for the direct communicability of a feeling, but at the same time a contingent indication of a possible coincidence between nature and what constitutes the fundamental requirement of our reason concerning it, namely that of an integration of its absolute diversity.[21] It is here that the thesis of finality without any end comes in: it is a sort of *analogon* of the supersensuous coherence situated beyond our horizon as finite beings. For that very reason a utopian dimension is introduced into Kantian aesthetics, since the experience of finality without representation of any end shows us that the ultimate identity of the phenomenal world and the noumenal world, while it is inaccessible in the phenomenal world, is not a mere chimera. In other words, through the experience of finality without representation of an end we experience the unity of the sensuous and the supersensuous, even if it is in the simple mode of the "as if." It is clear that this functional interpretation of aesthetics is linked solely to specific requirements of Kantian philosophy—which seeks a direct experience of the supersensuous[22] that it elsewhere declares to be impossible (whence the paradoxical character,

which is purely formal, of aesthetic teleology); it is not called for by specific aesthetic considerations.

We are therefore justified in concluding that it is indeed the thesis of the harmony of the cognitive faculties that legitimates the essential characteristics of the judgment of taste as Kant conceives it, that is, its simultaneously universal and singular, necessary and subjective, character. It is universal and necessary (with a necessity of a prescriptive order) because it results from the experience of a harmony of the generic activities of the imagination and the understanding in free play, an experience that is not brought about by the material substrate of a private sensation, or determined by any practical interest. It is singular[23] and subjective because it always bears on a *singular* object and bears solely on the relation a *representation* (*that is not conceptually determined*) of this object maintains with a possible harmonious activity of our cognitive faculties, and not on objective properties of this object.

Insofar as it is experienced as a feeling of a subjective accord elicited by a sensation, the beautiful is thus always based on the innermost individuality of a concrete encounter. But to the extent that this sensuous representation gives rise to a feeling of the harmony of mental faculties considered in their genericity, Kant thinks that it results from an a priori principle grounded in the very nature of these faculties. In this respect it is universally communicable, since it makes "sense" for every human being: "This state of free play of the cognitive faculties attending a representation by which an object is given must admit of universal communication: because cognition, as a definition of the Object with which given representations (in any Subject whatever) are to accord, is the one and only representation which is valid for everyone."[24]

Thus the subjective harmony of the representative faculties, experienced in the beautiful and expressed in the judgment of taste, exhibits the subjective condition of the possibility of cognitive judgment as such. For the world to be knowable, it must first make sense for a human individuality and intersubjectivity. Now the subjective harmony between the imagination and the understanding, conceived as spontaneous experience of the activity of reason, is also the inner experience of the sense of "what is" for every human being. This experience is based on conditions that are (virtually) valid for every subject even though it expresses the innermost autonomy of the individual who experiences it. If this "representative state" (*Vorstellungszustand*)[25] were not directly communicable, no empirical, objective knowledge would be possible, for the simple reason that knowledge, if it is conceptual, is nonetheless also a phenomenal knowledge, that is, it always presupposes the existence of an accord between what is given in intuition and the conceptual activity that organizes this sensuous given. This accord has to be communicable as such, that is, in its genericity, for

otherwise nothing would allow us to presuppose (as we do) that in different individuals the same conceptual determinations are linked to similar givens; the intuitive givens could be radically different from one individual to another (if we except the formal universality of the a priori conditions of time and space), in which case scientific knowledge would have only a purely formal universality while at the same time remaining radically solipsistic at the level of its relation to the phenomenal world.

To put the point still another way: the activity of a schematism of the imagination, a schematism that makes knowledge possible by effectuating the passage between the understanding and the sensibility, presupposes the possibility of a generic, undetermined accord between these two faculties, that is, it presupposes the possibility of encountering objects such as might be shaped by the schematic construction of the imagination in accordance with the a priori rule of the understanding. The existence of an aesthetic *sensus communis* therefore guarantees that to the intersubjectivity of concepts there corresponds as well an intersubjective reality of the beings determined by these concepts: "But if cognitions are to admit of communication, then our mental state, i.e., the way the cognitive powers are attuned for cognition generally, and, in fact, the relative proportion suitable for a representation (by which an object is given to us) from which cognition is to result, must also admit of being universally communicated, as, without this, which is the subjective condition of the act of knowing, knowledge, as an effect, would not arise."[26]

It is evident that even if we bracket the postulate of finality without representation of any end, the Kantian interpretation of aesthetic experience implies a certain number of very strong theses concerning its status. Is his explanation the only one possible? The most delicate point resides, it seems to me, in the way in which Kant interprets the experience of the harmony of the mental faculties. Are we obliged—if we want to guarantee the public character of this experience—to admit that to it corresponds an a priori transcendental structure?

Generally speaking, the question is that of the relation between Kantian aesthetics and empiricist aesthetics. Hume, for example, has no idea of a transcendental foundation. He limits himself to reducing esthetic judgment to an empirical consensus explicable both by the identity of the human "fabric" and—in the artistic domain, to which, unlike Kant, he grants priority—by culture and education. The norm of taste results from "strong sense, united to delicate sentiment, improved by practice, perfected by comparison, and cleared of all prejudice.[27] The reference to the identity of the human "fabric" allows him to explain the general scope of the judgment of taste on the basis of the purely empirical identity of human sensibility. He might therefore have accepted Kant's definition of the beautiful as a feeling of the harmony of the faculties. On the other

hand, since Hume did not seek a transcendental foundation for this identity, he would have seen it as simply an empirical (biological) fact. A fortiori, he would have had no place for the "finality without representation of a specific end" that is supposed to link the experience of the beautiful with an ineffable supersensuous foundation.

Moreover, although for Hume taste has an *empirical* anthropological foundation, he immediately adds, as I have said, that taste depends just as much if not more on education. Aesthetic experiences are not all equal; the taste of an expert, which is founded on comparison, knowledge of the arts, and practice, is more reliable than that of an uncultured person. In other words, while the judgment of taste is a simple *empirical* judgment, it is *a judgment like others*, that is, it is determined by concepts. Hence when Kant says that the aesthetic sphere is one where the "universal feeling of sympathy" (*Teilnehmungsgefühl*) connecting men to each other and to nature is cultivated, and that its goal is to develop "the faculty of being able to communicate in an inward and universal manner,"[28] Hume could accept that description. But he would have insisted on the fact that this *universal* cultivation of feeling is an *empirical cultivation* among others.

This difference in the way in which the judgment of taste is legitimated has consequences at the level of its status: Hume's aesthetics is an aesthetics of normative consensus, whereas in Kant aesthetic judgment is connected with the autonomy of universalizable feeling. The author of the *Critique of Judgment* very strongly emphasizes this autonomy of aesthetic judgment, even in the domain of the fine arts where, as we shall see, he believes that the judgment of taste can only be impure: "If anyone reads me his poem, or brings me to a play, which, all said and done, fails to commend itself to my taste, then let him adduce Batteux or Lessing, or still older and more famous critics of taste, with all the host of rules laid down by them, as a proof of the beauty of his poem; let certain passages particularly displeasing to me accord completely with the rules of beauty (as set out by these critics and universally recognized): I stop my ears: I do not want to hear any reasons or any arguments about the matter. I would prefer to suppose that those rules of the critics were at fault, or at least have no application, than to allow my judgment to be determined by *a priori* proofs. I take my stand on the ground that my judgment is to be one of taste, and not one of understanding or reason."[29] The certainty that accompanies my judgment of taste is founded on the fact that, considered ideally (and I have to consider it ideally if I want to present it as a pure judgment of taste), it is not my judgment, but that of all humanity. To be sure, Kant does not go so far as to deny that the faculty of taste can be refined by education and experience, but fundamentally he believes that it is based on the spontaneity of the *sensus communis*.

The Kantian approach and the Humean approach rest upon very dif-

ferent conceptions of aesthetic judgment.[30] Kant privileges the autonomy based on inner feeling, whereas Hume privileges the normative character based on intellectual cultivation. Similarly, one privileges natural beauty, the other artificial beauty. The priority Kant accords to natural beauty is directly linked to his thesis of finality without representation of a specific end, a thesis that is more plausible in this domain than in that of art. His aesthetics remains fundamentally Rousseauist in the priority it accords to natural beauty, and also in its emphasis on the spontaneity and autonomy of aesthetic judgment. In fact, largely because he refuses to concede that the judgment of taste, at least in its paradigmatic form, can include conceptual determinations, Kant encounters difficulties as soon as he tries to extend his theory to the domain of the arts.

Some of the problems encountered by the attempt to give aesthetic judgment a transcendental foundation are illustrated by the ambiguity of the status Kant accords to the *sensus communis*. By making the aesthetic sphere the locus of direct human communication, and the only one capable of guaranteeing the communicability of human knowledge, it would seem that Kant is obligated to consider the aesthetic common sense as a *constitutive* principle. In fact, if aesthetic judgment is supposed to be the *foundation* of cognitive judgment and moral judgment, then its principle, the common human understanding, must have a constitutive status; it is difficult to see how a condition of possibility could be merely a postulated Idea. Such a determination of the status of the common sense is, however, unacceptable: it would in fact amount to a destruction of the Kantian conception of aesthetic judgment. In fact, if the common sense were a constitutive principle, it is no longer clear how the purely *obligatory* character of the universality and necessity of aesthetic judgment could be preserved. This problem is not encountered by empiricist aesthetics. If the *sensus communis* is indeed a natural aptitude, the latter has no foundational function for knowledge; moreover, it is perfectible through practice and is therefore in no way connected with constitutive rules given once and for all. In Kant, on the other hand, if the aesthetic sphere has to retain its specificity with regard to the cognitive sphere, the *sensus communis* must be a simply *regulative* principle; if this were not so, aesthetic judgments would become just as apodictic as cognitive judgments. In paragraph 22 Kant shows that he is well aware of the alternative: "This indeterminate norm of a common sense is, as a matter of fact, presupposed by us; as is shown by our presuming to lay down judgments of taste. But does such a common sense in fact exist as a constitutive principle of the possibility of experience, or is it formed for us as a regulative principle by a still higher principle of reason, that for higher ends first seeks to beget in us a common sense? Is taste, in other words, a natural and original faculty, or is it only the idea of a faculty that is artificial (*künstliche*) and to be acquired by us

. . .?"[31] Only the second option allows us to preserve the purely obligatory specificity of aesthetic judgment as Kant analyzes it elsewhere. Clearly, however, when it is thus conceived the *sensus communis* can no longer function as a subjective *condition of the possibility* of the communicability of a cognitive judgment; what aesthetics gains in autonomy it loses in founding power.[32] Even so, we must add that this autonomy may well be of short duration, for if we read attentively the passage just quoted, it appears that the common sense is supposed to be produced "for higher ends": contrary to what happens in Hume, where the perfectibility of aesthetic judgment promises essentially no more than a maximization of aesthetic pleasure, in Kant this pleasure points toward another domain that is not properly aesthetic but instead belongs to an ethical-social dimension.

We will encounter a similar hesitation in the discussion of art, where Kant constantly oscillates between the theory of genius and the theory of taste, between the utopia of a "natural" and "spontaneous" creation and the acceptance of art as a cultural fact. This "Rousseauism" of Kant's and his utopian aesthetics are not unrelated to the birth of the speculative theory of Art.

NATURAL BEAUTY AND ARTIFICIAL BEAUTY: THE STATUS OF THE FINE ARTS

The fact that Kantian aesthetics is linked to a transcendental anthropology far more than to a theory of art is illustrated in a striking manner by the priority it accords to natural beauty over artificial beauty.

As early as the nominal definition of taste with which the "Analytic of Aesthetic Judgment" opens, we find an indication of this irreducibility of the beautiful to the fine arts: "The definition of taste here relied upon is that it is the faculty of estimating the beautiful. But the discovery of what is required for calling an object (*Gegenstand*) beautiful must be reserved for the analysis of judgments of taste."[33] It is no accident that Kant speaks of an object rather than of a work: beauty, rather than being the predicate of a work, and more generally, rather than being the predicate of a class of specified objects, is a predicate of representational "objectness" as such, that is, it is not specified as having natural or artificial status. It cannot be said in advance to which class a beautiful object belongs; beauty is, let us recall, a matter of an absolutely contingent conjunction. This objectal indetermination is connected with the claim that there is no procedure allowing us to reduce aesthetic predicates to conceptually describable objectal properties (beauty has nothing to do with the logical sphere of the object). To adopt a term encountered earlier: the beautiful object is not so much the *object* represented as the object maintained in the *representative state* (*Vorstellungszustand*); it is on the latter that the disinterested and conceptually indeterminate reflective activity is exercised. The emphasis

on the disinterested character of aesthetic satisfaction thus does not have as its aim to establish the autotelic nature of the work of art (as will be the case in Schiller and in romanticism). It does not even result in the definition of an ontological sphere of specific objects that would be beautiful objects (aesthetic realism); it serves primarily to distinguish the aesthetic *relation* from other relations in the world: the same object can elicit diverse attitudes according to the differing orientations of human faculties. Naturally, an object has to fulfill certain conditions in order to function as a beautiful object. But since these conditions are not conceptually determined, they do not allow us to define a class of objects based on discriminatory characteristics. All one can say is that *if* an object pleases, then it fulfills the conditions in question, which are, let us remember, conditions of contingent subjective harmony: "one cannot determine *a priori* what object will be in accordance with taste or not—one must find out the object that is so."[34]

We find a particularly revealing indication of the "indeterminist" conception of the beautiful object in a passage devoted to the division of the arts and more specifically to painting. According to Kant, landscape gardening is part of painting. The thesis itself is a commonplace of the period. But the reason he gives is interesting: if landscape gardening can be considered as belonging to pictorial art, it is because painting cannot be reduced to the reproduction of nature (mimetic painting). *Every* beautiful visual arrangement has to do with painting. As a tableau in the strict sense of the term, every beautiful arrangement of material things exists only for the eye. This links it generically to pictorial art: "In addition I would place under the head of painting, in the wide sense, the decoration of rooms by means of hangings, ornamental accessories, and all beautiful furniture the sole function of which is *to be looked at*; and in the same way the art of tasteful dressing (with rings, snuff-boxes, etc.). For a *parterre* of various flowers, a room with a variety of ornaments (including even the ladies' attire), go to make at a festal gathering a sort of picture which, like pictures in the true sense of the word (those which are not intended *to teach* history or natural science), has no business beyond appealing to the eye, in order to entertain the imagination in free play with ideas, and to engage actively the aesthetic judgment independently of any definite end. No matter how heterogeneous, on the mechanical side, may be the craft involved in all this decoration, and no matter what a variety of artists may be required, still the judgment of taste, so far as it is one upon what is beautiful in art, is determined in one and the same way: namely, as a judgment only upon the forms (without regard to any end) as they present themselves to the eye, singly or in combination, according to their effect on the imagination."[35]

As this long quotation shows, Kant recognizes that from the point of

view of creative intentionality there is no unity in a fashionable party, just as he acknowledges that the creations that may be encountered there are connected with the mechanical arts rather than with the fine arts; and yet he considers the living tableau constituted by such a fashionable party a kind of painting, for the simple reason that when an observer who likes this sort of thing makes an overall judgment regarding the formal organization of the perceptual field thus offered him, it "is always uniformly determined," that is, it is based on the simple disinterested pleasure that the contemplation of this tableau awakens in him. We see here once again that the aesthetic predicate refers essentially to a receptive attitude and hence no difference in essence separates an art work from a composite visual arrangement, nor, one might add, from a natural landscape. In the case of the composite visual arrangement constituted by a fashionable party, a good many fortuitous factors are involved, for the overall formal effect presented by a decorated room enlivened by human movements and groupings can only be changing, a series of snapshots offering themselves for the disinterested pleasure of the observer.

It would be a mistake, however, to believe that the slender significance accorded the fine arts by Kant is due solely to the fact that he is interested in the aesthetic *relation* and that as a result the categorial differences among aesthetic *objects* are not important for him. Or rather, that holds true for the initial phase of his analysis. But very quickly he asserts that in fact the type of objects *is* very important: he even tells us it is only with regard to natural objects that the aesthetic relation can establish itself in all its freedom. Whence a genuine devalorization of artificial beauty which in Hegel, it is interesting to note, corresponds to the exactly contrary tendency to devalorize natural beauty.

In defense of his conception, Kant advances two reasons that seem to contradict each other. On one hand, artificial beauty is aesthetically less central than natural beauty because it almost never elicits a *pure* aesthetic judgment; on the other hand, it is less valuable because no direct moral interest accompanies it.

The first devalorization is entailed by the definition of aesthetic judgment and its object: aesthetic judgment legitimates universally the inner experience of a harmonious relation among our cognitive faculties that is "experienced" in relation to a perceptual object apprehended as manifesting a finality without representation of any specific end. According to Kant, when confronted by a natural object this pleasure is at once *stronger* and *purer* than when confronted by an artificial object.

Why is the pleasure stronger? Any human creative activity, whether artisanal or belonging to the fine arts, can be referred to a determinate intention (*Absicht*). Thus if we experience a finality in a work of art, this is in conformity with our expectations, since we know that such an object

corresponds to a specific end, namely the one that guided its creator. Inversely, if we experience such a finality in a natural object, we are always pleasantly surprised: not only does nothing lead us to expect such a finality in nature, but—as we have seen—the principles governing the knowledge of nature strictly *forbid* us to attribute to it any sort of real final intention (*Absicht*). Consequently, the pleasure derived from natural beauty will be much stronger than that produced by artificial beauty.

Why is it purer? Our understanding forbids us to subsume a natural object under a final cause, and hence it forbids us to make any determining use of our faculty of judgment in this domain. If we nonetheless encounter a finality without representation of a specific end, this experience will more easily remain pure; by virtue of the aforementioned prohibition, we will not in fact be tempted to subject it to conceptual determination. On the other hand, in the technico-practical sphere of human products, the situation is reversed: we spontaneously assume that human products *are* in conformity with specific ends that the artisan or artist had in mind, and thus we conceive them as determined by conceptualizable rules. As a result, when confronted by a product of the fine arts we will tend to make use of a cognitive judgment (determining or teleological) rather than a purely aesthetic judgment; that is, we will tend to refer the object to an intentional cause and to judge it in accordance with its conformity to its specific finality. Let us note that for Kant (at least at this stage of his reflection) this manner of proceeding is not only inevitable but also perfectly legitimate in the domain of human *artefacta*; nevertheless, it runs counter to the possibility of a *pure* aesthetic judgment, that is, one without reference to a determinate finality.

The question can also be approached from another point of view: every end presupposes an interest, that is, every final product can be referred to the faculty of desire of the person who created it. Whether the faculty of desire is determined a priori (by a practical law) or a posteriori (by technico-practical empirical maxims), in either case the fact that we know that it is fundamental to the work's existence (the work exists because someone has desired it) threatens to adulterate the purity of the aesthetic judgment we make concerning it. We will tend to refer its formal finality to the same faculty of desire, thus confusing the question of the foundation of the object's existence with the problem of its aesthetic quality.

Kant concedes that it might be objected that there are objects that have a technico-practical end and that we are nonetheless obliged in practice to apprehend as finalities without specific end, simply because we do not know what their specific end is. When we find a stone implement from the Paleolithic age whose use is unknown to us, do we not experience a finality without specific end? And yet it does not provoke any aesthetic pleasure

(at least according to Kant). We have to conclude that finality without representation of a specific end is *not* identical with beauty. Kant nevertheless considers this objection unimportant, since "the very fact of [such implements] being regarded as art-products involves an immediate recognition that their shape is attributed to some purpose or other and to a definite end. For this reason there is no immediate delight whatever in their contemplation. A flower, on the other hand, such as a tulip, is regarded as beautiful, because we meet with a certain finality in its perception, which, in our estimate of it, is not referred to any end whatever."[36] In other words, in the case of a prehistoric object we do not experience a finality without representation of a specific end; this end simply remains unknown to us. Thus the question is not whether we are capable of connecting the object with a determinate intention, but whether we *posit* such an intention. We do not posit such an intention for natural objects, and that is why, when they manifest a finality, it is a finality without representation of a specific end, giving rise to a pure aesthetic experience; in contrast, we do posit such an intention for human *artefacta*, and as soon as we know we are confronted with such an object, we posit a specific end (whether or not we are able to determine it), and hence we are outside the realm of pure aesthetic experience.

The second important argument Kant advances in favor of the privilege he accords to natural beauty is that it almost always elicits a moral interest. In fact, the author of the *Critique of Judgment* thinks the contemplation of natural beauty always refers us to the supersensuous, to the realm of ends as a practical Idea:

> I willingly admit that the interest in the beautiful of art (including under this heading the artificial use of natural beauties for personal adornment, and so from vanity) gives no evidence at all of a habit of mind attached to the morally good, or even inclined that way. But, on the other hand, I do maintain that to take an immediate interest in the beauty of nature (not merely to have taste in estimating it) is always a mark of a good soul. . . . One who alone (and without any intention of communicating his observations to others) regards the beautiful form of a wild flower, a bird, an insect, or the like, out of admiration and love of them, and being loath to let them escape him in nature, even at the risk of some misadventure to himself—so far from there being any prospect of advantage to him—such a one takes an immediate, and in fact intellectual, interest in the beauty of nature. This means that he is not alone pleased with nature's product in respect of its form, but is also pleased at its existence, and is so without any charm of sense having a share in the matter, or without his associating with it any end whatsoever. . . . The superiority which natural beauty has over that of art, even where it is excelled by the latter in point of form, in yet being alone able to awaken an immediate inter-

est, accords with the refined and well-grounded habits of thought of all men who have cultivated their moral feeling.[37]

There is therefore a great difference between the contemplation of natural beauty, defined as solitary contemplation linked directly to an interest of reason, and the contemplation of artificial beauty, linked to social life, including its vanities. Contrary to artificial beauty, which can be referred only to taste (but to a judgment of taste that is rarely pure, since considerations of intentionality are involved), natural beauty gives rise not only to a judgment of taste (pure, because not linked to any idea of a specific final intention), but also—and in a paradoxical manner—to a practical judgment, since I take an interest in the existence of the object. This practical judgment is also a pure judgment, since it is not linked to any sensuous characteristic or to any subjective end: it judges the pure conformity (which is contingent) of a natural object with a supersensuous interest. Reason takes an immediate interest in the Ideas being realized in the sensuous world; every experience of a final form, even if indeterminate, is a trace, in nature, of the Idea of supersensuous causality postulated by reason. The moral priority accorded natural beauty is thus directly linked to the purity of the experience of a finality without representation of a specific end: this only shows once again to what extent the thesis of finality without representation of a specific end goes beyond the aesthetic problematics. Far from guaranteeing the latter's autonomy, it subjects it to a practical finality. Let us also note that Kant here explicitly devalorizes formalism, which is nonetheless at the very foundation of his definition of aesthetic judgment: although artificial beauty may surpass natural beauty insofar as the form presented is concerned, natural beauty must still be preferred by virtue of the moral interest attached to it.

According to Kant, there is no contradiction between the idea that the judgment of taste applied to natural beauty is a pure aesthetic judgment par excellence—thus disinterested—and the idea that it is directly linked to a supersensuous interest. The two judgments, though connected, remain independent: the judgment of taste on natural beauty remains pure because moral reflection *is added* to it without resulting in the slightest mixture of the two. The aesthetic judgment on natural beauty elicits, as it were, a second, reflective judgment that bears on the aesthetic judgment proper and refers to a possible supersensuous end the finality without end that founds it. In contrast, the work of art, in its very specificity, seems to presuppose the idea of an end. This idea *precedes* the judgment of taste, so that in making the latter, if it is to be pure, we must carry out the inverse task, which consists in *forgetting* that we are confronted by an intentional product, that is, a product that is "clearly intended to satisfy us." A pure aesthetic judgment with regard to a human product would be possible

only if its intentionality could remain invisible; we shall see that this will occur in the case of a work of genius, but the latter is the exception rather than the rule. In conclusion, if a judgment on natural beauty is a judgment of pure taste (based on the feeling of a finality without representation of any end) linked directly with a supersensuous interest, a judgment on artificial beauty is on the contrary always a judgment of applied taste, that is, mixed with considerations of formal perfection governed by a specific end.

Whatever we think of Kant's decision to accord priority to natural beauty because of its ethical implications, it is not pertinent from the strictly aesthetic point of view, since the analysis of aesthetic judgment has been carried out without the slightest reference to this moral function. At different times, Kant has been praised or attacked for having made aesthetic pleasure lead to a moral function: in fact, if moralism is superadded to aesthetic analysis proper and is logically independent of it, we are not obliged to take it into account evaluating the aesthetic theory proper.

The distinction introduced earlier between the judgment of taste and the judgment of applied taste is closely linked to the pair constituted by free beauty (*pulchritudo vaga*) and beauty that is merely dependent (*pulchritudo adhaerens*). Dependent beauty always presupposes a concept of what the object should be and it conceives the perfection of the object in accord with this concept. It therefore introduces conceptual determinations and does not give rise to a pure judgment of taste:

> In the estimate of a free beauty (according to mere form) we have the pure judgment of taste. No concept is here presupposed of any end for which the manifold should serve a given Object, and which the latter, therefore, should represent—an encumbrance which would only restrict the freedom of the imagination that, as it were, is at play in the contemplation of the outward form. But the beauty of a man . . . , the beauty of a horse, or of a building (such as a church, palace, arsenal, or summer-house), presupposes a concept of the end that defines what the thing has to be, and consequently a concept of its perfection; and is therefore merely appendant beauty. Now, just as it is a clog on the purity of the judgment of taste to have the agreeable (of sensation) joined with the beauty to which properly only the form is relevant, so to combine the good with beauty (the good, namely of the manifold to the thing itself according to its end), mars its purity.[38]

This passage must be analyzed somewhat more closely, for it indicates a recurrent difficulty in Kantian aesthetics. Up to this point I have implicitly assumed that the idea of a specific end was connected with any human production. This is, moreover, a conception Kant himself repeatedly defends. In light of the passage just quoted, however, it seems to require further examination.

For one thing, the examples of determinate finality concern not only artificial products but also biological organisms: human beings, horses, etc. It would nevertheless be a mistake to believe that this view is valid for the biological organism as such, in other words, that biological organisms must be excluded from natural beauty in the paradigmatic sense of the term. In fact, in the paragraph preceding the one from which this quotation is taken, we read: "Many birds (the parrot, the hummingbird, the bird of paradise), and a number of crustaceans, are self-subsisting beauties which are not appurtenant to any object defined with respect to its end, but please freely and on their own account."[39] Thus within the realm of nature itself we must distinguish free beauties from dependent beauties, that is, those determined by an end: in the horse, the adaptation of its anatomical constitution to the mode of locomotion produces a dependent beauty; inversely, the plumage of exotic birds or the forms of certain marine crustaceans belong to natural beauty because (according to Kant) they do not correspond to any specific end. One could obviously ask what ground could be established for making such a distinction. Elsewhere, giving in a rather helter-skelter manner the human form, the form of a horse, and architectural works as examples, Kant blurs the dividing line between natural objects, which are not susceptible of any teleological interpretation, and artificial objects, which are human products corresponding to an end.

The situation becomes even more complicated, for there are also free beauties among the products of human activity: "So designs *à la grecque*, foliage for framework or on wall-papers, &c., have no intrinsic meaning; they represent nothing—no Object under a definite concept—and are free beauties. We may also rank in the same class what in music are called fantasias (without a theme), and, indeed, all music that is not set to words."[40] When free beauties were contrasted with architecture it seemed that the latter was not accessible to a pure aesthetic judgment since it includes a functional dimension. But the examples of geometric and decorative designs, as well as the examples of improvised music and music not set to words, seem to introduce a second factor of impurity: the representational relation. For to what are opposed designs *à la grecque* and foliage that "represent" nothing, if not to representational painting? To what should we oppose music not set to words if not to music "set to words," that is, to works having a representational verbal component? Nevertheless, even if they are not representational, geometric designs, foliage, and even "pure" musical compositions still correspond to an *Absicht*, to a specific end: these are in no way natural concretions but human products that are just as intentional as a representational picture. In other words, just like a figural work of art, foliage, designs *à la grecque*, and "pure" music have to mobilize a judgment concerning their conformity to

a specific end. As for the implicit opposition (which derives from the example of architecture) between purely aesthetic works and works that have a "utilitarian" function, it is clearly not congruent with either the one between "free beauties" and representational works, or the distinction between "finality without representation of a specific end" and specific finality. When Kant said that pure aesthetic judgment was incompatible with the idea of a specific finality, the *type* of this finality ("utilitarian" or "hedonic") was not important. What prevented the possibility of a pure aesthetic judgment in the domain of artworks was the generic fact that *qua* human products they are the result of a specific intention. This problem is completely independent of the opposition between a utilitarian end and a purely aesthetic end.

Whatever we say about these manifest contradictions, taken as a whole the passages we have just analyzed reinforce the depreciation of the domain of the fine arts. If we accept the thesis concerning finality without representation of a specific end, no pure aesthetic judgment is possible in the fine arts; since artistic products are intentional products, they are governed by specific ends, and therefore can be judged conceptually. If we accept the (inconsistent) criteria analyzed last, the outlook is hardly brighter: the art is the most in conformity with the pure judgment of taste will be purely decorative art. Inversely, the canonical arts (with the exception of "pure" music) are either representational (literature, painting, sculpture, vocal music) or linked to a utilitarian function (architecture); thus they seem to preclude any pure judgment of taste, the utilitarian *or* the representational function interfering with the purely contemplative apprehension of the form. But this preeminent place accorded to the decorative arts collides head-on with *another* Kantian thesis, according to which purely decorative works belong to the category of the agreeable rather than to that of the beautiful, for they please chiefly at the level of empirical sensation. Thus we learn that ornamentation (of which the use of colors in painting is moreover part) is acceptable only insofar as it brings out the formal beauty; as soon as it becomes autonomous, it no longer belongs to the category of the beautiful.[41]

Therefore Kant has to shift his aim in order to escape these unwanted consequences of the thesis of a finality without representation of a specific end. This is where the theory of genius comes in. It is through this theory that the author of the *Critique of Judgment* will seek to reconcile art with aesthetics: it will allow him to introduce free beauty, the pure judgment of taste, into the domain of the canonical arts. This is a move heavy with consequences since it abolishes the thesis of the intentionality of artistic products and thus cuts them off from other human *artefacta*; romanticism will take off from precisely this radical separation between the domain of the canonical arts and that of other human activities (including ones that

obviously have a significant aesthetic dimension, such as the decorative arts). Thus the difficulties inherent in the theory of pure aesthetic judgment—essentially the paradoxical consequences of the thesis of a finality without representation of a specific end—lead Kant to lay the ground for what will be one of the central components of the speculative theory of Art, namely the thesis that the artwork is autotelic, its own end.

GENIUS AND TASTE

The difficulty to which the theory of genius claims to respond is perfectly summarized in the formula with which Kant introduces his study: "the finality in the product of fine art, *intentional though it may be, must not have the appearance of being intentional*; i.e., fine art must be clothed with the aspect of nature, although we recognize it to be art."[42] Every art presupposes rules through which an object is represented as possible; otherwise we could not speak of an artistic product. On the other hand, however, a pure judgment concerning the beauty of a work must not be derived from any rule that has a concept for its determining ground. In particular, it cannot be derived from a concept of the way in which the product is possible. Kant's initial analyses had clearly suggested that such a pure aesthetic judgment was simply impossible in the domain of the arts. The theory of genius revokes that impossibility and claims to show that art *can* be susceptible of a pure aesthetic judgment by combining two contradictory characteristics: being an object produced intentionally, but one in which the intentionally is effaced.

Kant starts out from the traditional identification of genius with talent, the latter being defined as an innate gift deriving from "the subject's nature."[43] Thus a work of genius will be one in which the nature of the subject (talent) gives the rule to art. This definition satisfies the two contradictory requirements set forth above. On one hand, the genius is incapable of rationally grounding his rules himself, since they are grounded in his nature; they are undergone by him passively and not actively elaborated, as in the case of concepts. In this way we avoid the idea of a conceptual determination of the rules, which would be incompatible with the "finality without representation of a specific end" of beauty: "where an author owes a product to his genius, he does not himself know how the ideas for it have entered into his head, nor has he it in his power to invent the like at pleasure, or methodically, and communicate the same to others in such precepts as would put them in a position to produce similar products."[44] On the other hand, the genius *gives* the rules, and we shall see that these rules, which ground the exemplarity of the work of genius, can in a certain way be discovered by its receivers. Thus paradoxically the latter can interpret the work of genius as making use of compositional rules, and thus as cor-

responding to a specific end, an interpretation that cannot be made by the individual genius himself.

The mental faculty through which the genius expresses himself is the productive imagination. Its specificity resides in the fact that contrary to the *reproductive* imagination, it is not limited to reactivating sense impressions, but rather projects, as it were, intuitions that do not correspond to any real past experience and, especially, intuitions to which no concept of the understanding could be adequate. There are two reasons why the products of the productive imagination cannot be subjected to a conceptual determination. First, the productive imagination frees itself from the law of association (of sense impressions) that limits the reproductive imagination; in artistic creations we borrow materials from nature, to be sure, but it is possible for us to transform them "into something else—namely, what surpasses nature." In this way the productive imagination creates "a second nature out of the material supplied to it by actual nature."[45] Secondly—and this is, Kant adds, the "most important reason"—this irreducibility has to do with the fact that the products of the imagination are inner intuitions and hence irreducible to any concept. Such an inner intuition gives rise to an aesthetic idea, a "representation of the imagination which induces much thought, yet without the possibility of any definite thought whatever, i.e., concept, being adequate to it, and which language, consequently, can never get quite on level terms with or render completely intelligible."[46] Hence it approaches the rational Idea, which is also irreducible to any concept of the understanding. It can thus serve as an indirect expression of a rational Idea, which no doubt explains why Kant thinks artistic expression is essentially figural. To put the point in current terms: by virtue of the connotative force of figural expression, the aesthetic Idea can constitute itself as an *analogon* of the rational Idea, both of them being (for different reasons, to be sure) irreducible to any conceptual denotation. Thus the work of genius can, *qua* result of the productive imagination, elevate us beyond empirical reality and constitute itself as a sensuous presentation of a rational Idea.

It is in light of this conception of the imagination—which will in many ways be adopted by the romantics—that we must try to understand the claim that the genius cannot transmit the rules of his art. *Qua* work of the creative imagination, the work of genius achieves an intuitive presentation irreducible to any determinate concept. At the same time it manifests a finality without representation of a specific end, and in this it rejoins natural beauty: the work of genius is an autonomous work that, like natural beauty, pleases by its form alone, without its being possible to link the latter's aesthetically attractive character with a conceptually determined end. Of course, the aesthetic Idea is the presentation of a practical Idea: but it is an indeterminate, free presentation, that is, it is not subject to a

practical *law*; the moral dimension arises in connection with the aesthetic presentation without determining it conceptually (let us recall that the same is true of the immediate interest elicited by natural beauty[47]).

Thus it is exclusively in the degree that the work of genius is not conscious of its own ends that it can acquire a status comparable to that of natural beauties. But we shall see that Kant quickly backs away from the consequences of his own theory: even the work of genius presupposes a mechanical side, that is, it requires the intervention of an end that is describable conceptually. Moreover, it has to present itself *as* a work, that is, a human product; it must have the appearance of a natural product, to be sure, but at the same time we must know that it is *not* a natural product. Hence a component of *Schein* (in the sense of "deceptive appearance") will always be involved in the finality without representation of a specific end exhibited by the work of genius.

One can assume that if Kant puts restrictions on his theory of genius, it is chiefly because it is difficult to reconcile it with the conception of artificial beauty set forth earlier, which—as we have seen—denies that the work of art can manifest a true finality without representation of a specific end. Clearly, he does not want to abandon his originary conception of natural beauty, but at the same time he wants to maintain his definition of the genius. Whence his corrections on two particularly sensitive points: the question of the transmissibility of a "recipe" for producing a work of genius, and the problem of how to distinguish, within the work, between the properly artistic element and the mechanical element.

In examining the first point, we must distinguish two aspects. On one hand, although the work of genius is profoundly original and cannot be imitated, it must nonetheless be able to function as an exemplary model serving to spur on other geniuses. On the other hand, it can serve as a standard or rule of judgment for ordinary works that are not works of genius. Among artistic products, works of genius are the exception rather than the rule, and Kant admits that in fact many works are governed, at least partially, by models. Therefore it must be supposed that rules can be transmitted.

But what kind of transmission can this be? The transmission of a conceptually determined doctrine, which is already excluded by the theory of taste, is even more excluded by the definition of the genius. We have seen in fact that "where an author owes a product to his genius, he does not himself know how the ideas for it have entered into his head, nor has he it in his power to invent the like at pleasure, or methodically, and communicate the same to others in such precepts as would put them in a position to produce similar products."[48] The situation seems paradoxical: the genius cannot transmit precepts and yet his work must be exemplary, in the sense that other geniuses must be able to take inspiration from it and that more modest successors must be able to extract rules from it.

Let us begin with the question as to how an artist of genius can learn something from a predecessor. According to Kant, the artistic rule, although it remains opaque to the genius who created the work, can be abstracted from it by his successors: "the rule [must] be gathered from the performance, i.e., from the product, which others may use to put their own talent to the test, so as to let it serve as a model, not for imitation, but for following. The possibility of this is difficult to explain. The artist's ideas arouse like ideas on the part of his pupil, presuming nature to have visited him with a like proportion of the mental powers."[49] But this last point implies the existence of a preestablished harmony. Moreover, it explains at most how the disciple can produce a work similar to that of his model, but not how he can abstract the rules that governed the production of that model, and that remained hidden from its author. If the ideas aroused are analogous, this analogy ought also to imply the nonconscious character of the rules, and hence the impossibility of any operation of abstraction. In addition, Kant's explanation does not allow us to see how the disciple's work can be *different* from that of the master; but it has to differ profoundly from its model, since it is a matter of an exemplary heritage and not of an imitation.

In any event, this attempted explanation, as Kant himself acknowledges, concerns solely the relation between one genius and another. It therefore does not account for the continuity in the formation of artistic traditions, since genius is a rare phenomenon. The tradition cannot be based on "a like proportion of the mental powers" in all artists, for otherwise there would be *only* works of genius. Hence Kant is forced to admit after all the possibility of a *conceptual* transmission of the rules of the work of genius, no longer as an exemplary inspiration for another genius, but as a genuine model that will be *imitated* by other, ordinary artists: "Yet since the genius is one of nature's elect—a type that must be regarded as but a rare phenomenon—for other clever minds his example gives rise to *a school*, that is to say a *methodical instruction according to rules*, collected, so far as the circumstances admit, from such products of genius and their peculiarities. And, to that extent, fine art is for such persons a matter of imitation, for which nature, through the medium of a genius, gave the rule."[50]

This is, to say the least, a very odd way of reconciling the theory of genius with the one that conceives the work as an intentional object: if the work remains essentially opaque to the genius who produced it, and even to the genius-disciples who are inspired by it (their inspiration seems in fact to be nonconscious, to the extent to which it is due simply to a "like proportion of the mental powers"), by what miracle can it become transparent for ordinary receivers who can only be imitators? We are confronted by a strange dance back and forth between the genius and the spirit of a school: the first can create but he cannot know what he has

made; the second knows what the first has made but cannot produce a work of the same stature. Such a conception is not clear and therefore needs to be justified. But Kant nowhere justifies it. On the contrary: he very quickly abandons the distinction between works of genius and ordinary works in favor of the distinction between the element in the work that is essentially connected with the fine arts and the element that has to do with a mechanical art, and thus between what is not conceptually determinable and what can be determined by a concept: "there is . . . no fine art in which something mechanical, capable of being at once comprehended and followed in obedience to rules, and consequently something academic does not constitute *the essential condition* of the art. For *the thought of something as end must be present, or else its product would not be ascribed to an art at all, but would be a mere product of chance*. But the effectuation of an end necessitates determinate rules which we cannot venture to dispense with."[51] Does this distinction bear on the problem of the conceptual transmissibility of the work of genius? In other words, is the distinction between an exemplary heritage (*Nachfolge*) and imitation (*Nachmachung*) congruent with the distinction between those aspects of the work that are connected with the invention of aesthetic Ideas and those that are connected with the mechanical element? Kant does not explicitly answer this question, but it is difficult to imagine another way out of the difficulties resulting from his desire to naturalize art by way of the notion of finality without representation of a specific end.

As if the situation were not already sufficiently cloudy, it appears that the notion of genius cannot—as Kant himself acknowledges—provide us with a definition adequate to the fine arts, contrary to what had been suggested by the introduction of the notion by the incisive formula, "Fine art is the art of genius." Certainly, Kant maintains, genius is an artistic factor, but it is neither a necessary condition (because artworks exist that are not works of genius) nor a sufficient condition. Genius is not a sufficient condition because there could be no work of art without the involvement of technical know-how: "Genius can do no more than furnish rich *material* for products of fine art; its elaboration and its form require a talent academically trained, so that it may be employed in such a way as to stand the test of judgment."[52] Here again the distinction, considered in itself, is traditional: genius is responsible for the *inventio*, whereas taste is manifested in the *dispositio*, the formal *Gestalt* of the work. Within the Kantian theory, however, this distinction is not without difficulties. In fact, in § 49, the genius had been defined by his "exemplary originality" in the "free employment of his cognitive faculties," by "subjective finality in the free harmonizing of the imagination with the understanding's conformity to law." Therefore the work of art manifests a finality without representation of a specific end and can thus give rise to a pure judgment of taste: the ex-

pression "free harmonizing of the imagination with the understanding's conformity to law" that defines genius had already been applied to the pure judgment of taste. Now we learn that the genius merely provides the matter of the work, and that the true act of creation requires a talent "academically trained" and capable of satisfying "the faculty of judgment." It might be objected that the expression "faculty of judgment" is ambiguous, and that it does not necessarily refer to the "faculty of taste." But the following passage shows clearly that Kant is thinking about the judgment of taste, since he asserts that the difference between genius and taste parallels that between imagination and judgment:

> To ask whether more stress should be laid in matters of fine art upon the presence of genius or upon that of taste, is equivalent to asking whether more turns upon imagination or upon judgment. Now, imagination rather entitles an art to be called an inspired than a fine art. It is only in respect of judgment that the name of fine art is deserved. Hence it follows that judgment, being the indispensable condition (*conditio sine qua non*), is at least what one must look to as of capital importance in forming an estimate of art as fine art. So far as beauty is concerned, to be fertile and original in ideas is not such an imperative requirement as it is that the imagination in its freedom should be in accordance with the understanding's conformity to law. For in lawless freedom imagination, with all its wealth, produces nothing but nonsense; the power of judgment, on the other hand, is the faculty that makes it consonant with understanding.[53]

If we look closely we perceive here a double shift. In the first place, genius, which was supposed to allow the establishment of an analogy between nature and art (and thus the legitimation of the notion of a finality without representation of a specific end in the artistic domain), is here reduced to just *one* of the two faculties that make this experience possible, namely the imagination, whereas it was initially defined as the faculty of the free harmony *between* the imagination *and* the laws of the understanding. In other words, genius cannot guarantee the work's finality without representation of a specific end: it is solely the faculty of inventing aesthetic ideas. The second shift concerns the faculty of judgment, and it is just as full of consequences. In § 49 Kant defines the work of art as a "beautiful presentation of an object" that always refers to the object's perfection, and thus to a conceptual determination. Now, he adds, in order to give this perfect form to the object, it suffices to have taste (*"wird bloss Geschmack erfordert"*). In other words, taste is linked here with the ability to create an artistic form *that is in conformity with a specific end* (perfection). If we compare this passage with the one from § 47 quoted above, according to which the "elaboration [of the material provided by genius] and its form require a talent academically trained, so that it may be employed in such

a way as to stand the test of judgment," it is difficult to avoid the conclusion that Kant is here reducing taste to *intellectualized taste*. In this he returns to his initial conception of the fine arts as opposed to natural beauty, but on the other hand it is no longer possible to see how genius can still be the faculty that defines the fine arts: if genius only provides the work's material, if aesthetic judgment always bears solely on the form (a thesis central to Kantian aesthetics), and if in the case of a work of art taste comes in to judge the conformity of the work's form with "academic" rules, one no longer sees how the work can seem to us to be a natural object, as a finality without representation of a specific end. The theory of genius cannot explain the status of the work of art, since its form, which is the main concern of aesthetic judgment, is not due to genius.

If we take into account the whole of the *Critique of Judgment*, we have the impression that Kant is sketching out several alternative conceptions of the relations between aesthetics and the theory of art, without finally deciding on one of them, whereas this point concerns the relations between aesthetics and the theory of art.

The *Critique of Judgment*'s starting point is an intentionalist, or rather a mixed conception of artistic activity: the work of art does not belong to the sphere of pure aesthetic judgment, since it involves intentional factors that are irreducible to any reflective judgment founded simply on an inner feeling elicited by a beautiful form. As soon as aesthetic judgment is applied to a work of art, it is no longer pure, because in such a case the experience of a finality without representation of a specific end is always opposed by the actually intentional character of the object contemplated.[54] The beauty of the artistic object is not self-sufficient because we always sense the hand (and thus the intention) of its human creator. Let us add that when we judge the object *entirely* with regard to its specific finality, and thus entirely as a product and no longer as a "natural" thing, we find ourselves in the field of what Kant, following a well-established tradition, calls the mechanical arts. The products of the mechanical arts are in fact judged solely with regard to their conformity to the functional end that they are supposed to serve. Such a product, if it is successful, must be called "perfect" rather than "beautiful," if it is true that perfection consists in conformity to a specific end. In short, this amounts to saying that the fine arts are situated at the intersection of the domain of pure aesthetics and that of the mechanical arts.[55]

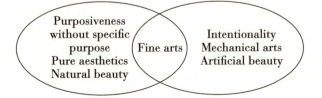

When the theory of genius is introduced, its function is to correct the initial position, that is, to *reduce* the field of the fine arts to that of pure aesthetics. It therefore implicitly abolishes the distinction between natural and artificial beauty, between pure aesthetics and the theory of the fine arts. There is henceforth only a single sphere, the aesthetic sphere, which includes the domain of the fine arts *identified* with genius:

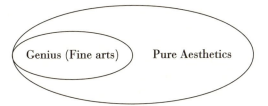

In other words, artificial beauty, which according to the first categorization *intersected* with natural beauty, is now only one of its *aspects*. Or rather, the distinction between natural beauty and artificial beauty has a tendency to transform itself into a distinction between taste, the receptive aspect of pure aesthetics, and genius, its productive aspect:

In a third phase, Kant seems to draw back from the consequence of this second conclusion. The ultimate solution he envisages comes down to maintaining that the work of art results from the combination of taste and genius. In other words, taste and genius, which in the preceding schema were the two aspects, receptive and productive, of the *aesthetic* sphere, are here opposed as two *productive* principles in the domain of *art*, genius being responsible for the content (the Ideas), taste for the form. But at the same time genius is reduced to the imagination, and taste, intellectualized, is intimately connected with the understanding; the finality without representation of a specific end and the pure judgment of taste both disappear from the artistic horizon:

It might seem that in so doing, Kant is returning to his original position. And in fact at first sight the two schemas coincide. But this formal identity conceals an important shift: genius now occupies the place that had been that of the pure judgment of taste, whereas taste is reduced to the field which, in the original conception, belonged to intentionality (and was *opposed* to taste). Even if we admit that the last schema concerns production, while the first refers to reception, the two are not congruent, since genius refers to the content of the work, and the (pure) judgment of taste is connected solely with the form.

Leaving aside for a moment the question whether in the domain of natural beauty our judgment is not in fact conceptually determined, there is hardly any doubt that insofar as the domain of the arts is concerned, the initial conception and the final conception (in spite of their incompatibility) are easier to defend than the theory of genius in its radical form. It is difficult to see how one could deny the presence, in our judgments on works of art, of elements connected with conceptual determinations. In order to appreciate a work of art, we always have to start from a cognitive base, not only because the creation of the work is always linked to the application of cognitive procedures, but also because its identity is inseparable from specific categorial determinations (its genre, formal rules, representational conventions, etc.).[56] Moreover, from the point of view of its ontic status, no work is reducible to a pure perceptual object, whereas according to Kant, a pure aesthetic judgment bears always and exclusively on a sensuous form. This irreducibility is particularly evident in the case of verbal art, where pleasure is clearly not elicited by the contemplation of the text as a sensuous image. But it is also valid for the visual arts, as is powerfully shown by certain developments in contemporary art, in Duchamp's work, for instance, or in conceptual art, practices that are much more connected with an art of ideas than with a sensuous art: in order to know Duchamp's "L.H.O.O.Q.," it is not necessary to contemplate the work; a verbal description allows us to know it just as well.[57] Of course, this does not mean that the sensuous aspect never plays a central role; in order to appreciate Leonardo's "Mona Lisa" we have to *also* have a direct sensuous experience. But even in this case (which is the paradigmatic case for the plastic arts) the direct sensuous experience is not *sufficient*. This irreducibility of the artistic dimension to a purely perceptual reception speaks strongly in favor of the compromise solution Kant adopts, whereas his theory of genius, if one takes it seriously, could not account for artistic facts depending on direct sense perception.

This necessity of compromising is required only because, as we have seen, Kant begins by constructing an absolute opposition between pure aesthetic feeling and conceptual judgment. But this operation itself is governed by the notion of finality without representation of a specific end.

Thus we find ourselves back at our initial observation, namely that most of the difficulties encountered by Kantian aesthetics are connected with the postulate of a finality without specific end.

THE WORK OF ART IN KANT AND IN ROMANTICISM

By way of the theory of genius, and more precisely by the thesis of a finality without specific end, Kantian aesthetics is connected with the romantic theory of Art. In fact, to the extent that it emphasizes the "natural" aspect of the work of art, the theory of genius opens the door to a conception according to which the work is defined not by its communicational status but rather by its paradoxical ontic character: the work (of genius) represents nature in art, just as natural beauty represents art in nature. Now as we shall see, this neutralization of the dichotomy between nature and art in favor of their transcendent unity is at the very heart of the romantic project.

All the same, in spite of certain undeniable relationships, the theory of art Kant defends could not be assimilated to that of the romantics. This can be shown for each of the points on which Kant's theory comes closest to that of his successors.

The notion of "productive imagination," by virtue of its importance in the theory of genius and in romantic aesthetics, lends itself well to a comparative analysis. Let us start with Kant: the importance he accords to the imagination is echoed in his hierarchy of the arts. In fact, if poetry occupies the first rank in this hierarchy, it is because it is the sole art through which the imagination, defined as the ability to produce inner intuitions, expresses itself directly. In all the other arts it expresses itself only indirectly through an external mediation. Thus in the plastic arts it has to pass through the intermediary of a visual (in painting) or visual-tactile (in sculpture) representation; as for music, that "beautiful play of sensations," it has to borrow the exteriority of auditive sensations. This implies *a contrario* that for Kant the sensuous, oral exteriorization of poetry is no longer central for him, whereas it is inseparable from music.[58]

It is true that at first glance any romantic thinker might have subscribed to Kant's definition of poetry:

> Poetry (which owes its origin almost entirely to genius and is least willing to be led by precepts or example) holds the first rank among all the arts. It expands the mind by giving freedom to the imagination and by offering, from among the boundless multiplicity of possible forms accordant with a given concept, to whose bounds it is restricted, that one which couples with the presentation of the concept a wealth of thought to which no verbal expression is completely adequate, and by thus rising aesthetically to ideas. It invigorates the mind by letting it feel its faculty—free, spontaneous, and independ-

ent of determination by nature—of regarding and estimating nature as phe-
nomenon in the light of aspects which nature of itself does not afford us in
experience, either for sense or understanding, and of employing it accord-
ingly in behalf of, and as a sort of schema for, the supersensuous. It plays with
semblance, which it produces at will, but not as an instrument of deception;
for its avowed pursuit is merely one of play, which, however, understanding
may turn to good account and employ for its own purpose.[59]

First, let us note the idea that "among the boundless multiplicity of possi-
ble forms accordant with a given concept," the poetic imagination offers a
form "to which no verbal expression is completely adequate." Taken liter-
ally, the thesis is unintelligible: how could poetry, which is a linguistic act,
present itself in a form such that "no verbal expression" is perfectly ade-
quate to it? The problem lies in the fact that Kant never really distin-
guishes between the inner poetic intuition, which is semiotically neutral,
and its actual realization in verbal art; that is, he does not have at his
disposal something that would be, for example, on the order of the Hei-
deggerian distinction between *Dichtung* and *Poesie*. Nor does he have at
his disposal the "classical" romantic solution that consists in dividing lan-
guage into conceptual language and poetic language. Within the frame-
work of such a conception, poetic language, which is irreducible to con-
ceptual language, is invested with the ability to present the indeterminate,
which remains inaccessible to conceptual language.[60] That does not mean
that his conception is fundamentally different from that of the romantics;
it is simply that he does not yet have at hand the necessary concepts for
thinking it in a coherent manner.

The second noteworthy point in the passage quoted resides in the as-
sertion that poetry can make use of nature "as a sort of schema" for the
supersensuous, that is, that it can contemplate it to reason's advantage.
This assertion does not merely prefigure the romantic idea of the poetic
transfiguration of nature, considered as a sensuous presentiment of the
Absolute, but also and especially it indicates a possible link between po-
etry and reason (conceived as the faculty of ideas in Kant, as the faculty of
the Absolute in the romantics). Now here again the author of the *Critique
of Judgment* is moving across a minefield: according to the *Critique of Pure
Reason*, there can be no schema for the supersensuous. A schematism,
whether it is a matter of the a priori schematism of mathematical construc-
tion or of schematism as it is involved in the conceptual construction of the
empirical world, is always defined in the first *Critique* as the representa-
tion of a universal procedure of the imagination whose purpose is to obtain
an image corresponding to a concept of the *understanding*. The possibility
of there being a schematism of a rational Idea is excluded in advance, since
there could not be any intuitive presentation adequate to an Idea. Thus

Kant remains prudent: poetic presentation is a schema, as it were (*gleich-sam*), that is, it is not really one. But the fact that he envisaged such a link is nonetheless revealing: from the moment that poetry is put into relation with the faculty of Ideas, the question of their logical connection can no longer be avoided. The romantics, for their part, will have only to omit the "sort of" and identify the notion of "schema of reason" with the notion of "symbol of the Absolute" in order to arrive at a speculative theory of poetry.

However, we must not for all that underestimate the restriction implied by the expression "sort of." It is in fact one of the many indications of Kant's resistance to the "romantic tendency," that is, to the new conception of the arts that was being born at the end of the eighteenth century. In his work the imagination always remains connected with sensibility, and all the more since in art it could not have a schematic activity in the true sense of the term but solely an indeterminate imaging activity. To be sure, if he gives poetry priority over painting—even though his aesthetics is an aesthetics of vision—it is because in painting the imagination is always reined in by the principle of analogical visual representation, which is not the case for the poetic imaging activity. Nonetheless, even poetry remains connected with a sensuous origin. It is just that it has a greater freedom than painting with respect to this origin: it can make use of it as a simple starting point in order to produce an inner intuition, whereas the plastic arts are both reproductive and productive of a sensuous appearance.[61] Finally, the end product of poetic activity is always an image in the sense of a sensuous presentation of an ideal *otherness*, even if this image is purely internal. The two poems that Kant cites, a few lines by Frederick the Great and a line from an obscure poet who, according to the commentators, may be Johann Withof, an imitator of Haller, are in any event revealing. Kant translates Frederick's verses into German prose: the royal poet constructs an explicit *similitudo* between the aging king and the setting sun. The passage from Withof is in the same vein: "Die Sonne quoll hervor, wie Ruh aus Tugend quillt" ("The sun shone forth, like the peace that shines forth from virtue"). This preference for the figure of explicit simile clearly shows that for Kant poetry is a sensuous presentation of a rational Idea (thus the sun represents royal majesty or virtue). Whence also the fact that in his view a prose translation of Frederick's verse does not affect the poetic substance of the work.[62]

On the other hand, in the romantics the productive will be diametrically opposed to empirical sensibility. Henceforth it will be only in a secondary way the faculty of the poetic image conceived as *similitudo*, and will expand to become the place where language is creative. In it verbal representation is abolished as a secondary element with respect to an origin that is supposed to precede it, in order to become a presentation of the self-

development of Being. To put this in simpler terms: for the romantics, poetry will be an imaging activity in the strong sense of the expression, that is, it will be held to create its own referent. Contrary to what is still the case in Kant, all transitivity and all relation to an otherness will be banned from it.

Another point on which Kantian aesthetics is connected with the romantic theory of Art is the use of the notion of an "artistic symbol."[63] We have already encountered on several occasions the idea that beauty, and especially natural beauty, elicited a moral interest. In § 59 of the *Critique of Judgment*, Kant returns to this thesis. To the extent that beauty is the conformity of an object to an inexpressible a priori rule, this rule cannot be a concept of the understanding, since such a concept *can* always be formulated. Therefore only a rational idea can be involved here. I use the term "inexpressible," but actually, in § 59, Kant moves from the question of the expression of the a priori rule that guides aesthetic judgment to a rather different topic, that of hypotyposis, defined as an act that makes a concept sensuous (*Versinnlichung*). He distinguishes more precisely between the presentation of an empirical concept, that of a (pure) concept of the understanding, and that of a rational Idea. In the first case the presentation is on the order of an example: the single intuition is a specifying determination of the empirical concept. In the second case we are concerned with a schematic presentation: the understanding gives the a priori rule to the imaginative faculty and the latter achieves the synthesis of apperception that is the formal condition of any empirical intuition. On the other hand, no intuitive presentation can correspond adequately to a rational Idea; an Idea can be represented only in a *symbolic* manner. Hence it is referred to an intuition that is "such that the procedure of judgment in dealing with it is merely analogous to that which it observes in schematism. In other words, what agrees with the concept is merely the rule of this procedure, and not the intuition itself. Hence the agreement is merely in the form of reflection, and not in the content."[64] *Symbolic* representations are thus indirect presentations by analogy, by *similitudo*.

Therefore, according to Kant, symbolic presentation implies a double activity on the part of the faculty of judgment. First an intuition that will represent the Idea is sought. This intuition always—and inevitably, we might add—corresponds not to the Idea but to a *concept* (empirical or pure) of the understanding: in fact an intuition in the true sense of the term can refer only to a concept of the understanding. Next, this rule (which guides reflection on this intuition) is applied to an entirely different object, in this case a rational Idea; since the same rule of reflection is applied both to the relation between the intuition and its concept (of the understanding) *and* to the relation between this first relationship as a whole and reflection on the rational Idea, an indirect link is established

between the intuition and the Idea. Kant's explanation is very abstract, but he gives an example that clarifies it somewhat: we are accustomed to represent the monarchical state by means of the image of an organic body, even though there is no direct resemblance between them; however, reflection on the organic body elicits in us thoughts similar to those that are produced by reflection on the monarchical state: the interdependence of the limbs and the brain, between the subjects and the king, etc. Because of this similar reflective activity an indirect link between the notion of the monarchical state and that of an organic body is established.

More generally, Kant claims that "the beautiful is the symbol of the morally good." In fact, the morally good, that is, our supersensuous foundation, cannot give rise to a direct representation. A beautiful object, on the other hand, can yield a symbolic representation of it; not only does it show me in nature the *analogon* of a supersensuous finality, but it also pleases me in a necessary and yet free manner, as the morally good would please me were it directly representable. In reality, the symbolization operates on two levels. On one hand the beautiful as such in its genericity, that is, in the disinterested pleasure that finality without representation of a specific end elicits, constitutes a symbol of the pleasure that a direct contemplation of the good would provide, if such a direct contemplation were possible. On the other hand, beautiful objects in their diversity are also symbols, not of the morally good in its generality, but of specific moral Ideas.

This Kantian conception of the symbol as an indirect representation of the morally good incontestably anticipates the romantic theory of the poetic symbol. And yet the two theories do not refer to exactly the same thing. For the romantics, it is *the Absolute* that must be presented symbolically, because it cannot be *thought speculatively*. In the Kantian theory it is the *morally good* that must be presented symbolically, because it cannot be presented in a direct intuition; on the other hand it is perfectly conceivable (even though it is not knowable). To be sure, in his *Anthropology* Kant opposes, like the romantics, symbolic knowledge to discursive knowledge, and again like the romantics, he establishes a distinction between motivated signs and arbitrary signs. But unlike them, he nowhere *identifies* the distinction between symbolic knowledge and discursive knowledge with that between arbitrary signs and motivated signs. Moreover, he rejects the idea of a verbal symbolism conceived as a kind of knowledge proceeding by means of motivated signs; hence he could not defend the idea of a poetic language that was symbolic and motivated, as opposed to everyday language. Finally, and this is surely the most important point, for Kant the function of symbolism cannot be to provide an ontological revelation. The visible world cannot be, as it will be for Novalis, the symbol of the invisible realm of Being. The author of the *Critique*

of Judgment explicitly attacks that conception, which seems to him to have more to do with enthusiasm than with philosophy: "To say, with Swedenborg, that the real phenomena of the world present to the senses are merely a *symbol* of an intelligible world hidden in reserve is *fanaticism* (*Schwärmerei*)."[65] This is precisely what the romantics will do.

The thesis of finality without representation of a specific end, insofar as it invests the theory of genius, leads directly to the romantic theses of the autonomous and autotelic nature of the work of art. The move Kant sketched out in the theory of genius, that is, the transformation of artistic artifacts into quasi-natural entities, radically distinct from other human products, was later to be taken up and systematized by romanticism and ultimately became the central characteristic of the whole speculative theory of Art. But we have also seen that Kant very quickly retreats from the theory of genius and tries to limit its scope. Furthermore, at the level of the fundamental impulse of the *Critique of Judgment*, the theory of finality without representation of a specific end concerns aesthetic *judgment* and not an aesthetic *object*. Kant repeats over and over that there can be no question of an objectal determination, whereas the thesis of the autonomy of the work of art functions as an objectal proposition (as a cognitive objective judgment, in Kant's terminology). Finality without representation of a specific end is never reducible to describable properties of the object, but indicates solely the agreement between the object and our cognitive faculties, that is, it expresses a relation between a representation and a subject, and not between a representation and its object.

Finally, in a general manner, the position the fine arts occupy in Kant's aesthetics is incompatible with the romantic theory of Art. In the latter, artistic activity becomes the supreme human activity, and—still more important—Art becomes the center, not only of aesthetics, but of all philosophical reflection. We have seen that in Kantian aesthetics, on the contrary, the fine arts play only a secondary role compared with natural beauty. The idea of a hegemony of art (including the art of genius) within the aesthetic sphere, or even that of a special philosophic dignity of art, ideas that are so central in romantic aesthetics and in the whole tradition of the speculative theory of Art, are foreign to Kant. An eloquent indication of this can be found in the fact that the image of the ideal Greece he projects is not so much that of an artistic ideal as that of a humanist ideal:

> There was an age and there were nations in which the active impulse towards a social life regulated by laws—what converts a people into a permanent community—grappled with the huge difficulties presented by the trying problem of bringing freedom (and therefore equality also) into union with constraining force (more that of respect and dutiful submission than of fear). And such must have been the age, and such the nation, that first discovered

the art of reciprocal communication of ideas between the more cultured and ruder sections of the community, and how to bridge the difference between the amplitude and refinement of the former and the natural simplicity and originality of the latter—in this way hitting upon that mean between higher culture and the modest worth of nature, that forms for taste also, as a sense common to all mankind, that true standard which no universal rules can supply.[66]

The sphere of aesthetic judgment is linked to the ideal of a humanity living in a harmonious society far more than to an artistic paradigm. If Kant's aesthetics possesses a utopian dimension—and it is incontestable that it does—the utopia is aesthetic-social much more than artistic.

AESTHETICS, META-AESTHETICS, AND THEORY OF ART

If the question of the relationships between Kant's theory and the romantic theory (considered here as representative of the whole tradition of the speculative theory of art) with regard to the *status of art* is complex and can only be answered in a complex manner, the situation is much clearer with regard to the possible *status of aesthetic discourse*: the opposition here is irreducible.

We must recall that Kant's aesthetics is essentially a *meta-aesthetics*, since it seeks to analyze aesthetic judgment and its legitimation. In this it already differs from the speculative theory of Art, which is not a metatheory but an objectal theory. The opposition is not absolute, to be sure, since Kant also proposes a theory of art; nonetheless, the fundamental theoretical impulse of his analysis is meta-aesthetic in nature.

This difference in the object studied does not in itself imply any incompatibility. However, in his meta-aesthetic analysis Kant thinks he can show precisely that no *doctrine* is possible in the aesthetic domain, including the domain of the fine arts. Now the speculative theory of Art *is* a theoretical doctrine, since it is explicitly founded on a fundamental metaphysics, a transcendental inquiry (in the Kantian sense of the term, that is, an inquiry that claims to go beyond the world accessible to empirical experience) of which Art is one of the objects. In other words, Kant's meta-aesthetic analysis excludes from the outset, not *any* objectal theory of art, but the *type* of objectal theory that seeks to construct the speculative theory of Art.

We have seen that for Kant aesthetic judgment belongs to the category of reflective judgments and not to that of determining judgments. A determining judgment is one that subsumes intuitions under a concept or law given in advance: it brings about the specification of a concept by subsuming an intuition under it. It is therefore not based on its own principle,

since it limits itself to acting in conformity with the rule provided to it by the understanding. It is a cognitive judgment in the strict sense of the term, that is, each determining judgment that is true augments our knowledge of the object on which it bears. Reflective judgment, on the other hand, is solely "the consciousness of the relation of given representations to our different sources of knowledge."[67] Or again: it is a reflection on a given representation regarding the possibility of applying a concept to it. In other words, as we have already seen, it does not bear on the relation between the representation and its object, but solely on the relation between the latter and our cognitive faculties. It therefore does not increase our objectal knowledge. That holds true even for *teleological* judgment, that is, a reflective judgment that postulates an objective finality in nature and relates our empirical knowledge to principles of practical reason. It is certainly a cognitive judgment in the sense that it is guided by a concept, in this case the concept of a practical end, but it does not directly increase our empirical knowledge of the world: it is not descriptive and limits itself to playing a regulative role in the organization of already given objectal knowledge. As for the *aesthetic* reflective judgment—the only one that concerns us here—it cannot be qualified as a cognitive judgment, in either the strong sense of the term (since it contains no assertion regarding the objective properties of the object) or in the weak sense of the term (since contrary to teleological judgment, it is not determined by a concept, even a practical concept).

Certain important consequences follow from this analysis. They concern the status of aesthetic discourse, that is, the discourse that is embodied in aesthetic judgment, and its relation to a possible theory of the arts.

Let us start with the first point. Aesthetic discourse is not a cognitive discourse, since it does not formulate any assertion concerning the properties of its object. We have seen that this thesis had to be interpreted in a very strong sense, that is, that it implied in particular the impossibility of a deduction or derivation of any judgment of taste from a cognitive judgment bearing on the beautiful object. Aesthetic judgment and cognitive judgment thus seem mutually independent of each other, since the inverse possibility of a deduction or derivation of a cognitive judgment from a judgment of taste is also precluded: it is impossible to derive a conceptual determination from a proposition whose principal characteristic is the absence of such a determination. Of course, the fact that aesthetic judgment is opposed to cognitive judgment does not imply that it has an irrational status (on the order of a simple command or *Machtspruch*). It remains rational, since it is grounded in an a priori principle (or, if one does not accept Kant's transcendentalism, in an empirical principle of a psychological order) that allows me to hope that it will be universally communicable. But this universal communicability is that of a feeling, and not that

of a cognitive proposition; the judgment of taste requires only that the same object give rise to the same feeling of pleasure in every rational being, and more precisely in every being for whom the knowledge of the world depends on the same subjective conditions of agreement among the cognitive faculties.

According to Kant, aesthetic judgment possesses still another noteworthy peculiarity: it can never be detached from its object. Or to be more precise: its communicability always implies that the object on which it bears is directly accessible. A cognitive judgment on the tectonics of the geological plates responsible for the formation of the Alps is communicable independently of any direct experience of its object. I can (at least within certain limits) form my own cognitive judgment on the genesis of the Alps without my having to repeat all the geological experiments on the object in question; when a sufficiently elaborated theory is concerned, I can even correct my judgment (and that of others) on the basis of purely formal considerations, on the basis of a simple "calculation" (as Heidegger would say), without any "sensuous contact" with the Alps.[68] The same is not true in the case of a judgment of taste: the universal communicability of my judgment concerning the beauty of Mont Blanc (or the Matterhorn) requires that the mountain be perceptually accessibile to other subjects who judge aesthetically. I certainly require that my judgment be considered as universally valid, but solely on the condition of a corresponding experience on the part of other human subjects (since it is impossible to derive from my own judgment determinations that are conceptual—and thus detachable from direct experience[69]). It is clear to what extent aesthetic reflection—in its utopian form—is for Kant a reflection that is always autonomous but universally shared with regard to an object that is always particular but universally accessible.

The purely "obligatory" universality of aesthetic judgment goes hand in hand with the fact that it is presented as an example of an a priori rule and not as a simple empirical judgment. Nevertheless, we have seen that this rule can never be formulated. In other words, in the *Critique of Judgment*, the question of the possibility of aesthetic judgments does not arise within the dichotomous opposition between the a priori and the empirical, but finds its resolution in a third term, the a priori that is not conceptually determined. According to Kant, this third term makes it possible to provide an a priori ground for aesthetic judgment (I shall not discuss further here the difficulties inherent in this conception of aesthetic judgment; it suffices to note that it is in any case incompatible with a speculative theory of Art).

Some of Kant's successors did not take into account this distinction between the empirical and the a priori that is not conceptually determinable, and this led them to a misunderstanding of his aesthetics. This is the

case for Schiller, who, in his *Kallias-Briefe* (1793, thus three years after the publication of the *Critique of Judgment*) credits Kant with the claim that taste is empirical: "The difficulty of elaborating objectively a concept of beauty and legitimating it in an a priori manner by starting out from the nature of reason is almost incalculable. . . . So long as this has not been achieved, taste will always remain empirical, which Kant thinks inevitable. But it is of just this inevitable character of empiricity, of this impossibility of an objective principle of taste, that I have still not been able to persuade myself."[70] Yet a few lines farther on, he correctly describes the Kantian solution as a subjective-rational solution, and opposes it to Burke's sensualist-subjective empiricism as well as to Baumgarten's rationalist-objective solution. But at the same time he seems to think that only an objective principle, or more precisely a principle capable of conceptually determining its object, allows a genuine escape from the empiricist solution. I shall not enter here upon a discussion of his own solution, which determines beauty as a sensuous-objective quality and claims to escape simultaneously empiricism, rationalism, and what he takes to be a nonsolution, namely Kant's "subjective rationalism." Here I want simply to emphasize that what motivates Schiller to reject the Kantian solution and to qualify it as empirical does not have to do with the judgment of taste and is linked to the project of a theory of art. In fact, when Schiller observes that if one accepts the Kantian solution, "taste will always remain empirical," he has in mind not the question of the status of aesthetic judgment, but that of the existence of an a priori conceptual criterion that would make it possible to define art. In other words, he postulates in advance that aesthetic judgment *is* linked to an objectal knowledge. According to Kant there are not, and could not be, any a priori objectal criteria, and thus there could not be any aesthetic *doctrine*, but only a *critique* of aesthetic judgment; the criteria themselves could only be empirical and conjectural.

In summary we may say that according to Kant, there are two reasons why aesthetic judgment cannot give rise to a *doctrine*:

a) Aesthetic judgment is a judgment not on an object but on the relationship the representation of that object entertains with our faculties. If we happen to speak as if aesthetic judgment referred to conceptually determined properties of the object, that is solely by an abuse of language. In reality, an aesthetic judgment merely relates the subject to the representation of a given object, and it "brings to our notice no quality of the object, but only the final form in the determination of the powers of representation engaged upon it."[71]

b) The judgment of taste is based, to be sure, on a rule, of which it claims to be an instance, but this rule cannot be formulated and is subjective: it concerns the universal communicability of a disinterested feeling

elicited by a finality without representation of a specific end. In other words, the judgment of taste is not determined by a conceptual and objective principle: aesthetic universality "does not join the predicate of beauty to the concept of the Object taken in its entire logical sphere, and yet does extend this predicate over the whole sphere of judging Subjects."[72] Hence if one cannot indicate a rule in accord with which someone could be obliged to recognize the beauty of something, that is because there is no conceptual criterion of beauty that could guide the judgment of taste: "There can be no objective rule of taste by which what is beautiful may be defined by means of concepts. For every judgment from that source is aesthetic, i.e., its determining ground is the feeling of the Subject, and not any concept of an Object. It is only throwing away labor to look for a principle of taste that affords a universal criterion of the beautiful by definite concepts; because what is sought is a thing impossible and inherently contradictory. But in the universal communicability of the sensation (of delight or aversion)—a communicability, too, that exists apart from any concept—in the accord, so far as possible, of all ages and nations as to this feeling in the representation of certain objects, we have the empirical criterion, weak indeed and scarce sufficient to raise a presumption, of the derivation of a taste, thus confirmed by examples, from grounds deep-seated and shared alike by all men, underlying their agreement in estimating the forms under which objects are given to them."[73] It is important to grasp the true scope of the Kantian thesis, for it has often been incorrectly interpreted. While Kant claims to demonstrate the impossibility of any doctrine of the beautiful, of any aesthetic doctrine, his analysis in no way prevents one from making cognitive judgments on objects that are otherwise qualified as beautiful. Nowhere does he say that beautiful objects are intrinsically unknowable objects; he simply requires that one distinguish cognitive judgments from aesthetic judgments. What is at stake is not a *type of objects* but a *type of mental attitude*. It is true that insofar as Kant is interested chiefly in the domain of natural beauty, it is solely within this framework that he presents explicitly the distinction between aesthetic and cognitive judgments. Thus he says that a flower can be approached from a cognitive point of view (for example, by a botanist) as well as from an aesthetic point of view (possibly even by the same botanist). But logically, the distinction is also valid for the domain of artificial beauty, for the domain of art: it is therefore always possible (and even desirable) to study, for example, an architectural work as an object, and more specifically as an achievement that corresponds to a human intention, and thus as a structuration that, far from appearing without warning in the domain of contingency (nature), is anchored in a horizon of already-constituted individual and historical practices.

This distinction between aesthetic judgment and cognitive judgment

must not be confused with the one between the aesthetic and mechanical aspects of the fine arts. The cognitive attitude in question here is not reducible to the judgment of taste made concerning a work of art according to its conformity to "academic rules." It is not a judgment of taste, even an impure one, but rather a determining judgment in the same way as cognitive judgments concerning natural objects. In other words, a purely cognitive judgment is also possible concerning a work of genius (in the contrary case it would be difficult to see how it would be possible concerning a natural object, since the work of genius is the *analogon* of a natural object).

To give a reliable account of the meta-aesthetic impulse of the *Critique of Judgment* we have to distinguish three domains:

a) *pure aesthetic judgment*, which is a judgment founded on an inner feeling;

b) *aesthetic-normative judgment*, which is founded on the assumption of certain rules; it implies a cognitive component, since it is legitimated only insofar as one has first analyzed whether or not a given work is in conformity to rules that are accepted as norms, but its function remains evaluative; and

c) *cognitive judgment*, which analyzes works of art as objects of knowledge without putting this analysis in the service of an evaluative judgment.

Unfortunately, in Kant's text these distinctions are not always as clear as one might desire. Thus we have seen that he never says explicitly that in the domain of art, as in the domain of natural beauty, the impossibility of a doctrine in no way prevents the existence of a positive knowledge of the works considered independently of the evaluative attitude. In a certain sense this is to be expected, since what interests Kant in the *Critique of Judgment* is pure aesthetic judgment in its specificity in relation to other judgments of value, and particularly normative judgment based on conceptual rules. Nonetheless, this silence has had important consequences, not in the domain of natural beauty, but in that of artificial beauty, that is, in the domain of the theory of art. Kant has generally been made to say that knowledge of art was impossible, whereas he simply maintains that aesthetic judgment cannot be based on such knowledge, nor can it provide the basis for knowledge. The "doctrine" of which he speaks concerns solely the domain of aesthetic judgment, thus the domain of the evaluative definition of art, and not that of descriptive knowledge of art.

That said, the romantic revolution and more generally the tradition of the speculative theory of Art cannot be explained simply as a misunderstanding of the true scope of Kantian aesthetics. In reality, the romantics *refused* to conceive a discourse on the arts that was not doctrinaire. The example of Schiller is eloquent: what he regrets is that Kant thinks that an a priori knowledge of the *beautiful*, and thus of the *evaluative* definition of

art, is impossible. Among the Jena romantics the refusal is even more radical, since they reject the general prohibition formulated by Kant regarding *all a priori* objectal knowledge; nascent idealism, in which romanticism participates, attacks the *Critique of Pure Reason* even more than the *Critique of Judgment*. In other words, even if the romantics had understood that Kant's theory did not in any way preclude a knowledge of the arts, they would have rejected this knowledge as "empirical," just as they rejected the natural sciences. A positive knowledge of the arts, such as was made possible by Kant's aesthetics, could not fulfill the task that romanticism set for a theory of art. The speculative theory of Art arises from the clearly assumed will to construct, in opposition to Kant, a *doctrine* of Art, that is, a definition of essence founded on an evaluation. We must continue to emphasize this point: the specificity of the speculative theory of Art consists not in the fact that it wants to give a definition of art, or even that it wants to give a definition of essence. The speculative theory of Art seeks to establish the *excellence* of Art, its ecstatic character *qua Art*, in contrast to other human activities. Now this is precisely the kind of definition that Kant's aesthetics declares to be impossible, since it asserts that the criteria of excellence could not be universal criteria, grounded "objectally" and objectively, but only subjective criteria, valid for an individual subject confronted by a particular object, and incapable of leading to a definitional universalization.

The question as to whether or not an objectal knowledge of the fine arts is possible must also be distinguished from the one concerning the status of the descriptive propositions in which aesthetic judgments may be formulated. The two questions have nothing to do with each other: the status of the descriptive propositions in which aesthetic judgment is formulated, that is, the problem of aesthetic predicates, concerns solely the analysis of aesthetic judgment. Kant addresses it only very indirectly, which is unfortunate, for doing so might have led him to refine or clarify his theory of the nonconceptual character of aesthetic judgment. In fact, even a pure aesthetic judgment, insofar as it is still a judgment (and is not limited to being a private feeling) must be capable of being motivated. As for the aesthetic judgment applied to the fine arts, it always implies, as Kant himself acknowledges, a legitimating component that appeals to descriptive propositions, since it conceives the work as an artificial product structured in accord with certain rules. In other words, most judgments of taste, when they are formulated, contain descriptive propositions that bear on qualities referred to the aesthetic or artistic object.

This is already shown by Kant's paradigmatic proposition of the judgment of taste: "*a* is beautiful." This is a predicative proposition and it predicates a quality of the object and not an affective state. To be sure, according to Kant, this grammatical form does not correspond to the deep

structure of the sentence, which is itself expressive and evaluative (since it is supposed both to express a feeling and to propose a value). Nonetheless, even if it is a surface structure, this grammatical form shows that an aesthetic judgment, *qua* public discursive act, often presents itself as motivated by descriptive propositions concerning the object. Let us add that the propositional structure mentioned by Kant, namely "*a* is beautiful," oversimplifies the actual structure of aesthetic judgments, especially when they concern works of art. The structure is rather: "*a* is an *x* such that 'beautiful.'" In other words, it rarely happens that an object is qualified as beautiful in the absolute: it is so qualified rather in relation to a specific contextual categorial field.[74] Now this implies the idea that one object can be compared with other objects; can this comparability reasonably be described as being simply a kind of universalizable feeling? Doesn't it rather imply the possibility of describing the distinctive characteristics of that cause me to agree to say that "*a*" is an "*x*" that is beautiful?

What is at stake here is surely the sharp opposition between feeling and concept, or between a pure aesthetic judgment and an applied or "impure" aesthetic judgment. It would seem that pure aesthetic judgment and "impure" aesthetic judgment simply correspond to two stages in the development of human aesthetic faculties; and pure aesthetic judgment (the direct expression of a feeling) certainly represents the more primitive of these two stages. That at least is what studies in developmental psychology applied to the domain of aesthetic judgment tend to show. In fact, pure aesthetic judgment corresponds quite closely to the description given by Michael J. Parsons, in his experimental study of the development of the faculties of aesthetic judgment, of the first stage of this development, which one finds realized in the aesthetic judgments of children "Liking and judging are equivalent ideas. It is as if our intuitive response is already a judgment, and the judgment is identical with the only reason we could give for it: the fact that we like it."[75] The fact that Kant ranks natural beauty over artificial beauty is in accord with the attitude adopted at this stage of development, in which visual beauty identified with the beauty of things reproduced, and thus with natural beauty. But Parsons also shows—as one might have expected—that the later development, far from limiting itself to this kind of expression of an inner feeling, even if accompanied by a requirement of universality, tends to increasingly open up to the acceptance of conceptual determinations, whether they involve empirical knowledge concerning the object being judged or norms concerning the criteria of judgment. To be sure, as Kant maintained, my judgment is always ultimately founded on my attitude with regard to the work, but this attitude may very well be modified by arguments of a conceptual order that lead me, for example, to see things I had not seen, or that show me that my reaction is inappropriate, simplistic, etc.[76] In other words, devel-

opmental psychology lends Kant's thesis support insofar as it demonstrates that aesthetic judgment is in fact founded on the pleasure or displeasure felt by the person who formulates it, but at the same time it demonstrates that the source of the feeling of pleasure itself is very complex, and can include a reference to cognitive facts that are public property in the same way as knowledge about the world is. This holds true not only for art, but also in the domain of the appreciation of natural beauty: in Chinese and Japanese civilizations, which possess an aesthetics of natural beauty far more complex than ours, the appreciation of natural beauties depends upon an acquired culture rich in conceptual determinations far more than upon a spontaneous sensibility. That is why the opposition between natural and artificial beauty is not reducible—contrary to what Kant thinks—to the opposition between pure and impure aesthetic judgment; it refers rather to the distinction between a pure aesthetics of reception and a theory of art that could not skip over the intentional structure of its objects.

It is clear that accepting the existence of a conceptual component in the judgment of taste does not mean that it is reduced to a cognitive judgment. It is still an evaluative judgment, because the descriptive traits mentioned do not define the object *in se* but are rather the ones that elicited a feeling of pleasure (or displeasure) in the person who formulates the aesthetic judgment. *The descriptive traits are not selected because they are objectally decisive, but because they are subjectively attractive.*

As we see, Kant's conception of aesthetic experience (and more specifically of aesthetic judgment) poses certain problems. I do not claim to have provided conclusive solutions for these problems. I will be satisfied if I have shown that while his theory is incompatible with any attempt to formulate a speculative theory of Art, it is in no way opposed to a positive knowledge of the arts. That is, the difficulties encountered by his purely "emotivist" definition of aesthetic judgment are independent of the possible validity of his central thesis, which can be summarized in two points:

a) Meta-aesthetic analysis shows that the problem of the possibility of objective knowledge of the arts is independent from the question of the status of aesthetic judgment (pure or applied), from the question of the status of descriptive propositions that might motivate this aesthetic judgment, and from the question of the possibility or impossibility of an a priori aesthetic doctrine. It therefore in no way precludes a positive knowledge of art, a knowledge that has exactly the same status as other cognitive discourses; neither does it preclude the possibility that objectal descriptions might motivate aesthetic judgment, it being understood that the traits described are chosen by virtue of the pleasure they elicit and not as traits defining the essence of the object in question.

b) It asserts the impossibility of reducing an aesthetic judgment to the

motivating descriptive judgments, that is, it is incompatible with an aesthetic doctrine (the term "doctrine" being taken here in the strong sense it has in Kant, i.e., as a synonym of the determinist objectal theory), since the latter consists precisely in the claim to transform an evaluative judgment based on a sentiment of pleasure into objectal knowledge.

Thus with romanticism is born a confusion heavy with consequences: a *category error* that consists in confusing the cognitive discourse concerning the arts with a *doctrine* in Kant's sense of the term. In fact, the speculative theory of Art treats art as a specific ontic domain *by virtue of its value*: it bases an ontic category on an evaluative category. It confuses art as a phenomenal object with art as value: it defines it by its value and then valorizes it in return by means of its definition. Hence its distinction between art and non-art is inevitably a dividing line drawn within artistic practices: the act of exclusion is the complement of the sacralization.

What is at issue is not the fact that the speculative theory of Art abandoned Kant's meta-aesthetic move—even though it is regrettable that we had to wait until the twentieth century to see it reactivated (in Anglo-American analytical philosophy). The romantics' decision to turn toward the theory of art was certainly a positive act. The fact that in doing so they were forced to move away from Kant is just as comprehensible, given the underdeveloped and even incoherent character of his positions on art and the preference he accords to natural beauty. But the fundamental rupture—and the one with the most consequences—is situated elsewhere: in the sacralization of the arts and in the construction of a speculative doctrine that is supposed to legitimate this sacralization. The central aspect of the speculative theory of Art therefore does not reside in its attempt to go beyond Kant so much as in the factors that motivate it and in the way it conceived this "transcendence."

The Speculative Theory of Art

The Birth of the Speculative
Theory of Art

WHEN WE MOVE from Kantian aesthetics to romantic aesthetics it is difficult to get our bearings: we are in a completely different universe. To be sure, we very quickly see that the "technical" change concerns both the status accorded to art and that accorded to aesthetic knowledge, but at the same time we realize that the stakes go far beyond any strictly aesthetic question: the romantic revolution is the locus of a fundamental upheaval, a radical change in the way of conceiving the world and man's relation to this world, at the level of the most individual and private sensibility as well as at that of the overall view of human existence. This upheaval is condensed in the aesthetic domain, but it is its generalized character that makes the romantic revolution a major step in the history of Western culture, as important as the Renaissance or the Enlightenment.[1]

What is the nature of this revolution? The republicanism of the young Friedrich Schlegel or of F.W.J. Schelling, as well as the "radicalism" of many of the aesthetic theories of the Schlegel brothers or Novalis may mislead the contemporary reader: the romantic revolution, from the Jena period onward, was fundamentally "conservative," in the sense that its aim—largely achieved—was to stop the movement toward the secularization of philosophical and cultural thought that had been undertaken by the Enlightenment, and of which Kantian criticism is a good example.

It is scarcely possible to completely ignore the romantic "worldview," so intimately is it linked to aesthetic problems. The birth of the speculative theory of Art results, of course, from the conjunction of multiple social, political, and intellectual factors. But all these factors have the same secret center, which is twofold: on one hand the experience of an existential, social, political, cultural, and religious disorientation; on the other the irrepressible nostalgia for a harmonious and organic integration of all the aspects of human reality experienced as discordant and dispersed. Thus it is undeniable that the question concerning the status of art is related to the emergence of the figure of the "free" artist, that is, in fact, to the increasingly manifest introduction of the logic of the market into the circulation

of artistic and literary culture. The replacement of ties based on personal dependence by the anonymous and unpredictable sanction of the marketplace inevitably led artists and writers to ask themselves questions about the status of their activity.[2] In the specific case of German romanticism, it is important not to ignore the political factors. The collapse of feudal structures brought about by the French Revolution, which was at first welcomed and shortly after deplored by the German romantics, plays a part in the paradoxical double characteristic that defines their texts: a celebration of the most radical subjectivism combined with an increasingly pervasive nostalgia bemoaning the destruction of integrated, reputedly "organic" social structures. When Novalis, in the mystical flight of *Faith and Love* (1898), lauds the Prussian royal couple, or when, in *The Christianity of Europe* (1800), he sings the praises of the medieval Church and the Counter-Reformation, this is the same man who in his literary fragments defends the most innovative poetological conceptions.[3] His radical conception of poetry goes hand in hand with a social theory that has been described as conservative and moreover has been seen as anticipating, by its cult of unity, state, and hierarchy, the totalitarian ideologies of the twentieth century.[4]

The key word in the romantic ideology is incontestably *Unity*. This Unity has two characteristics. On one hand, it is not conceived as an abstract principle, but as a living and life-giving force, the soul of an organic universe in which everything is alive. It is theological in nature: the vicissitudes of romantic wandering through ancient pantheism, Spinozism, and then Catholicism are revealing, not so much in what distinguishes them, as in what unites them—namely, the demand for a theological vision of the universe. It has often been said that romanticism was a religion of art, but it is just as much the theory of a theological art: the sacralization of art is inseparable from its religious function.

But unity is at the same time failing: the writings of Friedrich Schlegel and Novalis never cease to revolve around the theme of its *loss* and the hope of its impending reestablishment. That is why Novalis longs for the monolithic unity of the medieval Church, deplores the dispersing, individualizing force that issued from the Reformation and the Enlightenment, and dreams of a restoration of the papacy as a supreme power once again unifying under its banner all the peoples of Europe. And it is for the same reason that the young Friedrich Schlegel longs for the organic unity of ancient culture, deplores the subjectivist dispersion of modern literature, and announces the reestablishment of a classical literature. It is true that, unlike Novalis, Schlegel thinks this reestablishment of a classical literature will not come about through a historical regression, but rather through an exacerbation of modern subjectivism, which of itself will produce its opposite, namely renewed objective culture.

But it is no doubt in the philosophical domain that the need for Unity manifests itself with the greatest amplitude, and we find it not only in Friedrich Schlegel and Novalis, but also in Hölderlin and the heavy hitters of objective idealism, Schelling and Hegel. Kant is the target: he is accused of having closed the door on ontology, of having limited the domain of knowledge to subjective forms and categories and to phenomenal objects, and of having reduced the question of the *hen kai pan*—of Being and God—to the status of a pure rational Idea inaccessible to theoretical speculation. Seeking to move beyond Kantian critique and to integrate it into a new ontological doctrine, the romantics and the thinkers of objective idealism brought the great metaphysical systems back into vogue. Whence their recourse to Leibnitz, Spinoza, Boehme, Plotinus—that is, to constructors of monistic systems of the universe—reinterpreted in a subjectivist perspective. Thus Novalis develops conjointly his theory of poetry and a metaphysics of the Universe inspired by Plotinus.

It is within this overall framework of the romantic worldview that we must situate the aesthetic revolution—and especially the new conception of the arts and the new definition of the status of discourse on the arts—if we want to understand their deep motivations. This worldview has been amply discussed; for a long time, the study of "the romantic soul" was one of the chief subjects of research on romanticism. More recently attention has shifted toward its aesthetic and poetological aspects. The most important result of these latter studies has been to show that the romantic revolution could be considered as the place where most of the aesthetic and poetological theses of "modernity" were born.[5] On the other hand, so far as I am aware, the problem of the status accorded to discourse on the arts and its connection with the sacralization of the arts has received less attention. Yet the passage from Kant to romanticism is also played out on the epistemological level of this status, and the relation between the sacralization of the arts and the emergence of a speculative theory concerning them is not merely a fortuitous parallelism.

The birth of romanticism nevertheless results from a more specific factor: the conviction that philosophical discourse is incapable of adequately expressing the renewed theological ontology. At the moment of its birth, the speculative theory of Art is inseparable from the idea that Art must replace a defective philosophical discourse. The romantics' fundamental experience resides in the idea that philosophy cannot be the place where onto-theology will blossom. In other words, it is because philosophical discourse is depreciated that the arts, and first of all poetry, will come to be invested with an ontological function.

This apparent dismissal of philosophical discourse is paradoxically the work of philosophical discourse itself.[6] The romantic philosophical impulse is bicephalic, straining between a methodological heritage that remains critical in nature and the new theological ontology. The two im-

pulses are situated at different levels: theological ontology functions as an evident truth whose discursive nature is at the same time not recognized; critical methodology, on the other hand, is held to represent philosophical discursivity par excellence. The monistic ontology appears to be impossible to formulate within the horizon of a philosophical discursivity dominated by the dualism of subject and object and thus by the impossibility of formulating their absolute unity.

Friedrich Schlegel expresses this noncoincidence of philosophy's ideal content and its discursive form by distinguishing between the spirit and the letter of philosophy: "Some people think they find the perfect form of philosophy in systematic unity; but they are wholly wrong in this, for philosophy is not a work external to the presentation (*Darstellung*): it is solely spirit and intention. . . . The concept, the very name of philosophy, as well as all its history, show us that it is nothing other than an infinite search that never ends (*ewiges Suchen und Nicht-Finden können*)."[7] Novalis, taking his inspiration chiefly from Neoplatonic theories, asserts that the fundamental reality is accessible solely through an ecstasy that escapes rational discursivity, since the latter always presupposes the duality between a subject that makes a statement and an object on which this statement bears. Only poetic creation has access to an ecstatic contemplation in which the poet is at once subject and object, self and world.

In short, the establishment of Art as an ontological revelation does not arise simply from a failure of philosophy as such, but in a more specific way from the incompatibility between its discursive form and its ontological content (or reference). Then it is Art that rises up: it will achieve the presentation of the content of philosophy.

The specificity of romanticism in relation to the later developments of the theory of Art lies in this double structure: not only is Art endowed with an ontological function, but it is moreover the *only* possible presentation of speculative ontology, of speculative metaphysics. In fact, on this precise point, objective idealism is diametrically opposed to romantic thought. In Schelling or Hegel, Art will nonetheless continue to be invested with a function of ontological revelation, but its relationship to philosophical discourse will be conceived differently. The idealist solution itself is unstable: Schopenhauer, Nietzsche, and Heidegger all address in new ways the problem, raised over and over again, of the respective hierarchical positions of Art and philosophy.

In the speculative theory of Art, the arts are thus caught in a pincers movement by philosophical discourse, both at the level of their function and at the level of their content. It is in this sense that the sacralization of Art and the genesis of a speculative theory of Art are inseparable: the *modalities* of sacralization are prescribed by speculative theory, but at the same time it is the sacralization that first motivates the elaboration of a

speculative theory that is supposed to legitimate it. That probably explains why the German philosophical tradition that came out of the romantic revolution thought itself always obliged to develop a theory of Art and to make a strategic place for it in its overall metaphysical construction. Ontological Art and metaphysics of Art mutually determine each other: the speculative theory of Art will always be a specific determination of both the content of Art and of the place occupied by it in a general ontology. In telling us that Art reveals Being, the speculative theory of Art must always also, and in the same act, situate it in the Being that it reveals; it is at once an ontological revelation and an object of ontology. For the romantics poetry reveals the Universe to us, at the same time that it constitutes its eschatological figure. In Hegel, art is simultaneously the sensuous revelation of the Absolute and one of the figures of spirit, one of the stages in a systematic hierarchy culminating in philosophic self-realization. At the other end of the historical chain, in Heidegger, the work of art is both the *poïesis* of Being's historical fate (as the Being of a historical people) and a fundamental category that is opposed to the thing and to the product.

Kant had declared that any doctrine of the beautiful was impossible, arguing that beauty was not a kind of conceptual determination. Applied to the arts, this thesis amounted to making cognitively null any philosophical doctrine based on an axiological definition, and to limiting aesthetic discourse to the evaluative criticism of works and to the study of technico-formal mechanisms. As for philosophy, it was to analyze not Art (as an axiological object), but the aesthetic judgment instituting aesthetic objects. Romanticism seeks to short-circuit the third *Critique* by reducing the Beautiful to the True and by identifying aesthetic experience with the presentative determination of an ontological content. At the same time, we no longer encounter artistic works but only manifestations of Art: if Art reveals Being, then artistic works reveal Art and are to be deciphered as such, that is, as so many empirical realizations of the same ideal essence. Thus it is because art works (and the arts) are reducible to Art that the latter can be a revelation of Being: the definition of Art as a presentation of onto-theology implies the reduction of art works (and the arts) to the theory of Art.

We cannot close this synoptic overview of the romantic revolution without mentioning a final characteristic: the thoroughly historicist nature of the romantic theory of Art. Historicism can be characterized as a theory that transforms historical events and facts into signs of a more fundamental reality, into empirical manifestations of transcendent determinations of essence (the forms can be multiple: self-development of absolute Spirit, the struggle for life, fate of Being, etc.). In other words, there is historicism when historical events and facts are no longer studied in their factual arrangement (that is, in relation to other elements of the same order of real-

ity or of another order of empirical reality), but rather as so many traces left by transcendent factors. It is a doctrine that is omnipresent not only in romanticism but also, of course, in Hegelianism: we encounter it in Schlegel's conception of the history of Literature and again in Hegel's historical systematization of the arts. It is absent in Schopenhauer, but we see it at work again, in a very different form, to be sure, in Nietzsche, and later in Heidegger.

This historicism is only one of the forms of the utopian messianism that is inherent in the speculative theory of Art. I have said that the romantic cult of Unity was a cult of a failing Unity, of a Unity to be (re)established; thanks to the historical doctrine, history is transformed into a movement toward Salvation.[8] In the ultimate destiny of the speculative theory this messianism takes many forms. Thus the function accorded to the contemporary period in historical dynamics is not always the same; in Hegel, for example, the contemporary period is the period of completion. The romantics are more undecided. In a first phase, they conceive the contemporary period as the dawn of the completion, but later they denounce it as being fundamentally antipoetic (whence the escape into the past). For the young Nietzsche and for Heidegger, the contemporary period is the age of alienation; whence the often polemical character of their writings, in the aesthetic domain as well. Schopenhauer, although he also defends an aesthetic doctrine of salvation, is the only one who does not propose a historicist eschatology. That is because as a strict Platonist, he denies all reality to history and to change.

It is within the framework of these general characteristics of romanticism that is located the double problem I propose to study here. First I shall take up the sacralization of poetry. I shall study it through Novalis's texts. It would obviously have been possible to analyze it in Friedrich Schlegel as well, but I have preferred to reserve the latter's texts for the study of another aspect, the genesis of the speculative theory of Art. Of all the romantics, Schlegel is the one who most rigorously pursues the project of an aesthetic theory, and more specifically a theory of literature, based on the sacralization of Art. The twofold fact that the tradition of the speculative theory of Art begins with a theory of literature and that this theory embodies itself in a history of Literature, is obviously not a matter of indifference with regard to the later destiny of the tradition in question.

Poetry as the Sublation of Metaphysics (Novalis)

If it is true that the romantic sacralization of poetry is the translation of a philosophical impulse and a problematics that is both aesthetic and artistic—and more specifically poetic—it is not surprising that the "appren-

ticeship years" of Novalis and Friedrich Schlegel, the two most radical minds of Jena romanticism, were devoted, if not exclusively, at least in large measure, to philosophical reflection. The manner in which the latter is connected with other fields of interest is moreover revealing: whereas Novalis prefers religious questions, and more generally problems of a theologico-political order, Friedrich Schlegel tries instead to link his philosophical works with philological and historical reflection. But these differences, no matter how interesting, must not make us forget the basic identity of the two friends' aspirations: the elaboration of an ontological doctrine that would be both the legitimation of poetic activity and its central theme. From the outset, poetic creation, and more generally artistic creation, is thus considered as coupled with a knowledge that grounds it and constitutes its theme: artistic activity is essentially reflective. Neither Novalis nor Schlegel would have admitted the possibility that artistic creation might be cut off from such a basic knowledge; and that is precisely why they lay the foundation for the modernity of art, and more specifically of literature.

The initial impulse of Novalis's intellectual activity is thus of a philosophical and not of a poetic order. The first major traces of his spiritual evolution are notes devoted to philosophical doctrines that were "fashionable" in the last decade of the eighteenth century: Kant's criticism and especially Fichte's philosophy. The young Novalis's readings of these authors show very clearly how, not finding what he is searching for, he introduces all sorts of distortions in order to bring them into line with his own aim. The latter, after a period of "incubation" corresponding to his notes on Fichte (1795–96), is formulated explicitly as early as 1797: the self-understanding of Being in all its plenitude can take place only in poetic creation.

From Philosophy to Poetry

The studies on Fichte constitute the first document of Novalis's philosophical apprenticeship; and they also already contain the first seeds of his own theological worldview. It should therefore be possible to use them to analyze how the move from the interest in philosophical analysis to the concern about worldview is negotiated, and to show the conceptual shifts that this kind of move implies.

There can be no question of following step-by-step Novalis's reflections, which are quite disconnected. I shall limit myself to trying to grasp their fundamental dynamics, namely the progressive realization that critical philosophy (even in its Fichtean form) is incompatible with the romantic project.

The most obvious characteristic of Novalis's reading of Fichte is its existential and vitalist dramatization of a philosophical project which, in spite

of its ambiguities, still remains very close to Kant's way of proceeding. Fichte's *Wissenschaftslehre*[9] sets itself a very precise goal: to go back to the absolute foundation of *knowledge*. This is an ambitious task, to be sure, but nonetheless narrowly circumscribed: the theory of the "absolute ego" claims to be valid only within the framework of the gnoseological problematics. At the same time the arrangement of the three fundamental Fichtean "propositions" (the absolute ego as the ultimate foundation, the non-ego as the "other" of the ego, the construction of the real as a mutual limitation on the ego and the non-ego) belongs essentially to the conceptual order: it is not an ontological theory of the ego, nor *a fortiori* a theory of the historical or psychological genesis of the human subject; the ego is considered only *qua subject of knowledge*. What is at stake here—as in Kant—is the deduction of the a priori conceptual conditions that make human knowledge possible. To be sure, just as Fichte's method is synthetic rather than analytic, his procedure is in a certain way genetic; but it is a matter of a logical genesis, of a genesis of concepts and not of an ontic genesis. The fact that he introduces a practical element (the will) into the deduction of the possibility of knowledge should not be understood as implying an existential psychologization of the gnoseological problem; rather, we should see in this the necessity, according to Fichte, of introducing the will to knowledge among the latter's a priori conditions.

Novalis—after a first period in which his aim is above all to master the Fichtean vocabulary—very quickly moves toward an overtly existential and speculative problematics, that is, toward a rejection that is at first implicit and later explicit, of the Kantian critical dimension in which Fichte, at least at that point,[10] was still operating.

The existential and speculative dramatization passes by way of the notion of "life" introduced as early as the first notebook, which dates from the winter of 1795: "If there existed a sphere still more elevated [than that of the opposition between ego and non-ego], it would be the one situated between Being and non-Being—the oscillation back and forth (*Schweben*) between the two. It would be something inexpressible, and here we are confronted with the concept of life. . . . Here philosophy stops and must stop—for life resides precisely in this, that it cannot be understood."[11] The idea of an opposition between life and philosophy is not original; it is found in Jacobi and more generally in the German pietist tradition. But Novalis—and this is what is new about the current of thought of which he is one of the most radical representatives—is not satisfied with an opposition between the two poles: he will seek to discover the place where they are united. In the Kantian critical tradition, philosophical ontology is circumscribed by the dualism of ego and non-ego; it therefore grasps Being solely in the modality of beings that can become objects of a consciousness. According to Novalis, "life" is precisely what is beyond—and thus at the

foundation of—the distinction between the ego and the non-ego. It is Being beyond beings, or as he puts it, the oscillation between Being and non-Being.

Nevertheless, if life is beyond philosophical discursivity, it is not ineffable. For Jena romanticism, as for nascent Idealism (until 1800 at least), "life," if it cannot be grasped by philosophy, can nonetheless be expressed by poetry, and more generally by the artistic sphere. This is the utopian dream that Novalis pursued in his mythological-theological novel, *Heinrich von Ofterdingen*, whereas Schlegel elaborated its theoretical form in his theory of the novel. Even Hegel, during his years in Nuremberg, proposed a "religion of beauty," a memory of the radical estheticism of the *Ältester Systemprogramm*, a text that came out of his sessions of "symphilosophy" with Hölderlin and Schelling. As for the latter, they also ranked art above philosophical discursivity, Hölderlin in his *Hyperion*, and Schelling in his *System des transzendentalen Idealismus* (1800).

The introduction of the notion of "life" as an absolutely primary term is a clue to the fact that, at the beginning of his philosophical apprenticeship, Novalis turns away from the Kantian question about the ground of knowledge and toward the question about the ground of Being. Hence it is not surprising that he quickly arrives at a paradoxical position: metaphysics as fundamental knowledge is seen as an absolutely desirable goal, but at the same time it appears impossible because of Novalis's idea of philosophical discursivity, which simply identifies it with Kantian criticism. But the latter, as Fichte clearly states, cannot go beyond the "pure ego," beyond the subject.

It is therefore no surprise that in Novalis organicist vitalism immediately takes on a religious orientation. As early as the same year, 1795, he introduces in his notes the triad "God-Nature-Ego," and makes it correspond to the philosophical notions of the necessary, the real, and the possible.[12] And in the same period we find this significant remark: "Spinoza rose as far as nature; Fichte as far as the ego, as far as the person. I rise up to the thesis of God."[13] The identification of the Fichtean ego with the person shows clearly that Novalis is not only asking the question about the genealogy of Being, but also trying to tear the Fichtean ego away from its original terrain, the question of the ground of knowledge. In addition, this passage formulates for the first time in an explicit manner what will become the leitmotif of Novalis's future reflection: the idea that God is identical with the *menstruum universale* of life, which is realized conjointly in nature and in the ego. Life is therefore not identified with nature, which constitutes only its visible form; it is the unity of nature and the ego, of the visible and the invisible.

It is significant that the emergence of the religious dimension and that of poetry go hand in hand. In fact, it is starting with the set of notes dated

from the spring to the beginning of summer 1796 that poetological observations appear with increasing regularity: the notes faithfully follow the curve of Novalis's interest, which begins to shift slowly from philosophy toward art. At the same time religion occupies an increasingly prominent place, since it is in this same set of notes that Novalis introduces the notion of "faith" (*Glauben*) that will henceforth play a central role in both his worldview and his poetic ontology: "Science is only one half. The other half is faith."[14] The link between religion and poetry is established by means of the concept of imagination, for on the same page we read: "Reason combined with imagination (*Fantasie*) produces religion. Reason combined with understanding produces science."[15] The term "science" refers here not only to the mathematical sciences or natural sciences, but also to the discourse of knowledge as a whole, including philosophy. As for "imagination," it refers, of course, to the domain of poetry. One can thus say that as early as the summer of 1796 Novalis has established the fundamental triad that will henceforth organize his thought: knowledge, religion, poetry.

The fifth set of notes on Fichte, dated summer 1796, is the most important of the whole series. In them Novalis definitively formulates the paradox—according to him, a constitutive one—of the philosophical enterprise; in a parallel manner, he introduces the notion of presentation (*Darstellung*), which will allow him to move from a theory of Art founded on a theory of the spiritual faculties to an onto-theological theory shifting the emphasis from creative subjectivity to the created work.

Let us begin with the problem of the paradoxical status of philosophical discourse. We have seen that Novalis had set philosophy the task of thinking the absolute foundation of Being, life, and that at the same time he had asserted that it could never accomplish this task. After many groping efforts, he succeeds in giving an acceptable form to this paradox in a fragment that is important for understanding what distinguishes romantic idealism from Kantian critical philosophy: "The act of philosophizing must constitute a specific mode of thought. What am I doing when I devote myself to philosophy? I am reflecting on a foundation. At the foundation of philosophy we therefore find an aspiration to conceive a foundation. But the foundation is not what is called a cause, in the true sense of the term—it is rather on the order of an internal constitution—connection with the Whole. All philosophy must therefore end with an absolute foundation. But if the latter were not given, if its concept contained an impossibility—then the philosophical domain would be an infinite activity—and thus without end, since moved by the absolute necessity of an absolute foundation, a necessity that could never be satisfied except in a relative manner—and that therefore would not cease. . . . Philosophy, that is, the result of the act of philosophizing, thus arises from an interruption of the impulse

toward *the knowledge of the foundation*—through a halt at the element at which one has arrived—abstraction from the absolute foundation and highlighting of the true absolute foundation of freedom through the connection (integration [*Vergänzung*] into a Whole of what is to be explained)."[16]

The resolution of the constitutive contradiction of philosophy, that between *ought* and *is*, thus passes through a distinction between the *philosophical act*, conceived as an infinite activity, and its result, *philosophy as a system*, as an organized totality. The latter could never be more than an *analogon* of the living totality, since it never reaches the absolute foundation. Nonetheless, to the extent that it is freely assumed, this limitation of philosophy, of philosophical discursivity, is at the same time the paradoxical manifestation of the ego's freedom, a freedom that is the sole true absolute foundation. In other words, the arrest of the philosophical impulse is the paradoxical manifestation of the absolute foundation that philosophical discursivity vainly seeks through its infinite movement.

It is important to clearly locate the point where the break with the Kantian critical enterprise takes place. In fact, one might be tempted to think that Novalis ultimately merely adopts the Kantian distinction between the domain of theoretical philosophy and that of the practical ideal. And it is undeniable that his concerns proceed from this distinction. But what is new (and at the same time very old) is that he identifies philosophical discursivity, not with the search for the *conditions of the possibility* of knowledge, but with the project of a *total* knowledge. The passage quoted is unambiguous on this point: on one hand, the foundation is defined absolutely, and no longer in relationship to a precise *explicandum* (knowledge); on the other, and this is the most important point, it is no longer situated in a reflection on the conditions of possibility but rather identified with the internal connection (*Zusammenhang*) of a totality. For Novalis, the true foundation is not an a priori condition; it is the totality of Being brought together in its original unity. The philosophical search for a foundation is only another word for the presentation of Being in its unity.

The most decisive difference between Fichte and Novalis is illustrated by an expression that I have italicized in the passage quoted above: *Erkenntnis des Grundes*, "knowledge of the foundation." This syntagm epitomizes the reversal in point of view that Novalis (and with him the whole romantic and idealist philosophical tradition) undertakes with respect to the Kantian critical enterprise. The latter in fact did not seek *knowledge of the foundation*, but rather *the foundation of knowledge*, not the *Erkenntnis des Grundes* but the *Grund der Erkenntnis*. The Kantian effort to go back to first principles remains within knowledge: it is a reflective movement in which knowledge ascertains its own conditions of possibility. With romanticism, on the contrary, we move (back) to the very different

question of the knowledge of the foundations as such, which is also knowledge of the "ground," of ultimate reality. What in Kantian critical philosophy was the infinite ideal of a state of completion of human knowledge, an ideal that as such escaped philosophic legislation in the strict sense, becomes (again) in the romantics the main question of philosophy. Hence the foundation is no longer relative (to knowledge), but it is reified into an absolute origin. When Fichte says that he wants to carry out the true project of critical philosophy, namely the construction of the foundation of knowledge, Novalis translates: philosophy should seek the foundation of Being. In other words, what for Fichte is situated at the meta-objectal level (the a priori conditions of an object of knowledge) shifts in Novalis to the objectal level (the foundation as the absolute object of knowledge). In the Fichte of the *Wissenschaftslehre*, the genitive in the syntagm "foundation of knowledge" is both objective and subjective: a foundation for and through knowledge. Novalis (and with him, the whole romantic tradition) separates the two terms and then inquires into their relationship; he arrives in this way at a reification of the foundation, which becomes the impossible object of philosophy, the latter being thereby called upon to yield to poetry.

It is in the notes devoted to his rereading of the works of Hemsterhuis and Kant that Novalis makes the definitive leap from philosophy toward poetry. These are two important stages in the elaboration of his poetological theory, since they lead directly to the threshold of the theory of poetry he develops between 1798 and 1800.

The reading of Hemsterhuis confirms him in his Neoplatonism and in the idea of a duality of knowledge (*Erkennen*), according to which it is cognition (*Wissen*) or faith (*Glauben*). Of course, if faith can be a kind of knowledge, this shows that the latter's domain is not limited to discursive knowledge grounded in a logic of rationality. Moreover, if there are two organs of knowledge, cognition and faith, and if these two organs do not coincide in their gnoseological dynamism, that is because they refer to two different orders of reality: the sensuous, material universe on one hand, the spiritual universe on the other. But since this dualism is situated within the framework of a conception of Unity, it elicits the requirement that it be transcended in a third term: here poetry comes in to connect the spiritual and the sensuous. If faith is the organ through which we know the supersensuous *in se*, poetry will be the organ that allows us to discover it *in* the sensuous. It is thus a particular form of the organ of faith; it is faith exercising itself in the domain of the visible.

It is in these same notes on Hemsterhuis that we find for the first time the idea of the priority of poetry over philosophy. This thesis had already been proposed by Hemsterhuis himself: "Moreover it is not without reason

that poetry is called the language of the gods; at least it is the language that the gods dictate to every sublime genius who has relations with them, and without this language we should make very little progress in our sciences."[17] Novalis reformulates this in the framework of a comparison between philosophy and poetry:

> If philosophy, through the formation of an external totality, or through its legislative activity, makes perfect poetry possible, the latter is so to speak the former's goal, that through which alone it is endowed with meaning and gracious life—for poetry shapes good society, or the interior totality—the family of the world, the beautiful universal economy (*schöne Haushaltung*). Just as philosophy, through systematic thought and the state, brings together the forces of the individual and the forces of the universe and the rest of humanity—making the Totality an organ of the individual and the individual an organ of the Totality—also poetry—with regard to enjoyment. —The Totality is the object of individual enjoyment and the individual is the object of total enjoyment. Through poetry, the loftiest sympathy and co-activity—the most intimate and most magnificent community—become real (through philosophy: possible). . . .[18]

The meaning of this passage is in part obscure, and the assertion of the priority of poetry is still largely implicit. Nonetheless, poetry is said to be the goal of philosophy. Novalis seems to acknowledge two motives capable of justifying the advantage accorded poetry. On one hand, whereas the totality formed by philosophy remains purely external, that of poetry is internal: it is not legislative but organic (as the references to the family and the household show). On the other hand, only poetry actually achieves the interpenetration (the community) of particularity and universality, of unity and totality, whereas philosophy merely makes them possible, that is, it merely formulates their a priori conditions. It is the opposition between the external totality, the object of philosophy, and the internal totality, the object of poetry, that seems to me most revealing: to the extent that romantic dualism implies a subjectivist reinterpretation of Platonic dualism, the opposition between Being and appearance coincides with that between subjective interiority and objective exteriority. By reducing philosophy to a totalizing activity within the domain of exteriority, Novalis simultaneously subordinates it to poetry, since the latter is supposed to achieve the ultimate synthesis, that is, the recuperation of exteriority into interiority. It is interesting to note that in 1798 Novalis returns to this fragment but replaces the term "enjoyment" (*Genuss*), which comes from Hemsterhuis, by "life" (*Leben*). The substitution is not trivial, since it explicitly links poetry to the supreme principle that philosophy was said, as early as 1796, to be incapable of attaining.

The notes on Kant dated 1797 move in the same direction. To be more precise, they inform us that poetry can actually achieve what philosophy can only postulate as an inaccessible horizon.

If in the notes on Fichte Novalis sought, at least at first, to situate himself within the Fichtean horizon, the motivation of the notes on Kant seems quite different. The only question that henceforth interests him is that of the transcendence of the limits that critical philosophy imposed on human knowledge: "The concept of sensibility (*Sinn*). According to Kant mathematics and the natural sciences refer to the forms of external sensibility. —Then what science refers to the forms of internal sensibility? Is there also a nonsensuous (*außersinnlich*) knowledge? Is there yet another way to get out of oneself and reach other beings or be affected by them . . . ?"[19] "Nonsensuous knowledge": this truly amounts to canceling the critical enterprise. But for such a knowledge to be possible, one would have simultaneously to move beyond the finitude of the human subject asserted by Kant; therefore a way has to be found that will make it possible to get out of oneself, or, to formulate it in Fichtean terms, beyond the empirical ego. It is no accident that this question arises as a result of reflection on a possible science of the internal sense: the exit from ourselves is in reality an entry into the depths of ourselves, a move toward the originary place where we are at once subject and object, self and universe.

This idea of an exit from ourselves is also found in another passage. There Novalis copies Kant's assertion (in the preface to the *Critique of Pure Reason*, B xx, p. 24) that "what necessarily forces us to transcend the limits of experience and of all appearances is the *unconditioned*, which reason, by necessity and by right demands in things in themselves." The romantic author obviously knows that after Kant this movement beyond phenomena leads to theoretical antinomies and therefore can have only a practical status. That is why he adds the following clarification to Kant's text: "or outside ourselves."[20] The shift may seem minimal, but it is fundamental. When Kant says that the requirements of reason push us beyond the world of phenomena, he does not mean that we can *actually* go beyond phenomena, but only that we feel the practical necessity of doing so. When on the other hand Novalis speaks of an exit from ourselves, he sees in it a *real act* that would actually allow us to transcend the world of phenomena.

In fact, we are here confronted by two concerns that intersect and will soon be unified. On one hand, it is a matter of "intellectual intuition": Fichtean in origin, this is defined by the romantics as a mode of access to knowledge of the Absolute (and thus as a possible access to the Kantian thing-in-itself). Schelling, in his *Letters on Dogmatism and Criticism* (1795), a work that Novalis studied in 1797, had offered an evocative definition:

> We all possess a secret and marvelous faculty that permits us to withdraw
> from the flux of time toward our innermost self (*Selbst*), purified of all exte-
> rior trappings, there to intuit in ourselves the eternal in the form of immuta-
> bility. This intuition is our most intimate experience, and the one that belongs
> to us most properly (*eigenste*): on it alone depends everything that we know
> and believe on the subject of a supersensuous world. . . . This intellectual
> intuition occurs when we cease to be an object for ourselves, when, retiring
> into itself, the self that intuits is identical with the intuited self. In this instant
> of intuition, time and duration disappear for us: it is not we who are in time,
> but time—or rather, not time, but pure and absolute eternity—that is in us.
> It is not we who are effaced in the intuition of the objective world, but the
> latter that is effaced in our intuition.[21]

Intellectual intuition is thus identical with the "path toward the interior"
described in fragment 17 of *Pollen*: "Is the universe then not within us? We
do not know the depths of our spirit. It is toward the interior that this
mysterious path leads. Eternity with its worlds—the past and the future—
is in us or nowhere. The external world is the world of shadows. It casts its
shadow in the realm of light."[22]

The second theme connected with the notion of an "exit from ourselves"
is that of ecstasy. It comes from Plotinus, who asserted that the absolute
One is inaccessible to discursive knowledge and even to noetic intuition; it
is revealed only in an ecstatic union in which the object seen and sight
coincide and in which individuality is abolished. Now these two factors,
the abolition of (empirical) individuality and the ecstatic union of the sub-
ject and object of knowledge, will become as early as 1798 defining ele-
ments of Novalis's conception of poetry. The "exit from ourselves" im-
plies, of course, a redefinition of the relations between theory and practice,
or to be more precise, a redefinition of practice, which is identified purely
and simply with the poetic dimension. In other words, the domain of prac-
tice is transformed into that of the "poïetic" faculty and hence ceases to be
an inaccessible, becoming an Ideal *in actu*: "Are not practice and the po-
etic one and the same thing?—poetic meaning simply absolutely practical
in specie."[23] Thus the poetic, a transformation of Kantian *praxis* into pure
"poïetics," is the superior organ that is beyond the dichotomy of the theo-
retical and the practical, since in it knowledge and action coincide: "We
know it (the unconditioned) only insofar as we achieve it."[24] In various
forms, the same assertion recurs in the notes and fragments written in 1798
and 1799, and will become a genuine leitmotif of Novalis's gnoseology.[25]

THE SPECULATIVE THEORY OF POETRY

The notes analyzed up to this point merely put in place, in a more or less
dispersed manner, the elements of Novalis's poetological conception; the

notes and fragments from 1798 to 1800 synthesize them and thus give his theory of poetry its definitive form. They fall, generally speaking, into two spheres of interest: on one hand the properly poetological reflections, and on the other, the reflections devoted to the philosophy of nature. The almost exclusive interest in poetry and in natural philosophy is anticipated in a programmatic way in a letter to A.W. Schlegel, dated 24 February 1798: "Henceforth I shall occupy myself only with poetry—all the sciences must be poeticized—I hope to be able to discuss at length with you this real [German: *real*], scientific poetry."[26]

Novalis's philosophy of nature will not be discussed here. I shall simply recall that his project of a poetic encyclopedia goes hand in hand with the project, defended at the same period by Friedrich Schlegel in the *Athenaeum*, of creating a new mythology:[27] in both cases, it is a matter of determining the content of the universal poetry that is supposed to replace philosophy in decline.

Let us come then to the poetological notes proper. To simplify the analysis I shall treat all the fragments from the last two years of Novalis as a single corpus. In doing so I neglect the undeniable evolution that can be observed even in this period; right up to his death, Novalis's thought was a thought in gestation, and my synchronic approach thus risks giving a somewhat distorted view of these last collections of notes and fragments. But with regard to the object of my analyses, the consequences are negligible, and I think it is therefore legitimate to contrast the years 1798–1800 as a whole to all the preceding stages.

To the extent that poetry is the presentation of "life," and hence of the impossible content of philosophy, it is not surprising that we see a certain hesitation with regard to their relationships. I have said that according to Novalis poetry was called upon to replace philosophy in decline. The assertion corresponds well to Novalis's project, but it must be refined. He hesitates in fact between three theses: according to the first one, philosophy must transcend itself in poetry; according to the second, it must form a synthesis with poetry; and finally according to the third, poetry must replace philosophy. These three conceptions are not completely contradictory, to be sure, and perhaps it is even possible to combine them. It nonetheless remains that they are not necessarily linked and that they must therefore be considered separately.

The first thesis, which coincides with the conception of a "mystification of the sciences" expressed in *Christianity or Europe*, postulates a poeticizing of the sciences and of the canonical form, philosophy: "The final form of the sciences must be poetic,"[28] and "Every science becomes poetry—after having become philosophy."[29] This trajectory leading from philosophy and the sciences in the traditional sense of the term to poetic philosophy is linked by Novalis to the blooming of a pure, absolutely free

creation: "Freedom grows with the thinker's . . . training and ability. . . . Ultimately the thinker is capable of transforming everything into everything—the philosopher becomes a poet. To be a poet is nothing other than the supreme degree of thought, of sensation, etc. . . . The separation between the poet and the thinker is merely apparent—to the disadvantage of both of them."[30] Or again: "The art of poetry is surely nothing other than the free, active, productive use of our organs—and it might be that poetry is nothing else—so that thought and poetry would be one and the same thing."[31] Thus the poeticizing of philosophy comes down to the idea of an absolutely free thought, that is, one that is not dependent upon some sensuous impression imposed on us from outside and that would escape our jurisdiction.

The second thesis, rather than postulating a repetition of philosophy in poetry, admits the idea of a superior imaginative activity that would synthesize in itself thought and poetry in the restricted sense of the term. This conception seems to impose itself every time Novalis conceives the opposition between philosophy and poetry as an opposition between two faculties, for example, between discursivity and intuition, or between the understanding and the imagination. If according to the first hypothesis the difference between philosophy and poetry was resolved through a *transformation* of the first term, here there is instead a *transcendence* of the two activities by a third one, which is supposed to synthesize them. The result is the same, since we still arrive at a philosophical poetry or a poetic philosophy. Only the path taken differs: according to the second conception poetry, in its present form—that is, separated from philosophy—must also be transcended. It is in this perspective that Novalis opposes the discursive thinker to the intuitive poet. The former approaches reality only through a sort of semantic atomism; hence he destroys living nature and puts in its place a work of art (but also: an artificial work) formed of thoughts (*Gedankenkunstwerk*). As for the intuitive poet, he is opposed to any rule or fixed form; for him everything is life and liberty. The opposition between them is to be transcended by the artist (*Künstler*): he will synthesize discursivity and intuition in the activity of the productive imagination.[32] Later on we will encounter again this central but obscure notion, which Novalis here places at the apex of his theory of the faculties.

According to the third thesis, poetry is supposed to replace philosophy. This conception comes in every time Novalis puts the question of the relation between poetry and philosophy into a directly eschatological perspective: "The poet concludes the movement, just as he begins it. Whereas philosophy merely orders everything, posits everything, the poet undoes all the bonds. His words are not general signs—they are sounds—magical words that move beautiful groups around them."[33] Sometimes the thesis is formulated more vaguely and more mundanely (so to speak): "It will be a

beautiful epoch when one will no longer read anything but beautiful compositions—literary works of art. All the other books are only means and
they fall into oblivion as soon as they cease to fulfill their function properly—and that cannot fail to be soon."[34] This beautiful epoch will obviously be that of completed knowledge, since it is only then that one will be
able to get along entirely without books functioning as means (to attain
knowledge). In another passage, repeating a passage from Schlegel,[35] he
opposes, in fidelity to the tradition of the romantic philosophy of nature,
three ontological domains: that of life, qualified as vegetable and chemical, that of thought, qualified as mineral and mechanical, and that of poetry, qualified as animal and organic.[36] Of course, animality and organicity are hierarchically primary in relation to the four other terms, and this
grounds the superiority of poetry.

The differences among these three theses are in some ways minor, since
they all amount to acknowledging the superiority of poetry. The hesitation
concerns solely the question as to how the poeticizing of philosophy and
the sciences will be achieved: must philosophy raise itself up to the level of
poetry, must it on the contrary form a synthesis with poetry to arrive at a
poetic philosophy (or a philosophical poetry), or must it be transcended
(and incorporated) by poetry alone? The hesitation seems to me to reveal
the difficulties romanticism encounters when it tries to maintain a distinction between poetry and philosophy. For if poetry is the presentation of
philosophy, it is both poetry *and* philosophy, and it is hard to see how one
can maintain a genuine distinction between them.

In any case, to legitimate the preference accorded poetry, Novalis
clearly has to show that it is capable of presenting the *hen kai pan* (the
One and All) that escapes philosophy. Poetry must therefore not only be
defined as ontological knowledge, but also, in some way or other, endowed
with characteristics permitting it to be contrasted with philosophic discourse, in spite of the fact that their content is identical.

Why then is the One and All accessible solely to poetry, why must philosophy be poeticized? Novalis replies to these questions in a famous
fragment:

> The disposition (*Sinn*) for poetry has much in common with the disposition
> for mysticism. It is a disposition oriented toward the particular, personal,
> unknown, mysterious, toward what is to be revealed, toward the necessary-
> contingent (*Notwendigzufällige*). It presents the unpresentable (*Er stellt das
> Undarstellbare dar*). It sees the invisible, senses the nonsensuous, etc. . . .
> The poet is out of his senses (*sinnberaubt*) in the true meaning of the term—
> that is why everything comes together in him. He represents the subject-
> object—the soul and the world—in the most literal sense of the term. Whence
> the infinite character of a good poem, its eternity. The disposition for poetry
> is closely related to the prophetic and religious disposition, to the visionary

sense (*Sehersinn*). The poet orders, fuses, selects, invents—without under-standing himself why he acts in this way rather than in another.[37]

At first glance this fragment may well seem obscure, and one might be tempted to see in it a characterization of poetry that is itself "poetic," an allusive, indirect, and paradoxical approach to something that is supposed to elude any conceptual determination and to be on the order of an ineffa-ble mystery. But in light of the philosophical notes we have presented, the fog dissipates, and a more "technical" reading becomes possible. In fact, the fragment has two sides. One side refers to the *object* of poetic presenta-tion: the unpresentable, the invisible, the nonsensuous, the necessary-contingent, are so many negative or paradoxical characterizations refer-ring to the *hen kai pan* (the One and All) as its stamp is projected by Novalis's worldview. The other side concerns the conditions that make it possible for poetry to present this totality. Two conditions can be distin-guished. First of all, poetry is a sensuous presentation: it makes us *see* the invisible, it makes us *perceive* the nonsensuous. To refer to sensuous pres-entation is to refer to a particular, concrete presentation: it presents the universal in the particular, in the personal, and thus also the necessary in the contingent. Secondly, poetry is a "pure" presentation, that is, freed from a *re*-presentative bond: whereas re-presentation is linked to the dual-ity of subject and object, poetic presentation is situated at the point where they converge, where they fuse and meld into absolute unity. In other words, if the poet can present the One and All, it is because he himself has already attained it, in the sense that he is outside his empirical ego (that is, of the subject to which an object is opposed), in the essential interiority from which both subjective interiority and the exteriority of objective real-ity proceed. The poet, like the mystic, sees the universe in God: poetry is "the self-consciousness of the universe."[38]

This definition of poetry is intimately connected with a theory of the productive imagination: "The imagination is that marvelous sense that can replace all the other senses—and which is already largely in our power. Whereas the external senses seem entirely subject to mechanical laws, the imagination does not seem to be bound to presence and to the contact with external stimuli."[39] In another passage Novalis gives the imagination the task of realizing the synthesis of the internal sense and the external senses. "The imagination must become both a direct (external) sense and an indirect (internal) sense. The indirect sense must become a direct and self-acting—living—sense; at the same time the direct sense must become an indirect and self-active sense."[40] If the imagination can replace all the senses, if it can and must become both an internal sense and an external sense, this means that it does away with all exteriority and all alterity: it is self-acting, drawing its figures from its own resources, creat-ing its objects through its presentative work.

A comparison of this theory with Kant's theory of the productive imagination reveals the abyss separating his critical philosophy from the speculative theory of Art. Let us first recall that Kant distinguishes between the reproductive imagination and the productive imagination;[41] Novalis is interested only in the productive imagination. Moreover, he assimilates the latter to fantasy (*Fantasie*): "A pure thought—a pure image—a pure sensation are thoughts, images, sensations that have not been elicited by a corresponding object, but rather arise outside so-called mechanical laws—outside the sphere of mechanism. Fantasy is such an extra-mechanical force (magic or syntheticism of fantasy. Philosophy appears here entirely as magic idealism)."[42] Here we are very far from Kant, as the reference to magic idealism shows. Let us briefly recall Kant's theory. He distinguishes two forms of the *produktive Einbildungskraft*: the empirical productive imagination, which brings together in images (*Bilder*) the manifold of our intuitions,[43] and the pure a priori productive imagination, which he identifies with the faculty of schematism, that is, with the faculty through which intuitions can be subsumed under concepts. The empirical imagination presupposes the pure imagination, that is, the faculty of images can be put into operation only insofar as it is guided by the schematism of concepts. This schematism, by virtue of which the sensibility harmonizes with the understanding, is only very imprecisely defined by Kant: neither concept nor image, it is the "representation of a universal procedure of imagination in providing an image for a concept."[44] The central feature of this conception has been strongly emphasized by Heidegger.[45] He points out that in Kantian criticism, the faculty of productive imagination is the place where the finitude of human knowledge is anchored: in fact, to cease to be empty and to be endowed with denotation (*Bedeutung*),[46] concepts must pass through the schemata; their scope is thus limited to the domain of what is given in sense experience. This means that the productive imagination, although it proceeds in accord with its own a priori determinations, is pertinent only insofar as it is applied to intuitions that are given to it (whether sensuous or pure). To be sure, it is distinguished from reproductive imagination in that it can freely invent the form of its object, but at the same time Kant maintains—if we except an ambiguous passage in the *Critique of Judgment* analyzed in the preceding chapter[47]—that it is "not capable of producing a sensuous representation that has never been previously given to our sensuous faculty, [that] the matter that refers to the latter can always be located."[48]

In Novalis, on the contrary, and in romanticism generally, the productive imagination is truly creative from the ontic point of view. It is the place where the autonomy and at the same time the infinitude of the subject are realized, the place where all exteriority is abolished; through the imagination, contrary to what happens in the other senses, it is the subject

that "informs" the external world. Magic idealism, another name for the "active empiricism" called for by Novalis, is nothing other than putting to work the productive imagination as an autonomous creative faculty that draws the world from its own fund of resources and sets it in front of itself. The object is no longer dependent on the stimulus of the senses, but becomes an autonomous project of the productive imagination. The latter is thus truly the secret center of romantic ontology: what is, exists by virtue of the creative imagination. It is in this sense that the universe is a poem, and it is also in this sense that the productive imagination creates poetic philosophy, philosophical poetry, the utopian horizon of Novalis's poetics.

This theory of the imagination is obviously continued in the theory of poetic language. The claim that poetry is realized in a specific language, whose signs are motivated, and which is thus opposed to the arbitrary language of everyday communication,[49] is incontestably one of the romantic theses most firmly anchored in our current poetological assumptions. It has been analyzed in detail by Tzvetan Todorov,[50] and I mention it here only to indicate its close relationships with the theory of the imagination and more broadly with the romantic worldview.

It goes without saying that the very idea of a specific poetic language finds its justification in the claim that poetry is supposed to reveal truths inaccessible to nonpoetic discursivity. In this sense it is inseparable from the definition of poetry given by romanticism, and this definition in turn cannot be separated from the general ontology in which it is inserted, since it is only within this ontology that it deploys its pertinence. Todorov has shown that from the point of view of the theory of the motivation of linguistic signs that it presupposes, this ontology develops along two axes. They in turn give rise to two subtheories, the theory of vertical motivation (a theory of the poetic image and of sound symbolism) and the theory of horizontal motivation (a theory of the syntagmatic motivation of signifiers that are supposed to form a network of meaning that is purely autotelic without any referential bearing).[51] To this "linguistic" definition corresponds a philosophical distinction that coincides with the two possible readings of the productive imagination. In the latter (as it is seen by the romantics), one can in fact choose to privilege either its figurative function (the schematism) and its position intermediary between the sensibility and the intellect, or its autonomy with regard to any exteriority and its absolute creativity. In the first case one will tend to consider poetic language in its symbolic function, whereas in the second case one will insist more on the autotelic organization of the linguistic material. The theory of poetic language will thus be either a theory of the poetic image or a theory of poetic structure: it is clear that the two theories, though often defended together, are logically independent.

It may be observed that the choice of the theory that will be privileged

corresponds to different orientations of the underlying worldview. To speak only of Novalis, when we study the fragments that deal with his worldview we find that he oscillates between Spinozism and Neoplatonism. There seem in fact to be elective affinities between the theory of the symbol and Neoplatonism on one hand, and the theory of structural autotelism and Spinozism on the other. Thus, like Neoplatonism, the theory of the symbol postulates a hierarchical relationship between the intelligible and the sensuous, a relationship in which the former is the paradigm of the latter; at the bottom of every theory of the symbol is found the idea of an inadequation that the symbol abolishes by spiritualizing it.[52] If moreover the intelligible world is identified with the universal and the sensuous world with the realm of the particular, then one can define the symbol as the unity of the universal and the particular, and thus return to the thesis of the imaginative character and median position of the productive imagination, which is supposed to unite universality and particularity. Conversely, the theory of structural autotelism, since it remains inscribed within a gnoseological conception of poetry (and we shall see that this is the case in Novalis), is more in accord with a Spinozist worldview that postulates a strict homology between the sensuous and the intelligible. This Spinozist view poses problems when one tries to defend a theory of the symbol: if there is an absolute parallelism between the sensuous and the intelligible, the latter can just as well be described as a symbol of the former; thus the symbolic function loses its status as the sublation of the sensuous into the intelligible and thereby loses its ascensional dynamics. Neoplatonism, for its part, is scarcely in harmony with the thesis of a structural parallelism grounding the theory of horizontal motivation; if there is a structural parallelism, the sensuous is no longer simply a degenerate form of the intelligible, nor, as Novalis and Schlegel maintain, a simple illusion on the part of the empirical ego. More generally, we can say that romanticism's hesitation between Neoplatonism and Spinozism, and that between the theory of the symbol and the theory of structural autotelism, manifest the same fundamental tension that results from the joint assertion of a convenient ontological dualism—which splits experience into an essential domain and a domain of empty appearances—and of an irrepressible monistic requirement that cannot accept the slightest residue of unmasterable reality, even if it is reduced to the status of an empirical illusion. In any case, in conformity with the hesitation in his worldview, Novalis defends alternately the two variants of the theory of poetic language, or rather he sketches them out, since one cannot truly say that he develops them in a detailed manner.

Let us begin with the theory of the symbol. We know how brilliantly it is defended by Goethe, the Schlegel brothers, and Schelling.[53] One would seek in vain an equally coherent body of doctrine in Novalis, even though

he has at his disposal all the conceptual elements that would allow him to develop it, among them the distinction between the sensuous and the intelligible or between the material world and the spiritual world, as well as the notions of figuration and image. That said, in an important fragment he develops the theory of the symbol at least implicitly, since the idea of a synthesis between the figure and the meaning to which it refers corresponds quite precisely to the definition of the symbol found in other authors: "Words and figures are mutually determined through a continual exchange—words that one can hear and see are in reality word-figures (*Wortfiguren*). The word-figures are the ideal figures of the other figures. —All figures, etc., must become word-figures or linguistic figures (*Wort- oder Sprachfiguren*).—Similarly figure-words (*Figurenworte*)—interior images, etc., are the ideal words of the other thoughts or words—in the sense that all must become internal images. The fantasy that forms figure- words can thus be described as genius in the true sense of the term. We shall have reached the golden age when all words will be figure-words— myths—and all figures will be word-figures—hieroglyphs—and we shall learn to utter and write figures, to make words graphic and musical."[54]

This unity of figuration and meaning realized through the reciprocal interpenetration of the world of figures and the verbal world corresponds very well to the definition of the symbol. But Novalis's fragment is still interesting in that it shows that the domain of the symbol is not limited to poetry: it also includes the arts of (graphic) figuration. We must emphasize this aspect of the theory of the symbol, since it opens the way to the systems of Art. To the extent that the symbol is the work of the productive imagination it is situated in the privileged place where the universal and the particular, the intelligible and the sensuous, but also the formal and the material, the meaning and the figure, are represented in each other. If the verbal symbol represents the figure in the verbal world, the figurative symbol in turn represents the meaning in the figurative domain.[55] This mutual reflection, this exchange of essence between the domain of the figurative and the domain of the conceptual, makes possible the systematic unity of Art.

Nonetheless, it will be noted that what is lacking in Novalis's conception of the symbol is the reference to a transcendence. This is no accident: Novalis, contrary to the later romantic *doxa*, seems always to have been reticent about seeing art as mobilizing two different orders of reality. As a consequence, he finds himself obliged to reject a central aspect of the theory of the symbol, namely the idea of a relationship between two fundamentally different orders of reality. For Novalis, the symbol represents only itself: "Image—not allegory—not symbol of something else (*eines Fremden*)—symbol of itself."[56] The poetic creator does not put the sensuous world in relation with its spiritual foundation, he creates a divine

world. An absolutely free, absolutely autotelic creation, without any rela-
tion to any exteriority whatever.

Novalis thus inexorably moves from the theory of the symbol towards
the theory of poetic autotelism. The poet's task is not to translate the mys-
tery of being into symbolic figures, but to immerse himself in that being,
that is, to allow it to express itself in accord with its own inner nature. Now
being is the same everywhere, it is in everything; the poet must thus allow
himself to be borne by poetic language itself, to make the being that he *is*
resonate in himself. The poetic autotelism postulated by Novalis cannot be
interpreted as an emancipation of poetry from semantic and hermeneutic
constraints in favor of an autonomous play of sounds and rhythms, with
meaning being reduced to the totality of the fortuitous semantic associa-
tions evoked by a purely formal concatenation. To be sure, poetic lan-
guage is indeed defined as totally self-sufficient and autotelic,[57] but that is
in no way opposed to its capacity for ontological revelation. The theory of
poetic autotelism is inserted into a worldview that postulates a structural
parallelism between the organization of the real and the organization of
language, and thus conceives the capacity for ontological revelation as an
auto-revelation directly connected with autotelism. The idea that the poet
speaks under the constraint of language does not refer to some purely
formal definition of poetry; the poet is a *vates*, a prophet, and language, by
revealing *itself* through his voice, reveals in that very way the profound
reality of things.

It is hardly surprising that it is ultimately a gnoseological question that
is at the heart of Novalis's theory of poetry. That is only the logical conse-
quence of the postulate according to which poetic discourse presents the
inexpressible content of philosophy, that is, fundamental ontological
knowledge. Whence as well the necessity of a language that is specific to it;
whether it is in the form of symbolic coalescence or in that of structural
parallelism, poetic language can present the inexpressible only because it
is essentially distinct from rational or "everyday" discursivity. It leaves
behind the paths of universalizing abstraction as well as those of referen-
tiality, turning toward a revelation of the universal in the particular, of the
other in the same.

QUESTIONS

When we try to situate Novalis's sacralization of poetry (conceived as a
synecdoche of the sacralization of Art) within the overall framework of the
history of ideas, we can scarcely fail to be struck by its "restorative" char-
acter (whether we see in this a salutary move or a regression is of little
importance here). It runs counter to the general movement of ideas in the
West, which has been characterized since the Renaissance by an increas-

ingly extensive desacralization of life and of the world. In fact, the idea of romanticism does not consist solely in a sacralization of Art, but more generally—and *through* this sacralization of Art—in a resacralization of Being, of life, of the universe. This being the case, one of the most fascinating aspects of the speculative theory of Art consists in its capacity to survive the abandonment of romantic onto-theology, and thus to continue to develop itself even in the absence of the theological roots that alone seemed able to endow it with a certain plausibility. It is astounding to see Nietzsche, who was nonetheless skeptical with regard to every kind of "world beyond," or Heidegger, the thinker of man's finitude, adopting the central theorems of a conception of Art that could have meaning only within a positively theological view of Being.

The survival of the speculative theory of Art within the philosophical tradition is, in reality, less paradoxical than it appears if we take into account a second aspect I have already emphasized: independently of its theologico-metaphysical foundation, the speculative theory has a specific structural function within a philosophic strategy.[58] In fact, it makes Art the Other of philosophy, the place where it reflects itself, seeking its canonic reality, the promise of its future fulfillment, its inadequate figuration, or its dialogic partner. Thus, even though the worldview that gave rise to the speculative theory of Art is frayed (in Hegel) and then collapses (in Schopenhauer and Nietzsche), the ontological function of Art can remain intact: the presentation of absolute spirit, the presentation of the Idea in phenomena, the figuration of life, the "utterance" of Being.

The survival of the sacralization of art outside the philosophical tradition, in the art world, is hardly more surprising. In a certain way, the "forgetting" of its onto-theological foundation, far from undermining the sacralization of Art, only exacerbates it so long as the fundamental motivation, which is none other than the urgent need for a compensation with regard to a reality experienced as degenerate, continues to be present. Nietzsche says very rightly that hunger *does not demonstrate* that a nutriment capable of satisfying it exists, but only that it *wants* that nutriment.

In fact, this compensatory function with which Art (in the shape of poetry) is invested by the romantics, and after them by the whole tradition of the speculative theory, is multiple. In the first place it has to counterbalance scientific knowledge's "disenchanting" invasion of modern culture; we have seen this in Novalis's demand for a mystification of the sciences. It is found in all the thinkers of the theory of Art: objective idealism, Nietzschean vitalism, and Heideggerian existentialism all explicitly oppose themselves to scientific discourse and try to devalorize it. But the compensation also has to do with everyday, social, historical reality, and indeed with reality as such. For Novalis, poetry has to "romanticize" life, for Hegel, Art is supposed to realize the sublation of empirical being in the

Ideal, for the young Nietzsche, a reader of Schopenhauer, Art rends the veil of *maya* and frees us from the tyranny of the Will, and for Heidegger poetry pushes us outside our inauthentic *Dasein* toward listening to the "utterance" of Being. What unifies all these thinkers, beyond their undeniable differences, is always a kind of nostalgia for an "authentic," nondesacralized life.

There is hardly any doubt that this compensatory function accorded to Art must have corresponded to a deep need felt by part of the intellectual and artistic elite in the nineteenth and twentieth centuries. And certainly the persistence of this need has produced the historical success of romanticism and more generally of the speculative theory of Art. For analyzed dispassionately, this theory is founded on theses that are at the very least disputable. The opposition between Art (which is truth) and lived reality (which is beyond truth), between a transcendent artistic knowledge and purely phenomenal scientific knowledge, and more generally the assertion of the existence of a domain of truth more fundamental than that of our intramundane truths, and reserved for Art—all these theses are plausible only if it is granted that beyond our world there exists another, truer world, and that we are capable of acceding to this world by transcending our intramundane nature. That is indeed what the theological ontology of romanticism asserts. It is therefore impossible to accede to Art without placing oneself within this theological worldview. But it hardly seems reasonable to require such a fundamental commitment as the condition of the possibility of an understanding of artistic phenomena.

To be sure, the sacralization, if not of Art, at least of poetry, is not a romantic invention. The figure of the poet as an interpreter of the mantic voice, as a prophet or *vates*, and thus as an intermediary between the divine word and humans, is already found in certain Greek and Latin authors, beginning with Pindar, Democritus, and Plato.[59] It was moreover to be adopted by early Christianity, the *topos* of the invocation of the Muses being replaced by an invocation of God: in this form, the thesis of the mediating function of poetry occasionally emerges in the Middle Ages.[60] As for the Renaissance, it is well known how powerfully it reactivates the ancient figure of the poet inspired by the Muses.

These facts are incontestable, but it is important to clarify their significance and to situate them in their context. The originality of the romantic position comes out all the more clearly. We must first note that during antiquity and the Middle Ages, and in fact right up to the romantic revolution, the theory of poetry as inspiration was never able to establish itself in competition with the largely dominant rhetorical and mimetic conceptions. Moreover, regarding the interpretation of the Greek sources of the theory of divine possession or of the status of interpreter of the divine word conferred on the poet, we must not forget that originally, at least in part, Greek poetry *actually* had a religious and ritual function. The invocation

to the Muses, in those cases when it still has a genuine pragmatic-ritual function, it is only a particular case of the *general practice* of invoking adjunct spirits, that is, it is in no way peculiar to the poet's activity. Another observation: if the figure of the poet as spokesman for God is adopted in the first centuries of the Christian era, that is because the situation is, *mutatis mutandis*, similar to the one that doubtless existed in archaic Greece. The invocation addressed to God and the affirmation of the inspired nature of poetry are explicitly and exclusively applied to a *religious poetry* in the service of the new faith. This use of invocational formulas therefore cannot be conflated with their adoption outside ritual contexts, or in periods in which art no longer has a ritual function; in such cases, it is generally explained by their rhetorical and ludic function. The same can certainly be said of the Roman poets of the Augustan age, for instance, who use and abuse the *invocatio* as a rhetorical *topos*. Similarly, when the poets of the Renaissance or the neoclassical age invoke the ancient gods, no one is taken in by this; we rightly consider these invocations as part of a literary game. The same attitude should be adopted with regard to many texts from these periods that present the poet as a mediator between the divine and human orders.

The romantic idea according to which the poet's work is a sort of quasi-ontic creation is not absolutely new, either. It is nonetheless revealing that we find hardly any traces of it in classical antiquity. There are at least two reasons for this. The first is of an aesthetic order: the theory of *mimesis* precludes any idea of a poetic creation that would be a kind of ontic creation. To be sure, in the *Phaedo* Plato uses the verb *poiein* to describe the activity of the poet, but he does so in referring to his "fiction-making" ability. In other words, the poet is indeed a creator in the sense of an inventor of fictitious stories, but not in the sense in which he brings into being a new ontic reality. More generally, we must remember that Plato always associates mimesis with the simulacrum, and even with lies; he can therefore hardly see in the poet the revealer of an ontological truth. It is true that in the *Republic* Plato credits certain painters with "proceeding in accord with the truth,"[61] But this conception remains internal to the mimetic model: these painters are still imitators, even if they imitate supersensuous paradigms—that is, the ultimate ontological determinants—rather than simple appearances. They do not accede to any privileged knowledge *through their art*; they merely act as every just man ought to act, that is, in accord with the Ideas and not in accord with phenomenal reality. The interest of this passage in the *Republic* lies elsewhere: in it, Plato adopts an attitude more favorable than his usual one with regard to mimesis, the attitude that Aristotle later adopted. But for all that, mimesis cannot be an ontological revelation; the latter remains the prerogative of philosophy.

Much has been made of Aristotle's decision to elevate poetry over his-

tory: poetry arrives at general propositions, whereas history gives rise only to particular propositions. But he explains that the general propositions in question refer to the "type of thing that a certain type of man plausibly or necessarily does or says,"[62] that is, they establish what might be called a logic and a pragmatics of human acts. There is no reference to a metaphysical knowledge inaccessible otherwise than through poetry. For Aristotle, as for Plato, the poet remains a creator of stories, that is, a creator of simulations (*kata mimesin*).[63]

The second reason that antiquity does not conceive the poet as a creator in the ontic domain is connected with the dominant cosmology: a conception of poetry as being a kind of absolute creation is possible only on the condition that the idea of a creation *ex nihilo* is accepted as such. But this kind of conception is foreign to the Greek and Latin question, which in general starts from the principle of a demiurgic creation taking place on the basis of a *preexisting* chaos. The idea of an absolute creation is a Christian idea; it is therefore solely on its terrain that the thesis of an absolute "poetic making" and a parallel between the divine creator and the poet could arise.[64]

Another characteristic of the romantic revolution, traces of which are already found in earlier traditions is the rivalry between philosophical and poetic discourse. Here again one can go back to Plato, who recalls in the *Republic* that there is an "old quarrel" between poetry and philosophy.[65] This quarrel is intimately connected with the question of the relations between philosophy and rhetoric, whose first echoes go back, again, to Plato, and we find it later on in Cicero and Quintilian. But more disturbing is the extraordinary—though not dominant—movement to promote poetry at philosophy's expense that took place in the high Middle Ages. I shall limit myself solely to the example of poetry in Latin.[66] In the first place, it seems that it was only in the high Middle Ages that the verbs *poetari* and *poetare* began to be used to designate the poet's activity, whereas before more technical terms such as *canere, fingere*, and *dictare* had been used. This was also the period in which more and more poets began to sign their works, and in which some "modern" poets made their entry into the canon of rhetorical instruction alongside ancient authors. At the same time, poetic activity was commonly conceived as involving knowledge; some poets held that the content of poetry embraced the whole domain of the *septem artes*. This obviously recalls Novalis's project of a poetic encyclopedia. Finally, the doctrine of allegoresis, up to that point reserved for sacred literature, makes its entry into the domain of profane poetry. It was in this climate that some writers began to identify the poet with the philosopher; we find this attitude particularly, and this is no doubt not accidental, in the defenders of the philosophical-theological epic, a genre tradition that culminated, once it passed into the vulgar languages, in the *Divine Com-*

edy. Thus Albertino Mussato (end of the thirteenth century to the beginning of the fourteenth century) maintains that poetry has a divine origin and possesses a theological function. The same idea is found in Petrarch and Boccaccio.[67] Others go still further, claiming that poetry has the right to the supreme honor. That is the case in Henry of Avranches. He starts out from the idea that creation is diversified into three domains: intellect, things, and words. Their masters are respectively God, the emperor, and the poet. The latter is an absolute creator in the verbal order in the same way that God is an absolute creator in the domain of the intellect or the emperor in the domain of earthly things. The revealing absence of the theologian should be noted. Henry of Avranches adds that metrical discourse, hence the poet's discourse, is a divine manner of speech (*species divina loquendi*), since it is used by God in the Ten Commandments and by the prophets.[68] Naturally, philosophers didn't see things this way. Thus Michael of Cornwall sharply replies to Henry, accusing him of knowing only about grammar and being totally ignorant of the natural sciences and logic.[69] The famous quarrel between the school of Orleans, defending poetry, and the school of Paris, defending philosophical orthodoxy, takes place within the same framework: Henry of Andeli's *La bataille des VII ars* bears eloquent witness to the virulence of the dispute. Even if it is not easy to decide what in these assertions is simply on the order of a *topos*,[70] one can hardly fail to see in this quarrel parallels with the rivalry between the romanticism of Jena and the Hegelian project of an absolute philosophical science; we know that Hegel treated Friedrich Schlegel anything but gently. But neither must we forget a fundamental difference between the two situations: whereas the poets of the high Middle Ages opposed Scholastic philosophy from the outside, the romantic revolution was in fact, as our analysis of Novalis's texts has shown, an event that took place essentially within philosophy.

The romantic conception of poetry is thus connected with a venerable tradition that is, to be sure, marginal, but whose very existence shows us that the exaltation of poetry (and by extension, art) cannot be reduced to the strategy of a speculative theory; no doubt it also corresponds to a basic psychological conviction bound up with the very specificity of aesthetic experience. The speculative theory itself draws part of its persuasive force from this conviction, that is, it incontestably contains a certain psychological truth. But the romantic revolution confers a new, fundamental meaning on this exaltation of poetry. First, it puts it into a perspective entirely dominated by a theological ontology whose presentation is required even though it is declared to be impossible within philosophical discursivity; in this sense it is also a response to a philosophical crisis, which is not the case in the Middle Ages. Second, the sacralization of poetry, its definition as *species divina loquendi*, is put forth in a historical context that is itself

largely desacralized, and this completely changes its significance and in particular prevents it from being referred to an institutionally theological or liturgical function (if we except Novalis's *Spiritual Songs*, which are an integral part of Lutheran sacred music). We find again here what seems to me the fundamental characteristic of the romantic sacralization of poetry: it fulfills a compensatory function in connection with the crisis in the worldview—and particularly in dogmatic theology and metaphysics— brought on by the Enlightenment. This function is absent among the earlier defenders of poetry, for example those of the Latin Middle Ages (for whom it was indeed a matter of elevating themselves to the same level as that occupied by philosophy in the hierarchy of the seven arts, but within the framework of a theological worldview that is never challenged). It is moreover symptomatic that when Friedrich Schlegel was converted to the militant Catholicism of the Restoration, he abandoned his conception of universal poetry as the fundamental theological-metaphysical activity: as soon as revealed religion once again provided the basic hermeneutic framework, aesthetic religion faded away.

The History of Literature as a Speculative Project

(Friedrich Schlegel)

If Novalis's sacralization of poetry is at the same time the paradigm and the initial phase of the tradition of the sacralization of Art, the romantic theory of Literature constitutes the initial step in the construction of a speculative theory of the arts. Historicism requires that this theory be a history of Literature;[71] its goal will be to legitimate the sacralization of poetry by constructing a historical concept of Literature as the temporal deployment of its philosophical mission.

The genesis of the history of Literature is linked to the two Schlegel brothers. I shall limit my analysis, however, to Friedrich's texts. This bracketing of August-Wilhelm's writings—which would be inexcusable if my goal were to write a detailed history of romantic literary criticism— seems to me justified here insofar as I shall analyze not so much the concrete results of romantic philological labors as the overall theoretical framework within which they reside. Of the two brothers, it is incontestably Friedrich who is the more interested in the theoretical problems posed by a determination of the essence of Literature.

The theoretical framework of the history of Literature introduces not only a new conception of the *historicity* of literary facts but also, and more fundamentally, a new definition of their *theoretical accessibility*. History ceases to be one of the dimensions of the literary fact, and becomes the

place where Literature can be grasped in its essence. This conception mobilizes four main postulates: essentialism, nomologism, organicism, and historicism. The first three are all presuppositions of the fourth, which constitutes the heart of romantic historiography and, insofar as our problem is concerned, of the speculative theory of literature. It is moreover inseparable from two remarkable particularities: (1) the transformation of the venerable Quarrel of the Ancients and the Moderns into an ontological opposition between antiquity and the modern age, and (2) the genesis of a theory of literary genres conceived as the self-presentation of Literature in its organic unity. I shall discuss each of these aspects separately, even though they are closely connected in Schlegel's theory.

<div style="text-align:right">HISTORICISM</div>

What does "historicism" mean here? I mention first a banal point: not all historical thought is historicist. The Enlightenment, for instance, conceived the function of history very differently than does historicism; for historians such as Hume or Robertson, history was not the unfolding of a transcendent essence in human empiricity, but was constituted in and by the actions of human beings and their interactions with the physical environment. To study history was not to open the book of an ineluctable destiny, but to have access to a store of experiences, successful or unsuccessful, good or bad, some avoidable, some not, that might be capable of guiding us. To this pragmatic conception of historiography, historicism opposes not only the postulate of a historical determinism, but also, more fundamentally, that of a historical causality *transcending* human behavior or physical factors.[72] Let us add that rejecting historicism does not mean denying the intervention of laws *in* history, but only rejecting the thesis that there are laws *of* history, that is, laws that are specifically historical.[73]

The idea that there are specifically historical laws is doubtless based on a confused idea of what a (natural) law is. Thus Karl Popper maintains that historicism confuses the explication of particular facts with the establishment of laws, insofar as it claims to explain the "necessity" of particular facts by deducing them from laws.[74] A natural law always takes the form of a conditional proposition; it predicts that if x occurs, y will also occur. It therefore postulates a correlation between two events or two series of events, but it does not include any assertion concerning the existence of a particular x; it does not say that y must absolutely take place. Now, it is that kind of prediction that a historical "law" would have to provide, since historicism claims that the factual evolution of history is the result of a *necessary process*. Naturally, laws in accord with Popper's model may act as causal factors in the occurrence of a given historical event; for example, the laws of econometrics predict that a disequilibrium

between supply and demand will produce specific effects on the equilib-
rium of any economic system. Such laws thus permit us to determine cer-
tain causal factors involved in the genesis of an economic crisis. But they
do not "determine" that crisis, since the excess of supply over demand acts
in conjunction with other factors, most of which are contingent. Among
these factors that intervene to reinforce or counter the effects predicted by
the law of econometrics, there is moreover the very specific factor consti-
tuted by our knowledge of the law, a knowledge that allows us (at least
within certain limits) to influence the consequences by acting on the
causes.

We could add to this another argument of Kantian origin. Historicism
claims to be a causal explication of history conceived as a totality. Accord-
ing to Kant, asking the question of causality at the level of a totality makes
no sense at all. The category of causality functions only at the level of the
phenomena belonging to a given domain, not at the level of this domain as
completed totality.[75] Thus one might say that historicism mistakes the do-
main of the law of causality's applicability: that is no doubt why German
idealism distinguishes between mechanical causality, the *Ursache*, to
which the Kantian verdict applies, and the metaphysical foundation, the
Grund, which can be postulated at the level of the totality. But this solu-
tion implies recourse to a transcendent causality, a concept that, from a
Kantian point of view, is self-contradictory.

This transcendent causality,[76] which is capable of "overdetermining"
empirically accessible causalities, is in fact of a teleological kind; the so-
called historical laws come down to the postulation of a final principle
conceived as the *Grund* of history. This principle may be the idea of pro-
gress, or that of a Fall (*Sündenfall*), or that of a cyclical movement.[77]
Moreover, the historicist construction of history is almost always domi-
nated by an eschatology, that is, it "predicts" history's convergence to-
ward a particular event that will complete it (it matters little whether this
completion is supposed to occur after a finite or infinite length of time).
This event is a particular event not only because it is defined by its peculiar
quality (as are all historical events), but also, in the strong sense of the
term, because while it is the ultimate effect of the teleological principle, it
is itself no longer subject to this principle. In this way as well, historicist
predictions differ from scientific predictions: the latter can no doubt pre-
dict particular events, but not singular or grounded events, in the strong
sense of the term. When it is predicted that the sun will one day burn out,
this prediction concerns a future event that is certainly particular, but it is
not singular in the sense that it is grounded in an irreducible specificity of
the sun; the laws on which it is based are constant and universal physical
laws that are valid for every heavenly body and will continue to be valid
after the extinction of the sun.[78] In reality historicist determinism, in its

attempts at prediction, is circular: it reads the past in the light of a postulated future, whereas the latter itself is "fore-told" on the basis of this past.

Another problematic aspect of historicism is the objectivist illusion it cultivates. Voltaire and the English empirical historians of the eighteenth century had a naive conception of historical fact, since they tended to consider it as a brute given. But contrary to appearances, historicism does not in any way surmount this naive view. It is simply that the objective grasp of the facts, which the empiricists thought possible through empirical induction, is sought by historicism either through a deductive procedure anchoring facts in some more general ontological principle, or through an intellectual intuition acceding directly to the essence of a given historical phenomenon. It is interesting to note that in 1857 the great historian J. G. Droysen (who was, however, influenced by Hegel) criticized this illusion of the transparency of historical knowledge. He maintained in particular that there is always an insurmountable difference between the (postulated) past reality and historical knowledge concerning this reality.[79] To explain a historical fact is first of all to situate it. It can be situated, however, only in relation to a later point from which it is observed. Historical statements thus amount to descriptions that could not have been those of a witness of these events;[80] the "fact" is inseparable from the knowledge concerning it. Historicism implicitly acknowledges the existence of a transparent past, because the historian is supposed to account for its *intrinsic* meaning; but it forgets that the historian's knowledge, far from corresponding to a divine view of history embracing it in every detail and respect, is always itself perspective in character.

Droysen connects the illusion of transparency with the narrative nature of historical discourse.[81] To think that facts speak for themselves is an illusion, he says; they would be mute if there were no narrator capable of making them speak. Narrative procedure is inseparable from historical discourse, for two reasons. First, particular facts cannot be explained without being narratively ordered; our knowledge of causal connections always has gaps that can be filled only through a narrative procedure based on a general pragmatics of human actions. Second, the epistemological model of historical discourse can only be the testimonial account. Historical discourse constitutes, to be sure, an erudite and derivative (since the historian is rarely a direct witness of the events he is writing about) form of the testimonial account, but it does not transcend the latter to produce a quantifiable knowledge, even if it can make use of certain tools of the quantitative sciences in legitimating its reconstructions of the past.[82] Historicism's error thus lies not in its recourse to narration, but in its rejection of the epistemological rules that this characteristic imposes on it, and which are those of a pragmatics of the causality of facts and human acts in their interrelations and in their relations with the physical environment.

Historicism is closely linked with evolutionism, which explains another of its typical traits: the privilege accorded to chronological historiography in relation to what Paul Veyne calls history by "items," that is, comparative history. Historicism identifies history with the past (national or "universal"), the historian's task being to explain the present on the basis of this past; history is the epic of human time. The prejudice regarding the transparency of facts takes sustenance from the definition of history as the explanation of lived time (we know the role played by this idea in Heidegger and more generally in the hermeneutical tradition). Here again, historicism is the victim of the illusion of transparency. Far from being an epiphany of Time, history is a plot constructed by the historian on the basis of traces and documents whose evolutionist dynamics is in no way self-explanatory. There is no history, but only histories, and their multiplicity is that of plots compatible with a corpus of given traces.[83]

The concrete form taken by historicism in the domain of literary studies naturally introduces specificities not taken into account by our preceding discussion. But we shall for the moment defer discussion of these specificities.

Is there any connection other than a contingent one between historicism and the speculative theory of Art? It is undeniable that in Germany at least historicism arose in art history as much as, if not more than, in general history. And it is surely no accident that Friedrich Schlegel so often refers to Winckelmann. In his *History of the Art of Antiquity* (1764), Winckelmann outlines for the first time what will become historicism's fundamental *credo*, namely the belief in an organic historical development. In this work, he endeavors to study "the origin, growth, transformation, and decline"[84] of art, according to a model involving three periods: that in which art seeks the necessary, then that in which it seeks the beautiful, and finally that in which it seeks the superfluous.

In reality, the speculative theory of Art and historicism are closely linked insofar as the sacralization of literature implies that it be considered the locus of the historical totalization of human experience: "The way in which the texts of the past are soon to be presented by historians of literature is certainly linked to the new task assigned to literature in nineteenth-century bourgeois society: it replaced religion in the function of proposing a new cosmology. The texts of the past were no longer part of an ideal world, and were not yet the symptoms of a past world. Because they were considered to be media capable of unfolding a totalizing historical perspective before the reader's eyes, their cognitive value was hypostatized in a way never before seen. . . . In the nationalist variant of this conception according to which the totality of the past can be grasped through literature, it was thought that through the genius of great writers one could hope to grasp, perhaps once and for all, and in its totality, the national character of which national history was supposed to be the development."[85]

Historicism is required, moreover, by the organicist paradigm that dominates the speculative theory. The seductiveness of this paradigm goes back to Aristotle. We know in fact that in the *Poetics* he sets out to distinguish poetry "according to its kinds, each considered in relation to its proper end (*dynamis*, power)";[86] simultaneously he implicitly introduces an organicist problematics into the domain of literary facts. Similarly, he speaks of a "growth" of tragedy and adds that this growth continues until tragedy has finally "entered into possession of its own nature."[87] In Aristotle this crypto-organicism is nonetheless contradicted by the idea that the artistic work is a result of human *techne* and thus cannot be determined by an external causality. Moreover, in the *Physics*, Aristotle explicitly asserts that the art object differs from the natural object in that the former does not have an internal principle of movement:[88] therefore there can be no autonomous and internally determined evolution of either poetic kinds or the genre "poetry."[89]

Oversimplifying somewhat, one can say that up until romanticism Western thought concerning the arts generally privileged the "technological" side of the Aristotelian conception. Romanticism, in contrast, radically committed itself to the organicist conception: Art is nature.[90] Thus when Novalis and Schlegel define poetry as a revelation of Being, they do not intend to characterize its abstract essence, but rather its "life"; the speculative theory of Art is a form of vitalism.[91] For romantic thinkers, the essence of an object does not reside in a definitional abstraction, but in its soul, that is, in the sum of its vital potentialities. Romantic organicism thus cannot be identified with Aristotelian biologism: for Aristotle, the development of a natural object is a passage from the potential to the act, since it is only in the act that the object conforms to its nature, to its definition. In romanticism, on the contrary, Art is always already in conformity with its nature, since its nature *is* its evolution; thus its definition *is* its history. To know the essence of literature thus amounts to describing its organic development: the theory of literature *is* the history of Literature. But this proposition can and must also be reversible: to the extent to which organic development is the fulfillment of potentialities inscribed within the very nature of Literature, the latter's history is identical with the self-development of its definition. The two theories imply each other, and that is why historicism can be said to derive directly from organicist essentialism.

In conclusion, let us observe that organicist historicism presupposes a view of history as continuous. As W. H. Auden, among others, has noted, the history of art is discontinuous: "Natural history, like social and political history, is continuous; there is no moment when nothing is happening. But the history of art is discontinuous; the art historian can show the influences and circumstances which made possible and likely that a certain painter should paint a certain way, *if he chooses to paint*, but he cannot

explain why he paints a picture instead of not painting one."[92] Art is not a biological species capable of reproducing itself. Hence the central importance romanticism accords to the question of *genres*, which it treats as universal principles of engenderment that can integrate the discontinuity of works into the continuity of an organic evolution. This obviously implies a reification of the generic categories, which tend to become the true *realia* of the history of Literature. Thus it is entirely comprehensible that the history of Literature should find its culmination in a theory of genres.

<div align="right">LITERATURE</div>

The very project of a history of Literature presupposes the existence of a specific concept of Literature that can provide a basis for such a history. For Schlegel, this cannot be a simple empirical concept, a simple class name serving to designate the whole of the written productions of the belles-lettres tradition; such a notion would not make it possible to found a history in the historicist sense. In order to discover what is really at stake we may begin with the description-definition of literature he proposed in his *History of European Literature* (1803).

Schlegel starts out from a definition which, at first sight at least, seems purely nominal: "Generally we include within literature all the sciences and all the arts that act through language: poetry, the oratorical art, and history as well, insofar as its presentation is part of the oratorical art . . . ; then works on morals, if they can be considered as belonging to oratorical art or if they have had a more general influence, such as Socratic morality; scholarship; and finally, philosophy. . . . Poetry, the oratorical art, history, and philosophy are part of the genre that acts through language." The notion of "Literature" is thus the name of the class of *humanoria*: poetry, the oratorical art, history, works on morals, and philosophy. This definition excludes all intellectual activities that have direct practical or utilitarian goals; later on, Schlegel brings these other activities together under the two rubrics of economy and politics. The list corresponds more or less to the way the pre-romantics divided up the arts of language. One might think that the distinction between art and science is also in conformity with this traditional division, since, at least at first glance, its function is simply to distinguish between the object and its mode of presentation in philosophy, history, and the oratorical arts; in spite of their nonliterary object, these discursive practices belong to literature by virtue of their mode of presentation. In reality, however, we shall see later that the distinction between art and science prepares the ground for an essentialist reduction of Literature.

A first important shift soon occurs when Schlegel proposes to distinguish between the arts and sciences that act through language and those

that act through matter, that is, the ones that "make use of language solely as a secondary means of communication." The initial definition limited literature to the arts and sciences that act directly through language; logically, those that act through matter should therefore be excluded from the category of literature. But now we learn that *both* genres fall—depending on the practices concerned—into either the domain of art or that of the sciences, and that it is the whole of these two domains that forms Literature.

Schlegel next explains that this definition of Literature includes all the sciences and all the arts: "Philosophy, insofar as it is the soul (*Geist*) of scholarship and science, includes within itself, from the point of view of form, all the sciences that express themselves using signs. Similarly, poetry includes all the arts that act through a medium other than language. Just as mathematics, chemistry, and physics merely demonstrate in isolation, but in a more precise manner, that is, more specifically, what is already contained within philosophy, so painting, sculpture and music express separately, but in a vivid and better way what poetry realizes overall. *In this sense literature includes all the sciences and all the arts, it is the Encyclopedia.*" Here we glimpse the secret goal of the distinction between the arts and the sciences, as well as that between the linguistic medium and the material medium: it is a question of preparing the ground for the reduction of nonverbal arts to poetry (that is, to the essence of Literature) conceived as their common principle. Clearly, this reduction is possible only to the extent to which it has been previously established that Literature includes all the nonverbal arts as well. That is why Schlegel needs the aforementioned distinctions. His way of proceeding is complex. At the center of his argumentation is the idea that there is a parallel between the relationship that philosophy entertains with the mathematical and physical sciences, on one hand, and that entertained by poetry with painting, sculpture, and music. But in order to support this line of argument, he has first to show that mathematics and the sciences act through matter, as do the nonverbal arts. To maintain this idea, he is forced to define "act through matter" as meaning "act by signs other than linguistic." Now if it is true that physics and chemistry have recourse to nonlinguistic symbols, it remains nonetheless that these symbols are neither more nor less material than expression in language; they are artificial languages that, far from being in any way opposed to linguistic signs, merely extend them. To maintain the same idea concerning the relationships between poetry and the arts entails a much more significant reductionism. Even if all arts are semiotic, the fact of reducing their differences to a simple distinction between verbal and nonverbal signs produces an extremely impoverished view of what is specific to each of them.

In any case, through this parallelism Schlegel believes he can incorporate the nonverbal arts into Literature and bring them under the poetic

paradigm. If the sole difference between poetry and the nonverbal arts concerns their semiotic material, then nothing keeps poetry from playing for the arts the same integrating role that philosophy plays for the sciences. Just as philosophy demonstrates in terms of individual specificities, poetry expresses (*Ausdrücken*) generally what the other arts express in terms of individual specificities. Just as philosophy is the fundamental knowledge, poetry is the expression, or as Schlegel goes on to put it, the fundamental artistic presentation (*Darstellung*). This procedure of reducing the arts to poetry will be a central *topos* of the speculative theory of Art, since we find it, virtually unchanged, in Hegel and Heidegger.

This movement to unify the different genres is pursued through the assertion that Literature has a single content, "the Infinite, the Beautiful and the Good, God, the World, Nature, and Humanity," which thus corresponds to the different ontological determinations of Being (as conceived by romanticism). This thesis of the unity in content is essential to the strategy of the history of Literature: it grounds its organic unity and makes it possible to abandon the empirical enumeration of works and genres in favor of an organic differentiation, the same fundamental content specifying itself differently in accord with the different genres distinguished; and it is again this thesis that legitimates the reduction of the nonverbal arts to poetry.

Schlegel outlines three directions in which organic differentiation acts. The first results from the diversification of the mode of exposition: the arts present the Infinite (*Darstellung*), whereas the sciences explain it (*Erklärung*). The second, which we have already encountered, results from the diversity of semiotic media; on one hand we have coexisting, spatial signs (colors and proportions); on the other successive signs (language, sounds). The third results from the diversity of the spheres of the Absolute that the genres explain and respectively present. It goes without saying that this differentiation of the content concerns neither poetry nor philosophy, since they are characterized precisely by the universality of their content. They therefore form the center of Literature: "The tendency toward what is more elevated, toward the Infinite, is present in all the arts and sciences, but it is nowhere as dominant as in philosophy and in poetry. . . . Philosophy and poetry are, so to speak, the soul of the world (*Weltseele*) of the sciences and the arts, their common center. They are inseparably linked and form a tree of which philosophy is the root and poetry the most beautiful fruit. Without philosophy, poetry becomes empty and superficial; without poetry, philosophy is without influence and becomes barbarous."

The movement toward essentialist unification is not completed, however; it remains to reduce the duality between philosophy and poetry. To be sure, these two activities are already unified in the sense that they have the same universal content. But on the other hand they seem fundamen-

tally opposed, since one aims at explanation and the other at presentation. How can this duality be reduced, since the postulate of a unified Literature cannot dispense with a supreme synthetic term that would be, in its essential form, Literature with a capital "L"?

In reality, there is no doubt that Schlegel grants primacy to poetry. He must therefore try to reduce philosophy to it. Two ways of doing this seem possible. The first is based on the assertion of the originary character of poetry: "The objection according to which philosophy is of a more elevated dignity than poetry because it is directed toward the loftiest objects of human knowledge, . . . is without weight. . . . In fact, when poetry manifests itself in its true nature, it has the same object and the same dignity as philosophy. . . . Another reason that *it is necessary to grant primacy to poetry over philosophy* lies in the fact that, at least so far as Europe is concerned, poetry is the older activity and the common root of all the sciences and all the arts. The most ancient poetry is in fact mythological; and mythology is at once poetry, philosophy, and history."[93]

The second way of reducing philosophy to poetry is more indirect and is not outlined in the passage on which I have just commented. It nevertheless deserves to be presented, for it perfectly illustrates the ambiguity attached to the elevation of poetry in the speculative theory of Art. We have seen that all the sciences and all the arts have the same fundamental content: Being. We have also seen that this unity of content is represented by a paradigmatic genre that synthesizes all the other genres, in this case poetry. Now in other passages of the same text, Schlegel asserts on the contrary that only religion is the ultimate end of all the sciences and all the arts: "It is religion that must positively bring about the realization of the supreme destination of man. It is not a means, but an end in itself, from which proceed all the sciences and all the arts."[94] This assertion can be understood if we recall the year in which this text appeared, 1803; that is, at a time when Schlegel was about to convert to Catholicism. But this elevation of religion, if it deprives poetry of its supreme place, at the same time allows it to rise above philosophy. To this end, Schlegel adopts Novalis's antiphilosophical argument. The intrinsic finality of religion, and hence the ultimate goal of life, resides in man's reunification with God. Having lost God, man seeks to find Him and first of all to know Him. He looks first to philosophy. But all knowledge of the Infinite is, like its object itself, infinite and abyssal. Philosophy therefore fails in its task of explaining the Infinite. It is this failure that gives rise to the need for poetry, for "symbolic presentation."[95] "What cannot be resumed in a concept, can perhaps be presented through an image; and thus the necessity of knowledge leads to presentation, leads philosophy to poetry."[96] Hence the argument from the origin is seconded by the argument of the inaccessible character of the divine Infinite: Being cannot be explained, it can only be imaginatively presented.

Nonetheless, this second solution, even though it places poetry above philosophy, subordinates it to revealed religion, and this implies its relative devalorization as well as an implicit disorganization of the concept of Literature. In fact, if religion is the ultimate goal of human existence and the sole activity that is not in turn a means to something else, it is religion, not poetry, that should be the ultimate synthetic term, both a teleological principle and the unitary foundation for all Literature. It must be added that the tension is not due to the fact that Literature is defined as the revelation of ultimate (religious) truths, but to the introduction of religion as a specifically human *institution*. In other words, it is the passage from the poetic onto-theology of the Jena period to established religion that disrupts the organization of the project of literature conceived as universal Encyclopedia.[97] Religion is no longer the ultimate *definiens* of Literature, but accedes to the status of an ultimate *definiendum*, devalorizing poetry, which during the Jena period was supposed to be the ultimate *definiendum*. This same effect of disruption affects Literature's postulated autonomy: by subordinating poetry to religion, Schlegel at the same time destroys its autonomy.

To be sure, even after his conversion to Catholicism Schlegel never really abandons his concept of Literature. But he downplays the thesis of its universality conceived as the supreme unity of all the discourses in an autonomous and autotelic poetical-ontological revelation: Literature will be universal only in the extensional sense of the term, that is in the sense in which it is partially present in all cultivated peoples. The thesis of the organic unity of Literature is not abandoned, either, but simply shifted from the unity of theological content toward that of national literary organisms, conceived as expressions of the "life" of peoples. Schlegel's *History of Literature Ancient and Modern* (1813–1815)[98] thus constitutes one of the first examples of an evolutionary and comparatist history of Literature, seeking to grasp the unity of universal Literature (in the geographical and historical sense of the term) by means of a chronological and geographical construction.[99]

In spite of these ambiguities, the definition analyzed above is a quite faithful representation of the essential traits of "Literature" as an object invented by the speculative theory of Art. Let us set aside the problem of the hegemonic place accorded to poetry; though that is a central idea in the tradition I am studying here, it paradoxically lodges itself less in the history of Literature than in general artistic theories, for example in Hegel or Heidegger. Not proposing a general theory of Art, but solely a theory-history of Literature, Schlegel has less need to insist on the paradigmatic function of poetry. This does not mean, however, that the thesis is absent in his work, since we have seen that it comes into the institution of Literature as the absolute synthesis of spiritual activities.

The most central point in Schlegel's project seems to me to reside in the

essentialist-organicist definition of Literature. There is no lack of empirical objections to the specific form of essentialist definition maintained by Schlegel. To try to reduce the field of literature, or even the field of poetry, to the expression of the divine Infinite is either to condemn oneself to accounting for only a small part of literary productions, or to accept a hermeneutics at least as arbitrary as that of the theologians who tried to read Christian messages in Virgil's poems. But the empirical objections do not affect the essential point, insofar as the speculative theory of Art has recourse, depending on the author, to the most diverse essentialist definitions: the soul of the nation, the spirit of the race, class interests, the "language" of Being, etc., can fulfill exactly the same function as the divine Infinite.

The fundamental difficulty resides less in the essentialist project as such than in the undeniably evaluative rather than descriptive nature of its proposed definitions. That is evident in Schlegel's case: the definition of the essence of poetry he proposes coincides with that of Novalis. Now it goes without saying that the proposition: "literature is the revelation of the thing in itself" (or some equivalent formulation) is not a descriptive definition of literary phenomenality, but rather a definition at once evaluative and prescriptive, and hence, in reality, a criterion of excellence. Philosophy first gives itself this criterion and then projects it onto literary facts, retaining only those that agree with it. Schlegel explicitly justifies this procedure of selection.

The attraction this procedure can exercise resides, of course, in the fact that the selection claims to be cognitively motivated, that is, to flow from a (completely legitimate) separation between essential facts and accessory facts. Any cognitive procedure is selective, and in this sense it necessarily distinguishes between "typical" and "atypical" phenomena. One might therefore think that the reductionist move urged by the speculative theory of Art is only an explicit acceptance of this necessity. But this is a deceptive appearance: if the criteria of selection were cognitive, there would be no necessity to deprecate or attack works that prove recalcitrant, or to exclude them from the domain of "true" art. The essentialist definitions proposed by Schlegel and the other representatives of the speculative theory of Art are always swarming with exclusions, deprecations, and polemics, and this shows their evaluative character. The history of Literature arises from a reduction that is not cognitive but evaluative.

Theory and History of Literature

From the foregoing we can conclude that the birth of the history of Literature requires the conjunction of two factors: the existence of an evaluative definition of literature (based on the sacralization of poetry) and the acceptance of the historicist perspective as the paradigmatic method for the

comprehension of literary facts. The question as to why, toward the end of
the eighteenth century, such an importance came to be accorded to the
historical dimension will not concern me here. It suffices to note that for
Schlegel the central function of history is an established fact, to the point
that he writes to his brother: "I am revolted by any theory that is not
historical."[100] It is no accident that he uses the term "theory" (*Theorie*)
rather than the more neutral "knowledge" (*Wissen*) here: it is the system-
atic and fundamental knowledge, that is philosophical theory, that must
be historical. Thus far from being a jest, the exclamation quoted desig-
nates very precisely the central goal of his philosophical enterprise, in the
domain of the history of Literature as well: to make history itself the field
of theory, that is, the field of nomological determinations.

He sets to work on this project in his very first published text, *On the
Schools of Greek Poetry* (1794), even though at that point his reflections
are still limited to Greek literature: "The scholar's first glance at the extant
fragments and complete works of Greek poetry loses itself among their
immense multitude and diversity, so that he despairs of being able to dis-
cover a Whole in them. In the absence of that discovery, his knowledge will
always remain incomplete and uncertain; and yet he does not have the
right to do violence to the truth by making arbitrary subdivisions in order
to obtain by force an artificial continuity. Nevertheless, there is no need to
make such artificial divisions. The nature that gave birth to Greek poetry
as a whole also divided it into a few large masses, unifying them in accord
with a delicate order (*mit leichter Ordnung*)."[101]

Several central themes of the history of Literature are woven together in
this inaugural text. First there is the theme of unity and totality: an ade-
quate consciousness must grasp its object as an identity unfolding itself in
accord with its essential determinations. Next there is the thesis of the
"natural," and more precisely the organic, character of this totality: the
determinism is not external, is not of a mechanical type; it is a teleological
self-determinism. There is also, in the background, the paradigmatic role
played by Greek poetry as a completed natural totality (I shall return to
this later). In addition, there is an implicit ontological thesis: the relation-
ship that the multiplicity and diversity of literary facts entertains with
their unity is a relationship between appearance and essence. The totality,
grasped its fundamental identity, is the essence of the facts insofar as they
are the manifestations of a natural, organic genesis. This implies a gnose-
ological corollary: truth is not an attribute of our propositions, but rather
the other name of the essence, and more precisely, it is the essence insofar
as it makes itself visible to man in an adequate grasp. The four themes are
interdependent, and I shall separate them here only in the interest of con-
venient exposition.

Literary facts can be adequately understood only if they are grasped as

a unified totality. To the extent that literary traditions form chronological series, the will to grasp them as a unified totality assumes that they can be referred to an internal unity; every literary totality will also be a historical totality. In Schlegel's view, therefore, the diachronic, or more precisely the chronological dimension is essential to the very constitution of the science of Literature. Thus in *On the Study of Greek Poetry* (1795–97) he posits the principle that "pure science" must always be combined with history, a science without history being empty, just as inversely a (historical) experience without science is inchoate. This formula is one of the countless variations on Kant's statement that a concept without experience is empty and experience without a concept is blind. The fact that in Schlegel history takes the place of experience reveals the way in which history is "naturalized" in historicist discourse. History is not a discursive, epistemologically specific organization of human traces or documents (which might also be organized in accord with other criteria), but rather the direct presence of experience. The different functions that Schlegel in this same text accords to history are inscribed within the same horizon: in the first place it functions as an example, but also as a justification (*Beleg*), of concepts; secondly, it is the referential anchor-point of the analysis, simultaneously its factual domain (*Tatsache*) and its document (*Urkunde*); finally, in the case of Greek history, it provides us with an aesthetic paradigm (*ästhetisches Urbild*).[102] I leave aside for the moment the question of the aesthetic *Urbild*. It is interesting to note that on close examination the first two functions prove to be incapable of legitimating the status of the history of Literature, since they in no way challenge the mutual exteriority of history and the concept: if history is the exemplification or justification of a concept, it remains external to it. The same is true when history is considered as constituting the factual domain or the justification for the theory: in none of these functions does it possess its own nomological form, internal to its very evolution. In other words, the naturalization of history is not enough: the concept must at the same time be naturalized if it is true—as Schlegel later maintains—that "the science of art is its history."[103] The vision of history he presents in 1795–97 is thus still unilateral (from the point of view of historicism), since it does not go beyond the naturalization of historical "facts" and continues to accept the traditional model of a correspondence-truth for relations between these "facts" and the theory.

Here the necessity of the evolutionist thesis makes itself felt. Since according to Schlegel explaining a phenomenon amounts to revealing its essence, history can have an internal nomology only if it has its own ideal content. This ideal content must in turn be able to find its adequate explanation in a historical exposition: thus it must contain a developmental principle within itself. We already know that the ideal content of the history of Literature is provided by the postulates of the sacralization of po-

etry. Considered in themselves, these postulates do not imply the thesis of a peculiar internal historicity; one might just as well interpret the ontological function of poetry as an immutable principle. In order for the ideal content to function as a historical essence, it is therefore necessary to introduce a supplementary component, namely internal teleological principles, i.e., developmental laws. By virtue of these constraints, the historical evolution of the history of Literature is grounded in a general ontology.

This concern for the ontological foundation of history is a constant in Schlegel's thought. We find it particularly in the way in which he reinterprets the historical distinction between antiquity and the modern age. From his very first texts he tries to ground it ontically, that is, in accord with a certain number of characteristics that are in essence mutually exclusive. It is in this way that it will become the central historical category of romanticism and objective idealism, and will be invested with all the ontic differentiations postulated by idealist ontology: nature / freedom, reality / ideality, self-enclosed organism / infinite progression, finitude / infinitude, etc. Thus the "naturalization" of concepts joins that of history and the history of Literature becomes nomological: "reason demands . . . that the perceptions of artistic sentiment be strictly determined and conceptually organized, it demands that in the domain of the progression of the human soul and of the development of the arts as well we find *the necessary natural laws* (*die notwendigen Naturgesetze*)."[104]

This idea that there exist laws of historical development constitutes a fundamental break with Kantian criticism. The idea of a teleology of history is already found in Kant. In his *Idea of a Universal History from a Cosmopolitan Point of View* (*Idee zu einer allgemeinen Geschichte in weltbürgerlicher Absicht*) he defends the notion that one can consider the history of humanity by reading it in the light of the postulate of a "natural design" that is realized through it. Now, the idea of a "design" implies that of a teleological principle. In order for the teleological principle of a rational humanity to be realized, human beings have to do their part. That is the reason why Kant points out that the very fact of presenting a teleological conception of history to human beings can be considered as being "favorable to this natural design." The a priori theme (*Leitfaden*) he proposes for history thus remains on the order of a practical Idea and not of a nomological principle.[105]

The conception is nonetheless ambiguous, since Kant refers to a natural design; he stresses the fact that the philosopher cannot presuppose the existence, through history, of a rational design *peculiar to humanity*. Humanity as such does not pursue a coherent design. Whence the idea of a natural design. This hypothesis seems to open the way for a transcendental force to intervene in history; behind humans' deeds and acts there is to be deciphered some secret design that makes use of humanity in realizing

its ends (think of the Hegelian notion of the "cunning of Reason"). Another ambiguity concerns the epistemological status of this teleological postulate. It is found particularly in Schiller's historical works, which present themselves as adhering to the straight Kantian critical line. In his inaugural address at Jena in 1789, Schiller asserts that the teleological principle is a principle of order that the historian projects onto history: "One phenomenon after another begins to detach itself from the nearly blind, lawless freedom, and to incorporate itself as a concordant element in a harmonious totality (which, to be sure, exists only in its representation). . . . He therefore draws this harmony from within himself and transplants it outside himself in the order of things, that is, he introduces a rational design (*Zweck*) into the progress of the world and a teleological principle into universal history. . . . This principle, which he sees confirmed by innumerable concordant facts, he also sees refuted by the same quantity of divergent facts. But so long as important elements in the series of changes affecting the world are still lacking, so long as destiny defers the final word on so many events, he declares the question to be undecided. Then the opinion that provides the understanding with the most satisfaction and the heart with the most felicity"[106] wins out. The teleological principle is thus a projection that, at the level of the facts constituting the touchstone of historical discourse, finds as many events that confirm it as events that disconfirm it. Wisdom, in such a situation, does indeed counsel, as Schiller concedes, that the epistemological question be left undecided. But leaving the question undecided should prevent the historian from taking sides, whereas according to Schiller "the opinion that provides the understanding with the most satisfaction and the heart with the most felicity wins out." The problem arises from the fact that the project of a universal history as it is defended by Kantian criticism has already been given an orientation by the question of humanity's progress. Once we admit that that is the legitimate domain of historical discourse, the Kantian solution can hardly seem satisfying, as Schiller acknowledges in spite of himself.

Schlegel, in *On the Value of Studying the Greeks and Romans* (1795–96), was quite clear about this. He refers to Kant's brief work, but only to reject his solution. Schlegel wants to establish a complete history of humanity that would be internal to experience (it is to extend "as far as experience goes") *and* be governed by a "systematic order," a "systematic foundation," and a "universal design."[107] A little further on he explains: "The difficulty consists in finding an unconditioned unity, an *organizing, a priori theme [Leitfaden] for universal history*, that satisfies the requirements of both theoretical reason and practical reason, without infringing on the understanding's rights and without doing violence to the facts of experience."[108] While he adopts the Kantian expression "a priori theme,"

he does not do so in order to designate a teleological Idea, hence a *regulative* principle, but rather an a priori synthetic principle that is *constitutive* of history; for his objection is that Kant's conception cannot satisfy theoretical reason.

Schlegel's solution sets out from the critical definition of history as the interaction of nature and freedom. It soon deviates from this definition, however, when it asserts that freedom is also subject to a priori laws. In other words, history no longer derives from the interaction of nature and freedom (considered in Kant as two antinomical principles), but from the interaction of laws of nature and laws of freedom: "If freedom and nature are both subject to laws, if freedom exists (and that is in fact what consistent supporters of the absence of system and laws in history deny—and this denial is fundamental to their opinions), if man's representations form a coherent unity—a system—then the interaction of freedom and nature, that is history, must also be subject to necessary and immutable laws: if such an interaction exists, and if history exists, there must be a system of necessary, a priori laws that relate to it."[109]

Clearly, Schlegel is taking his inspiration from Fichte here: he has in view the transcendental deduction of the interactions of the ego and the non-ego that the author of the *Doctrine of Knowledge* identified with the interactions between liberty and nature. But for Fichte these principles are of a transcendental order; they determine the conditions of the possibility of history as an interaction between humans and nature, but they do not in any way permit the establishment of internal historical laws. The Fichtean principles claim to state the condition on which history can exist, but they do not at all claim to determine its developmental stages. But the history of Literature needs laws *of* history. And to arrive at such laws, Schlegel is inevitably forced to project the categories of the transcendental deduction onto history and to make the various historical figures into expressions of these essential determinations. The *transcendental principles* make room for a *transcendental causality*: the "naturalization" of concepts is perfectly summed up in this passage from the transcendental, and hence from a conceptual determination, to the transcendent, and hence to an ontic determination.

We cannot leave the question of the relations between history and theory without having discussed the relations between historical analysis and evaluation, that is, between theory and (literary) criticism. In fact, Schlegel is not only a philosopher and historian of Literature, but also a major literary critic. In this domain he wants to avoid both the dogmatism of the judge—the Wolffian *Kunstrichter*—and the subjectivist relativism of the *Sturm und Drang* generation. Walter Benjamin very pertinently observed that the romantics' choice of the term *Kritiker* rather than the traditional

term *Richter* is no accident: they claimed to attach themselves to philosophical criticism, that is, they wanted to move beyond the dichotomy between Wolffian dogmatism and relativist skepticism in the domain of art, just as Kant had done in the domain of knowledge.[110] But at the same time their speculative conception leads them to reject the Kantian thesis according to which an aesthetic judgment is a universal subjective judgment, that is, a cultural fact linked to an art of judgment and to a shaping of the sensibility in accord with regulative principles projected as desirable ideals. Whence an incompatibility between the principles that guide Schlegel's critical activity and the principles on which he bases the history of Literature. In his critical activity, he approaches literary works in accord with a regulative teleological principle, an ideal of literature; if there is criticism (in the current sense of the term) it is also because all works are not what they should be according to the postulated ideal. This ideal is the very one defended by Novalis in his sacralization of poetry. One may not agree with his program, but at least it is not open to the charge of making a category error so long as it is *explicitly* presented not as a definition of what poetry is, but as a requirement of what it should be according to the romantic ideal. The project of the history of Literature, on the other hand, implies the idea of an *objective* essence of poetry and of an autonomous development of Literature in accord with purely internal historical laws. Now, if this is the case, it is hard to see how the critic can justify his polemical comments. Thus we should not be surprised to find Schlegel—in the first issue of the *Athenaeum*—rejecting literary criticism as a judgmental activity (*beurteilen*) in favor of the history of Literature and of philosophical criticism, activities of understanding (*verstehen*) and explanation (*erklären*);[111] henceforth he will let the present criticize itself. Instead, he announces a project of "positive criticism" based on the objective laws provided by the history of Literature conceived as Encyclopedia: "I shall add just one thing concerning this Encyclopedia. It is here, or nowhere, that the source of the positive laws of all objective criticism are to be found. If this is so, it immediately follows that true criticism cannot take the slightest notice of works that add nothing to the development of art and science; I would go still further: a true criticism of what is not in relation with the organism of culture and genius, of what does not exist for and in the Whole, is impossible."[112] Here we have a candid acknowledgment of the fundamentally evaluative character of the essentialist definition of the history of Literature, for the "organism of culture and genius," the "Whole" whose existence Schlegel here presupposes, does not have to do with an extensional study (it is not a matter of constant traits discerned by means of a historical or structural analysis), but rather with a prescriptivist and evaluative study (it is a matter of texts that meet the criteria of

excellence as determined by the sacralization of poetry). The history of Literature is only one more literary canon, but it is all the more insidious insofar as it fails to recognize its own status and presents itself as grasping the essence of a supposedly transparent past.[113]

LITERATURE AS ORGANISM

The passage from a criticism of the literary monuments of the past to the history of Literature thus entails a transformation of the teleological principle: it becomes constitutive rather than regulative. This transformation passes by way of the introduction of organicism. When Schlegel, in his first published text, distinguishes arbitrary divisions from those produced by nature itself, he is in fact opposing divisions imposed from outside by human understanding to organic self-differentiation: "The organization can be understood only in a teleological manner."[114]

The specificity of the organism as it is defined by the romantics is fourfold:

a) *Autonomy*: the organism has within itself the foundation of its existence and evolution. This idea is central for the history of Literature, since it makes it possible to postulate that literary facts as a whole form an autonomous totality, that is, that Literature contains within itself its own existential and developmental basis and is not subject to external causal influences. Of course, this organic unity is always relative: what at one level of analysis can be seen as an organic unity will prove at a more elevated level to be simply an element in a more comprehensive organism; thus it is possible to consider the individual literary work both as an absolutely autonomous organism and as part of a higher organic whole, whether this be a genre or a literary period. Schlegel took this specificity into account in his famous review of *Wilhelm Meister*, where he says about the critic: "He will divide the Whole only into members, masses, and parts, without ever decomposing it into its originary elements, which are dead in relation to the work insofar as they no longer include elements of the same kind as those in the Whole; that in no way prevents them from being alive with relation to the universe and from being members or masses of it. It is to such elements that common criticism refers the object of its art, and thus it inevitably destroys the living unity, either by decomposing the object into its elements, or by considering it only as an atom of a larger mass."[115]

b) *Self-differentiation with the maintenance of the essential unity in the differentiations*: the organic unity unfolds, in accord with its own internal spontaneity, into diverse particularizations that are interdependent and are all related to the unity. Drawing vaguely on Leibnizian monadology,

Schlegel thus postulates that the diverse elements of an organic unity all express the totality: "The essence of all superior form and art resides in their relation to the Whole. That is why they have an absolute finality at the same time that they are absolutely gratuitous. . . . That is why all works are a single work, all the arts a single art, all poems a single poem. For all seek the same thing, the One in its omnipresence and undivided unity. . . . Every poem, every work must signify the Whole, signify it really and truly—and thus, through the Meaning and re-creation (*Nachbildung*), really be this Whole, in the degree to which, except for the superior being (*das Höhere*) toward which it points (*deutet*), only the Meaning exists and is real."[116]

c) *The concept as principle of development*: the active principle of organic development is none other than its internal spiritual principle, that is, its concept. Here we encounter again, of course, the essentialism according to which, to use Hegelian terms, the real *(das Wirkliche)* is nothing other than the concept's self-unfolding. Thus in the opening pages of his *History of European Literature* (1803–4), Schlegel asserts that the adequate concept of Literature is given only in and through the development of the history of Literature, so that any abstract definition could only be heuristic: "Before . . . beginning our historical exposition (*Darstellung*), it is necessary first to preface it with the concept of what literature is, to indicate the scope and the limits of the totality that it forms. This concept can only be provisional, to the extent to which the complete concept is the history of Literature itself."[117]

d) *Internal teleology*: This derives directly from historicist essentialism: the parts proceed from the whole conceived as an internal teleological principle, from the formal point of view as well as from the point of view of developmental concretizations. Just as in the dimension of their copresence the parts exist only by and for the organic unity, in the dimension of progressive genesis the unfolding of the organism in accord with successive historical concretizations is entirely predetermined by the originary unity. The internal teleological principle excludes all transitive, external causality; the organism's developmental finality is identical with the self-unfolding of its essence, and the organism can only become what it already is in embryonic form, without undergoing the slightest external influence.

In the domain of the explanation of cultural facts, organicism makes it possible to combine the idea of a necessary evolution with that of an evolution that is "free" because determined solely by an internal essence. Romanticism claims to go beyond Kant, who had asserted that we can never have more than a negative proof of freedom, in the form of an absence of external determinations, and that it is impossible to construct a theory that has freedom as its constitutive principle. Organicism, to the extent

that it allows freedom to be identified with internal determination, thus provides the constitutive principle romanticism needs for the historical-philosophical analysis of the domain of human facts.

This organicist model is absolutely hegemonic in the project of the history of Literature, on both the synchronic and diachronic planes. Because of historicism it is clearly the diachronic model that prevails, but the synchronic organic function nonetheless plays an important role at the level of the determination of the minimal units of the history of Literature. These units are always individual works: the history of Literature is a history of works. This elevation of the work to the level of a minimal unit derives from the principle according to which the work is a self-enclosed organism. Thus we read in the *Conversation on Poetry*: "It is only by forming a whole and being self-sufficient that a work becomes a work."[118]

The idea that literary traditions are sequences of works, or more precisely that in order for the formation of literary traditions to be understood they must be organized in accord with a chronology of works, is one of the self-evident notions with regard to which it is difficult for us to have any distance. Nevertheless, during most of Western history, cultural memory was much less a memory of works than a memory of paradigmatic passages or exemplary fragments. Michel Charles[119] has pointed out that the conception according to which literary traditions are organized into a sequence of works implies the existence of libraries that are both extensive and easily accessible. Such a model could be firmly established only with the massive increase in the circulation of books after the invention of printing. Before, that is in antiquity and in the Middle Ages, real libraries were (except in rare cases) private and very incomplete; the dominant model was rather that of the individual memory, an "ideal library" organized more according to analytical rubrics (rhetorical rubrics, for instance) than according to a sequence of works conceived as totalities, more according to "characteristics" (stylistic, thematic, etc.) than according to individual overall structures. Naturally, the works existed as such; nevertheless, they were perceived in such a way that their modeling function was situated much less at the level of their "being-a-work" than at that of some of their particular characteristics. In other words, the very formation of the literary tradition was based much less on the pertinence of the complete and closed individual work than it is today. The history of Literature, and through it Literature as a scholarly representation of literary facts, is closely connected with the elevation of the individual work seen as a closed organism and a basic chronological unit; and thus it obviously cannot take into account the historical variability of the pertinent units even at the level of the formation of literary traditions. Whence in particular a biased approach to oral literary traditions, which are irreducible to the notion of a work, even a collective or anonymous work.

A second important aspect of the synchronic function of organicism concerns the relations between different literary activities co-present at a given moment: Literature as the totality of the spiritual expressions of a given period forms an organic unity. As we already know, poetry is the soul, the life-giving principle of this organism. Thus in his article "Literature" (1803), Schlegel warns:

> Poetry will be the center and the goal of our considerations. In our opinion, that is in fact the place it occupies in the Whole formed by art and science. Philosophy is only an *organon*, a method that shapes true, that is, Divine, thought—the thought that is precisely the essence of poetry; philosophy is thus solely a means of instruction, a tool and a means for achieving what poetry is. . . . We therefore believe that poetry is the first and most noble of all the arts and of all the sciences; for it is also a science, in the fullest sense of the term, the science Plato calls dialectic and Jakob Boehme theosophy, that is, the science of the sole true reality. Philosophy has the same object, but approaches it only in a negative way and through an indirect presentation of it, whereas any positive presentation of the Whole inevitably becomes poetry.[120]

Thus, like Novalis, Schlegel thinks that the unity of the sciences and the arts around poetry is possible because ultimately they all have a single, identical content, which is at the same time the essence of Literature and the principle of its self-development: the "sole true reality," that is, either the One and All (for the young Schlegel) or divine transcendence (for the Catholic Schlegel).

But it is especially in the diachronic dimension, where the different synchronic organicist aspects appear as so many moments of a totalizing diachrony, that the organicist model is deployed in all its power. We can distinguish at least four levels:

1. *The whole of the works of a writer.* This whole forms a diachronic organic totality in the sense that it expresses the gradual artistic education (*Bildung*) of its author. In other words, the organic unity of the overall work of an author is based on the organic character of his spiritual development: "Art gives form, but it is also formed; for the one who forms is no less an organic totality than what is formed, and in the precise degree that he is an artist. Every artist has his history: understanding, explaining, and describing it is the first task of the science we call critical and which up to now has been more sought than found. It is right that the genesis of what is formed (*des Gebildeten*) should interest us, it is even the sole thing that interests the person who has risen to the contemplation of the Whole, to the contemplation of the truth in its unity with beauty."[121] Thus the series formed by the successive works of an author is not a simple chronological sequence, but a true organic diachrony, since it expresses the history of his mind. When Schlegel points out that "a work can be totally understood

only if it is resituated in the system of all the works of the artist,"[122] we must understand that the system in question is always historical-organic. To be sure, the rule of organic development does not hold for all authors, but only for those who have "an objective tendency," that is, those whose creative movement corresponds to an internal necessity. Schlegel opposes them to authors such as Jacobi and Kant (!) who have only a subjective intention (*Absicht*) instead of a tendency (*Tendenz*), that is, whose works do not proceed from an internal teleological necessity (which is also always the necessity of a given literary period) and express only personal idiosyncrasies.[123]

2. *The evolution of genres.* This proceeds from an internal teleology whose movement can be followed through three stages—which Schlegel finds in all the genres: initial germination, flourishing, and fading away. Since we shall have occasion later on to return to the problematics of genre in greater detail, I shall not further dilate on it here.

3. *The literary evolution of a historical period.* Insofar as it has its own internal principle, the literary evolution of a historical period follows an organic cycle: all the books of the same period form a single book. In the philological writings of his youth, and even in some texts contemporary with the *Athenaeum*, Schlegel asserts that only ancient poetry has followed a complete organic evolution: "All the classic poems of the ancients are mutually connected, they are inseparable, form an organic whole, and are, correctly perceived, a single poem, the only one in which the art of poetry itself is perfectly revealed."[124] As for modern literature, its evolution can approach such completeness only asymptotically, without ever really attaining it: "In an analogous manner, all the books of completed literature *must* be only a single book, and it is in such a book, *forever developing*, that the gospel of humanity and culture will be revealed."[125] This distinction between ancient poetry and romantic poetry is in conformity with the conceptions worked out in Jena. But as early as 1803, in *The History of European Literature*, it is all of European literature that is seen as an organic totality: "European literature forms a harmonic whole in which all the branches are closely linked, in which each aspect is based on another that explains and completes it. These links traverse all periods and all nations up to the current period."[126] Organicism's domains of application thus change according to the fields in which Schlegel thinks he can found a unitary conception of Literature: first ancient literature, then European literature.

4. *The evolution of universal literature.* This forms the total organism of Literature, the ultimate circle that subsumes all the historical particularities. Speaking of the spiral movement that leads the critic to discover more and more comprehensive spiritual organisms, Schlegel notes: "If you wish to attain the Whole, if you move toward it, you can be sure that you will

find no natural frontier, nor any objective reason that would cause you to stop before reaching the center. This center is nothing other than the organism of all the arts and sciences, its law and its history."[127] This universalist organicism finds its most fully developed expression in the *History of Ancient and Modern Literature*. This is a universalism centered on revealed religion and in which the arts and sciences henceforth have only a derivative function. Schlegel in fact attempts to conceive a universal literature as a progressive expansion of divine revelation: it is a sort of tree that branches out through history and through nations; divine revolution constitutes its root and the different arts and sciences its branches.

We know that romanticism long hesitated between a linear and a cyclical view of history. The former corresponds to the literary utopia proclaimed by Jena romanticism, the latter to the nostalgia for the past so typical of conservative, post-Jena romanticism. The question is important for the status to be accorded organicism: the latter seems in fact to be most in harmony with a cyclical view of historical evolutions, in accord with the schema of the growth and decay of vegetable and animal organisms. In Schlegel's first writings, for example in *On the Study of Greek Poetry*, that is how the organic model functions: birth, youth, the flourishing of the adult age, old age, and decrepitude are the integrating principles of a historical literary totality. Hence the model can be applied only to a completed literature, in this case the literature of classical antiquity: that is why Schlegel identifies the opposition between nature and understanding, between the finite and the infinite, with that between organic evolution and artificial cultivation (*künstliche Bildung*).[128] Nevertheless, in this same text, the idea of an overall approach to literature is sketched out. Thus Schlegel observes: "If one tears the different parts of modern poetry out of their context and considers them as totalities existing for themselves, they remain inexplicable. They have substance and meaning only in relation to each other. Nonetheless, the more attentively one contemplates the whole of modern poetry, the more it appears to be simply a part of a whole."[129]

But what might be the nature of that totality? According to Schlegel, the cultivation of the understanding and the concern for what is "interesting" are the dominant characteristics of modern literature. But clearly these two principles do not allow us to arrive at a unifying causality; in fact, Schlegel opposes the totalizing function of the natural organism connected with an always indeterminate goal (*Ziel*) to the specifying singularity of the concept of understanding, which always implies a determinate intention (*Zweck*) and thus cannot function as the integrating principle of an organic whole (since such a totality always has an indeterminate finality—here we find an echo of the theory of genius as Kant developed it).[130] In order to get out of this impasse, Schlegel resorts, in his later texts, to the

acknowledgment of a twofold organic model: that of the natural organism, cyclical in nature, and that of the spiritual organism, destined to infinite evolution. In the case of the spiritual organism, the law of progressive integration will take the place occupied by the law of the succession of ages in the natural model: the principle of unity is maintained, but it is projected onto the axis of an infinite integration rather than onto that of a completed cyclical figure. It is this conception of spiritual organic unity that will make possible the theory of universal poetry and mark the passage from the young Schlegel's philological notions to the romantic theory of the *Athenaeum* period.

It will be observed that the conception defended in the *Athenaeum* period does not take into account an alternative possibility: one might hold that modern literature, like ancient literature, is governed by the model of the natural cycle, and that therefore both are finite, with the simple difference that contrary to ancient literature, modern literature has not yet completed its cycle. If Schlegel does not take this alternative into account, it is because it contradicts the central thesis of the subjective idealism he is defending at that point: the thesis of an infinite progress of self-consciousness. Yet when in the last years of his life he takes it upon himself to reformulate the whole of his historical-philosophical conceptions within a conservative and Catholic framework, it is implicitly such a thesis that he defends, since he rejects the idea of an infinite progress of history. In *The Philosophy of History* (1828), he thus maintains that history is not governed by the principle of "infinite perfection" but by that of the "natural cycle." The modern period nonetheless does not lose all specificity with regard to antiquity: universal history is a single cycle, to be sure, but it is a cycle that does not end in degeneration but on the contrary in redemption; degeneration is only an intermediary stage, that of the Fall of Man, it being understood that the upward movement begins with the birth of Christ: antiquity, since it precedes the redemptive Passion of Christ, is thus profoundly different from the romantic period.[131]

All these rearrangements Schlegel makes in his conception of history are connected with transformations in his fundamental ideological options. But they are perhaps also due in part to the difficulties inherent in organicism conceived diachronically. The latter proceed essentially from the fact that an organicist view of history is obliged to consider history from the point of view of its real or postulated completion, that is, to consider historical phenomena from the point of view of a philosophy of History that denies what is constitutive for any actual history, namely its uncompleted and open character.

In spite of all its negative aspects, organicism is no doubt a response to a real problem. In a certain way, the history of Literature arose from dissatisfaction with traditional literary criticism. This dissatisfaction is con-

nected with the explosive expansion of literary production at the end of the eighteenth century, especially in Germany, and with criticism's subsequent inability to constitute an effective filter for contemporary writing. Although Nicolai's *Allgemeine Deutsche Bibliothek* was still trying, during the second half of the eighteenth century, to offer detailed reviews of *all* the new publications on the German literary market, this goal had gradually to be abandoned when confronted by the quantity of books appearing each year: more than 1,000 titles at the end of the eighteenth century, more than 4,000 around 1820, and more than 8,000 around 1840.[132] The same thing was happening all over Europe: whereas between 1600 and 1700 some 250,000 books were published in Europe, the number rose to 2 million between 1700 and 1800.[133] Friedrich Schegel's abandonment of his critical activity in 1801, and in the same year his brother August-Wilhelm's refusal to go on writing reviews of books (he had written more than 300 between 1796 and 1799 for the *Jenaische Allgemeine Literaturzeitung*[134]), anticipate the passage from criticism to the exclusive practice of the history of Literature. Friedrich Schlegel's assertion that only works that are in relation to the overall organism of literature are worthy of being considered by the critic certainly shows that the function of organicism is to replace critical comprehensiveness, which was no longer feasible, with a model that made it possible to select works according to criteria based on the speculative theory of Art. At the same time, it is the expression of an important institutional change: henceforth literature increasingly escapes conscious attempts at critical direction; its profile is governed above all by the aleatory developments of the market[135] and the fluctuations of a taste that is largely anonymous. Romanticism reacts in two ways to this impossibility of instituting a contemporary literary canon through a public activity of judging: first, by introducing an increasingly sharp distinction between great literature and mass literature, and second, by a retreat toward the works of the past and toward the construction of a historical canon. This prepares the way for a radical distinction between day-to-day critical activity and the transmission of the literary tradition, the former ultimately ending up in literary journalism, and the latter in the academic institutionalization of the history of Literature.

ANCIENT AND MODERN

In the history of Literature as its program is sketched out by Schlegel—and this goes for Schelling's and Hegel's artistic systems as well—the distinction between antiquity and the modern age plays a fundamental role. It corresponds to an ontic dichotomy: the "ancient" and the "modern" are two radically different modes of being.

The historical caesura between antiquity and the modern age is, in it-

self, something that was constructed by early Christianity, which sought to distinguish itself from the pagan past; the birth of the sole true religion had to correspond to a total break with the past, to a negation of any continuity whatever. In other words, this break is a central component of early Christianity's self-image. It is thus constructed on the basis of one of its two terms and not on the basis of a neutral position.

In spite of this break's religious function, from its very first formulation onward it concerns poetry as well. Some early Christian writers in fact condemn poetry as such. They repeat in their own way Plato's accusation: poets are liars because they talk about pagan gods, that is, about non-existent entities. This accusation is leveled against epic and lyric poetry in particular. Such condemnations do not appear to contemplate the idea of a possible Christian—and thus "truthful"—epic or lyric poetry. Another reproach does not attack the mendacious character of poetry so much as the damaging effects that are likely to be produced by the mimesis of reprehensible actions: the genre targeted here is clearly tragedy, which some writers lump together with circus acts.[136]

Nonetheless, these overall condemnations of poetry remained less common than the widespread idea according to which pagan poetry must be replaced by Christian poetry. The latter need not necessarily be explicitly religious, however; while it is true that in the Eastern Church the first poetry Christians opposed to the tradition of pagan poetry was in fact liturgical in nature, the first works by Christians in the West had no liturgical function. The important thing remains that everyone be persuaded that Christian poetry tells the truth, whereas ancient poetry told only lies. But often a distinction is drawn between content and form: many authors tend to accept pagan models as formal models. The question of the legitimacy of such a distinction (and of the concession to pagan poetry it implies) already contains in germ the whole Quarrel of the Ancients and the Moderns.

The contrast between antiquity and the modern age is thus anchored in the Christian view of history; in other words, the opposition—which is supposed to be purely literary—between ancient and modern poetry is in fact indebted to a Christian interpretation of European history. Romanticism, by considering the birth of Christianity the crucial turning point in universal history (including the artistic domain), explicitly bases the contrast between antiquity and the modern age on this interpretation.

The Quarrel of the Ancients and the Moderns is conceivable only within this Christian way of organizing history. If this quarrel, which began in the Renaissance, seems irrelevant to the religious problematics of the Middle Ages, that is only because it tends increasingly to misunderstand its own foundation. Hans Robert Jauss has very rightly pointed out that romanticism more or less put an end to the history of the Quarrel, and was able to

do so *because* it had recentered the debate: the theological basis for the dichotomy, which was often lost from view in the neoclassical quarrels, returned in all its power and was brought to a new philosophical "solution," since the opposition was given an ontic foundation.[137]

As soon as the evolution of literature (or of art) is conceived within the framework of a break between antiquity and the modern age, the question about the relation to the past takes a very special form. Thus those who counseled imitation of the ancients cannot limit themselves to an argument that was put forward by traditionalists in an undivided culture and that suggests that people should continue to act as they have acted in the past. Within the framework of the Quarrel of the Ancients and the Moderns, a rupture in fact separates the past in question from current practice. For the defenders of the ancients it is precisely this rupture that justifies *imitatio* insofar as the latter is irreducible to traditionalist reproduction and includes the idea of a difference in principle between the imitated model and the imitating practice. Of course, the justification given for this difference in principle may vary. In the seventeenth century it was legitimated chiefly by rationalist arguments: we have to imitate the ancients because their poetic productions coincide with reason's demands. The privileging of the idea of Nature in the eighteenth century produces a change in argumentation to which the young Schlegel's philological writings—though Winckelmann had preceded him in this—unambiguously testify: we must imitate the ancients because their poetry constitutes a perfect natural organism, that is, it exhibits all the characteristics of a literature that has developed by virtue of its inner nature. This change is important, since the weight of the argumentation no longer rests so much on the excellence of certain individual productions as on the internal completeness and coherence of a historical period of humanity: ancient literature is Literature par excellence.

As for the defenders of the modern age, the dichotomous structure of the historical schema prevents them from resorting to the idea of a continuous historical progress leading from antiquity to the modern age. If there is progress, it has to be discontinuous. Thus the "religious" version of modernism maintains that Christianity cannot follow pagan models (an argument that served particularly to prohibit the introduction of Christian miracles into epic poetry); the "lay" version, for its part, opposes antiquity's crudity to the rational enlightenment characterizing the modern period. Paradoxically, the religious basis of the dichotomy strengthens the modernist position more than their opponent's emphasis on *imitatio*, since only the modernist position retains the polemical barb directed against antiquity that was the initial motive behind the schema's genesis.

For Schlegel, antiquity is to the modern age as the age of Nature is opposed to the age of Reason. H. Eichner reminds us that, in the form of

the opposition between a spontaneous creation and a creation guided by theory, the distinction was already a commonplace in Germany—and in Europe as well—when Schlegel first adopted it. Moreover, it was developed simultaneously by Friedrich Schiller in his *Letters on the Aesthetic Education of Humanity* (1795) and in *On Naïve and Sentimental Poetry* (1795–96), but with a quite different aim.

In his studies on classical literature, Schlegel often opposes the objective character of ancient literature to the "interesting" (*interessant*) character of modern literature. Whereas ancient literature is a purely autotelic literature, a poetry of the beautiful, play, and appearance, modern literature is in contrast heterotelic: it presupposes an awareness of a schism between the real and the ideal, and it is characterized by an *interest* in the realization of the ideal, in latter's incarnation in the real.[138] The qualifier "interesting" applied to modern literature thus means that it is "interested," that it pursues a goal that transcends the simple manifestation of its own aesthetic appearance. In other texts, particularly in the *Athenaeum* period, the dichotomy is formulated differently, but its meaning remains the same: ancient poetry is a natural poetry, whereas modern poetry is artificial, in the sense that it is based on reflection and on the understanding. Hence the former constitutes an organic unity that is total, but finite, whereas the latter, although it lacks unity, nonetheless participates in the infinitude of the Ideal: "the sublime destiny of modern poetry is nothing less than the supreme goal of all poetry,"[139] that is, "absolute beauty, a maximum of objective aesthetic perfection."[140]

Schiller's opposition between the naïve and the sentimental makes use of the same criteria. Naïve literature is a natural, spontaneous poetry that always and everywhere expresses the same sensibility (*Empfindungsweise*), just as it derives from the lived unity of nature and humanity. Sentimental poetry, on the contrary, arises from the schism between nature and culture, man has lost nature, he becomes conscious of this loss, and—through poetry—seeks to reestablish the originary unity. Sentimental poetry is thus dominated by reflection; it is always guided by the awareness of a loss and by the interest in an ideal, that is, it always expresses specific sensibilities, whether satirical (the struggle against finite reality) or elegiac (the representation of unity as a lost origin or an ideal to come): "To the naïve poet nature has granted the privilege of always acting as an undivided unity, of being at all times an autonomous, perfect totality, and of incarnating in reality humanity in accord with its full content. To the sentimental poet she has given the living desire to reestablish through his own resources the unity that abstract life has suppressed within him, to make humanity complete in himself and to pass from a limited state to an infinite state."[141] As in Schlegel, finitude is the price naïve poetry pays for its perfection, whereas sentimental poetry compen-

sates for its defects by the absolute character of its Ideal: "All reality, we know, is inferior to the Ideal; everything that exists has its limits, whereas thought is unlimited. The naïve poet thus also suffers from this limitation to which all sensuous reality is subject, while on the contrary the unconditioned freedom of the faculty that invents Ideas serves the sentimental poet. Consequently, the naïve poet certainly fulfills his task, but the task itself is limited; the sentimental poet does not wholly fulfill his task, but his task is infinite."[142]

While Schlegel's description of the differences between the ancient and the modern parallels Schiller's description of the differences between the naïve and the sentimental, the dichotomy's status nonetheless differs in the two authors. In Schlegel the dichotomy forms the two poles of a dialectical historical schema: the opposition between the two poetries calls for their transcendence in a reconciling synthesis.[143] As early as the *Studium-Aufsatz*, we find the postulate of a historical synthesis governed by "the laws of an objective theory and by the example of classical poetry."[144] Similarly, in 1796 Schlegel begins to refer to the religious component in the modern period. In a review of a work by Herder, he notes that the desire to realize the "divine kingdom" is the common denominator of all modern poetry.[145] In the *Athenaeum* period, the dichotomy between antiquity and the modern age becomes an integral part of a general historical ontology, and hence is identified with the philosophical oppositions between objectivity and subjectivity, realism and idealism, and so on. According to this philosophical interpretation, poetry always merely expresses or realizes the tendencies inherent to its period: thus ancient literature is objective, finite, and realistic, whereas modern literature is infinite, idealist, and exalts subjectivity. The only important difference from the views defended at the time of the *Studium-Aufsatz* consists in the strengthening of the second pole of the dialectical structure: ancient poetry ceases to be seen as the perfect paradigm of art; modern poetry establishes itself on a equal footing with ancient, and their unity in universal romantic poetry implies a mutual interpenetration.

In Schiller, the picture is entirely different. The birth of Christianity does not come into it; thus the opposition between naïve and sentimental is not that between the ancient and the modern, but in much more specific way that between Greek (not ancient!) nature and all culture of understanding after the Greek golden age. The central idea in Schiller's work is an alienation of nature that is not inscribed within a historical dialectic, but within a linear evolution: there is no reversal or dialectical synthesis. Moreover, whatever period poets write in, they always have a single object, namely nature. Consequently, in the period of the culture of the understanding, far from expressing the fundamental principle of their age, they oppose it, since through a constraint inherent in their activity, they must

always define themselves in relationship to nature. There is therefore no necessary (or even tautological) identity, as in Schlegel, between the principles of a period and its poetry:

> To the degree that nature, disappearing from human life, ceased to be present in experience and in the acting and feeling subject, we see it appear in the world of the poets as an Idea and as an object . . . *Everywhere, by their very definition, poets are the guardians of nature.* Where they cannot completely be such, and where they already feel in themselves the *destructive influence* of arbitrary and artificial forms, or *where they have had to struggle against these forms*, they will appear as witnesses to and avengers of nature. Either they will be nature or they will seek lost nature. From this result the two entirely different poetic manners that exhaust the whole domain of poetry and measure its scope. *All poets who are truly poets will belong, depending on the time in which they flourish or on the contingent circumstances that influence their general culture and on the transitory disposition of their souls*, to the category of naïve poets or to that of sentimental poets.[146]

Schiller, contrary to Schlegel, does not start out from a historical construction, but from a concept, an a priori deduction of the beautiful and of poetry. Moreover, the naïve or sentimental nature of poetry is not a direct expression of a period that necessarily determines it; historical determinations and the specificity of the poetic "manner" are external to each other. In fact, it is by virtue of this exteriority that history can influence poetry, in the same way that fortuitous circumstances can do so. If the poets who write in the period of the culture of the understanding, far from being in harmony with the spirit of their time, oppose it, it is precisely by virtue of the immutable a priori definition of their activity: thus the influence is here wholly negative. Finally, Schiller emphasizes the fact that the distinction between naïve and sentimental is not primarily an opposition between historical periods, but rather between poetic "manners,"[147] and he reminds us that both types of poetry are found in *all* periods, even if naïve poetry is dominant in ancient Greece and sentimental poetry is dominant in later periods. Thus Euripides is already a sentimental poet, whereas Shakespeare, Molière, and Goethe remain naïve poets in a period that is nonetheless favorable to sentimental poetry. In short, Schiller's interpretation of the dichotomy is incompatible with a historicist view of poetry defined as the expression of the soul of the period.

In his *Letters on the Aesthetic Education of Humanity*, Schiller, having contrasted ancient poetry with modern poetry, goes on not to construct beauty historically but to deduce it a priori. Greek art is for him an absolute paradigm rather than a historical concept. The goal of Schiller's distinction between the naïve and the sentimental is thus not to found a history of Literature. For Schlegel, on the other hand, the paradigmatic function of

Greek art lies essentially in its history: its evolution forms, as we have seen, a perfect organism "whose specific history is the universal natural history of art."[148]

It is not that in Schiller there is no historical dimension at all. But whereas for Schlegel the transcendence of the dichotomy is a kind of a nomological historical synthesis that can be predicted, for Schiller it remains a kind of teleological principle. In Schlegel the unity of the ancient and the modern is only one aspect of a general historical eschatology leading to the unity of life and poetry, to the establishment of the divine kingdom on earth. That is why his proposed theoretical resolution of the Quarrel of the Ancients and the Moderns involves the reintroduction of its religious dimension and its insertion to the horizon of a salvation history (*Heilsgeschichte*) that is first pantheistic and later Christian. Schiller, on the contrary, emphasizes the fact that the reconciliation of the real and the ideal must always take place in the domain of aesthetic appearances, and not in existential or historical reality; aesthetic appearance and real existence are forever (*ewig*) separated by absolute barriers.[149] The "aesthetic State" Schiller refers to at the end of the *Letters on the Aesthetic Education of Humanity* is a regulative Idea and not the final stage of a dialectical historical process. Thus poetry, far from incarnating an eschatology of historical reality, remains fundamentally a kind of autonomous activity, and hence specific and local: Schiller pins all his hopes on the aesthetic education of humanity which would permit it to recover in the domain of aesthetic appearance the originary unity of feeling and thought definitively lost in the domain of actual history. For Schlegel, in contrast, modern poetry, just like ancient poetry, is a necessary step in the self-realization of the absolute poetical-historical unity that is inscribed within the very dialectic of the ancient and the modern.

The speculative-historical status Schlegel accords to the historical break is repeated in its dialectical structuration. The latter is elaborated around the notion of a "decisive moment" that is supposed to produce a reversal of historical evolution. This decisive moment is first of all the birth of Christ, but it is also the present moment, the one in which Schlegel is writing; it is only now that humanity is becoming aware of the true meaning of universal history and of the function fulfilled by the birth of Christianity. The idea is already present in the *Studium-Aufsatz*, which, far from being the expression of its author's infatuation with Greece (as Schiller thought) is in fact an artistic form of the question: What should we do? By way of a detour through ancient poetry, Schlegel seeks to impose a Copernican revolution on modern letters. In his preface, which dates from 1797, he remarks: "Perhaps the first text deals more with the modern than the title of the present volume might make it seem or allows. Nonetheless, the relationship of ancient poetry to modern poetry, and the point

of studying ancient poetry, in the absolute as well as more precisely for our own time, can be established only after a more or less complete characterization of modern poetry."[150] It is current needs that dictate the study of ancient poetry, and these needs are those of a decisive moment: "Philosophy is becoming poetic and poetry is becoming philosophical: history is dealt with in poetry and the latter becomes part of history. Even the poetic genres exchange their determinations: a lyrical mood (*Stimmung*) becomes the subject of a drama, a dramatic subject is compressed into a lyrical form. This anarchy . . . extends to the whole domain of taste and art."[151] Poetic culture has entered a decisive crisis that may turn out to be either beneficial or disastrous: "Urgent needs have often created their own objects. From despair emerges a new calm, and anarchy becomes the mother of a beneficent revolution. Cannot the aesthetic anarchy of our time pin its hopes on such a fortunate catastrophe? Perhaps the *decisive moment* has arrived: either taste will undergo a decisive improvement that will prevent it from ever regressing and that will cause it to progress necessarily, or else art will collapse forever and our epoch will have to entirely abandon all hope concerning beauty and the restoration of a true art."[152] In 1799, the idea that the contemporary age is decisive ceases to be a hope and becomes a certainty: "We have seized the poles of humanity and we are at the center. What now exists will continue to strengthen itself (*potentialisieren*) forever, but there will no longer be a new world or final stage; we are living in the ultimate Middle Age."[153] In 1804 he takes up the same idea: "The era has not yet begun, it is only in preparation. For the moment we are not living in an era, but in the obscurity and chaos of an intermediary time."[154]

The idea of a "decisive moment" is connected with two specific characteristics of Schlegel's discourse: its programmatic aspect and its historicist aspect. The former is found especially at the time of the *Athenaeum*; it makes Jena romanticism the model of the modernist avant-gardes of the twentieth century. The second aspect is present in all Schlegel's texts, in the classicist period as well as in the Jena period and after his conversion to Catholicism. Historicism does not seem able to get along without the idea that the present moment, the one contemporary with the philosopher-historian, cannot help being a decisive moment: whether it is a question of the aesthetic revolution of the Jena romantics, the stage of absolute knowledge in Hegel, the genesis of the overman in Nietzsche, or, in a negative variant, the age of utter banality in the late romantics or that of "extreme danger" in Heidegger—the persistence of the same *topos* is striking.

I shall not discuss further Schlegel's problematics of the ancient and the modern. It is enough to have shown that it has a structuring function in the dialectical conception of the history of Literature, and that it is based on a Christian interpretation of history. This interpretation is only implicit in

the philological studies written between 1794 and 1797, whose subject is still largely limited to the literary sphere. But in the Jena period it becomes explicit and combines with the philosophical categories of idealism to give rise to the utopia of universal poetry; at this point the literary opposition between the Ancients and the Moderns is only a metaphor for an ontic rupture that divides history in a historical-ontological eschatology. The latter will play a central role in the whole tradition of speculative thought about Art which, far from challenging it, only increasingly radicalizes it, as we shall see when we analyze Nietzsche's and Heidegger's positions.

THE THEORY OF GENRES

In the history of the theory of literary genres, Jena romanticism is known above all for its dialectical triad of epic, lyric, and drama. We know that this conceptualization was adopted by objective idealism and ultimately became a commonplace of Western literary studies. Its recent retreat is more often due to decreasing interest in the generic problem as such than to a critical attitude regarding the presuppositions of the triadic theory.[155]

I shall be primarily concerned here with the *function* of genre theory in the project of the history of Literature. I am not interested in the triad as such, but only in its epistemological status. In this sense it is on an equal footing with the alternative conceptualizations proposed by the romantics, and which have enjoyed less historical success. These other conceptualizations are numerous: without mentioning the multiple variations on the distribution of the differing genres in relation to the philosophical categories of objectivity and subjectivity, there are triads that no longer use the dialectic of the objective and the subjective, but notions borrowed from natural philosophy (epic being described as chemical, lyric poetry as mechanical, and drama as organic), and even systems with four terms,[156] and so on. All these more or less convincing conceptualizations fulfill the same function in the strategy of the history of Literature. I shall therefore not dwell on their specific advantages and disadvantages, and it is solely in the interest of simplifying my argument that I shall henceforth refer exclusively to the triad that became canonical.

In the project of the history of Literature, the theory of genres is involved in both the synchronic and diachronic conceptions of organic unity. When we analyze Schlegel's ideas, we find that genres are conceived both as a conceptually closed system and as a necessary historical sequence. In his theoretical fragments, Schlegel proposes essentially synchronic systems, whereas in his historical studies the diachronic aspect is dominant. According to strict historicist logic, these two aspects should obviously be complementary, in the sense that the essential determinations (the synchronic system) are supposed to develop historically (in a

diachronic system). We nevertheless observe that Schlegel encounters many difficulties in bringing them into a single vision: this is essentially due, as we shall see, to an interference between the principles of the generic classification and certain consequences deriving from the dichotomy of antiquity and the modern age. Less of a virtuoso than Hegel in his handling of a multidimensional dialectic, Schlegel never succeeded in truly integrating into a unity these two competing systems of classification. It was perhaps this failure that led him, in his literary studies of the post-Jena period, to increasingly play down his theoretical claims in favor of a historical-chronological narrative.

Schlegel's theory of genres serves as a fundamental classificatory principle that makes it possible to constitute Literature as an organic totality: the genres *are* Literature, which implies that works belong to their genres, or express them. The zoological and botanical connotations of the notion will be shamelessly exploited (especially in the evolutionist tradition of the second half of the nineteenth century), and this notion connects the microcosmic organism of the individual work (which is, let us recall, the history of Literature's fundamental unit of analysis) with the macrocosmic organism of Literature in its historical development. Moreover, in historicism genres function as basic historical semantic units, in the sense that in their respective specificities they are always linked to the general historical determinations that they manifest: the spirit of an age or of a people, ontological determinations, class interests, and so on. In an 1803 text Schlegel states: "Through the literature of a people we become acquainted with its spirit, the degree of its culture; in a word, its specific being and essence."[157] Since literature unfolds its essence in genres, the latter are always intimately connected with general historical determinations. Genre is thus situated at a crucial point in the historicist project: it makes it possible both to integrate literary phenomena into the unity of an essential literary determination and to connect this literary determination with a general historical determination.

In fact, Schlegel identifies the theory of genres with the theory of Literature. But the theory of Literature is in turn, as we have already seen, the history of Literature. The theory of genres, the history of genres, the theory of Literature, and the history of Literature are thus only different terms for designating the same thing: the knowledge of Literature as an organic totality. In Schlegel's *Conversation on Poetry*, Marcus points out that a genuine generic classification would be simultaneously a history and theory of poetry.[158] Ludoviko adds: "It would show us how the imagination of a poet—himself the product of a poetic creation, and who, as an archetype, would be the poet of all poets—is obliged, by virtue of its very activity, to limit itself and share itself." And Lothario explains a little further on that "Poetic genres are, properly speaking, poetry."[159] We find the

same idea in an 1804 text: "the specification of genres, achieved in a thorough way, will sooner or later lead to a historical construction of the totality of art and poetry."[160]

It is here that the diverse generic schemas, including the famous triad, come in. The idea that epic, lyric poetry, and drama are the three fundamental poetic genres is not a romantic invention; what is new is the project of reducing these three supposedly basic forms to a systematic unity that can ground their claim to describe the field of all possible poetry. By anchoring the generic triad in the three dialectical moments of idealist ontology, Schlegel thinks he can legitimate their a priori necessity. The dialectical aspect of this classification lies moreover not only in the progress toward a synthesis of the two opposing terms, but also in the idea that the three moments are not mutually exclusive but could combine with each other. The idea is obviously a truism in the case of the synthetic moment, since by definition it includes the two opposed moments; Schlegel thus discovers the lyric and epic elements in ancient drama, and goes so far as to speak of the "epic character" of Greek drama.[161] Novalis goes still further, since he wonders whether the three fundamental forms are not instead the constitutive elements of any poem: "Are not epic, lyric, and drama simply the three elements of any poem—drama properly speaking being only a poem in which the epic element is particularly stressed, and so on for the other genres . . . ?"[162] Thus the systematic unity is not grounded on the external relations among three irreducible forms, but on an internal relation that diversifies itself according to three aspects that combine in varying proportions.

The other aspect of the generic systematicity lies in its historical unfolding. in 1794, in *Concerning the Schools of Greek Poetry*, Schlegel proposes a historical-systematic schema. He distinguishes an Ionian school, a Dorian school, and an Attic school; the first corresponds to the natural ideal of poetry, the second to the cultural ideal (*Bildung*), and the third, the highest stage, to the ideal of beauty. He makes a genre correspond to each of these three stages: first epic, then lyric, and finally drama.[163] He adds a fourth term, the Alexandrine school, characterized by scholarship and the practice of art for art's sake, but to which no specific genre corresponds and whose status is purely historical. With countless variations, this concern to master historical evolution within a systematic, organic unity is present in many later texts. Thus in 1803 the generic triad is identified with the triad of legend, song, and theatrical representation, and Schlegel explains that "these three elements or stages" are found in all poetry and establish the essence of epic, of lyrical poetry, and of drama.[164] In the background of all these postulated evolutions there is the same dialectical schema governed by the categories of objective and subjective.

Nevertheless, in reading through Schlegel's writings on the history of

Literature one observes that he does not really succeed in putting his historical exposition into the triadic schema. This is manifest in the essay "Periods of poetry" included in the *Conversation on Poetry*: the whole series of considerations is put under the sign of the organic model, but the metaphor of branching out is clearly dominant over that of a dialectical development. It is possible, of course, to discover a few traces that go back to the theme of a dialectical evolution; thus iambic poetry is described as the "exact opposite of mythical poetry," that is, epic, and Schlegel adds that it is *"for precisely that reason* the second focal point of Hellenic poetry."[165] But the text makes no reference to the synthetic function of drama and it lists, moreover, a great many other genres whose reducibility to the three fundamental genres is not at all clear. To be sure, this lack of integration of the theory into the history, which might be illustrated by many other examples, is perhaps not solely the result of an incapacity: contrary to Hegel, Schlegel—even at the time of the *Athenaeum*, when he indulges passionately in classificatory exercises that are as diverse as they are abstract—always retains a certain skepticism with regard any historical-systematic construction that claims to be totalizing. Nevertheless, by setting forth the ideal of an integration of theory and history, he puts himself squarely within the orbit of the Hegelian project, and it is hard not to measure him by the yardstick of what Hegel was to achieve.

The difficulties Schlegel encounters in structuring his historical reconstruction of ancient poetry with the help of the canonical triad are nothing compared with those with which he finds himself confronted as soon as he tries to account for modern poetry. Here in fact it is the very project of a generic theory that enters into open conflict with one of the fundamental principles of the dichotomy of ancient and modern: their opposition in accord with the categories of the objective and the subjective. If the modern age is the age of subjectivity and individuality, it is difficult to see how its poetic creations could be reduced to a system of genres, that is, to a set of objective, universal determinations. One of Jena romanticism's central propositions is precisely its negation of the validity of genre concepts in the domain of modern and romantic poetry. We find in Schlegel's works many categorical assertions to this effect: "All the classical poetic genres, in their rigorous purity, are now laughable."[166] Or again: "We can just as well say that there is an infinity of progressive literary genres as that there is only one. Therefore, there is not any at all; for a genre cannot be conceived without a co-genre."[167]

But we must distinguish two steps in this denial that generic categories are pertinent. As early as his classical studies, Schlegel asserts that modern poetry is characterized by the mixture of genres and the erasure of their mutual limits. In this it contrasts with Greek poetry, which as we have seen

constitutes the paradigm of a literary organism developed in accord with its essential determinations. However, if modern poetry is a mixture of *genres*, that means that it remains nonetheless entirely subject to generic determinations, to the point that antiquity can provide its paradigm: "The boundaries of [antiquity's] literary genres were not established artificially by arbitrary distinctions and mixtures; they were produced and determined by formative nature itself. . . . [Greek poetry] contains in reality the pure and primary elements in accord with which we must first analyze the mixed products of modern poetry in order to understand its labyrinthine chaos."[168] Antiquity thus is supposed to present in their purity elements that continue to determine modern poetry, but in an entirely chaotic way. At the time of the *Athenaeum*, the denial becomes more radical: Schlegel no longer limits himself to asserting that modern poems are generic mixtures but maintains on the contrary that they are radically a-generic. There is only a single romantic genre, which is universal poetry itself, infinitely developing; or, what amounts to the same thing, there are as many romantic genres as there are romantic texts—in other words, there is an infinite number of them. Each romantic book is its own genre. Obviously, from such a point of view the paradigmatic function of the ancient system of genres is abolished, and as early as the fragments in the *Lyceum* (1797) we read: "The Ancients are neither the Jews, nor the Christians, nor the English of poetry. They are not a people of artists chosen by God's decree; they do not contain the faith and beauty without which there is no salvation; they do not have a monopoly on poetry."[169] H. Eichner thinks this fragment constitutes a "public revocation of his early writings,"[170] but this expression seems to me too strong, since even at the time of the *Lyceum* and the *Athenaeum* Schlegel does not question the dichotomy between ancient and modern. What does change is his overall evaluation of modern literature and his conception of the ancient model in the future evolution of the modern age. When all is said and done, and in spite of many hesitations, Schlegel's early writings are still inscribed partly within the framework of an aesthetics of the beautiful, that is, within the framework of an a priori aesthetics that allows him to exhort Moderns to take ancient beauty as a model.[171] On the other hand, at the time of the *Athenaeum*, Schlegel abandons any idea of an autonomy of the realms of the beautiful, the just, and the true in favor of his theory of universal poetry conceived as fundamental ontological knowledge. This overturns the foundations of the dichotomy of the ancient and the modern, and makes possible, as we have seen, its historical-theological resolution. But at the same time Schlegel grants precedence to modern poetry, so that the synthesis no longer resides in the modern age's return to the (ancient) ideal of beauty, but on the contrary in an integration of the ancient beauty into

romantic poetry conceived as absolute synthesis—whence, in the domain of genre, the idea of a "romanticization" of ancient genres, that is, of an erasure of their specificity and determinate character.

Thus the opposition between the ancient and the modern, which, at the time of Schlegel's studies on ancient literature was supposed to establish the paradigmatic function of the ancient system of genres for the theory and history of Literature, ends up, because of its evolution toward an ontic opposition, opposing this initial goal, and at the same time making practically impossible the integration of the theory of genres into the history of Literature.

Schlegel was perhaps obscurely aware of the dead end at which he had arrived. This might explain his momentary effort to replace the model of the historicized system, or of the systematized history, by the distinction between a pure poetics and an applied poetics. A posthumously published fragment reads: "Only the poetic genres that have absolute validity can be deduced in pure poetics. The epic can be deduced only in applied poetics, like all the forms that are valid only for classical poetry or progressive poetry."[172] Another fragment is still more radical: "It may be that in a pure poetics no genre would subsist; poetics is at once pure and applied, empirical and rational."[173] But to go down that road would have entailed abandoning the fundamental project of the history of Literature, which was conceived precisely as a transcendence of the schism between the rational and the empirical, between the theoretical and the historical; thus it is not surprising that Schlegel abandoned his distinction between pure and applied poetics.

Ultimately, Schlegel appears not to have succeeded in developing his theory of genres in a coherent manner, even though such a theory was required as a central component of the history of Literature. He therefore never succeeded in giving a satisfactory answer to the question he asked in a fragment in the *Athenaeum*—a question that is *the* question of the history of Literature (insofar as it is an essentialist theory): "Must poetry be purely and simply divided? Or must it remain one and indivisible, or else move from division to reunion?"[174] A genuine answer to this question would have to wait for Hegel.

The System of Art (Hegel)

To READ Hegel's diatribes against the Jena romantics (and especially against the Schlegel brothers) in his *Aesthetics*,[1] one might suppose that his aesthetic conceptions were irreducibly opposed to the theory developed by the Jena thinkers. But as often happens, these attacks are the sign of a close relationship as much as of an irrevocable opposition: a close relationship in the function of ontological revelation with which Art is endowed, but also in the project of an evaluative definition of Art; an irreducible opposition with regard to the hierarchical positions of Art and philosophy. Whereas we have seen the Jena romantics put Art on the same level as philosophy, and even grant the former superiority over the latter, for Hegel, in contrast, the speculative function of philosophical rationality is more powerful than that of Art.

By once again clearly separating Art from philosophy, Hegel avoids an epistemological difficulty that was the backdrop of romantic theory, even if it had hardly been made explicit. This difficulty takes two forms, depending on whether one approaches it from the intensional or extensional point of view. From the intensional point of view: if Art equals or even surpasses philosophical discourse in speculative power, how can philosophical discourse still constitute itself as a discourse *on* Art? Or again: if Art is the fundamental organic speculative organ, how can there still be a *theory* of Art? The problem also arises if the absolute character of Art is determined extensionally, that is, if we see in it the completed totality of all the fundamental discourses (religion, philosophy, politics, ethics), and even of all human activities: how can philosophical discourse make Art its object if it is itself one of its elements?

This difficulty had already been encountered by Schelling. At first, in the period of transcendental idealism, he still conceived Art as did the romantics, that is, he granted it a certain privilege with regard to philosophy. Like the Jena thinkers, he believed that philosophy, contrary to Art, is incapable of gaining access to absolute identity: "The work of art alone reflects what could not be otherwise reflected, absolute identity, which is already divided even in the ego; only the magic of art causes to be reflected in its works that which the philosopher divides in the primordial act of

consciousness and which remains inaccessible to any other intuition."[2] Whence the famous claim in the *System of Transcendental Idealism* that "art is the sole and unique *organon*, the sole and unique proof of philosophy,"[3] a claim that is a distant echo of reflections of Hölderlin, Schelling, and Hegel in *The Oldest Systematic Program of German Idealism* (1794), where we read: "I am convinced that the supreme act of reason, the one in which it embraces all ideas, is an *aesthetic* act and that *truth and goodness are sisters only when united in beauty*."[4] However, if art is the *organon* of philosophy, it can hardly become an object of philosophy; it is rather a part of it.[5] Thus Schelling, far from anticipating a speculative deduction of Art, expresses hope that philosophy will return to the primordial ocean of poetry.[6]

It is only when Schelling has put the final touches on his philosophy of identity (from 1801 onward), that is, when he has granted philosophical discursivity the ability to accede to the One and All, that he can contemplate the possibility of *also* developing a philosophy of Art. And we must add that in *The Philosophy of Art* (1802) the situation is not always very clear. To be sure, Schelling sets out from the idea that henceforth it is not philosophy that needs Art, but the reverse: "Only philosophy is capable of reopening for reflection the primitive springs of art that have dried up."[7] Similarly, the genericity of philosophy is more important than the specificity of its object: "Our science must be philosophical. That is the essential point: that it is a philosophy of art is only a contingent aspect of our concept."[8] But this contingency is entirely relative, for "only that which, in its singularity, is able to open toward the Infinite can be the object of a construction, and hence of philosophy." "Art, in order to become an object of philosophy, must therefore represent, or at least be capable of representing, the Infinite through its own singularity."[9] Like nature, and like history, Art is an incarnation of the Absolute. Therefore, since it is not an *organon* of philosophy, it must be an *analogon* of it: "[art's] dignity equals that of philosophy; whereas the latter presents the absolute in the *Urbild*, art presents it in the *Gegenbild*."[10] If philosophy presents the archetype (*Urbild*) of the Absolute, that is because it presents it in ideality; if Art presents the counter-type (*Gegenbild*) of the Absolute, that is because it presents it in objective reality; but ideality and reality are both potentialities (*Potenzen*) of the Absolute, and as such they are isomorphic. Hence Art must trace in objectivity exactly the same figures that philosophy traces in the domain of ideality: the system of the arts is only a particular realization of the fundamental ontology; Art is the "real presentation of the forms of things as they are in themselves, and thus it presents the forms of the *Urbilder*."[11] It is clear that the gap between philosophy and Art is minimal. Is it enough for Art to be an *object* of philosophy? According to Schelling, to the extent that ideality is always a more elevated reflec-

tion of the real, the ideal reflection that is in the philosopher is more ele-
vated than the real reflection that is in the artist. Yet philosophy, insofar
as it is opposed to art, is always only ideal: it thus remains deficient (it is
only ideal, *nur ideal*), and hence the two activities join at the summit,
without one of them being reducible to the other. In other words, philoso-
phy can certainly take Art as its object, but it nonetheless remains incapa-
ble of absorbing its objectivity and ensuring that it is subsumed without
remainder.[12]

This idea that philosophy has a deficiency, even if minimal, and that
therefore a reduction of Art to philosophy without remainder is impossi-
ble, is not accepted by Hegel; the separation between Art and philosophy
that he establishes is intended to be sharper. Of course, although he pro-
poses to separate the two activities more firmly, that does not mean that he
returns to the situation before the romantics. Before romanticism, the sep-
aration was due to the nonexistence of *Art* as a philosophical concept; the
two domains were separated because philosophy had nothing to say about
artistic practices, or rather had no more to say about them than about any
other human activity. Hegel, on the other hand, retains the heart of the
romantic revolution, namely the establishment of Art as ontological
knowledge, and hence the definition of artistic practices as having a spec-
ulative function. If Art can (once again) be an object of philosophy, it will
nonetheless be a special object in the sense that, as in Schelling, Art is more
closely connected to philosophy than are other objects.

The Hegelian solution to the epistemological problem inherent in ro-
mantic theory consists in considering Art as a speculative representation,
but in placing it lower than philosophy, and doing so in a much more
consistent manner than Schelling. If we could interpret the Hegelian sys-
tem in a synchronic perspective, we could say that he conceives the rela-
tionships between the philosophical theory of Art in accord with a sort of
theory of logical types: philosophy is of a type superior to Art, and that is
why it can bear on Art, without the latter ceasing to be situated in funda-
mentally the same sphere as it is. The relation is asymmetrical: to the
extent that philosophy is the logically superior type, Art cannot, contrary
to what the romantics thought, make any assertion whatever concerning
philosophy. This logical distinction is also found, by virtue of the histori-
cist postulate, in the diachronic domain: if Art is inferior to philosophy,
this also implies that it comes *before* philosophy, that it constitutes philos-
ophy's past. Because of this historical thesis, the separation of the two
spheres is much greater than it is in Schelling.

Nonetheless, even the Hegelian solution remains problematic, to the
extent that the hierarchy continues to be situated within the boundaries of
a *single* domain, which is that of absolute Spirit, the ultimate stage in the
self-development of Being or of God. Because it enters into the domain of

absolute Spirit, Art is, for example, distinguished from the political-juridi-
cal sphere, which is also a stage on the way to the self-realization of Spirit,
but a stage that belongs to an inferior sphere, that of objective Spirit. In
other words, the relationships Hegel sets up between Art and philosophy
(like those between religion and philosophy) remain privileged and am-
biguous. Thus he finds himself forced to reduplicate the distinction be-
tween artistic representation and philosophical knowledge concerning it
by means of a hierarchy of the speculative organs: philosophy is not only
the metadiscourse *of* Art, but it is also and at the same time of a kind of
truth more fundamental *than* Art. That is, the logical distinction between
discourse and meta-discourse (or between artistic representation and the
philosophical knowledge that has this representation as its object) is re-
peated in an evolving hierarchy of representational and discursive prac-
tices. Hegel thus does not really succeed in defusing the conflict between
the two speculative activities.

The *Aesthetics* cannot be reduced to the role it plays in the tradition of
the speculative theory of Art. It is also, and especially, one of the great
texts in the Western aesthetic tradition. Hegel is, if not an art critic, at least
a literary critic whose intelligence and sensibility are often fascinating.
Moreover, once one has eliminated all the aspects that link the *Aesthetics*
to the tradition of the speculative theory of Art, one has still not finished
dealing with his theoretical project. Hegel's profound originality resides in
the fact that he is the first theorist of art who tries seriously to associate a
historical hermeneutics with a semiotic analysis of the arts: a double pro-
ject, represented respectively by the theory of the three forms of art (sym-
bolic art, classical art, and romantic art) and by the semiotic system of the
five arts (architecture, sculpture, painting, music, and poetry). Taken sep-
arately, neither of these two ideas is original; the semiotic analysis goes
back to Aristotle, and the historical hermenutics is a typically romantic
project (Friedrich Schlegel's history of Literature bears witness to this).
But the romantics had never seriously attempted to unify them, and al-
though one can find elements of such an attempt in Solger or Schelling,
their solutions never attain the scope of the Hegelian construction.[13] One
cannot help but admire the formidable inclusive power of Hegel's system,
his capacity to mix together the most diverse elements, and to maintain in
spite of everything the coherence of his overall worldview.

ART

Like the romantics, Hegel defines Art both as a speculative enterprise op-
posed to the prosaic knowledge of the understanding and as an ecstatic
being-in-the-world opposed to empirical being-in-the-world. To use his
own terminology: in Art, Spirit leaves the sphere of finite Spirit as it is

embodied in man's individual and social life and accedes to its final stage of development, that of absolute Spirit, that is, the stage where knowledge and reality, subject and object, spiritual and sensuous, etc. are reconciled. This opposition between Art and the understanding is conceivable only because Art *as such* is defined—there again in accord with romanticism—as a form of knowledge, *eine Gestalt des Wissens*.[14] It is based on the idea of a close relationship between Art and reason, and hence between Art and philosophy. This parallel between reason and Art and their common opposition to the understanding aims first of all to establish the autotelic character of Art. In fact, the understanding is always subordinated, because it grasps the real as an external objectivity that is opposed to it and to which it subjects itself. Therefore it finds its determination outside itself. Inversely, reason is autotelic, since it no longer considers the real as something that opposes knowledge from outside; on the contrary, it sees itself as identical with it. In the understanding's knowledge, alterity appears as exteriority, whereas for reason it is only a specific phase of knowledge, the one in which it gives itself an objective reality. Reason thus has within itself its own object and its own finality. The same autotelic character is found in Art: the *true* artistic work is not in the service of a transcendent meaning (as is an imperfect work, that of symbolic art) or an external goal (as is an artisanal product), whether this goal be usefulness or pleasure; it finds its finality in its own *Dasein* which is the unity of sensuous external appearance and internal spirituality, the unity of manifestation and signification. Truth is not symbolized by the work, it is incarnate in it.[15]

There is, however, a difference between Art and reason, or at least between Art and pure Thought, that is, philosophical speculation. In the domain of thought, absolute Spirit is determined as the unity of the ideal (Knowledge) and the real (Being) *in thought*, whereas in Art this same unity is realized in *sensuous reality*, whether in the three-dimensional materiality of the plastic arts, the two-dimensional appearance of painting, the evanescent sound of music, or the imaginative representation of poetry. This difference, as we shall see, is heavy with consequences, since it will ground the superiority of philosophy over Art.

To ground his opposition between Art as ecstatic reality and empirical being-in-the-world, Hegel first criticizes the commonplace according to which art works are merely illusions (*Schein*) opposed to the material reality of the world. In fact, he objects, this commonplace must be reversed in order to find the true definition of Art. Here Hegel takes advantage of the ambiguity of the term *Schein(en)*, which means both manifestation (phenomenon) and illusion. He defends a twofold thesis: a) it is the sensuous world that is an *illusion* (*Schein*), because it presents itself as a self-sufficient reality, and thus fails to see that it is grounded in Spirit; b) Art, on the contrary, to the extent to which it transforms the sensuous world into

an *appearance* (*Schein*) produced by the artistic imagination, at the same time transforms it into a *manifestation* (*Scheinen*) of Spirit, and thus reveals its true being, its Truth. When classical sculpture represents the human body as an ideal body, as the manifestation of the divine soul liberated from all imperfection due to biological contingency, it simultaneously reveals what it really is, namely an objectification of Spirit. Inversely, the biological body, subject to the vicissitudes of life and time, succeeds in this only very imperfectly and rarely. Far from being an illusion, a statue of a Greek god makes its sensuous substrate transparent and makes it glow with its own internal spirituality; it thus accomplishes the sublation (*Aufhebung*) of sensuous reality, transforming it into an epiphany-like manifestation of Spirit. In other words, artistic representation abolishes the realm of illusion constituted by a sensuous reality that is reified (cut off from its ideal foundation): it changes it into a manifestation of the truth, which is nothing other than the unity of the essence and of its manifestation *in the phenomenon*—a unity that goes unrecognized in the sensuous immediacy of this same reality: "The essence is found [. . .] not behind the phenomenon or beyond it, but, because the essence is what exists, existence is a phenomenon (*Erscheinung*)."[16]

The artistic work, the incarnation of the Idea in a sensuous form, is thus the truth of sensuous reality. This ability of the artistic world to transform the world of sensuous reality into the transparent substratum of the Idea results from the fact that art is created by the artist, and is thus, by birth, the conscious exteriorization of Spirit, and more precisely of the imagination (*Phantasie*).[17] Like pure thought, the imagination is part of the domain of reason, and hence of Spirit, which produces itself to the extent that it is conscious of its identity with the forms in which it exteriorizes itself. But unlike reason, imagination gives a sensuous form[18] to its spiritual content, because it is only in this sensuous form that the imagination is able to become conscious of it, to apprehend it.

As the unity of the sensuous and the spiritual, Art thus arises from a twofold impulse. On one hand, sensuous reality—which enters into the artistic work only as appearance (and not as materiality and weight)—is transformed into a sort of ideal sensibility: it is spiritualized. But inversely as well, spirituality, to the extent that it is mediated by the imagination, is made sensuous. Art is thus the coalescence of sensuous reality and its spiritual foundation. It saves the phenomena, the finite world, so to speak, by anchoring them in the Absolute: "Art liberates the true content of phenomena from the pure appearance and deception of this bad, transitory world, and gives them a higher actuality, born of the spirit."[19]

Like any romantic theory, Hegel's theory of Art is an aesthetics of content: the unity of Art is guaranteed by the universality of its content, which is common to all the arts; the latter's differentiations are due solely to the

semiotic diversity of the substrates in which Art is incarnated. Because of the speculative character of Art, and hence because of its participation in the sphere of absolute Spirit, this content is the same as that of philosophy and religion; the differentiation of these three spiritual activities is also realized solely through the distinction of their semiotic forms.

What then is this content that Art shares with religion and philosophy? In general terms, we already know the answer to this question, but it becomes specific depending on level of analysis one adopts. At the most abstract level of analysis, art's content is the Idea, that is, the Concept insofar as it is at the same time the whole of reality, that is, once again, the Absolute, the truth of Being. At a less abstract level of analysis, Hegel tells us that Art must make conscious and formulate (*zum Bewußtsein bringen und aussprechen*) "the Divine (*das Göttliche*), man's most elevated interests, the most fundamental truths of the Spirit."[20] The theological reference is in no way metaphorical: for Hegel, Art is truly in conformity with its essence only when it manifests theological contents. But he immediately adds that to the extent that artistic representation is always individualized and diversified (since it represents the Absolute in a form that is sensuous, and thus necessarily particular), it cannot represent the Divine in its *absolute* universality. The latter is accessible only to determinations of thought, and it cannot be represented in a sensuous form.[21] Whence the Hebrew prohibition of any sensuous representation of God. Art can represent universality only to the extent that it individualizes itself, particularizes itself in sensuous forms. Thus it can represent the Divine only if it is particularized and realized through particular figures, each of them having its own determination. These particular figures are the pagan gods, and especially the Greek gods, since of all the ancient religions, only Greek religion succeeds in diversifying the universality of the Divine into a set of particular figures that form a complete circle in which the Divine makes itself explicit in an organic manner. As for the Christian religion, although it is not directly opposed to artistic representation, unlike Greek religion it no longer finds in the latter its paradigmatic form.

However, if the content of Art were limited to the representation of the gods, its domain would be reduced to religious art in the strict sense of the term. That is clearly not what Hegel means. More generally, any *substantial* human reality can become the content of Art, it being understood that human reality, as soon as it involves the interests of Spirit, participates in the Divine and expresses it (at the same time that it manifests the immanent character of the Divine). Thus Art is not limited to the representation of the world of Greek mythology, even if the latter is *the* world of Art par excellence.

In view of the paradigmatic function Hegel here attributes to the Greek theological world, the religious determination of Art may seem paradoxi-

cal: artistic activity reaches its summit when it expresses a still inadequate theology, namely the pantheistic theology of the Olympian gods; inversely, it proves inadequate to the expression of the completed theology of Christianity. To be sure, to the extent that in the figures of Christ, the Holy Family, the saints and the martyrs, Christian religion also acknowledges a relative diversification and multiplicity of the Divine, it remains *compatible* with artistic representation. Moreover, romantic art can clearly also represent purely human reality when the latter expresses the substantial realities of Spirit. Nonetheless, this external diversification is never more than secondary, especially since it maintains only a purely contingent relation with spiritual interiority. Hegel thus reminds us that in Christian art, Christ is not represented with an ideal body, as the Greek gods are; his body is no longer the adequate expression of interiority but merely his mortal shell (it can thus be shown tortured by pain, just as it can be represented as a cadaver). This does not mean that Christian theology must be identified with the abstract universalism characteristic of the Hebrew God; on the contrary, Hegel accords a capital philosophical and historical importance to the fact that the Christian God was made flesh, and thus incarnated himself in a particular sensuous reality. In fact, whereas the religions of the Orient fall short of the Greeks' religion of Art, Christianity surpasses the latter, since it takes the sensuous incarnation of God to its dialectical resolution, to its Truth, to its self-transcendence in the passion, death, and resurrection of Christ.

All this explains why romantic art moves away from the point of perfect equilibrium that was classical art (and especially classical sculpture): it is characterized by the hegemony of the spiritual element over the sensuous element, and hence its interest shifts from sculpture—an art of the equilibrium between interiority and exteriority)— toward the arts in which interiority is predominant: painting and music (poetry, although described as romantic art in one of the intermediary rubrics of the *Aesthetics*—these rubrics are in any case probably not Hegel's—in reality occupies a far more complex position). Let us add that to the extent to which spiritual interiority detaches itself from its sensuous garb, the latter can paradoxically free itself and be artistically cultivated for its own sake: Hegel sees an example of this in the Dutch painting, which develops in the direction of a pure virtuosity of colors and chiaroscuro.

The content of Art is theological, yet Art is not limited to religious *motifs*. Any fact that expresses a substantial reality, i.e., that is intelligible as a determination of absolute thought, has a theological dimension and can thus become a motif of Art. The determination of its content (which one finds in the chapter entitled *Die Bestimmtheit des Ideals*[22]) is thus not limited to the enumeration of religious motifs, but also takes into account motifs borrowed from human reality when the latter manifests itself as the finite existence[23] of the Divine.

In his progressive specification of the content, Hegel distinguishes three levels:

a) The general state of the world (*der allgemeine Weltzustand*), which is incarnated in a worldview (*Weltanschauung*). By virtue of the general definition of Art (the unity of universality and particularity in a sensuous actualization), all worldviews are not equally favorable to artistic representation. The state of the world that is most suitable is the one in which the universal determinations and human individuality in its particularity and subjective autonomy coincide, and hence where particularity is the immediate incarnation of universality. For the unity must be immediate and not mediated by abstract thought, as is the case in the life of the understanding, and also in that of philosophy. This immediate unity incarnates itself in the individual and in social life. At the level of the individual, it corresponds to the determinations of the character and the soul. The man who realizes himself through his character and his soul does not situate himself *facing the world* (as does the man who apprehends the world through his understanding), he lives *in the world*. Social life, for its part, must not be regulated by a legal order, in other words, ethics, justice, etc. must not yet have taken the form of an objective external necessity in the form of the State and public law; on the contrary, the soul must coincide with its values, must draw them from its own resources. This is the "heroic age," the world of the Homeric epics and, to a lesser extent, that of the epic poems of the Middle Ages. The individual in the heroic age finds the source of his actions in his own character, his individual soul and pathos. But this individuality is not opposed as a particularity to the universality of a State or civil society, as does the formal subjectivity of the prosaic age (that is our own). On the contrary, it is always identified with the universality of a clan, a tribe, or a family; the heroic individual, if he absolutely coincides with what he is doing, absolutely coincides at the same time with the values of his community, with the soul of his people, the *Volksgeist*. The individual of civilized ages, on the other hand, to the extent that he is split into a private individual and a public individual, distinguishes between his states of mind and his external action; he accedes to the status of an abstract juridical person cut off from traditional bonds. The modern individual is therefore scarcely a good subject for artistic representation (at most, he can be incarnated in the hero of a novel, and we know how ironic Hegel is about the heroes of novels).

The thesis of the ethnic nature of all art is central in the *Aesthetics*. Art always realizes itself in a specific *Volksgeist*, so that to write the history of Art amounts to writing the history of the national arts. At least in principle: in fact, and especially as soon Hegel moves on to romantic art, he is often (fortunately, I would add) unfaithful to his postulate. In any case, the claim that the state of the world suitable for Art is the one realized by the heroic ages, that is, the ages in which individuals (and especially great

individuals) identify themselves with the soul of their people, provides the justification for this ethnic conception. If art must represent spiritual universality insofar as the latter incarnates itself in particular sensuous realities, if moreover this incarnation is possible only when the lives of great individuals coincide with the soul of their people, and finally if this coincidence can be achieved only in the heroic ages when peoples are strongly individualized and oppose each other as so many collective individuals, then it goes without saying that Art is always linked to an ethnically specified worldview and that it can truly flourish only when the life of peoples is incarnated in pronounced ethnic particularities.

b) The "particularity of the situation" that particularizes itself against the background of the worldview: it results from the individualization of the Divine into autonomous, specific wills; it introduces difference and possibly conflict. Hegel distinguishes three possibilities:

1) The absence of situation (*Situationslosigkeit*), that is, the representation of substantial individuality in an entirely tranquil immobility. This is achieved, for example, in the hieratic postures found in Egyptian sculpture.
2) The nonconflictual situation, which is still called "indifferent activity." This is found chiefly in Greek sculpture, which has a predilection for representing non-conflictual activities; think of Lysippus's *Hermes at Rest*, Myron's *Discobolus*, etc.
3) The conflictual situation, that is, the struggle between two individual wills, each of which represents a substantial aspect of the Divine. This situation is the object par excellence of dramatic art,[24] and more generally of verbal art, which is alone capable of bringing a conflict to its resolution (the plastic arts can represent only a moment of the conflict, but not the conflict in its totality as a process of separation and reconciliation).
4) The action as a particularity that results from the conflictual situation insofar as the latter includes substantial differences that lead to a collision of wills. The action is the completed concretization of the Ideal of the Beautiful and the nodal point of Art: "The action is the clearest revelation of the Individual . . . and action, because of its spiritual origin, wins its greatest clarity and definiteness in spiritual expression also, i.e. in speech alone."[25] What are the motives of the action? They are, Hegel tells us, "the eternal relationships of religion and morality: family, homeland, State, Church, glory, friendship, social status, dignity, and, in romantic art, honor and love and so on."[26] The most concrete determination of Art, that of the motifs of conflictual action, thus shows us at the same time what the substantial interests are, the stakes and the contents in which the Divine particularizes itself in its intramundane existence.

The first thing that strikes us in this determination of the content of Art is the extent to which in reality it always refers to specific arts, which

moreover change depending on the level of analysis. Thus the general definition of Art, opposing the sensuous incarnation of the idea achieved by Art to its presence as thought in philosophy, clearly refers to the model of sculpture. The latter is moreover said to be Art par excellence, since, notably through the representation of the Olympian gods, it realizes the fundamental principle of Art, the incarnation of spirituality in a sensuous, corporeal form. On the other hand, when Hegel deduces the specific determinations of the content of Art in order to arrive at the action as an essential moment, it is clear that he has changed his paradigm; he is no longer concerned with sculpture but with literature, and more precisely with dramatic poetry, since he explains that the motifs of the action must be incarnated in an individual pathos, the latter being "the proper center, the true domain, of art."[27] The matter becomes still more complicated by the fact that when he determines the situation of the world that is the most adequate to Art—a determination that is absolutely essential, since all the later historical axiology is oriented with respect to it—and asserts that this age is none other than the heroic age, the way in which he defines the latter clearly refers to the paradigm of the Homeric epics. Now, it is not easy to see why this heroic age, that is, archaic Greece, should also be the period most favorable to the other arts, for example to sculpture and lyric poetry, to take only two examples.

Clearly, one might reply that to the extent that classical Greek art has as its essential content myths and legends rooted in the archaic period, it is still this state of the world that provides the content. Hegel indicates, moreover, that art is not contemporary with the flourishing of the heroic age and develops only when it begins to slip into the past. But even if we were willing to concede this point, it would remain that the different determinations that he gives of the essence of Art always refer to very specific arts rather than to characteristics that are supposed to be common to all the arts. That is because, depending on the level of analysis on which it is approached, the essential characteristics of Art undergo metamorphoses: sensuous representation *versus* spiritual interiority (sculpture), heroic age *versus* prosaic age (epic), actantial concretization *versus* abstract determination (dramatic poetry). In order to justify these different determinations, Hegel constructs a hierarchy of the arts, but we shall see that this hierarchy itself poses problems.

The second fact that very clearly emerges as soon as this general determination of Art is made is that Hegel's aesthetics is a hermeneutics. This is inevitable as soon as Art is defined as a speculative activity intimately connected with religion and philosophy: since the three moments differentiate themselves in their form, and since they must nonetheless be identical, they can be so only in their content. What holds for the distinction between Art on one hand, and religion and philosophy on the other, also

holds—let us recall—for the distinctions internal to Art: the different arts are so many specifications of a single fundamental content, specifications imposed by specific sensuous materials that limit more or less strictly the sphere of the Absolute that is representable in a given art; similarly the different forms of art (symbolic, classical, and romantic art) are so many specifications of this same content imposed by worldviews and specific historical periods. In other words, the whole *Aesthetics* can be read as the study of the hermeneutic specifications undergone by a single theological-philosophical content, insofar as this content is modified either in accord with worldviews (and thus, ultimately, by History) or in accord with the materials of its realization (the materials of the different arts), it being understood that it already undergoes a fundamental modification by the simple fact that this content is represented artistically rather than incarnating itself religiously or formulating itself philosophically.

ART, PHILOSOPHY, AND RELIGION

We have seen that Art, even though it is defined, in accord with romantic theory, as speculative knowledge and as an ecstatic mode of being, ceases in Hegel to be the supreme term of the knowledge of Being. Beyond the artistic sphere is situated philosophical thought, "the truest reality" (*wahrhaftigste Realität*). Hegel justifies this (relative) depreciation of Art by saying that it represents the Absolute in and through a sensuous realization, thus insofar as it has an external appearance, whereas in thought the Absolute thinks itself and for itself in its infinite freedom. To be sure, in the romantics as well Art was an indirect, symbolic expression of the Absolute, but that was because *any* direct representation was said to be impossible. In Hegel, on the other hand, direct representation *is* possible: it is realized in the form of the philosophical system. Thus on one hand Hegel maintains the romantic definition of Art as an indirect manifestation of the Absolute, and in this sense he opposes it to immediate existence and to the knowledge of the understanding: "in comparison with the appearance of immediate existence and of historiography, the pure appearance of art has the advantage that it points through and beyond (*hindurchdeuten*) itself, and itself hints at something spiritual of which it is to give us an idea."[28] But on the other hand, this indirect manifestation of the Absolute as *geheimes Inneres*, secret interiorization, is no longer an inevitability inherent in our relationship to Being. It is simply a matter of a limit on the speculative power of Art as compared with philosophy, a limit that is closely connected with the fact that Art is condemned to sensuous representation and that only philosophy, the language of reason, can advance toward the conceptual exposition of concrete universality in its own element, which is that of the *logos*. The hermeneutic interpretation of Art

moreover finds therein a new justification, for "one can think of representations as metaphors of thoughts and of concepts."[29]

Hegel had not always maintained such sharply defined conceptions regarding the relations between art and philosophy. In his early writings he had in fact adhered to the direct line of the romantics' aesthetic religion. In *The Spirit of Christianity and Its Fate*, he had written: "Truth is beauty."[30] In this same text he examines the relationship between Art and religion, and maintains that only Greek religion realized the authentic essence of religion, *because it alone is a religion of beauty*.[31] Art is thus related not only to philosophy, but also to religion, and to understand its specific status it must be inscribed within this triangle.

The study of the evolution of Hegel's conceptions concerning the relationship between Art and religion is fascinating. It allows us to see more precisely to what point the relative depreciation of Art is also due to the fact that it will be linked to an unachieved form of religion. Whereas in his early writings Hegel was fighting against Christianity and in favor of the Olympian gods, in the *Phenomenology of Spirit* (1807) the hierarchy is reversed: Art continues to be considered as a form of religion, but this form itself ceases to be the achieved religion. In fact, religion is organized in accord with a series of three forms in which the same content is set forth (Spirit knowing itself), but according to modalities more or less in conformity with its essential determinations[32]:

a) The religion of nature, in which Spirit represents itself not as a subject, but in the form of substance. This is the religion of primitive peoples and of oriental despotism. First Spirit deifies natural objects (light in Persia, plants and animals in India). Then it tries to transcend this naturalism, but it does so in a way that is still instinctive, and thus imperfect: this is the stage reached by Egyptian religion. There is no Art yet, but only religious artisanal work, that is, "instinctive work like that of bees constructing their honeycombs."[33] Hegel is thinking particularly of the pyramids; these illustrate the mismatch between the sensuous reality (which is purely geometrical) and the spiritual content it is supposed to represent (the soul of the deceased). This depreciation of Egyptian art is also found in the *Aesthetics*, where the pyramids are also seen as the paradigmatic expression of symbolic art, that is, Art which is not yet in conformity with its essence.

b) The religion of art, that is, the phase of "beautiful individuality": here the sensuous is the adequate expression of the spiritual. This stage corresponds to Spirit's consciousness of itself as finite humanity. Hegel distinguishes three stages within the religion of art:

1) The abstract work of art that celebrates the gods in the form of objective truth (the plastic arts) and in that of pure interiority (hymn-like lyricism). In this text visual art is considered a still incomplete form of Art (because it

lacks spiritual concreteness), whereas in the *Aesthetics* sculpture occupies the central place.

2) The living work of art, that is, ritual festivals, games, mysteries, and so on, which are seen as art forms celebrating the alliance between gods and men.

3) The spiritual work of art: this is the achieved reality of Art in the form of literature, or more precisely of epic, tragedy, and comedy. Comedy, moreover, leads to the self-dissolution of the religion of art: to the extent that its theme is the negation of divine substantiality in the individual's happy self-confidence, it abolishes the artistic worldview. This worldview is in fact inseparably connected with the assertion of divine substantiality, a condition that is indispensable for the realization of its task, that is, the incarnation of the universal (the divine world) in the particular (the human world).

c) Manifest or revealed religion, that is, Christian religion, for which Art ceases to be an essential reality. Hegel here formulates his famous thesis of the end of art, which one also finds in the *Aesthetics*: "Statues are now cadavers whose living soul has left them; hymns have become words from which faith has withdrawn. The table of the gods is henceforth without spiritual food or drink, and after games and festivals consciousness no longer encounters the happy experience of its unity with its own essence. . . . Thus when destiny offers us these works it does not also give us their world, the springtime of cultural life that saw their blooming, the summer that saw them mature, but only the veiled memory of their reality. When we evaluate them . . . we are engaging in an activity that remains entirely external . . .; it does not accede to the interiority of the cultural reality that produced the works and breathed its spirit into them; it cobbles together a complicated construction on the basis of the dead elements of their external existence, of their language, their history, and so on. We do not live in them, we merely represent them in us."[34]

In the *Phenomenology*, art is thus the median point in the evolution of religion, the stage of Greek religion. Thus if Hegelian aesthetics is classicist, this is for theological reasons as well: the completed form of Art can only be Greek art, because Art is the Greek form of religion. This also explains why the status of Art depends in part on the status accorded Greek religion: as long as the latter constitutes the form of religion par excellence, Art has a paradigmatic status; once the achieved form of religion is Christian religion, Art acquires a more precarious status. It is in fact difficult to see which plays the determining role, classicism or the theological perspective.

The problem is further complicated by the fact that religion itself changes in status when one moves from the early writings to the *Phenomenology*. Whereas in the Frankfurt writings, for example, religion was the activity par excellence, and was thus placed above philosophy ("philoso-

phy must end precisely when religion begins"[35]), in the *Phenomenology* it is already the philosophical *logos* that occupies the highest rank: absolute thought is the sublation of religion. To the extent that Art is identified with a stage of religion, it is thus also depreciated. In other words, the place accorded Art depends both on the place accorded Greek religion in religion as such, and on the place the latter is accorded in relation to philosophy. The emphasis laid on these two factors varies according to the work in question: in the *Aesthetics*, for instance, the thesis of Christian religion's transcendence of ancient religion is not, to be sure, wholly forgotten, but Hegel lays greater stress on the problem of the relations between Art and philosophy. Hence, as we shall see, Art acquires at least a relative autonomy with respect to religion, since the very expression "religion of art" is no longer used.

This position is sketched out in the abridged version of the *Encyclopedia*:[36] Art ceases to be one of the autonomous stages of absolute Spirit, *alongside* actual religion and philosophy. It is the first stage of absolute Spirit, in which Spirit is presented as concrete intuition, as Ideal. The Ideal is the incarnation of the Idea—of the Divine—in a particular sensuous form, in such a way that the latter is henceforth only the sign, the manifestation, of divine interiority. The relative autonomy to which Art accedes is thus already evident in the summary of the paragraphs devoted to absolute Spirit. The latter is divided into three parts: art, religion, and philosophy, and no longer—as one might have expected in light of the *Phenomenology*—into two: religion and philosophy. The second phase of absolute Spirit is now that of revealed (Christian) religion; it is the "future" (*Zukunft*) of pantheistic religion and hence it is the future of Art. Christianity is the Divine's self-manifestation as interiority, and it is realized through spiritual representation and the community of believers. Finally, the third moment, that of philosophy, realizes the unity of Art and religion, since the philosophical *logos* is a spiritual intuition conscious of itself.

Nonetheless, this autonomy of Art is merely relative. While Hegel grants it a specific category distinct from that of religion, he continues to associate its canonical form with Greek pantheistic religion: "On the subject of the close relation between art and religions, we must note more precisely that *beautiful* art can belong only to religions in which the principle is *concrete spirituality*, which has become free in itself, but not yet absolute."[37] On the other hand, he asserts that in a certain way *the whole* of the sphere of absolute Spirit is the sphere of religion:[38] actual religion, Art, and philosophy are merely the different forms taken by this absolute theological content. In spite of an undeniable shift in emphasis, there is thus no fundamental contradiction between the *Phenomenology* and the *Encyclopedia*. Art remains closely linked to religion, since the whole sphere of absolute Spirit is in fact the sphere of religion. At the same time, Art is

destined to be surpassed by *Christian* religion and by philosophy. But whereas in the *Phenomenology* it was absorbed into religion as such as one of its phases, in the *Encyclopedia* (and in the *Aesthetics*, as we shall see), it is rather pantheistic religion, as a specific religion, that is absorbed by Art.

In the *Aesthetics*, the question of the relationships among art, religion, and philosophy is set forth in the chapter entitled "The Idea of Artistic Beauty or the Ideal." Art is there defined as immediate knowledge of the Absolute, realized in the form of sensuous intuition. It is contrasted with religion, the second phase of absolute Spirit: it is the internal consciousness, the *feeling* of the Absolute. Finally, Art is also distinguished from philosophy, the ultimate stage in which the Absolute thinks itself. There too, if religion takes over from Art, it is the *Christian* religion. Philosophy, for its part, realizes the ultimate synthesis, that of Art and religion as such: it is both Art—but without the limits due to the sensuous element—and religion—but without the limits due to feeling.

In fact, Hegel seems to hesitate between two triads, "Art-religion-philosophy" and "religion of Art–Christian religion–philosophy." It is no accident that in the *Phenomenology* he emphasizes the second triad, whereas in the *Encyclopedia*, and even more in the *Aesthetics*, the essential weight is put upon the first triad. In the case of the *Aesthetics*, the choice of the first triad is easily explained: since Hegel decides to devote one of the areas of his *Realphilosophie* to Art, he has to accord it a certain autonomy with respect to religion; moreover, since he defines Art as a speculative activity, he has to oppose it to conventional existence and also differentiate it from philosophical speculation, and he cannot do this if he simply and purely identifies Art with Greek religion, since in that case the pertinent opposite pole might well still be Christian religion rather than philosophy.

In Hegel, conceptual distinctions tend to be simultaneously developmental stages, since "the succession of philosophical systems in history is the same as their succession in the logical derivation of the categories of the Idea."[39] This developmental component is strongly marked in the opposition between Art on the one hand and religion and philosophy on the other. Thus if it is not the self-representation of Being in its plenitude, Hegel concludes that it can be only a *transitory* stage in the self-revelation of the Absolute, a stage that has been surpassed by philosophy. In the same way, when he opposes Art to religion, Hegel tends to transform the opposition into a historical evolution, the passage from Greek art to Christian religion being at the same time the passage from Art to religion in the movement of absolute Spirit. In the Christian era, Art ceases to be an adequate manifestation; the Absolute will henceforth be incarnated in philosophy, the ultimate stage of absolute Spirit and hence the ultimate stage of religion (in the sense in which the latter is identified with the Absolute as such).

Thus the relationship that connects Art with religion and especially with philosophy is not synchronic. It is inscribed in a historical evolution; works of art are "the first reconciling middle term between pure thought and what is merely external, sensuous, and transient, between nature and finite reality and the infinite freedom of conceptual thinking"[40] This first stage is destined to be supplanted by (Christian) religion, which in turns finds its truth in philosophical thought. Since Hegel believes that with his own philosophy the absolute self-realization of philosophy *is* attained, he concludes that Art belongs to the past. This claim clearly does not mean that there will no longer be any arts in the empirical sense of the term, but rather that from the point of view of the self-realization of absolute Spirit, Art as speculative knowledge no longer has a historical mission. It can therefore no longer be in conformity with its essence, with its internal categorial finality (and, in truth, had not been ever since the end of antiquity).

The thesis of the end of Art is ambiguous. We have just seen that it is connected with the fact that Art no longer has a historical mission, the torch of speculative knowledge having been handed on to philosophy. According to this interpretation, even if we may long for the splendor of Art that has disappeared forever, we have not really lost anything, because philosophy not only takes up the same speculative content but also confers upon it its paradigmatic form: the Absolute is *logos* and it is therefore wholly normal that it should find its ultimate fulfillment in the conceptual discourse of reason rather than in the sensuous figuration of Art.[41] Taken in this sense, the thesis is merely an attempt to provide a radical solution for the conflict of the speculative faculties. Nevertheless, Hegel also links the end of Art more generally with the prosaic nature of modernity. In other words, the end of Art seems to result as well from the hegemony of the *understanding* (which is *not* identical with philosophical reason), of abstract reflection, in modern civil (*bürgerlich*) society. In this perspective, the end of Art takes on a different appearance: it is not connected with philosophical discourse's move beyond artistic work, but with the unilateral nature of the culture of the understanding, with its incapacity to rise to the substantiality of the synthesis of the individual and the universal, of thought and sensibility—a synthesis that defines Art.

The thesis of the end of Art implies not only that in the contemporary period it has lost all speculative function of its own, but also that we are irremediably cut off from it: we can no longer live *in* Art, our relationship to it remains external. This idea, which we will find in Heidegger, presupposes another: every historical culture forms an organic whole closed in upon itself, a *Lebenswelt* or lifeworld (as it will later be called) that is accessible only to those who are part of it. That does not mean that we can no longer derive any immediate enjoyment[42] from Art, but it does mean

that we are henceforth incapable of living in the universe of the work, in its actual truth, in its own speculative dimension (or, as Heidegger will say, in the world opened by it):

> In all these respects art, considered in its highest vocation, is and remains for us a thing of the past. Thereby it has lost for us genuine truth and life, and has rather been transferred into our *ideas* instead of maintaining its earlier necessity in reality and occupying its higher place. What is now aroused in us by works of art is not just immediate enjoyment but our judgment also, since we subject to our intellectual consideration (i) the content of art, and (ii) the work of art's means of presentation, and the appropriateness or inappropriateness of both to one another. The *philosophy* of art is therefore a greater need in our day than it was in days when art by itself as art yielded full satisfaction. Art invites us to intellectual consideration, and that not for the purpose of creating art again, but for knowing philosophically what art is.[43]

But, as the end of the passage just quoted shows, the fact that it is no longer possible for us to live in the world of Art has a positive counterpart: we can understand what Art was, we can define its profound essence and truth. The death of Art makes possible speculative knowledge concerning it, just as a cadaver makes forensic medicine possible.

PHILOSOPHICAL KNOWLEDGE OF ART: SYSTEM AND HISTORY

The very existence of *Aesthetics*, conceived as knowledge of Art as a systematic totality, is possible only because Art belongs to the past. In fact, philosophical knowledge, contrary to the history of art or criticism, cannot limit itself to a partial, empirical knowledge of Art: its task is to "unfold and prove the object, according to the necessity of its own inner nature."[44] But only what is accomplished in accord with its essence can be known "in its logical and metaphysical nature."[45] The thesis of the end of Art is thus closely linked with the requirements of historicist essentialism: if in order to know the categorial essence of an object (in this case, Art) we must grasp its dialectical development, that is, follow the progressive unfolding of the essence in its different phases up until its final accomplishment, knowledge is always fated to be a knowledge of a past reality.

In the chapter entitled "Historical Deduction of the True Concept of Art," Hegel indicates a second condition that presides over the birth of aesthetics, a condition that is internal to the development of philosophy. Art, as we have seen, is the site of a synthesis of the sensuous and the spiritual, of the particular and the universal. It follows that only a philosophy capable of conceiving this synthesis can conceive Art. The philosophies of the understanding, that is, the pre-Kantian philosophies, are incapable of this, since the understanding is always conceived as abstract

universality opposed to the particularity of the sensuous. Only the philosophy of reason, that is, idealist philosophy, provides itself with a means of going beyond this opposition and achieving an absolute reconciliation of its terms. Kant, in the *Critique of Judgment*, was the first to take up the problem, but Hegel thinks he failed to the extent that he accorded only a subjective status to the reconciliation realized in aesthetic judgment. Hegel adds that it is Schiller's historic merit to have dared, in *The Aesthetic Education of Humanity*, to maintain that the reconciliation must have an objective value.

The evolution of the idea of Art as Hegel outlines it here is revealing: on one hand, so that Art may be conceived in accord with its essence, philosophy has to be raised to the level of a philosophy of the Absolute; but on the other hand, this way of thinking the Absolute was itself rooted in an aesthetic questioning. Hegel maintains that Schelling was the first to inscribe the conception of the Absolute over the portal leading to a general ontology rather than to a theory of Art:

> This *unity* of universal and particular, freedom and necessity, spirit and nature, which Schiller grasped scientifically as the principle and essence of art . . . has now, as the *Idea itself*, been made the principle of knowledge and existence, and the Idea has become recognized as that which alone is true and actual. Thereby philosophy has attained, with Schelling, its absolute standpoint; and while art had already begun to assert its proper nature and dignity in relation to the highest interests of mankind, it was now that the *concept* of art, and the place of art in philosophy was discovered . . . in its high and genuine vocation.[46]

Thus if philosophy is now capable of conceiving Art, it is also because it has assumed the task of producing the absolute reconciliation that romantic theory had reserved for Art (Hegel refers to Schiller rather than to Novalis or the Schlegel brothers chiefly because of his animosity with regard to Friedrich Schlegel). The *Aesthetics* is the speculative theory of Art's return to itself, enriched (at the same time that its originary object is limited in its competence and possibilities) by its accession to the status of an overall ontological theory.

The knowledge of Art in accord with its essence is supposed to reveal its internal arrangement and organization. It is also supposed to determine the place it occupies among the different forms taken by Spirit in its metaphysical odyssey. The first point is realized by the exposition in the *Aesthetics*, conceived as one of the facets of the overall ontological system; before studying the arts in their phenomenality, Hegel has first to determine the place of Art as a specific form taken by Spirit. To put it another way, what Art is and can be is vouchsafed in an a priori manner by the place it occupies in the overall system. The field of the *Aesthetics* is thus

not autonomous: it is founded by and in the overall system. It is in this sense that Hegel can say that his analyses of Art in the *Aesthetics* do not have an independent status. They are ultimately based on the *Logic*, whose pertinence is presupposed by the theory of Art: "For us the Concept of the beautiful and Art . . . is a presupposition given by the system of philosophy."[47]

The consequences for the *Aesthetics* are important: Hegel's central hermeneutic thesis—the idea that Art's content is theological in nature—as well as the historical thesis connected with it—the identification of the achievement of Art's essence in Greek art—derive not from a determination of the specificity of Art but from the general determination of the sphere of absolute Spirit as a religious sphere. There is thus a double movement: it is because Art is a speculative activity (a legacy of the romantic theory of art) *and* because the domain of speculative activity—that of absolute Spirit—is basically religious (Hegel's philosophical thesis) that Art is necessarily theological in nature.

This determination also has a historical side. It is the development of religion that provides the framework of overall historical development. In this sense the history of religion *is* the history of the world: "It is for the philosophy of religion to know the logical necessity in the process of the determinations of the essence that is recognized as being the absolute, to know first which determinations correspond to the specificity of a form of worship, and then in what way self-consciousness in the world, the consciousness of what constitutes man's highest determination and, consequently, the nature of a people's culture, the principle of its law, of its true liberty and of its Constitution, as well as of its art and of its science, correspond to the principle that constitutes the very substance of a religion. Seeing that all these stages in the actuality of a people constitute a single systematic totality is the foundation that then allows us to see that the history of religions coincides with the history of the world."[48] This principle holds for the history of Art as well: the three forms of Art, the symbolic, the classical, and the romantic, correspond to three stages of religion, the religion of nature, Greek pantheism, and revealed religion (which is the truth of *all* religion). Hence the historicity of Art is not identical with that of religions: whereas religion is not necessarily linked to a particular people (even though it may be, as is shown by Greek religion), Art is always the expression of a national spirit. The history of Art is a history of the national arts (at least this is its determination in principle).

The subordination of Art to the sphere of religion—whether from the point of view of its general categorial determination (and hence from that of the determination of its generic content) or from the point of view of its historical evolution—is in any event the stamp set upon the *Aesthetics* by the requirements of the overall philosophical system. These requirements

sometimes enter into conflict with a phenomenological analysis of the arts that claims to respect the specific differences of the activities analyzed. When Hegel finds himself confronted by such a conflict between the theory of Art as it derives from his system and his actual artistic analyses, he resorts to various attempted solutions. The first consists in what can only be called more or less convincing conceptual juggling; this is what happens in architecture and music (which are, nonetheless, two of the five arts postulated as canonical). The most striking case is that of music. Hegel admits, honestly and lucidly, that pure music is ill suited to express a differentiated content. Even a musical theme is essentially the site of formal issues; to vary a theme is to vary not a content but a form. This fact endangers Hegel's system of the arts, which is based on a criterion of content. In order to extricate himself from this difficulty, he is obliged to postulate that music, in order to be in conformity with the essence of Art, must resort to the aid of language, which alone can endow it with a determinate content. Whence the paradoxical conclusion that music is in conformity with its essence when it ceases to be purely musical.[49]

The second solution consists in marginalizing resistant artistic phenomena. This is what happens to the novel (though this does not prevent Hegel from devoting the most dazzling pages in the *Aesthetics* to it), and even more to dance and landscape gardening. There are two chief places where these procedures of marginalization occur.

The first place is the system of the arts. Only the five canonical arts form "the inherently determinate and articulated system of what art is in both essence and reality";[50] the other arts, and particularly dance and landscape gardening, are only "hybrids," "not really perfect." Now, "a philosophical treatment has to keep to differences determined by the essence of art and to develop and comprehend the true configurations appropriate to them."[51] This principle makes it possible to immunize the system of the arts against any accusation of a lack of completeness: what the system excludes is ipso facto what is not in conformity with the essence of Art. The second place is the theory of the historicity of the forms of art (symbolic, classical, romantic). Here Hegel's way of proceeding is more complicated. He distinguishes two types of historicity. First, there is contingent historicity,[52] which is empirical and governed by simple chronology; all events have the same value and temporal succession is the only pertinent relationship (type I). This type of historicity is opposed to the historicity peculiar to the progressive unfolding of the determinations of Spirit; the latter is governed by the necessity of the concept and in it chronology always expresses conceptual relations (type II). At the end of his discussion of sculpture, Hegel thus asks whether empirical historical relationships (type I) existed between Egyptian sculpture and Greek sculpture, in other words, whether the former could have served as a model for the

latter. He replies: "we can leave this purely historical question alone and have only to see if, instead of this, an inner and necessary connection can be exhibited."[53] Such an internal and necessary connection exists, he goes on, namely, a type II historical consecutive connection. In fact: "The ideal, and art in its perfection, *must be preceded* by imperfect art, and it is only through the negation of this, i.e. through getting rid of the defects still clinging to it, that the ideal becomes the ideal."[54]

What is the link between empirical historicity (type I) and conceptual historicity (type II)? The passage devoted to Egyptian sculpture seems to suggest that the two can be completely independent: even if there was no empirical historical relationship between the two types of sculpture (though Hegel strongly believes in the existence of such relationships), Egyptian sculpture would still be a *Vorstufe* (preliminary stage) of Greek sculpture. Such a way of seeing things is nevertheless hardly in accord with Hegel's general conceptions, since Spirit must *also* be realized in and through empirical historical reality; thus the *Phenomenology* claimed to demonstrate that Napoleon was not merely an empirical historical individual, but also the incarnation of a conceptually determined stage in the historicity of Spirit. There it must be admitted that there is a link between the two types, or rather a double link.

On one hand, one can move logically from conceptual historicity to empirical historicity. Thus, to the question as to whether painting—a romantic art—could also have had an important function in Greek antiquity Hegel replies: "If we look only at empirical facts, then this or that has been produced at the most different periods in this or that manner in this, that, or the other nation. But the deeper question is about the *principle* of painting, i.e. to examine its means of portrayal, and therefore to determine what that subject-matter is which by its very nature so precisely harmonizes with the form and mode of portrayal employed by painting that this form corresponds exactly with that content."[55] Now, because of its low degree of materiality (compared with sculpture), painting is especially adapted to the expression of subjective interiority, which is in fact, according to type II historicity, a romantic art. Thus, even though he candidly acknowledges that we know very little about ancient painting and its role, Hegel believes he can postulate that ancient painting *could not* attain either the perfection of romantic painting or that of ancient sculpture. In other words, a specific empirical historical state (type I) is *postulated* on the basis of conceptual historicity:

> however excellent even these original paintings may have been, we still have
> to say that, compared with the unsurpassable beauty of their sculptures, the
> Greeks and Romans could not bring painting to that degree of proper devel-
> opment which was achieved in the Christian Middle Ages and then especially
> in the sixteenth and seventeenth centuries. This backwardness of painting in

comparison with sculpture in antiquity is quite naturally to be expected, be-
cause the inmost heart of the Greek outlook corresponds, more than is the
case with any other art, precisely with the principle of what sculpture, and
sculpture alone, can achieve. But in art the spiritual content is not separated
from the mode of presentation.[56]

Inversely, when an empirical historical state of affairs seems to contradict
conceptual historicity, Hegel discounts it: "it can occur at once to any
critic that not only in Greece and Rome were there excellent painters who
reached as high a level in this art as others then did in sculpture, i.e. the
highest level, but that other peoples too, the Chinese, the Indians, the
Egyptians acquired fame on the score of their paintings,"[57] but "this is not
the point;"[58] what matters is the conceptual history that derives from the
categorial determination of painting, and everything that falls outside this
conceptual historicity is without meaning for the evolution of Spirit. In
order to justify this abandonment of historical facts when they become too
burdensome, Hegel maintains that empirical historicity carries along a
great deal of debris, contingent facts without meaning, and that it only
imperfectly expresses the development of Spirit.

The fundamental stake in all these distinctions seems to me to reside in
the will to preserve at all costs the principle of historical-systematic deter-
minism. Unfortunately, it is possible to do so only at the price of indulging
in sleight of hand. In fact, at the level of type II historicity, Hegel makes
use of the categories of the necessary and the contingent. Certain determi-
nations of Art are necessary, while others are merely contingent; the se-
quence of the three forms of art (symbolic, classical, romantic) is a neces-
sary feature, just like the unfolding of sculpture in Greek antiquity,
whereas the possible existence of an ancient art of painting, to the extent
that it cannot be deduced from the ancient worldview, is a purely contin-
gent one, that is, without meaning for the comprehension of the essence of
Art. At the level of type I historicity, however, the opposition in force is
that between what is important and what is secondary: Hegel makes use of
this categorization when he tells us, for example, that sculpture is central
to Greek artistic activity, whereas painting occupies only a secondary
place in the latter. This is obviously a paralogism: demonstrating the his-
torical importance of an event is not the same thing as demonstrating its
necessity; inversely, we can imagine historical events that are rigorously
determined but nevertheless have only a secondary importance (with re-
gard to their consequences, for example).

This paralogism serves the claim that what is real is rational (and vice
versa). The pair important/secondary is connected with the real, whereas
the pair necessary/contingent is connected with the sphere of rationality.
By identifying the two pairs and by basing himself, according to the case,
either on the real (factual history) to legitimate his deductions ("it hap-

pened, thus it had to be"), or on the rational (the system) to make his way through the thicket of rebellious reality, Hegel has discovered an absolute panacea: like a snake biting its own tail, theory and history mutually legitimate each other within a closed circle.

<div align="center">ART AS AN ORGANIC SYSTEM</div>

As it has been transmitted to us by its publishers, the *Aesthetics* is divided into three parts:

a) The *universal* determination of Art according to its content, that is, its definition as Ideal; this determination, as we have seen, sets out from the general determination of Art as a sensuous realization of the Idea, passes by way of an exposition of the worldview corresponding to Art, and then progressively descends to the core of the Ideal, which is nothing other than conflictual action.

b) The *particular* determinations of Art according to the specification of the spiritual content, that is, according to the particularization of the worldviews that are invested in it and that correspond to the stages of religion. Here the reference is to the three forms of art, the symbolic, the classical, and the romantic, which follow each other categorially and chronologically.

c) The *individual* determinations according to which the Ideal and its historical specification (the form of art) are embodied in a specific material: inert and opaque matter in the case of architecture, material "informed" by the appearance of organic life in the case of sculpture, the two-dimensional surface serving as visual appearance in the case of painting, the pure subjective, evanescent interiority of sound in the case of music, concrete and determinate representation, exteriorized in speech, in the case of poetry. The categorial order in which the arts are presented corresponds to the progressive interiorization of the sensuous material, but also to the progressive concretization of the spiritual: poetry is both the art that is most interiorized[59] and the one in which the spiritual content finds its extreme concretization (in dramatic action).

The essential problem encountered by this very powerful system—which is not without its attractions—is that of the relation between the forms of art and the individual arts. Hegel in fact presents *two* levels as historical-categorial specifications of the universal determinations of Beauty, while at the same time one of them is referred to the sphere of particularity and the other to that of individual singularity. The relationship between the two levels is thus far from obvious. This difficulty is increased by the fact that even when considered separately the two classifications already pose a certain number of problems.

Symbolic art, which is the first stage, is characterized by a separation

between the spiritual content and the sensuous realization it gives itself. Whence its denomination, since the symbol arises as soon as there is a motivated but inadequate relation between the sensuous sign and the signified spiritual content: when we symbolically identify strength (spiritual content) with the lion (sensuous realization), we are making use of a sign that is both motivated (the lion is in fact strong) and inadequate, to the extent to which there is no unequivocal connection between the signifier and the signification (the lion is not the only animal that is strong, and strength is not its only quality). In other words, symbolic art is characterized by a twofold defect: on one hand, the sensuous reality chosen as a vehicle for the message always represents something more and different than the single spiritual content of which is it supposed to be the sign; on the other hand, this spiritual content is linked only contingently to the sensuous reality that expresses it, and could just as well be expressed by another reality. At least that is how it goes at the level of what Hegel calls "conscious symbolism," which he finds, for instance, in allegories, and also in fables, metaphors, and so on.[60] So far as "unconscious symbolism," the core of symbolic art represented by Indian and especially by Egyptian art, is concerned, Hegel says less precisely that in this case the spiritual meaning is incapable of embodying itself in an adequate sensuous form. Indian art, although it presupposes a differentiation between the Absolute and natural objects, can conceive this differentiation only in a quantitative form: the Absolute is merely a hyperbolic natural object. Whence statues of the gods with multiple arms, monsters, etc. The Egyptians, for their part, are certainly capable of conceiving a categorial distinction between the Absolute and the sensuous, but they do not succeed in synthesizing the two poles in an artistic unity: the Absolute remains on the order of a hidden interiority, and the sensuous figure does not signify itself but points toward a meaning that is external to it. Thus the pyramid is supposed to express the Spirit that inhabits it (the soul of the deceased), but it succeeds only very imperfectly in doing so: not only are the two aspects of the sign partly indifferent to each other (a geometric form cannot be an adequate expression of spirituality), but spirituality is hidden in the pyramid and not expressed by it.[61] The symbolism of Egyptian art is characterized by an indetermination of the meaning; the symbol is a mystery, and that is why Hegel sees in the Sphinx not only the emblem of Egyptian art, but also the symbol of symbolic art as such.

Only in classical art do we arrive at a mutual correspondence of content and sensuous form, that is, at an art in conformity with the definition of Art. The reconciliation of Spirit and matter becomes possible because classical art makes the sculptural representation of the human figure its central concern. Now, of all sensuous objects, only the human body is able to express the spirituality that inhabits it. Symbolic art is above all archi-

tectural, and when it is sculptural it represents either animals and mon-
strous beings or—in Egyptian sculpture—figures that are quasi-human,
to be sure, but inexpressive.[62] Classical art, on the other hand, discovers
man as a sensuous form that expresses his own interiority in and through
his life. Humanity is the adequate content of Art: man is the sole sensuous
object in which Spirit expresses itself directly (the formal definition of
Art); similarly, humanity is the immanent receptacle of the development
of absolute Spirit (the hermeneutic definition of Art). It follows that the
ideal of classical art is visual in nature—which justifies the central place
occupied by sculpture in the system of the arts—and that the center of
visual art (and thus also that of Art as such) must be the human figure. It
goes without saying that man is here considered insofar as he is related to
the Divine, and thus as Ideal; and this means that classical representation's
object is primarily the divine body and only secondarily the mortal body of
man. The latter must, moreover, always be idealized, so as be presented in
his spiritual substantiality, in the strength of his soul, which is nothing
other than the Divine become immanent in man. Of course, when the divine
element becomes too singularized in its human determination, that is, as
soon as the relationship with spiritual universality is lost and sculptural
representation seeks to be either merely pleasant and attractive (*an-
genehm, reizend*) or naturalistic, classical art dissolves itself.

Thus classical art is the "fulfillment (*Vollendung*) of the realm of
beauty." But Spirit cannot be content with the existence it gives itself in a
sensuous figure (even if it is mediated by the creative imagination in an
artistic *poïesis*), since it is fundamentally *logos*: it can achieve itself fully
only in the element of its own spiritual interiority. To be sure, classical art
discovers human interiority as a realm of Art, but this interiority is still
identified with its immediate, that is, bodily, form: it is not yet represented
as an interiority knowing itself as *infinite subjectivity* irreducible to any
sensuous incarnation. That is why classical art is only a moment of transi-
tory equilibrium that is surpassed by romantic art. The latter can be con-
sidered the effect, *within Art*, of this new stage of Spirit that pushes it to go
beyond Art. Hence, like symbolic art, romantic art is characterized by a
separation between meaning and sensuous realization. But whereas in the
first case the schism resulted from a lack of determination of the spiritual
content, here the inverse is the case: the spiritual content has grown too
rich, too determined, to continue to find its adequate formal reality in a
sensuous form. The domain peculiar to Spirit is henceforth the interiority
of infinite subjectivity, and no longer the sensuous form of beauty. The
defective character of romantic art, seen from the point of view of the
essence of Art, is thus due to the fact that it has to express artistically what
rightly no longer belongs to Art.

It is important to notice that romantic art does not arise directly from

classical art, as the latter arose directly from symbolic art. The passage from the Ideal of classical art to the content of romantic art is not a transition internal to Art: the romantic worldview is not a product of Art as was the classical worldview. On the contrary, it arises in the history of events in the strongest sense of the term, since it originates in the pivotal event constituted by God's becoming man. To be sure, the determination of Art still remains religious: but whereas classical art *had developed* ancient religion (*Greek religion is a religion of art*), romantic art does not in any way develop its own content; the latter *is given to it* from the outside, as a worldview already historically constituted (*romantic art is an art of religion*). The battle between the ancient gods and God does not take place in the field of Art but in that of real historical reality (whereas the site of the battle between the "earlier gods" and the Olympian gods was artistic representation): "Consequently, in connection with the higher content which art has to embody in new forms, art acquires a totally different position. This new content is not validated as having been revealed by *art*, but is independently revealed without it."[63] If classical art was an originary revelation of truth, this is not the case in romantic art, which merely shapes a truth that has already been revealed elsewhere, a content that has already been developed elsewhere.

Why is Christian religion "the fundamental essence"[64] of romantic art? The answer is simple: it is through God's becoming man, through the life and passion of Christ, that interiority comes to know itself in its own infinitude. Hegel distinguishes two stages in what is for him the central event of universal history. The first stage paradoxically resides in the most complete exteriorization of the Absolute constituted by the incarnation of God in a mortal body. This exteriorization is much more radical than that of ancient sculpture: the latter manifested the congruence of interiority and exteriority, whereas in the figure of Christ the Absolute incarnates itself in an absolute empirical singularity.[65] God becomes man who suffers in his body. But this exteriorization pushed to the extreme limit is realized only in order to be immediately negated: that is the function of the Passion, of the death of the God-man, the infinite negation of the sensuous and the triumph of absolute interiority (the resurrection of Christ, the manifestation of the Holy Spirit, etc.). Since that event, no sensuous reality could any longer conform to the interior richness of the soul; infinite subjectivity is beyond any sensuous incarnation (it is therefore not opposed to the latter as its other, but leaves it behind as a phase that belongs to it but no longer satisfies it). It follows that Art can no longer be plastic. It becomes the Art of interiority (content) *in* the element of interiority (form): painting, music, and poetry. But at the same time it ceases to be in conformity with its essence (which resides in sensuous plasticity) and moves on toward its own end: romantic art is in fact only the slow death agony of Art as a speculative organ.

This very powerful historical vision encounters a certain number of difficulties, essentially at the level of the relations between the forms of art and the different arts. As we have seen, Hegel associates each form of art with one or several specific arts: architecture is associated with symbolic art, sculpture with classical art, painting and music with romantic art. As for poetry, its status seems at first to be uncertain. In the titles that organize the system of the arts it is included in romantic art.[66] This thesis is repeated in the text itself: "Poetry is the third of the *romantic* arts, painting and music being the other two."[67] But other passages assert on the contrary that poetry, to the extent that it is the universal art, is not connected with a specific form of art:

> The sensuous aspect acquires importance in the plastic arts and in music. It follows that, owing to the specific determinacy of the material they use . . . we have brought each of the specific arts into close connection with only *one* of the particular art-forms which this and no other art seemed best able to express adequately—architecture with the symbolic art-form, sculpture with the classical, painting and music with the romantic. . . . Now poetry cuts itself free from this importance of the material, in the general sense that the specific character of its mode of sensuous expression affords no reason any longer for restriction to a specific subject-matter and a confined sphere of treatment and presentation. It is therefore not linked exclusively to any specific form of art; on the contrary, it is the *universal* art which can shape in any way and express any subject-matter capable at all of entering the imagination, because its proper material is the imagination itself, that universal foundation of all the particular art-forms and the individual arts.[68]

The coherence of the system requires that poetry be, not a particular art, but the universal art: thus it must be excluded from the sphere of the specifically romantic arts. However, Hegel's assertion to the contrary can be explained: if poetry transcends the specific forms of art, how can one still maintain that these three forms correspond to the systematic-historical organization of Art as an organic totality? Hegel thinks in fact that there is a necessary link between the organization of Art in accord with the three forms of art and the distribution of the arts among these three forms: "But since it is the differences immanent in the Idea of beauty, and proper to it, that art transfers into external existence, it follows that in this Part III the general forms of art must likewise be the fundamental principle for the articulation and determination of the individual arts; in other words, the kinds of art have the same essential distinctions in themselves which we came to recognize in the general forms of art."[69] But if poetry is the universal art, this correspondence between forms of art and artistic genres is broken, because there is no form of universal art that would synthesize the three forms of symbolic, classical, and romantic art.

Provisionally bracketing the case of poetry does not, however, make the

difficulties disappear. In fact, if there are necessary connections between the diverse forms of art and the specific arts, then the system of the arts itself has to be historicized; in other words, the conceptual succession of the arts (according to their degree of interiority) must also be a temporal succession. Architecture is not only the first art from the point of view of conceptual determinations, but also from the historical point of view. Just as the form of art to which it belongs—symbolic art—is historically the first form of Art, in the same way architecture is the first of the arts in human history. Generalizing, and distinguishing according to the three conceptual stages of universality, particularity, and singularity, we would have the following schema:

Universality	*Ideal of Beauty (poetry?)*		
Particularity	symbolic art	classical art	romantic art
Singularity	architecture	sculpture	painting, music (poetry?)

historical evolution→

Hegel is well aware that this kind of correspondence cannot be maintained in a rigorous way, and this leads him immediately to add: "But, on the other hand, these art-forms, universal as they are despite their determinateness, break the bounds of a *particular* realization through a *specific* kind of art and achieve their existence equally through the other arts, even if in a subordinate way. Therefore the particular arts belong, on the one hand, specifically to one of the general forms of art and they shape its adequate external artistic actuality, and, on the other hand, in their own individual way of shaping externality, they present the totality of the forms of art."[70] In other words, while belonging in a privileged manner to a given form of art, each art nonetheless specifies itself according to the three forms. Thus although they are historically linked in a privileged way to a specific historical moment, the different arts nonetheless have a transhistorical or synchronic aspect. Each art is represented in all the forms of art, but finds its paradigmatic realization in the form whose worldview corresponds most closely to the status of its semiotic material. As for poetry, because of its universality it retains its specific status as a supplement present in every form of art, even if, as the art of interiority, it is in the romantic form that it should find its most adequate realization.

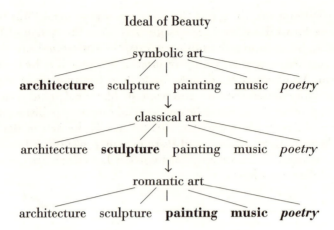

Unfortunately, this alternative categorization, which is more complex, is not defended by Hegel in a coherent manner. Thus we learn that architecture, the specifically symbolic art, finds its paradigmatic realization in . . . the Greek temple, and hence in classical art! On the other hand, in the chapters on painting and music, he discusses only their romantic realization, without saying a word about the classical or symbolic forms. As for poetry, which is supposed to be the universal art, he presents as a sort of synthesis, sometimes of the plastic arts and music, and sometimes only of painting and music.

Some of these uncertainties and hesitations may have to do with the composite status of the text of the *Aesthetics*. But it seems to me that there is still another, less fortuitous reason, one that has to do with the fact that Hegel mobilizes two procedures of derivation that are independent of each other, and which he tries afterward to bring together. The first of these deduces the forms of art from the Ideal of Beauty and distributes the five arts among these three forms. This derivation corresponds to his concern to establish the central character of classical art and to show that sculpture, the perfect synthesis of the spiritual and the sensuous, is Art par excellence. On the other hand, when he turns to the discussion of the different arts, he hierarchizes them not only with respect to a median synthesis (sculpture), but also with respect to an *ultimate* synthesis, realized by the most spiritual art, in this case, poetry. Although sculpture remains the point of equilibrium between interiority and exteriority, its function is challenged by poetry (the second valorized term), which represents the most spiritual (*ideell*) art. This valorization of poetry no longer takes place in the name of Art, but in the name of the overall movement of absolute Spirit, which produces an increasingly profound interiorization, that is, a repetition of Art in pure thought.

By passing from the derivation of the forms of art to that of the different arts, Hegel thus changes his point of view: whereas the first point of view is situated in the framework of the definition of the essence of Art as a synthesis of the sensuous and the spiritual, the second is surreptitiously guided by a point of view that transcends the properly aesthetic domain in order to take into account the overall movement of absolute Spirit. At the most general level, the difficulties we have encountered arise from Hegel's attempt to unify these two derivations, which are governed by fundamentally different concerns and manifest the internal fracture of the *Aesthetics*, which is torn between artistic logic and the general logic of the ontological system.

Other contradictions arise from the historicist temptation that leads Hegel to want to historicize *all* the conceptual divisions he acknowledges. To the extent that he maintains the evolutionary character of the forms of art *and* of the arts, it is difficult to tell which of the two levels might be the specification of the other. And it is no accident that he constantly hesitates as to the place that the forms of art and the different arts occupy in the hierarchy of the conceptual analysis. In theory, this analysis takes place on three levels: that of the universal determination, that of the particular specification, and that of the singular realizations. Hegel proposes two concurrent variants of this hierarchy. According to the first,[71] the Ideal of Beauty corresponds to the universal stage of Art, the forms of art are its particular stages, and the different arts constitute its singular realizations. But elsewhere[72] he tells us that the forms of art correspond to the universal stage of Art: in fact, the sequence of the different worldviews is described as universal (*allgemeine*) evolution. As for the different arts, they are identified with the stage of particularity (*besondere Künste*). According to this second point of view, the singular realization of the Ideal of Beauty is no doubt found in individual works, even though the text does not specifically say so. Stephen Bungay[73] maintains that neither of the two divisions is acceptable and that in all Hegelian rigor we would have to see in the Ideal of Beauty the universal stage, in the different arts the particular stages of this universal Ideal, and finally in the forms of art the different singular stages referable to the singularity of the worldviews that the works are supposed to incarnate. But whatever one thinks of the intrinsic value of the two triads Hegel proposes, it is their simultaneous existence itself that is revelatory: it shows that from the moment he tries to historicize *together* the two levels of analysis constituted by the forms of art and the system of the arts, he disrupts the organization of his system. In fact, if one of the two levels has to be the specification of the other, they cannot both be referable in the same way to an ultimate historical concretization. Either forms of art are the historical specifications of the arts, or the arts are the historical specifications of the forms of art; either historical evolution runs

through all the arts and goes from symbolic art to romantic art by way of classical art, or else the inverse historical evolution goes from architecture to music (still bracketing poetry) by way of sculpture and painting; but in this case, the three forms of art could no longer be anything but abstract determinations realized by the different arts. The attempt to combine the two and to identify the paradigmatic realization of such and such an art with such and such a particular form of art is doomed to fail, if only because by virtue of the general definition of Art the paradigmatic realization of any art *qua Art* could not take place anywhere other than in classical art, since it is there that Art unfolds the full plenitude of its essence. The only coherent solution would be to abandon the historicization of the division of the arts and limit oneself to that of the forms of art. But this solution is excluded to the extent that the logic of the system *also* requires an evolution of the different arts, an evolution leading to interiority in painting, music, and especially poetry. This requirement does not follow from the strictly aesthetic analysis, but from the necessity of integrating it into the overall philosophical system that "programs" for the whole sphere of absolute Spirit a movement of progressive interiorization that eventuates in the transcendence of Art by thought, a transcendence that implies its self-dissolution in comedy, the point of no return for poetry and thereby for Art.[74]

The Arts

If there are only three forms of Art, that is, three stages that correspond to the progressive explication of the essence of Art, and if the different arts can be referred to these stages, why are there more than three arts? And if there are not three, why are there five rather than six or seven? The question is less absurd than it looks, since the *Aesthetics* claims to describe Art in accord with its essential nature, which implies that each stage isolated is necessary, but also that there exist no others in addition to these: the system seeks to be complete and closed. In fact: "the genuine division can only be derived from the nature of the work of art; in the whole of the genres of art the nature of art unfolds the whole of the aspects and factors inherent in its own essence."[75] Since this is the case, the question of the number of the arts, of the provenance of this number, and of its legitimation, is crucial. The problem does not come up for the forms of art, since they are directly deduced from the dialectic of interiority and exteriority, a dialectic that legitimates both their number and the order of their succession. The same cannot be said of the arts: the fact that there are five canonical arts seems not to be the result of a philosophical derivation but the registering of a contingent fact: if in the Western tradition (obviously things are different in other traditions) we have witnessed the progressive

elaboration of a hierarchy of the arts eventuating in the five canonical arts, that is a mere historical contingency.[76] These five arts do not circumscribe the whole spectrum of human aesthetic activities, nor that of the institutionalized artistic activities in the West; we have only to think of the art of dance or landscape gardening (still present in Kant's aesthetics), two arts that the tradition of the speculative theory of Art marginalizes.[77]

The difficulties Hegel encounters in his attempt to bring the system of the five arts into conformity with their hermeneutic foundation (the three forms of art) are multiple.[78] At the beginning, there is a satisfying (from the point of view of the system) triadic classification. There is the field of the three plastic arts, each of which is referred to a form of art; architecture to symbolic art, sculpture to classical art, painting to romantic art. But this classification, which establishes a term-for-term correspondence between the forms of art and the arts, is then thrown off balance by the need to make room for music and poetry as well. We have already seen the uncertain status accorded to poetry: is it a romantic art or a universal art? By qualifying it as "the *universal* art,"[79] Hegel can identify it with the Ideal of Beauty, and hence with Art in its absolute unity. But at the same time it is no longer a *singular* specification of Art, which has to pass through the *particular* specification of the forms of art. In other words, if poetry is the universal art it is categorially irreducible to the other arts. Inversely, if it is a romantic art, how is it that Hegel can not only devote most of his analyses to ancient poetry, but draw the fundamental determinations of its genres (epic, lyric, dramatic) from ancient poetry as well? The case of music poses other problems, which paradoxically affect painting. On one hand, by associating music with painting, Hegel is obliged to "disconnect" the latter from the other plastic arts and make it wholly an art of spiritual interiority. But at the same time, he thinks that music is the true art of interiority, and in this regard he opposes it to painting defined as the art of external appearances. Whence the ambiguity of the status of painting, which emerges quite clearly from the initial pages of the chapters devoted to poetry, in which Hegel compares the latter to the other arts. Poetry is in fact supposed to be sometimes the synthesis of the plastic arts and music, and sometimes the synthesis of painting and music, according to whether Hegel considers it as the universal art or as the third romantic art. In other words, painting is sometimes a specific plastic art, the one that realizes itself in the romantic form of art, and sometimes it is the representative of plastic art as such insofar as it is opposed to the pure interiority of music. Compared with the other plastic arts it is an art of interiority, whereas compared with music it remains an art of external appearances. In every case its grouping together with music disorganizes the system.

Other problems arise at the level of the chronological dimension of the system of the arts, a dimension that is inevitable, since every categorial

differentiation is subject to an evolutionary schema. Hegel in fact distinguishes three schemas:

a) the evolution of each art through the three forms of art;

b) the internal evolution of each art conceived as a historical organism; every art has three stylistic stages that follow each other necessarily, namely the austere style, the ideal style, and the pleasant style;

c) the evolution that leads from one art to another and from one genre to another; architecture is not only the first art according to the categorial determination, but also from the point of view of historical genesis; in the same way, within poetry, epic is both the first form according to its conceptual determination and the historically originary literary genre.

The connections that exist among these different temporalities are far from clear. Thus Hegel tells us that the autonomous evolution of the arts according to the schema of the three styles is "independent of the forms of art" and "common to all the arts." These three styles correspond in fact to the three key movements of every organic movement: "Each art has its time of efflorescence, of its perfect development as an art, and a history preceding and following this moment of perfection. For the products of all the arts are works of the spirit and therefore are not, like natural productions, complete all at once within their specific sphere; on the contrary, they have a beginning, a progress, a perfection, and an end, a growth, blossoming, and decay."[80] Does this mean that within the temporal field delimited by a given form of art, each art goes through this organic growth and decline, or that this organic evolution of the arts is on the contrary superimposed upon the whole of the three forms of art, the symbolic form representing the genesis, the classical form the perfection, and the romantic form the decline? Hegel no doubt chose the first option, since he refers to the evolution of the arts "within their specific domain"; one might assume that this expression refers to the forms of art. However, insofar as the triad of symbolic, classical and romantic is itself governed by a movement that goes from an initial disequilibrium toward a moment of equilibrium and ends in a final disequilibrium, the distinctions between the two orders of temporality tend to become blurred; thus the privilege accorded Greek art as Art par excellence and the theory of the death of art sketch out a organicist-evolutionist conception of Art *as such* that seems merely to be reflected in the cycles that the different arts pass through within a given form of art.

Of the three chronological movements postulated, the most difficult to accept seems to me to be the one that is supposed to connect the different arts with each other. And yet it is made inevitable by Hegel's evident desire to connect each art with a form of art, and thus with a historically specific worldview. The artificial character of the correspondence between the forms of art and the arts is nowhere more manifest than it is here.

Hegel's problem is illustrated by his hesitations as soon as he tries to move from the general thesis to its concrete instances. We have seen that in the case of architecture, he is categorical: "What *we* have to do is to establish the beginning of art by so deriving it from the Concept or essential nature of art itself that we can see that the first task of art consists in giving shape to what is objective in itself, i.e. the physical world of nature, the external environment of the spirit, and so to build into what has no inner life of its own a meaning and form which remain external to it because this meaning and form are not immanent in the objective world itself. The art on which this task is imposed is, as we have seen, architecture which originally began to be developed earlier than sculpture or painting and music."[81] The same goes, within poetry, for epic, which is "an original whole;" a people's epics are the "absolutely earliest books which express for it its own original spirit."[82] On the other hand, in the case of sculpture and painting, Hegel limits himself to a weaker form of his thesis. Thus a pre-classical sculpture does exist, but it truly flourishes only when architecture itself has already attained its fulfillment: a statue of a god presupposes the existence of a (Greek) temple. Painting, to be sure, is not strictly later than sculpture, since there were also famous painters in antiquity; nevertheless, we have seen that it is solely in the romantic period that it can flourish in conformity with its essence.

Music deserves a somewhat more detailed treatment here. The chapter Hegel devotes to it is a genuine foreign body within the *Aesthetics*. Thus Hegel does not establish a musical paradigm, whereas the discussion of the other arts takes place around such a paradigm, which is supposed to express their hermeneutic essence: the Greek temple, the statue of the god, Italian and Dutch painting, the Homeric epic or Sophoclean tragedy. With the exception of music, the only other art for which Hegel does not establish a paradigm is lyric poetry. This is surely not accidental: lyric poetry is the expression of internal subjectivity, as is music in a much more radical way—that is, in a more formal way. Hegel adds that in these two cases the interiority in question lacks concrete determination: hence its (generic) exteriorization becomes a vague mass with unclear subdivisions. This is especially the case with music: "But if after this general indication of the principle of music and the division of the subject we propose to go on to distinguish its particular aspects, we are met in the nature of the case with a peculiar difficulty. Since the musical element of sound and the inner life, in which the content proceeds, is so abstract and formal, we cannot go on to particularize without at once running into technical matters such as numerical relations between notes, differences between instruments, keys, concords, etc."[83] In other words, one is obliged to move directly from the most general determination of music to the determination of its technical aspects. There is no continuity between these two extreme levels; there is

no intermediary level, which is represented in the other arts by the treatment of the hermeneutic ideal, an ideal on the basis of which Hegel claims to derive the technical aspects. For example, the preference he accords to the division of tragedy into three acts as opposed to the division into five acts derives directly from the hermeneutic determination of the ideal tragic action, a determination that contains three terms: two poles that are opposed to each other and their final reconciliation. If this level, intermediary but central from the point of view of the system (since it makes it possible to connect the general philosophical determinations with a technical normativity) is lacking in music, that is because of the purely formal character of music's material, sound, which is incapable of expressing in a determinate manner the ideal (*ideell*) content from which it proceeds: "what it lacks is giving to itself an objective configuration whether in the forms of actual external phenomena or in the objectivity of spiritual views and ideas."[84]

This leads to an unfortunate consequence: to the extent that music is purely formal, it is susceptible only of quantitative determinations; yet any genuine determination is a determination of content, and any determination of content is of a qualitative order. This defect of music from the point of view of hermeneutic representation makes of it an art that is constantly threatening to move beyond the scope of Art in the strong sense of the term. This is the case for instrumental music: to be sure, the theme can represent a state of mind, but the development of this theme no longer corresponds to any development of this initial content, which remains ever the same: "The meaning to be expressed in a musical theme is already exhausted in the theme; if the theme is repeated or if it goes on to further contrasts and modulations, then the repetitions, modulations, transformations in different keys, etc. readily prove superfluous for an understanding of the work and belong rather to a purely musical elaboration and an assimilation into the manifold realm of harmonic differences etc. which are neither demanded by the subject-matter nor remain carried by it; while in the plastic arts, on the other hand, the execution of individual parts down to individual details is solely an ever more exact mode of bringing the subject-matter itself into relief and an analysis of it in a living way."[85] In other words, so that music might have a determinate content, this content must be given to music from the outside, by words. Without such a preceding content that is already clear in itself "music remains empty and meaningless (*bedeutungslos*), and because the one chief thing in all art, namely spiritual content and expression, is missing from it, it is not yet strictly to be called art."[86] Whence the conclusion to which we have already alluded: only vocal music, insofar as it is capable of endowing music with a qualitatively determined content and thus with a concrete meaning, can elevate it to the dignity of a true art: the human voice is the

instrument par excellence of musical art. One could hardly imagine a more paradoxical conclusion: music is a true art only insofar as it ceases to be an autonomous art and allies itself with poetry. What is at issue here is not so much the fact that Hegel grants preference to vocal music over instrumental music, but that this preference concerns a type of music that is not in conformity with the definition of the essence of music that he gives elsewhere. Had he defined music as vocal music, and later derived instrumental music as a secondary form, the situation would have been less paradoxical. In vocal music, song, *melos*, sound and meaning are inseparable, purely formal organization and signifying structure, and Hegel could have inserted it into his hermeneutic system (at the price of marginalizing instrumental music). The paradox is clear: his general philosophical determination of music defines it as a *purely formal* representation in sound of the interiority in its abstraction, and this marginalizes vocal music; at the same time, music is a true Art only if it ceases to be purely instrumental, that is, if it becomes vocal, and thus ceases to be in conformity with its essence, that is, if in a certain way it ceases to be an art. In order to be artistic (in the generic sense) music must cease to be *an* Art (as a specification of the system of the five arts).

However one examines the problem, the consequences for the internal coherence of the Hegelian system are serious: music is the art in which the fundamental assumption of Hegel's theory of art, namely the idea that the unity of Art is the unity of a hermeneutic determination, is demolished. If (instrumental) music is an art, the essence of Art cannot reside in its content, since music is incapable of expressing a content.[87] Hence music cannot be an Art, at the risk of damaging the credibility of the Hegelian system, since contrary to arts like dance or landscape gardening, music—and this holds for instrumental music as well—is, in the opening decades of the nineteenth century, firmly established as a canonical art.

Difficulties of the same kind emerge in relation to architecture. A symbolic art, it is in fact marked by a hermeneutic defect: the sensuous form only very imperfectly translates the spiritual interiority that informs it. We have already encountered the paradoxical assertion that even though architecture is the symbolic art par excellence it finds its adequate realization not in symbolic architecture, but in classical architecture. This paradox is illuminated here, when we recall that symbolic architecture, insofar as it realizes the essence of architecture, is an autonomous architecture: "The productions of this architecture should stimulate thought by themselves, and arouse general ideas without being purely a cover and environment for meanings already independently shaped in other ways."[88] Classical architecture is on the contrary purely functional: it is only the hermeneutically inert structure that surrounds the statue of the god. Thus the pair autonomous architecture and functional architecture corresponds

to that of pure music and vocal music: in both cases, what should appear as a defect in relation to the purity of the essence of the art in question, is revealed to be its paradigmatic realization. Like pure music supplanted by vocal music, autonomous architecture is replaced by functional architecture; in both cases, the semiotic materials, inert matter or pure sound, are incapable of becoming the supports for a determinate and concrete meaning. Architecture thus attains its full development only when it ceases to try to signify by itself and puts itself in the service of an art that can adequately express spiritual interiority, in this case sculpture. This classical stage of architecture is that of the Greek temple. Contrary to the edifices of the symbolic period (the Tower of Babel, for instance), it no longer has its own meaning and becomes purely functional (*zweckmässig*): as the god's dwelling, its model is the human house, and the choice of its components (columns, walls, peristyles, etc.) is governed by purely formal motives.

At least two paradoxes are involved here. On one hand, architecture is the symbolic art, and thus its *nature* is defined as an inadequate exteriorization of the spiritual content; the sensuous realization imposes an opacity that the meaning can hardly penetrate. But the definition of Art as such is to be the coalescence of the sensuous material and the spiritual meaning. Architecture thus cannot be an Art in the full sense of the term, but only, as Hegel puts it with regard to symbolic art, a preparatory stage leading toward Art. In other words, the very definition of architectural art is that it is not truly an Art. On the other hand, and this is a still greater paradox, architecture is realized all the more perfectly in the degree that it moves away from its own essence, that is, that it ceases to be symbolic, that it ceases to possess a hermeneutic dimension. The paradox is greater than in the case of music: music could be subordinated to poetry because it did not have a hermeneutic dimension; yet architecture does indeed have its own hermeneutic dimension, even if the latter is inadequate. Thus its paradigmatic realization, that is, functional architecture, presupposes that it somehow ceases to be an art (since it loses its hermeneutic dimension, which defines art as such) and realizes itself fully (but as what?). It is clear that Hegel is here the victim of a conflict between the conviction that architecture does not have a representational function and the requirements of his system that define Art as such in relation to a specific representational content.

All these inconsistencies in the system of the arts are in large part due to two fundamental postulates of the *Aesthetics*: the idea that conceptual differentiations unfold progressively in History (historicism) and the hermeneutic thesis according to which the unity of the arts is guaranteed by the identity of their content. The first postulate is responsible for the fruitless attempt to correlate the semiotic system of the arts with the historical system of the forms of art; the second leads to definitions that are paradoxi-

cal, to say the least, of architecture and music, two arts that it is not easy to reconcile with the claim that forms are only the translation, the mobilization, of a content, of a worldview.

It is perhaps not accidental that it is in discussing these two arts that the question of the aesthetic aspect of art—a question that is the great absence in Hegel's *Aesthetics*—can be glimpsed. I shall limit myself to the example of architecture. The unfortunate character of the absence of a specifically aesthetic problematics emerges in the course of the discussion of functional architecture. In what way can a building that is defined solely by its "appropriateness to purpose"[89] still be beautiful? The fact that it is in the service of an external goal seems to be irreconcilable with having its end in itself, which is so central in the Hegelian conception of Art. On the other hand, the domain of the Ideal of Beauty is excluded from architecture when the latter ceases to have its own meaning. Nonetheless, Hegel tries to introduce architectural beauty: "But if these primarily purely useful forms are to rise to beauty, they must not remain at their original abstractness but must go beyond symmetry and eurhythmy to the organic, the concrete, the varied, and the self-complete. But in that event there enters as it were a reflection on differences and characteristics, as well as an express emphasis on and formation of aspects which for pure purposiveness is wholly superfluous."[90] The imprecision of the terms marks a deep problem: in reality, Hegel is seeking the impossible third term that would be neither pure functionality nor the Ideal of Beauty defined as hermeneutic content incarnating itself in a sensuous form. One cannot help thinking of the finality without representation of a specific end in Kantian aesthetics. Thus we learn that the forms of architecture must indeed approach organic forms, but without going so far as to actually represent them, in which case we would fall back into symbolic architecture, which makes use of organic forms by endowing them with a hermeneutic dimension. Moreover, this architectural beauty must not become "an adornment merely,"[91] that is, it must always remain connected with functionality. Classical architectural beauty would thus be situated between the Idea of Beauty, with which it dispenses the better to serve sculptural works, and pleasing beauty, which falls outside the domain of genuine beauty. But this (Kantian) third term is strictly unthinkable in Hegelian aesthetics, for which the domain of the Beautiful is coextensive with that of the sensuous expression of a worldview, and thus with a hermeneutic definition of the Beautiful.

We could demonstrate that the same difficulty arises in music, with regard to its purely formal dimension and to the question of how to evaluate this dimension when it is no longer referable to a content. In both cases the *Aesthetics* runs up against the limits imposed by its theoretical framework. At the same time it involuntarily reveals that the theory of art can-

not be reduced purely and simply to a hermeneutics, that form is not the simple clothing of the content, that beauty is not reducible to representation, and that the arts do something other than express a worldview.

THE ART OF ART: POETRY

Insofar as Hegel considers the arts almost exclusively from the hermeneutic point of view, it is not surprising that he privileges verbal art. To be sure, the question of the paradigmatic art is complex, since poetry seems to be in competition with sculpture. But to the extent that the paradigms have different meanings, this competition is merely apparent.

Sculpture is the art par excellence when Hegel is defining Art in relation to the knowledge of the understanding and to speculative thought: the sculptor's work realizes in an exemplary manner the dual nature of artistic representation, which is distinguished from discursive knowledge by *being* both a sensuous reality and a spiritual meaning. From this point of view, poetry appears as atypical, since it reduces its sensuous realization, sound, to the rank of a simple "meaningless sign."[92] It no longer has an artistically significant value as a sensuous phenomenon, but solely as an arbitrary support for a meaning: "Consequently in the case of poetry proper it is a matter of indifference whether we read it or hear it read; it can even be translated into other languages without essential detriment to its value,and turned from poetry into prose, and in these cases it is related to quite different sounds from those of the original."[93] By thus minimizing its dependence on the sensuous, poetry deviates from the conceptual determination of Art: "poetry destroys the fusion of spiritual inwardness with external existence to an extent that begins to be incompatible with the original conception of art, with the result that poetry runs the risk of losing itself in a transition from the region of sense into that of the spirit."[94] Whence also the danger that constantly dogs it, that of falling back below art into the discourse of the understanding, or of attempting to go beyond Art toward speculative discourse.

Yet when one adopts the point of view of the hermeneutic definition of Art, the superiority of poetry over other arts explodes. In fact, *all* the other arts are limited with regard to the domain of the content of Art, of the Ideal of Beauty, that they can represent; this limitation is due precisely to the specificity of their sensuous realization (of their material), which always remains partially opaque with regard to the spiritual meaning. The more an art succeeds in freeing itself from the limits inherent in the opacity of its material, the greater the domain of the ideas it can express: "Now poetry cuts itself free from this importance of the material, in the general sense that the specific character of its mode of sensuous expression affords no reason any longer for restriction to a specific subject-matter and a con-

fined sphere of treatment and presentation. It is therefore not linked exclusively to any specific form of art; on the contrary, it is the *universal* art which can shape in any way and express any subject-matter capable at all of entertaining the imagination, because its proper material is the imagination itself, that universal foundation of all the particular art-forms and the individual arts."[95] As the end of the passage quoted shows, the advantage poetry has over the other arts is not solely quantitative but also qualitative. It not only expresses more contents than do the other arts, but possesses a special status, in the sense that it works directly in and on the imagination.

How does poetry free itself from this dependence with regard to materials? After all, verbal matter also has its specificities, and thus, it would seem, its limits. To be sure, but the true material (*Material*) of poetry is not—as one might at first think—verbal expression as a physical phenomenon; it is the internal representation itself that constitutes the poetic material: "It is *spiritual* forms which take the place of perceptibility and provide the material to be given a shape, just as marble, bronze, color, and musical sounds were the material earlier on."[96] Poetic sound does not have the same status as musical sound or the sculptor's stone; it is a material only in a figurative sense of the term: "Spirit . . . has speech only as a means of communicaton or as an external reality out of which, as out of a mere sign, it has withdrawn into itself from the very start."[97]

Two difficulties immediately arise. The first has to do with the fact that internal representation is supposed to be the *content* of every art, and thus also of poetry: "we must not be led astray by the statement that ideas and intuitions are in truth the subject-matter of poetry."[98] But it is precisely here that the specificity of poetry explodes: it is the sole art in which the material and the content are in a certain way one and the same. Then a second difficulty arises: if the internal representation is both the material and the content of poetry, how can it still be distinguished from prosaic discursivity? In fact, in order for the material of representation to be transformed into poetic content, it has to be transformed by the imagination. It is this transformation that is lacking in the common representation: "We can put this difference in general terms by saying that it is not ideas *as such* but the artistic imagination which makes some material poetic. . . . The basic demand necessitated here is limited to this: (i) that the subject-matter shall not be conceived either in terms of scientific or speculative thinking or in the form of wordless feeling or with the clarity and precision with which we perceive external objects, and (ii) that it shall not enter our ideas with the accidents, fragmentation, and relativities of *finite* reality."[99] This imaginative transformation also belongs, of course, to the domain of internal representation (*Vorstellung*), so that poetry is indeed the art that realizes itself in and through internal representation: "this objectivity . . .

acquires an existence only within consciousness itself as something spiritually presented and intuited."[100]

Poetry thus does indeed have an atypical status: it is the place where the sensuous element of Art fades away in order to become a pure, transitive sign of interiority. Paradoxically, this characteristic, which situates it at the boundaries of Art if it is approached from the point of view of its *semiotic* specificity, situates it at Art's center if one adopts the point of view of its *hermeneutic* status. Poetry resides on the boundaries of Art insofar as it tends to minimize the sensuous element, but it occupies its center insofar as its material, which is purely spiritual, is at the same time its content, and this content is nothing other than the content of Art as such.

By virtue of this theory, Hegel thinks he can maintain that poetry is, in the proper sense of the expression, the art *of* Art: it is Art stripped of any external limitation and reduced to its essential core, which is the creative imagination. In other words, the boundaries of poetry are the limits of Art as such: empirical, nonsubstantial reality on one side, speculative reason on the other.

Thus poetry, as a reproduction of "the totality of beauty,"[101] is the synthesis of all the arts: "on the one hand, poetry, like music, contains that principle of the self-apprehension of the inner life as inner, which architecture, sculpture, and painting lack; while, on the other hand, in the very field of inner ideas, perceptions, and feelings it broadens out into an objective world which does not altogether lose the determinate character of scupture and painting. Finally, poetry is more capable than any other art of completely unfolding the totality of an event, a successive series and the changes of the heart's movements, passions, ideas, and the complete course of an action."[102] Since it is the total art, it is also the most systematic art, in fact the *only* art that reduplicates within itself the fundamental determinations of the Idea of Beauty. Literary genres are the place where this reduplication occurs. Poetry is the only art that specifies itself in a speculatively pertinent generic system, because its flourishing, not being limited by a unilateral material, is nothing other than the unfolding of Beauty as such: "As a totality of art, not exclusively confined by any one-sidedness in its material to one particular sort of execution, poetry takes for its specific form the different modes of artistic production in general; and therefore the basis for dividing and articulating the different *sorts* of poetry must be derived from the *general* nature of artistic presentation."[103]

In its reduplication of the theory of Art, does the system of genres reproduce the system of the forms of art, or rather that of the arts? On one hand, we learn that epic poetry, to the extent that it represents the developed totality of the spiritual world in the form of external reality (event), reproduces the principle of the visual arts—with the important difference that in the case of the plastic arts the reality is material, whereas in epic we are

confronted by an ideal reality that exists only as an imaginary projection. Similarly, Hegel repeatedly establishes the links between lyric poetry—the poetry of subjective interiority (state of mind)—and music; moreover, the most important genre of lyric poetry is the *Lied*, the song. This being so, one might expect that dramatic art would be the reproduction, within poetry, of the synthesis of the plastic arts and music, that is, the reduplication of poetry *as such* (since we know that poetry as such is *already* the synthesis of the plastic arts and music). And in fact Hegel defines dramatic poetry by the action; the action is the synthesis of the representation of objective reality (event) and the representation of the interiority of the subject (state of mind), which corresponds to the definition of poetry as such. Moreover, dramatic poetry is the supreme stage of poetry: "Because drama has been developed into the most perfect totality of content and form, it must be regarded as the highest stage of poetry and of art generally."[104] In other words, just as poetry as such synthesizes the other arts, dramatic poetry synthesizes the other literary genres, and thus poetry: it is the poetry of poetry. But poetry is already the art of Art. Dramatic poetry is thus the outcome of a double reduplication of both the other arts *and* the other literary genres:

But the distinction between objective poetry (epic), subjective poetry (lyric), and objective-subjective poetry (dramatic poetry) is not only a reduplication of the system of the arts. It must also be related to the theory of the forms of art, the latter also being organized around the dialectic of objectivity and subjectivity. Hegel links symbolic art with the representation of external objectivity, romantic art with the exteriorization of subjectivity, and classical art with the synthesis of objective representation and subjective expression.[105] As was already the case at the level of the system of the arts in its totality, this parallel between the hermeneutics of the forms of art and the semiotics of the arts disorganizes the generic system.[106]

It is at the level of epic and of dramatic poetry that the system falls apart. Thus, in light of the characterization of lyric poetry—which is linked with music—epic should be closely related to architecture, an art of objective representation and a symbolic art; as for dramatic poetry, one would expect to find it associated with sculpture, the classical art par ex-

cellence. Yet when Hegel compares epic with the visual arts, he does *not* refer to architecture, but rather to sculpture: epic works are "sculptural pictures."[107] The reason for this choice is not hard to find: dramatic poetry cannot be referred to the plastic arts, to sculpture for example, because in the reduplicated system, the plastic arts, far from representing the ultimate synthesis, correspond to the objective pole; on the other hand, making epic the reproduction of architecture would have meant connecting a literary genre Hegel considers fundamental with an art that he devalorizes. We might also note in passing another inconsistency: by grouping the plastic arts on the side of the pole of objective representation, Hegel has to cut off painting and music, whereas elsewhere he sees in them two romantic arts; at the same time he is obliged to connect architecture with sculpture, whereas the former is supposed to be a symbolic art and the latter a classical art.

All these inconsistencies, deleterious from the point of view of systematic coherence, also have an undeniable advantage: they make Hegel's procedure more fluid, and it gains in analytical finesse what it loses in systematic rigor. The chapters devoted to poetry are incontestably the glory of the *Aesthetics*, not only because in this vertiginous reduplication Hegel brings once again into play all the categorial distinctions developed in the theory of the forms of art and in the semiotics of the arts, but also because it is in the domain of literary art that the architectonic power of his thought is most felicitously wedded to his aesthetic sensibility. Nonetheless, the attempt at reducing the system of the arts to a historical-philosophical hermeneutics once again shows itself to be problematic.

To the extent that Hegelian literary theory is a theory of genres, that is, to the extent that it situates literary reality in the triadic system of epic, lyrical poetry, and drama, it also ends up reducing all the historically attested genres to these three fundamental categories. This reduction also produces some strains.

Thus Hegel appears to be trying to make the triad of genres function on three different levels:

First, the distribution of literary works among the different categories seems to depend on distinguishing their modalities of enunciation. Thus the chapter devoted to dramatic poetry groups brings together the forms belonging to the mimetic mode. The chapter on epic poetry contains considerations on cosmogonies, theogonies, stories and novels, so that it may seem to represent narrative literature. But this criterion no longer holds for lyric poetry: the lyric poem is the expression of a state of mind, that is, it is defined by its content. There is therefore no triadic system at the level of the modalities of enunciation.

Next, a second categorization resorts to a sort of logic of actions: epic poetry is the representation of an exogenic conflict, that is, one between

heroes who belong to different communities; dramatic poetry, on the contrary, has an endogenic plot, that is, it represents conflicts internal to a given community; as for lyrical poetry, it has no action and limits itself to describing internal states of mind. If this model functions fairly well for ancient epic and tragedy (although there are notable exceptions: Aeschylus's *Persians* is a tragedy with an exogenic plot), it can no longer be valid as soon as modern narrative literature is taken into account; few novels have exogenic conflicts as their subject; on the contrary, the "domestic" character of most modern narrative plots is clear, and Hegel is the first to point this out.

Finally, the third categorization defines the genres by their hermeneutic structures, and more precisely by the worldviews they convey. It is at this level that the reduction proves to be most difficult.

Let us begin with the definition of the epic: "the content and form of epic proper is the entire world-outlook and objective manifestation of a national spirit presented in its self-objectifying shape as an actual event. . . . As such an original whole the epic work is the Saga, the Book, the Bible of a people, and every great and important people has such absolutely earliest books which express for it its own original spirit."[108] This determination of the essence of epic poetry as such is *in fact* an analysis of the Homeric epics. Whence the marginalization of all the narrative traditions that are not reducible to the hermeneutic model elaborated on the basis of (and for) the *Iliad*: theogonies, cosmogonies, didactic literature (fables, etc.), extra-European epics, without mentioning the immense field of the novel (which—if it holds the special attention of the critic and of the philosopher of history—has little value in the eyes of the theoretician of the system of the arts). Hegel justifies this marginalization by resorting to the distinction between essential and contingent forms—which is not quite sufficient.[109]

On the other hand, when Hegel analyzes lyric poetry he does not, as we have seen, establish a classical paradigm, and the examples he analyzes are drawn at random from ancient, oriental (Hafiz) and "romantic" poetry, with a clear preference accorded the latter (especial Goethe's and Schiller's poems). The absence of a paradigm has to do with the fact that lyric poetry is the expression of subjectivity and consequently an intrinsically unstable form of unlimited individual diversity. In this sense, it continues to be the foreign body it was in most of the three-genre systems.[110]

In the case of dramatic poetry, the situation is more complex. Hegel admits at the outset a subdivision into three subgenres, tragedy, comedy, and drama,[111] each of which has its own specificity. In the general determination of dramatic poetry, he consequently limits himself to analyses that bear on the specificity of dramatic action and unity in relation to epic action and unity (endogenic conflict vs. exogenic conflict), on the themes

of the dramatic conflict and on the formal organization of the drama (diction, dialogue, meter, etc.), in other words, analyses that seek to determine what one might call the poetological status of dramatic art. But it is in the system of subgenres that the difficulties arise. First of all, Hegel dispenses entirely with the tripartite classification of the symbolic, the classical, and the romantic, which is replaced by a dyadic schema opposing the ancient to the modern. Formally, this schema determines six forms. But they do not have the same status. Thus ancient tragedy alone is a *true* tragedy, because it represents conflicts between substantial forces, expressing all the fundamental human determinations (*Antigone*); modern tragedy, on the contrary, presents conflicts that arise from the contingency of a character (*Othello*)[112] or from a passion (*Romeo and Juliet*), themes that generally lack any substantial justification of their own. The same thing holds, even though to a lesser extent, for comedy: its paradigm is also ancient, modern comedy being either too serious (*Tartuffe*) or too prosaic. The true modern dramatic genre is the drama (*drame*): a mixture, even a sort of synthesis of the elements of tragedy and comedy, it certainly exists in antiquity as well (the satyr play, the tragicomedy), but it flourishes essentially in the modern period (Goethe's *Iphigeneia*). In other words, alongside the synchronic schema tragedy-comedy-drama a diachronic schema is outlined, tragedy and comedy being reserved for ancient art, and drama for romantic art. This schema is apparently dialectical: tragedy represents the triumph of substantiality over subjectivity (tragic heroes are destroyed, because the unilateral nature of their goals has to be absorbed into the substantial unity); comedy represents the triumph of subjectivity; as for drama, we already know that it is a quasi-synthesis of substantiality and subjectivity. We would thus have a supplementary reduplication of the triad of objectivity, subjectivity, and their synthesis, this time within dramatic poetry itself, which is the synthesis of poetry; the latter is the synthesis of the other arts and reproduces the three forms of art within itself. Hegel scarcely exploits this schema, since it would amount to situating the ultimate synthesis of Art in a modern form, whereas by virtue of the general historical-philosophical thesis, only classical art is the site of the synthesis. That is why drama is only a *quasi*-synthesis: in fact, even though Hegel actually uses the term "mediation" (*vermitteln*) to characterize it, he immediately adds that this genre is less important than tragedy and comedy, and that it is intrinsically unstable to the extent that it constantly threatens either to move beyond the dramatic proper (into lyric poetry) or to fall into the prosaic element.[113]

We see that in each of the three paradigmatic genres noted, the attempt to maintain a strict correspondence between the semiotics of the arts and the hermeneutics of the forms of art leads to more or less serious inconsistencies. Assuredly, these are inconsistencies only when measured by the

yardstick of the Hegelian ideal of systematicity, in the name of which the author of the *Aesthetics* claims to accede to a kind of knowledge opposed to the knowledge of pedestrian science; but if we want to do him justice, we can do so only by judging him by his own criteria. Moreover, it is precisely within this systematic framework that Hegel's central contribution to the tradition of the speculative theory of Art resides. In actuality, the thesis of the ontological function of Art is not a Hegelian invention; we have seen that it was developed by the romantics, and Hegel thus merely adopts it. On the other hand, the elaboration of a speculative historical-systematic theory of Art, which is supposed to legitimate its sacralization through a philosophical analysis of the arts, had remained largely at the planning stage among the romantics, even if the genesis of the history of Literature as we have analyzed it in Friedrich Schlegel's work already established some of its essential mileposts (and already revealed some of its limits). We must add that the Hegelian system of the arts leaves the analogous attempts made by Solger and Schelling far behind, and in this sense it is truly Hegel who accomplished the romantic project of a speculative science of Art. It is therefore not surprising that his system also exhibits most clearly the most debatable assumptions of this project, and that he had to confront most directly some of its aporias.

Ecstatic Vision or Cosmic Fiction?

WHETHER HEGEL is seen as the fulfillment of romanticism or as its transcendence, it cannot be denied that the author of the *Aesthetics* is linked to his predecessors by a deep philosophical solidarity based on idealism. Schopenhauer and Nietzsche, in contrast, seek deliberately to situate themselves outside that tradition. Schopenhauer claims to be Kant's sole legitimate heir, and considers null and void the "imposture" of Fichte, Schelling, and Hegel. Nietzsche challenges the *whole* of the post-Socratic philosophical tradition, including Kant and Plato, whom Schopenhauer, his early master, considered the two leading lights of Western thought. Nietzsche thus quickly moves away from the author of *The World as Will and Idea*, whose pessimism and depreciation of earthly life he rejects. Nonetheless, even in his later writings, Nietzsche is still wrestling with Schopenhauer.[1] What is more important for us is that when these two philosophers are situated in relation to the romantic and idealist tradition, their differences fade away in comparison with their common break with this tradition. In the case of Schopenhauer, this break does not reflect a chronological sequence, since the first edition of *The World as Will and Idea* (1819) is practically contemporary with Hegel's lectures on *Aesthetics* (begun in 1819). However, Schopenhauer became influential only after Hegel's death, so that from the point of view of the social history of philosophy, he still comes after his great rival.

We cannot examine this break here, and I shall limit myself to a brief enumeration of a few of its essential aspects; only in this way will the continuity that exists in the domain of the theory of Art emerge with all its significance. The continuity is massive insofar as Schopenhauer's philosophy of Beauty and Nietzsche's earliest writings are concerned. It is more paradoxical in the case of Nietzsche's mature writings; after having severely criticized the postulates of the speculative theory of Art when he was writing *Human, All Too Human*, he nonetheless ends up reintroducing them in his philosophy, albeit in a modified form..

Generally, one can distinguish two points on which Schopenhauer and Nietzsche are fundamentally opposed to the romantic-idealist tradition:

1. This tradition was a philosophy of the *logos*, that is, a mode of

thought for which it was self-evident that the ontological structure of the
Universe finds its plenitude in an act of self-knowing (mediated through
humanity as a spiritual entity). Whether one thinks, with the romantics,
that this equivalence between rational discourse and the Absolute can be
realized only through an infinite approach, or, on the contrary, follows
Hegel in maintaining that absolute knowledge can be realized *in actu* in
the philosophical system, in either case it is incumbent upon discourse,
philosophical or poetic, to realize this equivalence between the real and
its knowledge-of-itself. According to this conception, in view of its self-
revelation the order of the world is fundamentally goal-oriented, its ade-
quate knowledge coinciding with its spiritual plenitude. As for the materi-
ality of the universe and the sensuous nature of man, they are on the side
of appearances and are thus destined to be absorbed into the spiritual
essence. For Schopenhauer, in contrast, man is primordially a sensuous
being situated in a material space and subject like every being to the iron
law of the will, a self-engendering and self-destroying cosmic force: the
will is the true Thing-in-Itself, the absolute other of the phenomenal
world, and thus of the world of representation. It escapes all rational
knowledge and is the nonrepresentable par excellence: even philosophy,
which is knowledge of the Universe as representation in its totality, is inca-
pable of going all the way back to the final foundation. As for ordinary
knowledge, it is even worse off: it is no more than a simple tool in the
service of the will, and thus has only a pragmatic value.

Nietzsche emphasizes above all this second aspect: if knowledge, with
the exception of philosophical knowledge, is also in the service of the will,
it is the notion of truth as such that becomes problematic. It might very
well be the case that truth is ultimately no more than a useful fiction, since
it is sanctioned by criteria that are not internal but only external; we con-
sider that to be true whose consequences please us, what leads to success,
etc. Our "Truths" are merely tools, instruments by means of which we act
in and on our life; their status is pragmatic and not ontological.

Because of this devalorization of rationality, the ideal of philosophical
discourse for both Schopenhauer and Nietzsche can no longer be deduc-
tion, demonstration; rather, it is a question of describing a fundamental
intuition concerning "life": the will as the central vital fact. The goal also
changes: it is no longer pure knowledge that is sought, but rather a lesson
in wisdom. Philosophy must shake up its disciples, put them in a state of
crisis, make them emerge from the inauthentic existence (the veil of Maya
in Schopenhauer), and lead them either toward abandoning the will to live
(Schopenhauer) or, on the contrary, toward an exacerbation of the will to
power (Nietzsche).

2. These oppositions at the level of the status and function of phi-
losophical discourse have further consequences at the level of the view of

humanity. Idealism—and here it is faithful to its romantic origins—saw in humanity an infinitely perfectible organism, composed of the sum of particular historical communities destined to unite in order to form a collective spiritual body. Whence, as we have seen, an eschatological view of history. In contrast, Schopenhauer refuses to see in humanity anything but the identity of a biological determination, that is, the identity of an objectification of the historically transcendent will. In this sense it has been rightly said that his thought is a philosophy of the body rather than of the subject.[2] Explicitly opposing Hegel, he rejects as inconsistent the very idea of a collective historical subject: "since only the individual, and not the human race, has actual, immediate unity of consciousness, the unity of the course of life is a mere fiction. Besides, as in nature only the species are real, and the genera are mere abstractions, so in the human race only the individuals and their course of life are real, the peoples and their lives mere abstractions."[3] Whence the radical rejection of historicism, which Schopenhauer considers incompatible with any true philosophical thought: "While history teaches us that at every time something else has been, philosophy tries to assist us to the insight that at all times exactly the same was, is, and shall be. In truth, the essence of human life, as of nature in general, is given complete in every present time, and therefore only requires depth of comprehension in order to be exhaustively known."[4] Later on, he explains: "All those who set up such constructions of the course of the world, or, as they call it, of history, have failed to grasp the principal truth of all philosophy, that what is is at all times the same, all becoming and arising are only seeming; the Ideas alone are permanent; time ideal."[5]

Nietzsche, even though he quickly comes to reject Schopenhauer's Platonism and his radical denial of history, nonetheless discards any idea of a teleology or a historical determinism in favor of the contingencies of a genealogy: "What, can statistics prove that there are laws in history? Laws? They certainly prove how vulgar and nauseatingly uniform the masses are; but are the effects of inertia, stupidity, mimicry, love and hunger to be called laws? Well, let us suppose they are: that, however, only goes to confirm the proposition that so far as there are laws in history the laws are worthless and the history is also worthless."[6] When Nietzsche is writing "On the Uses and Disadvantages of History for Life," from which the passage just quoted is taken, he is still under the influence of Schopenhauer, as is shown by his defense of a suprahistorical (*überhistorisch*) view of humanity: he speaks of "the powers which lead the eye away from becoming towards that which bestows upon existence the character of the eternal and stable (*gleichbedeutend*), toward *art* and *religion*."[7] But at the same time he is already beginning to move away from his master: when he

says that life is "a thing that lives by negating, consuming, and contradicting itself,"[8] he does so in order to celebrate its power as transformative and thus evolutionary in the largest sense of the term, whereas Schopenhauer sees in it no more than empty superficial agitation. If for Nietzsche there is no historical teleology, history is nonetheless the site of constant vital disturbances. Thus in his later writings we find history returning as the essential dimension of human existence—not of humanity as developing logos but humanity as life: history is the history of the great individuals who create events, and who make them their work. Thus the goal Nietzsche assigns to humanity is not the harmonious development of the species, but, as he maintains in his earliest texts, the full development of its "highest exemplars."[9] To this voluntarist theory of history as act corresponds a utilitarian conception of historical discourse: rejecting the conception of history as pure knowledge, Nietzsche makes himself the defender of a history in the service of life, whether as exemplary history, collective myth, or critique of the past.

One might object that these Schopenhauerian and Nietzschean conceptions, while they certainly constitute a break with idealism, nevertheless seem to adopt one of romanticism's central ideas: the thesis of the irreducibility of "life" to philosophical logos, a theme that was already present in Friedrich Schlegel and Novalis. However, the content itself of the notion of "life" has completely changed. Friedrich Schlegel's "philosophy of life" was a Christian philosophy, and the "life" sung by Novalis was that of a soul whose inexhaustible wealth, founded on its status as a *speculum Dei*, was supposed to transcend any philosophical representation. With Schopenhauer and Nietzsche, it is biological, physiological life that makes its entrance on the stage, in opposition to disembodied logos, to be sure, but also to the effusiveness of the romantic soul

These breaks at the level of the overall philosophical project obviously also had repercussions as the level of the conception of the arts. In fact, Schopenhauer marks a genuine fracture within the tradition of the speculative theory of Art, a fracture that Nietzsche and Heidegger only deepen.[10] The twofold rejection of deductive knowledge and historicist determinism (which does not necessarily imply an abandonment of historicism itself, as I hope to show in the case of Heidegger) prohibits any construction of Art as a historical organism; its essence will no longer be identified with its historical development or with its generic organization. In Schopenhauer, Nietzsche, and Heidegger, the speculative theory of Art is far less a theory *of* the arts than it was in romanticism and in Hegel. Whether Art is conceived as vital experience (in Schopenhauer and Nietzsche) or as an investigative thinking of the question of Being (in Heidegger), in either case

critical meditation on exemplary works replaces extensive study of the forms of art and their history in its function as a support for speculative theses. Whereas in Hegelian historicism comprehensive study (the conceptual definition) was supposed to come together with extensive study (the historical development), this ceases to be an obligation in Schopenhauer and his successors. In other words, the view of the essence of Art becomes increasingly independent from its relation to the arts in their plurality and historical variability. Even though this tendency is not very pronounced in Schopenhauer himself, who provides a traditional survey of all the canonical arts, it clearly asserts itself in the young Nietzsche, for whom Art reduces itself *de facto* to Greek tragedy and to music. The same can be said of Heidegger, whose theory of Art essentially proceeds from the analysis of a few exemplary works: the later poems of Hölderlin, a few poems by Trakl and Rilke, a painting by Van Gogh. Through such a procedure, speculations on Art as an unspecified generality inevitably become more prevalent and also more reifying, thus allowing the speculative theory of Art to reproduce itself indefinitely without any compromising contact with the phenomenality of the arts in their empirical multiplicity.

Thus the break achieved by Schopenhauer, whose repercussions extend as far as Heidegger (in spite of himself), far from weakening the speculative theory of Art, actually allows it to develop in all its purity in two forms: the sacralization of the arts as ontological knowledge and philosophy's claim to provide a knowledge of its essence. Definitively freeing itself from "pedestrian knowledge" (Jean Bollack), in this case that provided by the different empirical disciplines studying the arts, the speculative theory can all the more easily define itself solely in relation to its own past and to its own problematics, that is, in relation to itself as concept. It ceases to draw its legitimacy (as it still did in Hegel) from its claim to explain more fundamentally the phenomena that pedestrian knowledge analyzed empirically. Henceforth it increasingly draws its legitimacy from its own existence as a concept, that is, from its own historical persistence as a theory, a persistence that is also, more banally, a cultural and academic inertia, and that endows it with an evidential power that is *sui generis*.

From Anagogy to Artistic Redemption (Schopenhauer)

THE PLACE OF ART

While Schopenhauer claimed to be Kant's only legitimate descendant, in the domain of aesthetics he deviates from him in a radical way. Whereas for Kant a philosophical doctrine of Beauty was impossible, Beauty not being an ontologically stable phenomenon but rather a disputed ideal to

be debated, a product of human culture and not one of its natural determinations, Schopenhauer explicitly seeks to establish a philosophical doctrine of Beauty. Thus, setting forth his ideas before an audience of students, he says: "What I shall propose here is not an aesthetics but a metaphysics of Beauty."[11] And in fact there is not the slightest doubt of this: the theses he sets forth in the third book of *The World as Will and Idea* constitute a variant of the speculative theory of Art, even though it is a specific variant.

I have defined the particularity of this tradition in terms of the strategic place Art occupies in it, closest to philosophical discourse and to ecstatic being-in-the-world, and thus at the opposite pole from the place occupied by scientific discourse and everyday or prosaic being-in-the-world. Schopenhauer does not in any way retreat from this conception. It is simply that in view of the diametrical opposition between his fundamental philosophical theses and those of the romantic-idealist tradition, the conceptual determination of this strategic place undergoes significant changes.

The essential shift occurs by way of a rearrangement of the Kantian triad of the spiritual faculties: intuition, the understanding, and reason. On one hand, Schopenhauer makes the understanding coincide with intuition, or rather he sees in the former an essential aspect of the latter. Intuition, he tells us, is always intellectual (connected with the understanding), since it is always representational, that is, it implies a structuration of lived experience in accord with the categories of our subjectivity, and more precisely in accord with the principle of reason (*Satz vom Grunde*) in its temporal specifications (the law of succession), spatial specifications (the law of position), and material specifications (the law of causality). Intellectual intuition is the fundamental human faculty. This entails a demotion of the faculty of reason, which since Kant had been considered the primary faculty.

There exist—let us immediately note, reserving a fuller discussion until later—states of knowledge that accede to a reality situated beyond the principle of reason: the intuition of the eternal Ideas. But this same ideal (*ideell*) world is still linked to the representational duality: there is an object only for a subject, and thus all knowledge is of an object that is relative to a subject, whether individual, empirical (attaining only endoxical knowledge according to the principle of reason that governs the interconnection of the phenomenal world) or pure (having access to the ecstatic contemplation of the Ideas).

Intuition is thus our sole mode of access to the Universe: "All profound knowledge, even wisdom properly so called, is rooted in the *perceptive* apprehension of things, . . . All primary thought takes place in pictures."[12] Now, to the extent that intuition is structured representationally, this

amounts to saying that our knowledge can never go beyond the world of representation: intuition is the ultimate foundation (*Erkenntnisgrund*) of all knowledge. Philosophy itself is thus an *immanent* knowledge whose foundation is empirical; it does not claim to "explain the existence of the world in its ultimate grounds: it rather sticks to the facts of external and internal experience as they are accessible to every one, . . . It therefore arrives at no conclusions as to what lies beyond all possible experience."[13]

We know that in the idealist tradition the third faculty, that is, reason, was precisely the properly philosophical organ, the one that made it possible to go beyond the phenomena to their ultimate foundation. Schopenhauer, by depreciating reason, is thus altogether consistent in his immanentist conception of philosophical discourse. On one hand, contrary to what objective idealism maintained, reason also remains, in its spontaneous exercise, heterotelic: like the intuition-understanding, it is in the service of the will to live, that is, it pursues purely utilitarian goals. On the other hand, epistemologically (and even when it succeeds, as in the case of pure contemplative knowledge, in liberating itself from its subjection to the will) it is wholly dependent on intuition: it is therefore not a source of autonomous knowledge, but solely the "abstract reflex of all that belongs to perception in that conception of the reason which has nothing to do with perception."[14] This abstract reflection, far from increasing the certainty of our knowledge, diminishes it, since it carries it further away from its intuitive foundation. In fact, the essential usefulness of reason is of a communicational type: it does not enlarge the field of the knowable (it cannot legislate regarding the real but solely regarding the logical truth of our abstract propositions), but it does facilitate its transmission and memorization, thanks to its discursive and thus public character (whereas intuition, although similarly structured in all humans, is essentially private and evanescent): "The greatest value of rational or abstract knowledge is that it can be communicated and permanently retained."[15]

It is therefore not surprising to see the realm of reason—that is, the realm of human history that in the form of absolute Spirit had been the culmination of Hegelian teleology—emptied out by Schopenhauer in a short paragraph: "It is only thanks to language that reason can realize its greatest effects, for example the common action of several individuals, the harmony of the efforts of thousands of men in a preconceived design, civilization, the State; then on the other hand science, the preservation of the experience of the past, the grouping of common elements in a single concept, the transmission of the truth, the propagation of error, reflection and artistic creation, religious dogmas and superstitions."[16] There is no need to point out here the anti-Hegelian perfidy that makes reason responsible for

the survival of errors as well as for that of the truth, for the transmission of dogmas and superstitions as well as for that of thought and poetry.

As far as our subject is concerned, two important consequences flow from this rearrangement of the triad of the faculties. The first directly affects philosophy, and it therefore cannot avoid affecting Art as well. If reason is not a source of specific knowledge, and if philosophy—which is an abstract discourse—must remain in spite of everything the enterprise par excellence, it can no longer draw its legitimation from its discursive nature, that is, from its purely deductive structure, but solely from the originary character of the intuition on which it is based and from the impartiality of its contemplative attitude: more than a deduction, philosophy is the arrangement of a small number of originary intuitions. It is therefore related to Art, which is also defined as the intuition and contemplation of ideal objects. That is why Schopenhauer says: "My philosophy must be distinguished from all preceding ones, with the exception of Plato's, in that it is not a science but an art."[17] In the same way, he identifies the fundamental faculty of philosophy with the faculty that defines the artist: genius, that is, the ability to have originary intuitions.

We see what the reversal carried out with regard to Hegel consists in: whereas according to the Hegelian conception the relationship between Art and philosophy was supposed to justify the adoption and transcendence of the intuitive results of the artistic work in and through philosophical rationality, for Schopenhauer, on the contrary, it is a matter of grounding the abstract concepts of philosophy in an intuition having the force and the infallibility of artistic intuition. It goes without saying that if philosophy is supposed to retain an advantage over Art—which is the case in Schopenhauer, in spite of everything—this advantage must reside elsewhere than in the specific character of its knowledge.

Schopenhauer's theory of knowledge has, as we have seen, a second aspect: it concerns his central thesis according to which the will, and more specifically the will to live, constitutes the thing-in-itself, the *ens realissimum*, the foundation of all things, including knowledge. Hence, in their normal activity, all the faculties of knowledge are subject to the goals of the will and serve its desires: they are heterotelic. Knowledge is not sought for its own sake: "knowledge generally, rational as well as merely sensuous, proceeds originally from the will itself, belongs to the inner being of the higher grades of its objectification as a pure *mechanè*, a means of supporting the individual and the species, just like any organ of the body."[18] This makes it impossible for Schopenhauer to ground the ontological character of the knowledge provided by philosophy and Art (and which is opposed to the simple knowledge of the relationships between phenomena that science attains) concerning the existence of a specific faculty of

knowledge (which would be, as is the case for Reason in the idealist tradition, intrinsically autotelic, and thus not subject to any goal other than disinterested contemplation, *theoria*): ontological knowledge is possible only through an ecstatic use of faculties that are otherwise heterotelic.

The status of philosophy and of Art thereby becomes even more unstable and improbable. The passage of our everyday being-in-the-world toward philosophical or artistic ecstasy is no longer the simple passage from an inferior state of our spiritual essence to a superior one; it now requires a genuine crisis (we must liberate ourselves from what is deepest in us: the will), a leap beyond ourselves: "The transition which we have referred to as possible, but yet to be regarded as only exceptional, from the common knowledge of particular things to the knowledge of the Idea, takes place suddenly; for knowledge breaks free from the service of the will, by the subject ceasing to be merely individual, and thus becoming the pure will-less subject of knowledge, which no longer traces reason, but rests in fixed contemplation of the object presented to it, out of its connection with all others, and rises into it."[19] This leap can only remain mysterious and unmotivated, since nothing in Schopenhauer's view of man, neither a specific faculty nor even a predisposition based on his spiritual nature, grounds it. On the contrary, everything makes it improbable; if the ultimate reality is the will, and if man with his faculties is an objectification of this will, it is hard to see how he could suddenly run up against what grounds him.

Schopenhauer defines philosophical and artistic knowledge as "knowledge of the Idea" and opposes it to scientific knowledge. How does he motivate this opposition, which is common, as we know, to the whole of the tradition of the speculative theory of Art? In the first place, scientific knowledge does not give us true knowledge of objects, but solely a knowledge of the *relations* between objects. This has to do with the fact that he asks only about causal connections: where? when? why? to what end? That is, he approaches the Universe from the point of view of the principle of reason. Since this principle structures the phenomenal world, scientific knowledge can never go beyond this world toward the thing-in-itself (that is, the will).[20] Only artistic and philosophical knowledge can go beyond phenomena; they are not interested in the relations between objects, but contemplate them in their essence, that is, they accede to their Ideas through particular representations (Art) or abstract concepts (philosophy). They ask the question "Why?" and seek to know objects according to their ontological nature.

Schopenhauer's description of philosophy quickly takes on a mystical tone. This is not surprising: knowledge of the Idea is possible only if we abstract from our individuality (that is, from our subjection to the will) in order to rediscover ourselves as pure subjects and accede to the intuition of the object in its autonomous presence, to the point of coinciding with it,

"so that it is as if the object alone were there, without any one to perceive it, and he can no longer separate the perceiver from the perception, but both have become one, because the whole consciousness is filled and occupied with one single sensuous picture."[21]

This is not a contemplation of an object in its empirical singularity; on the contrary, it is vision of its *generic* essence, since the Ideas are the generic essences of natural objects. In order to understand this, we must elucidate the claim that the Universe is the objectification of the will. This objectification is generically hierarchized, that is, it is realized on a number of levels; the lowest level is that of the forces of inanimate nature and the highest level is that of man. The different levels correspond to a progress in the will's becoming-representation; it is in man that it represents itself to itself with the greatest clarity and perfection. We must add, however, that this hierarchy is static and not evolving: all the levels eternally coexist. The Ideas that the artist or philosopher contemplates are nothing other than the generic essences of these levels or grades of the will's objectification: "the grades are just the determined species, or the original unchanging forms and qualities of all natural bodies, both organized and unorganized, and also the general forces which reveal themselves according to natural laws."[22]

The world we encounter in everyday life and in scientific knowledge is only the sum of the individual singularities through which the Ideas present themselves to our common representation. The world of phenomena and that of the Ideas are related to each other as copy (*Nachbild*) to model (*Vorbild*). That is, multiplicity as well as temporality, spatiality, and causality are only characteristics of the world of phenomena, whereas the Idea remains one and eternal.

Thus we see why philosophical and artistic knowledge implies an existential ecstasy: time, space, objectal multiplicity, and causality are in fact constitutive of the individual and of his "sphere of knowledge" (*Erkenntnissphäre*): "If, therefore, the Ideas are to become objects of knowledge, this can only happen by transcending the individuality of the knowing subject."[23] Let us recall once again that this same ecstatic knowledge does not attain the thing-in-itself, the will. The latter is the absolutely unrepresentable, and the knowledge of the Ideas, while it frees itself from the principle of reason and the principle of individuation, nevertheless remains a representation, and is thus still entangled in a relation of object-for-a-subject: "The Platonic Idea . . . is necessarily object, something known, an idea, and in that respect is different from the thing-in-itself, but in that respect only. It has merely laid aside the subordinate forms of the phenomenon, all of which we include in the principle of sufficient reason, or rather it has not yet assumed them."[24] In the supplements in the second edition of 1844, Schopenhauer is even more categorical: "the Ideas

reveal not the thing in itself, but only the objective character of things, thus still only the phenomenon; and we would not even understand this character if the inner nature of things were not otherwise known to us at least obscurely and in feeling."[25] This obscure feeling that precedes and surpasses all knowledge is ultimately founded on the fact that, in a certain way, we ourselves *are* the will.

In summary, we must distinguish three ontic spheres: a) the will, which is the ultimate and radically unknowable core of Being; b) its objectifications in the Ideas, that is, once again, in natural forces and natural species accessible to the ecstatic knowledge of Art and philosophy; c) the world of the multiple and the singular as it is given to us in common intuition and in scientific knowledge.[26]

The gratuitous character of Schopenhauer's theory of the Ideas has often been pointed out, its entry onto the stage being imposed by a pure gesture of authority; nothing in the theory of knowledge he defends elsewhere makes plausible the possibility of a knowledge of the Ideas. This problem goes hand in hand with that of the implausibility of the ecstatic knowledge supposed to be realized by Art and philosophy. To be sure, Schopenhauer himself emphasizes that all genuine philosophical knowledge must be based on a fundamental intuition, and the latter is a kind of feeling (*Gefühl*) and not a theoretical conviction. One can therefore see why it cannot be grounded deductively. It nonetheless remains that the theory of the Ideas he defends is profoundly opposed to his theory of knowledge. The latter is in fact fundamentally empiricist,[27] if not sensualist, and it has no place for spiritual entities such as the Ideas. I doubt that the appeal to inner feeling suffices to neutralize the lack of internal plausibility.

Whatever one thinks of this general objection, the theory of the Ideas poses a multiplicity of problems in the domain of Art. In the first place, to the extent to which knowledge of the Ideas is identical with the intuition of the fundamental forces of nature and to the contemplation of the natural species, it is difficult to connect it with artistic representations that are always *individualizing*. To illustrate what he means by "knowledge of the Ideas," Schopenhauer gives this example among others: "The ice on the window-pane forms itself into crystals according to the laws of crystallization, which reveal the essence of the force of nature that appears here, exhibit the Idea; but the trees and flowers which it traces on the pane are unessential, and are only there for us."[28] This example perfectly illustrates the problem: if the Idea is represented by the laws of crystallization, it is hard to see why this knowledge would be inaccessible to science, and especially why it would be accessible to the arts; the pictorial representation of a frosty pane can hardly pass for a revelation of the laws of crystallization!

The same goes for another example, in which Schopenhauer tells us that when one contemplates a brook, one must distinguish between the intuition of the Idea that grounds it, which is nothing other than the law of gravity incarnating itself in a liquid mass, and the "eddies, waves, and shapes formed by foam," which have only a phenomenal existence. But a landscape painter who represents a brook or rushing river certainly paints the "eddies, waves, and shapes formed by foam" more than the law of gravity!

Obviously, it might be objected that Schopenhauer means that while the artist does represent particular objects and events, through this representation, insofar as it is ecstatic, the Ideas are revealed. In the artistic symbol, as Goethe had already asserted, the particular and the universal coincide. Thus the painter, while painting the eddies and waves, is supposed to reveal in reality the Idea of gravity, of which these eddies and waves are only a phenomenal manifestation. But this explanation does not resolve all the difficulties encountered by Schopenhauer's theory of the Ideas. In fact, the view of the reality of universals he defends is particularly restrictive, since he acknowledges the existence of Ideas only for natural objects, and rejects the existence of universals corresponding to artifacts or abstract terms: there is no Idea of a bed, but only an Idea of its natural material. This being the case, any pictorial representation of artifacts *qua* artifacts is situated *de jure* outside the domain of Art. In the same way, any allegorical representation of abstract universals, for instance ethical universals, would be excluded. Let us add that if the artistic reproduction of the Ideas is limited to the representation of natural forces and natural species, all works that represent the same type of object have in fact the same content: every picture of a landscape has as its content the representation of the forces and laws of inanimate and vegetable nature, every literary mimesis has as its content the representation of the Idea of the human species. Works that can be referred to a single objectal domain are thus distinguished from one another solely by the manner in which they present their content, that is, by the individual form through which they attain the Idea. Such a view might be defensible, but unfortunately Schopenhauer's aesthetics does not provide itself with the means for conceiving this formal differentiation. In the absence of this kind of conception, which alone could allow him to conceive the individuality of works, it is hard to see how he can avoid absurd consequences such as the following: once one has seen one painted landscape one has seen them all!

We shall have occasion later on to take up two further problems connected with this determination of Art as a place where the Ideas are known. The first concerns Schopenhauer's system of the arts and more precisely the irreducibility of music to the determination of the essence of

Art; the second concerns the tranquilizing function of Art, a function it is difficult to connect with the cognitive definition just set forth. But before approaching these problems we must first consider the classification of the arts proposed by Schopenhauer.

FROM ART TO THE ARTS

In order to understand the conception of the arts that Schopenhauer defends, we must start from the fact that his aesthetics is an aesthetics of contemplation. The latter, he tells us, has two sources or conditions. First, a subjective condition, disinterestedness: we must cease to see objects as motives for our will and contemplate them as pure representations. Second, an objective condition: the object contemplated must express its Idea. However, since *every* (natural) object expresses its Idea, on the condition that we regard it disinterestedly and purely, this second condition in fact repeats the first. At most one might say that certain objects facilitate the contemplation of the Idea more than others (in that they express it more clearly), and that certain objects represent more complex Ideas than others, according to the degree of objectification of the will that they embody.

Because of the importance accorded to aesthetic intuition, the work of art possesses a derived status: "Its one source is the knowledge of Ideas; its one aim the communication of this knowledge."[29] To be fully exact: the work of art is the repetition (*Wiederholung*), the reproduction (*Reproduktion*) of the knowledge of the Ideas attained in aesthetic intuition. Thus the process of creating the work does not in itself involve specific knowledge; the knowledge of the Ideas *precedes* the work, which simply reproduces it.

An important consequence follows: the "metaphysics of Art" studies artistic activity less as the activity of creating works than as the faculty of genius giving rise to the knowledge of the Ideas that the work merely reproduces. The intuition's ability to free itself from the motivations of the will and to contemplate the Ideas in a disinterested manner, as "clear vision of the world,"[30] is nothing other than genius. Genius is the fundamental faculty from which philosophy and Art proceed: "What is properly denoted by the name genius is the predominating capacity for that kind of knowledge . . . from which all genuine works of art and poetry, and even of philosophy, proceed. Accordingly, since this has for its objects the Platonic Ideas, and these are not comprehended in the abstract, but *only perceptibly*, the essence of genius must lie in the perfection and energy of the knowledge of *perception*."[31] Specifically artistic genius resides simply in the ability to maintain itself in that state long enough to reproduce the Ideas thus intuited. In the second volume, dated 1844, Schopenhauer still expresses his skepticism regarding the possibility, even for the artist, of

maintaining oneself in the ecstatic state for a long time; whence the prefer-
ence he accords to preliminary sketches over finished canvases, the latter
generally being achieved only "through continued effort, by means of skil-
ful deliberation and persistent intention,"[32] that is, at the price of falling
away from the vision of the Ideas.

In Schopenhauer, the theory of genius (and the theory of *Phantasie*
associated with it) thus allows the formulation of an aesthetic conception
that maintains the ecstatic character of Art while skipping over the crea-
tion of the work of art, and explicitly over its artifactual aspects. But this
tendency, which becomes even stronger in Heidegger, was probably in fact
virtually inscribed in the speculative theory of Art from the outset: from
the moment that Art is defined by the specificity of a vision, of a cognitive
faculty, rather than by the specificity of a "making" that gives rise to a
formally constructed artifact, everything connected with artistic activity
proper risks being devaluated as purely technical.

To resolve the latent conflict between the philosophical conception of
Art as ontological knowledge and its status as a work, Schopenhauer
chooses a solution that will later be adopted by Heidegger: he simply de-
nies that the work of art is an artifact. We have already seen that he refuses
to grant the existence of Ideas corresponding to objects produced by
human beings. This implies that artifacts never express the Idea of the
worked form (for example, a bed never expresses the Idea of a bed—which
does not exist), which is no more than a pure *forma accidentalis*, since it
merely expresses a human concept. The sole Idea that artifacts can express
is that of their material substrate, that of their *forma substantialis*.[33] Ac-
cording to Schopenhauer's cognitive definition of the work of art, the lat-
ter is intrinsically mimetic, that is, its value is not based on its material
support, but only on its representational status, which arises from the cre-
ative action exercised on this support. Therefore it is absolutely necessary
that it *not* be an artifact, since then it would be incapable of expressing an
Idea at the representational level (which would be in this case a simple
forma accidentalis). Schopenhauer proposes this opposition between
work of art and artifact with regard to visual art, which is entirely logical
insofar as the latter makes use of natural materials. It is in fact necessary
to avoid at all costs being led to be able to consider a sculpture only as
expressing the Idea of its material (the weight of the stone, for instance):
"It is needless to say that by manufactured article no work of visual art is
meant."[34]

In reality, Schopenhauer's position is a little more complex: the opposi-
tion between mimesis and artifact does not completely correspond to that
between work of art and utilitarian product. Thus architecture tends to-
ward the artifact much more than toward the mimetic work; it constitutes
the lower limit of art. But the opposition does not thereby coincide with the

distinction between representative arts and nonrepresentative arts. In fact, music is not a mimetic art either; it is nonetheless not considered to be an artifact—on the contrary, it is art par excellence. Therefore, the definition of art's essence as mimesis coexists with an implicit hierarchy among the arts.

Thus we must distinguish in the first place between the arts that express solely the Idea of the material and the properly mimetic arts that reproduce the Ideas of the natural objects they represent (obviously ceasing thereby to express the Idea of the material they use). Landscape gardening and architecture, since they are not mimetic, belong to the first group. They merely express the Idea of their material: "Gravity, rigidity, fluidity, light, and so forth, are the Ideas which express themselves in rocks, in buildings, in waters. Landscape-gardening or architecture can do no more than assist them to unfold their qualities distinctly, fully, and variously."[35] From this, Schopenhauer deduces among other things the impossibility (!) of an architecture in wood, this material manifesting only very imperfectly the relations between weight and resistance, which are the fundamental Ideas that architecture is capable of expressing. The architectural imperfection of wood seems to be due to its vegetable nature, but it has to be noted that Schopenhauer, while very proud that only his system allows this "impossibility" to be explained, hardly grounds it.[36] Of course, he opposes his conception of architecture to Kant's formalist theory, which had seen architecture as an art of perceptual and mathematical proportions, and even to an art of ornamentation. Schopenhauer's rejection of formalism is entirely logical, since the play of proportions and symmetries is the result of a calculation: it proceeds from a purely human teleological concept, could represent only the *forma accidentalis* of a work, and thus is referable only to its status as an artifact. It nonetheless remains that as Schopenhauer defines it, architecture is very close to artifacts, since the latter also express only the Idea of their material. Since in spite of all that he considers architecture an art, it is hard to see how *other* artifacts can be excluded from the realm of art—a consequence that risks putting in question the very idea of a water-tight wall between craft-work and art that Schopenhauer, like all the representatives of the speculative theory of Art, claims is absolute. At the most one might say that in architecture, we are more interested in the *forma substantialis*, the Idea of the material, whereas we value utensils for their *forma accidentalis*, insofar as it corresponds to their utilitarian goal.

This hierarchy of the arts according to their mimetic or purely expressive character is coupled with a hierarchy according to their objects, or rather according to the Ideas reproduced. We know in fact that the Ideas correspond to the more or less complex degrees of the objectification of the will: inanimate nature, vegetable nature, animal nature, and finally

human nature. Man represents the highest degree of the will's objectifica-
tion, the one in which all becomes conscious of itself and of its perpetually
self-devouring and self-creating nature. This recognition is obviously sup-
posed to eventuate in the acknowledgement of the harmful nature of the
will and finally in its negation through an act of absolute resignation: an
ascetic resignation that only the saint can achieve. Thus man is the theme
par excellence of Art, and the arts that reproduce his Idea are the most
important. This is true of sculpture and painting, which represent the
human form; it is especially true of poetry, which represents human ac-
tions, that is, the will itself in its supreme objectification: "Therefore it is
that man is more beautiful than all other objects, and the revelation of his
nature is the highest aim of art. Human form and expression are the most
important objects of visual art, and human action the most important ob-
ject of poetry."[37]

The two hierarchies, the one based on the semiotic status (expression/
mimesis) and the one based on the objects, partially overlap, since the
nonmimetic arts are also those that express the least complex Ideas, those
of inanimate nature (architecture) and vegetable nature (landscape gar-
dening). Similarly, in the mimetic arts the genres devoted to reproducing
Ideas of inanimate or vegetable nature, for example landscape painting or
descriptive poetry, are minor genres.

Finally, the hierarchy according to the objects represented corresponds
to the distinction between arts in which the subjective condition of aes-
thetic contemplation is primary and those in which the objective condition
is primary. In the nonmimetic arts, the source of pleasure resides essen-
tially in the state of mind of the person who is contemplating them, that is,
it resides in the disinterested character of a person's attitude with regard
to what he intuits and not in the nature of the Ideas he apprehends, since
the latter, which correspond to inanimate and vegetable nature, are still
very crude. The inverse is true in the mimetic arts, where the objective
condition, that is, the clarity with which the Idea is represented, is more
important than the receiver's state of mind.

Poetry, where Schopenhauer merely adopts the triad of epic, lyric, and
dramatic poetry (concentrating essentially on the latter), poses a problem
for him not unlike that encountered by Hegel. Like Hegel, he sees intuitive
knowledge in Art; it would therefore seem logical to say that the visual arts
constitute Art par excellence. And in fact, in the supplements to the second
volume of 1844, he notes in passing that the visual arts, to the extent that
they are situated most near intuitive knowledge, embody artistic activity
in a paradigmatic way.[38] That does not prevent him from maintaining
explicitly that poetry is the highest representational art, since it is better
suited than other arts to representing the will's struggle with itself (as it
embodies itself in human conflicts). It is also poetry that, in the form of

tragedy, fulfills with the greatest power the tranquilizing function of Art (I shall return to this point). Unfortunately, in his general linguistic theory, Schopenhauer identifies language, and thus the semiotic material of poetry, with reason, that is, with the faculty of abstraction par excellence.[39] Therefore, in one way or another he must show that the poet is capable of making language more concrete. In order to do this, he develops a theory of poetic epithets that is curious, to say the least: to the extent that they always specify a generic name, they make its scope less general and thus make the concepts more concrete. But this function of epithets, far from being opposed to "everyday" usage, including scientific usage, is one of its most constant characteristics; moreover, even a concept whose extension is limited by an adjectival specification remains a concept, and thus an abstract notion. The logical specification produced by epithets thus can scarcely fulfill the function of demarcation incumbent upon it.

But these are only minor problems compared with the genuine puzzle constituted by the status of music. The latter is the supreme art, but at the same time, as Schopenhauer himself acknowledges, it cannot be integrated into his system of the arts: "It stands alone, quite cut off from all the other arts."[40] In fact, whereas Art had been defined as reproduction of the Ideas, we now learn that this definition is in no way suited to music. Music is not a mimetic art in the same sense as the other arts: "In it we do not recognize the copy or repetition of any Idea of existence in the world."[41] However, he adds, if it is an art, it must enter into a relationship between representation and represented (*Darstellung zum Dargestellten*), between copy and original (*Nachbild zum Vorbild*).[42] In order to reconcile music with this requirement, he has to admit that while it is a representation, a *Darstellung*, it is nonetheless not a reproduction of something that is on the order of a *Darstellung*, and thus it is not a reproduction of Ideas; it is a *direct presentation* of the will itself. Understand: it is not identical with the will as thing-in-itself, since the latter is the unrepresentable absolute, "which, from its nature can never be idea."[43] But it is an originary representation of the will, in exactly the same way as the Ideas.[44] Far from reproducing the Ideas, it belongs to the same order of reality as they do: "Music is as direct an objectification and copy of the whole will as the world itself . . . Music is thus *by no means like the other arts, the copy of the Ideas, but the copy of the will itself whose objectivity the Ideas are.*"[45]

This being the ontological status of music, in one way or another its structuration must be analogous to the structuration of the world of the Ideas. In other words, for Schopenhauer the specific character of music does not reside in the fact that it lacks (as Hegel thought) a genuine hermeneutic dimension; on the contrary, to the extent that he accepts the general theses of the speculative theory of Art, the fact that he grants precedence to music leads him to postulate that it is a hermeneutic system, the

only one capable of attaining the inner being of things. Whence his famous theory of the equivalence between musical facts and the structure of the universe (developed in detail in the 1844 *Ergänzungen*), a theory not lacking in charm, though hardly convincing. Thus, in the domain of harmony, the bass (the fundamental sound, *Grundton*) corresponds to the mineral realm, the tenor (with its interval, the third) to the vegetable realm, the alto (and its interval, the fifth) to the animal realm, and finally the soprano (and its interval, the octave) corresponds to man. As for the relationship between consonances and dissonances, it reflects the struggle between the forces hostile to our will and those that satisfy it (I shall return to this later). Finally, melody, which arises from the relationships between rhythm and harmony, is the moving image of human desire: "the constant disunion and reconciliation of its two elements which there takes place is, when metaphysically considered, the copy of the origination of new wishes, and then of their satisfaction."[46]

The first difficulty with this theory of music lies in its ambiguity. Thus we have just seen that music occupies the same place as the Ideas; it is therefore an immediate objectification of the will, and is opposed not only to visual art and literature, but also to the physical world, which is merely the multiple appearance that the Ideas give themselves in unfolding in accord with the principle of individuation. But Schopenhauer sometimes asserts on the contrary that there is a parallelism between this apparent world and music: "According to all this, we may regard the phenomenal world (*die erscheinende Welt*), or nature, and music as two different expressions of the same thing, which is therefore itself the only medium of their analogy."[47] But if music is an *analogon* of the world of appearance, it cannot be an *analogon* of the Ideas that are the foundation of this world: thereby it would lose its precedence over the other arts.

Moreover, if music and the Ideas are the direct expression of the will, why are they so different from each other?[48] Why isn't ecstatic contemplation a contemplation of music rather than of the Ideas? And then, how can music be connected with human faculties? How can it be brought into the human world, since it seems to be the object of an intuition (when it is ecstatic, intuition intuits only the Ideas)? All these questions remain unanswered, insofar as Schopenhauer nowhere explains how music can be both an originary expression of the will and a human product.

But the gravest problem concerns the relationship between music and the other arts. The mimetic arts, we have learned, reproduce the Ideas. Music, on the other hand, is the direct expression of the will, an expression parallel to the Ideas. But if this distinction does in fact succeed in grounding the superiority of music, at the same time it puts in question the ecstatic character of the aesthetic contemplation of the Ideas. Thus we read: "This is why the effect of music is so much more powerful and penetrating

than that of the other arts, *for they speak only of shadows, but it speaks of the thing itself.*"49 The opposition between a vision of shadows and a vision of being comes, of course, from Plato's myth of the cave. As Schopenhauer uses it here, it flagrantly contradicts his definition of Art. Moreover, when it is a question of comparing the arts, not with music, but with endoxical knowledge, he uses this same myth—on the contrary, and in accord with his definition of art—to identify artists with those who contemplate the real sun.

Why these inconsistencies and contradictions? I believe they result in large part from the fact that Schopenhauer is using two categorizations at the same time. The first is ontological in nature. It has to do with the dichotomous structure of essence and appearance: the will is the essence or being, the phenomenal world is appearance. The second is gnoseological in nature and contains three terms: the will as unrepresentable thing-in-itself, the phenomenal world as representation, and the Ideas, a middle term that is supposed to be located somewhere between the two spheres. Now this third term, which is distinct from both the thing-in-itself and phenomena, disorganizes the initial opposition between the will (essence) and the phenomenal world (appearance). Hence the status of the Ideas is unstable; seen from the point of view of the will, they constitute only a derivative order of reality, but seen from the point of view of the world of appearance, they constitute its foundation, its *Wesen*, its reality, etc. In the theory of music, this ambiguity of the status of the Ideas becomes wholly evident. By virtue of the dichotomous scheme, it is entirely normal that the definition of music as the direct expression of being should lead to a depreciation of the other arts, which are condemned to be limited to shadows, that is, to appearance. Unfortunately, this depreciation of the arts also affects the status of the Ideas. And in fact, while maintaining that music is the expression of "the inner nature, the in-itself of all phenomena, the will itself,"50 Schopenhauer says elsewhere that it "passes over the Ideas."51 But in that case, how can it be an expression *parallel* to the Ideas?

How can one escape from these difficulties? Must we admit that there is a hiatus between a reality (for example, the Ideas) and its repetition, its reproduction? If there were such a hiatus, one would understand why the nonmusical arts are inferior to music. But that would amount to depriving philosophy of its status as fundamental knowledge, since Schopenhauer defines it as well as a repetition and reproduction (of the Ideas). Sometimes he seems to envisage another solution. He maintains on several occasions that the arts are founded on a contemplation of the Ideas, to be sure, but they show these Ideas only insofar as they are embodied in individuals, and thus insofar as they present themselves in the phenomenal world. One might see in this a new justification of the claim that the visual arts and poetry refer only to shadows. Unfortunately, this solution destroys

Schopenhauer's *whole* metaphysics of Beauty, which explicitly assumes that the arts (and philosophy) achieve the *direct* intuition of the Ideas.

In reality, the contradictions cannot be eliminated for the simple reason that Schopenhauer has shut himself up in a situation from which he cannot escape. His initial theory foresees only a single conceptual place for ontological knowledge, the one occupied by the arts and philosophy. At the same time, however, this place—even though ecstatic with regard to scientific knowledge and endoxical life—nonetheless still has a defect, since it does not accede to the thing-in-itself, the will. One has the very clear impression that music is called upon to correct this defect, since it is the direct expression of the will. But this beyond-the-arts cannot fail to claim for itself alone what was earlier reserved for all the arts; it will therefore be the true ontological knowledge, to the point that Schopenhauer says that a complete philosophical explanation of music would be equivalent to an explanation of the universe. Hence the visual arts and poetry no longer achieve ontological knowledge, but must be content with a shadowy knowledge.

There are thus two conceptions of the arts in Schopenhauer's work. The first, based on the visual arts and poetry, opposes Art to science and to everyday life. Art is defined as a cognitive activity (contemplation of the Ideas) and thus shares the limitations inherent in representation, including philosophical representation, namely the impossibility of acceding to the thing-in-itself in all its purity. The second conception, based on music and valid only for the latter, opposes Art as direct expression of the thing-in-itself to representation, which is always mediated; Art is then not defined as human cognitive activity, even if that activity is ecstatic, but rather as the self-expression of the will, of the thing-in-itself. Most of the inconsistencies in Schopenhauer's theory result from the fact that he moves without warning from one to the other of these conceptions, and perhaps without always realizing it himself.

From Art as Detachment to Philosophical Wisdom

In the preceding set of considerations, I have acted as though in Schopenhauer art and philosophy shared exactly the same place, and thus had the same hierarchical position. However, more closely examined, this is not the case. Even if they proceed from the same faculty (genius as the faculty of originary intuitions freed from the motivations of the will), even if they have, in a way, the same object (the Ideas), philosophy is nonetheless elevated in relation to Art (with the exception, let us repeat, of music). This precedence accorded to philosophy is in no way legitimated by the theory of the Ideas, and one might think that Schopenhauer recognized only after the fact that this absence of legitimation was a problem: his emphasis on

the precedence of philosophy is particularly marked in the 1844 *Ergänzungen*, whereas the 1818 edition was much less explicit. According to the 1844 text, one can distinguish five arguments, of varying weight, in favor of the supremacy of philosophy:

a) The arts are interested in the "how?" of things (*"wie ist es eigentlich beschaffen?"*), whereas philosophy is interested in their "what?" (*"was ist das Alles?"*). Art is interested in the structure of beings; philosophy alone asks the question of Being as such. This assertion is in flagrant contradiction with the theory of the Ideas developed in the third Book, according to which knowledge of the Ideas, that is, Art, is an ontological knowledge that asks the question "what?"[52]

b) The arts have a purely intuitive status and hence the knowledge they yield is less serious and more evanescent than that of philosophy, which is formulated in an abstract language: "But all the arts speak solely the naïve and childish language of perception, and not the abstract and serious language of *reflection*; their answer is therefore a fleeting image: not permanent and general knowledge."[53] After reading the very passionate defense of intuition against abstraction, after learning that all knowledge is grounded in an intuition and that the most certain knowledge is that given directly in intuition, one would surely not anticipate this sudden turnabout that transforms it into a "naïve and childlike language"!

c) The arts provide only a fragmentary knowledge, and for that very reason a provisional knowledge, whereas philosophy provides a knowledge of the essence of the Universe in its totality, and thus a knowledge that is valid forever: "Their answer, however correct it may be, will yet always afford merely a temporary, not a complete and final, satisfaction. For they always give merely a fragment, an example instead of the rule, not the whole, which can only be given in the universality of the *conception*. For this, therefore, thus for reflection and in the abstract, to give an answer which just on that account shall be permanent and suffice for always, is the task of philosophy."[54] However, elsewhere Schopenhauer had insisted on the fact that aesthetic contemplation is a direct contemplation of the Ideas; it is hard to see how such a direct contemplation could be merely fragmentary (how can one have a direct and yet fragmentary contemplation of an Idea, since the latter is given in an intuition, and thus by definition in an overall apprehension?).

d) The arts give us only a virtual and implicit knowledge, whereas philosophical knowledge is actual and explicit. Thus "in the works of the representative arts (*darstellende Künste*) all truth is certainly contained, yet only *virtualiter* or *implicite*; philosophy, on the other hand, endeavors to supply the same truth *actualiter* and *explicite*, and therefore, in this sense, is related to art as wine to grapes."[55] The truths of the arts require interpretation, whereas the truth of philosophy is already interpreted.

There again, it is hard to see how this argument can be reconciled with the theory of the contemplation of the Ideas: if the artist contemplates the Ideas and if the work reproduces them, then their existence could only be actual (how could one contemplate virtual Ideas?).

e) Neither do the arts equal philosophy from the functional point of view, that is, from the point of view of man's redemption, of his freedom from the torments of the will. In the case of works of art, we are not dealing with a "lasting emancipation, but only with a brief hour of rest, an exceptional and indeed only momentary release from the service of the will."[56]

I shall not further dilate upon the first four arguments, which only increase the incoherence of Schopenhauer's positions. Generally, they parallel the reasons advanced by Hegel: philosophy has the advantage over art of abstract theory over individualizing intuition. But the last reason deserves our attention, since it introduces a new, central, and specific characteristic of Schopenhauer's version of the speculative theory of Art, a characteristic that I have thus far only touched upon. For Schopenhauer, the cognitive aspect of Art and of philosophy is not an end in itself; it is always in the service of an existential finality. Art and philosophy are lessons in wisdom: "Not merely philosophy but also the fine arts work at bottom towards the solution of the problem of existence."[57] This "problem of existence" is the self-devouring tyranny of the will: existence is synonymous with pain and suffering. It is only in man that the will finally understands itself; having understood what it is, that is, an eternally self-engendering and self-destroying drive fated to dissatisfaction and pain, the will can, in a heroic gesture, turn against itself, it can cease to will, it can accept its own demise. I do not intend to set forth here the philosophy of "it would be better that nothing existed" that constitutes the singularity of Schopenhauer's voice in the concert of postclassical philosophy and that he articulates in such a magisterial manner. It suffices to note that Art is called upon to play a role in this ascetic resignation, in this abandonment of the will to live, in the will's acceptance of its own demise. This role is that of a "tranquilizer" that frees us—at least momentarily—from the tyranny of the desires and drives; through it, we emerge from the painful dream of individuation and glimpse the peace of a definitive annihilation, Nirvana.

How can the artistic contemplation of the Ideas, and thus the knowledge of the essence of the world, lead us to detachment? Schopenhauer gives at least two different answers to this question.

The first repeats (interpreting it differently) a traditional theme: the universe represented in a work of art is only an image, a simulacrum, and thus cannot become the object of our desires or hatreds, that is, it cannot become a motive for the will. Whence the emergence of the ecstatic state constituted by disinterested contemplation: so long as we are contemplating a work of art, our volitions are bracketed.

The second answer refers not to the representational status of Art, but to its content. Insofar as the work of art represents events and actions, it pictures the torments of the will to live; it can thus enlighten us concerning the profound truth of our existence, concerning the suffering and unhappiness that are its most faithful companions, and at the same time, it leads us to detach ourselves from it, to say "no" to it. This lesson is taught us above all by tragedy: "In the moment of the tragic catastrophe the conviction becomes more distinct to us than ever that life is a bad dream from which we have to awake. . . . In this consists the tragic spirit: it therefore leads to resignation."[58] To be sure, Schopenhauer is obliged to concede that most heroes of ancient tragedies are far from showing such a spirit of resignation. That is why he grants precedence to modern tragedy: "Shakespeare is much greater than Sophocles."[59] But even when resignation is endorsed by the characters in the tragedy, their misfortunes give rise to it in the spectator: "the summons to turn away the will from life remains the true tendency of tragedy, the ultimate end of the intentional exhibition of the suffering of humanity, and is so accordingly even where this resigned exaltation of the mind is not shown in the hero himself, but is merely excited in the spectator by the sight of great, unmerited, nay even merited suffering."[60]

While this thesis may appear fairly convincing insofar as tragedy is concerned, it is hard to see how it could be made to define Art as such without obvious implausibility. In other words, this definition of the ultimate essence of Art (its tranquilizing function) is prescriptive and not descriptive. Schopenhauer himself agrees that comedy, contrary to tragedy, tends to confirm us in our will to live; the non-painful and even pleasant nature of comic conflicts leads us to accept life. Similarly, one can hardly situate the principal effect of the visual arts in the negation of the will to live without reducing sculpture to the *Laocoön* and painting to crucifixions and other tragic scenes.

In reality, here again two different conceptions of Art appear in the background: on one hand, Art as a cognitive activity, that is, as a contemplation of the Ideas (natural forces and archetypes of the natural species), of which the visual arts constitute the paradigm; on the other hand, Art as leading to detachment through the representation of conflicts of the will in their ineluctable and catastrophic aspects, with tragedy as the paradigm. The cognitive conception and the ethical conception are not radically incompatible, to be sure, but they are not reducible to each other.

The two conceptions lead, moreover, to different historical valorizations. The definition of Art as ontological knowledge is accompanied by a classicist paradigm. It is this paradigm that is postulated for architecture and sculpture. Speaking of the former, Schopenhauer asserts that it was "perfect and complete in essential matters"[61] in ancient Greece. And he

adds, including sculpture, "For in this art, as in sculpture, the effort after the ideal unites with the imitation of the ancients."[62] With painting, things become more complicated, since Schopenhauer accepts the commonplace that sees in sculpture the art of antiquity and in painting that of the Christian era. Since sculpture is also the art of beauty and grace—another commonplace—and painting that of character, of expression, and of passion, Schopenhauer concludes: "From this point of view sculpture seems suitable for the affirmation, painting for the negation, of the will to live, and from this it may be explained why sculpture was the art of the ancients, while painting has been the art of the Christian era."[63] As for literature, his position is ambiguous at best. On one hand, we learn that "classical poetry has an unconditional, romantic poetry only a conditional, truth and correctness; analogous to Greek and Gothic architecture."[64] In fact, Greek poetry expresses the "purely human," whereas romantic poetry contains conventional and artificial elements. On the other hand, however, we have seen that insofar as tragedy is concerned, modern drama—that "summit of poetical art"[65]—surpasses classical tragedy.

One might seek to reconcile the two conceptions by maintaining that the cognitive definition is the same in both cases, but the ethical effect varies. When contemplation bears on the Ideas intuited as natural forces or as models of the natural species, the effect of detachment is not produced, since the will appears solely in the form of eternal Ideas each intuited in its own individuality, and not as a conflictual power in the way it manifests itself in individuation. Therefore the effect of the affirmation of life induced by sculpture would have to do with the fact that it only represents the Idea of man as a generic being, and abstains from representing conflicts. Yet from the moment representation pictures conflicts, the effect of detachment manifests itself: this would be the case for tragedy, but also for painting insofar as it is supposed to have as its object the representation of the passions and of character.

But then a new question arises: how can we reconcile the representation of conflicts—the condition of the effect of detachment produced by Art—with the definition of aesthetic contemplation as intuition of the Ideas in the purity of their *individual* essence, that is, beyond any relationship to any alterity whatever, and thus *a fortiori* beyond any conflict? Doesn't the contemplation of the Ideas exclude the conflictual? Let us take the case of poetry. From the cognitive point of view, it can be defined as a representation of the Idea of humanity (as a natural species). Now, there can clearly be no conflict within this Idea; if there were conflict, it could only take place between the different individualizations of the Idea in the world of appearances. But if that is the case, then the representation of conflicts is merely a representation of shadows, of the phenomenal world, and not a contemplation of the Ideas. This consequence in turn proves to be incom-

patible with the definition of Art as an ecstatic cognitive activity. Thus no matter how one approaches the problem, it is impossible to integrate Schopenhauer's various assertions into a coherent conception.

In the light of the preceding, it is not surprising that the same ambiguity is found as soon as one tries to motivate the superiority of philosophy over Art. We have already seen that this superiority was both cognitive and ethical; philosophical knowledge is more adequate than aesthetic intuition, and philosophical wisdom leads us more surely to give up the will to live than does aesthetic contemplation. But Schopenhauer has not finished surprising us. In fact, at the end of the sections devoted to Art, he suddenly tells us that in reality if Art cannot be a true liberation, that is because the artist is too fascinated by the spectacle of the objectifications of the will, that is, if words retain their meaning, by the contemplation of the Ideas: "He is chained to the contemplation of the play, the objectification of will; he remains beside it, does not get tired of contemplating it and representing it in copies; and meanwhile he bears himself the cost of the production of that play."[66] In other words, instead of turning away from the will to live, the artist admires the shimmering diversity of its figures. If this is the case for the artist, one can imagine that the same holds true for the art-lover: that is why Schopenhauer concludes that, all in all, art is a consolation, a *Trost*, rather than an incitement to negate life. In other words, if I have properly understood him: far from turning us away from the will to live, Art tends to make us even more its slave, since it provides us with a (necessarily illusory) consolation!

Now, philosophy rests upon exactly the same foundation: the intuition of the essence of the world, that is, the intuition of the Ideas, even if it is in their overall structure rather than in their individuality. Why then should philosophy succeed where Art fails? Why should the presentation of the structure of the world not *also* lead to a purely contemplative fascination that, far from turning us away from the will to live, would make us admire it? Mustn't one concede that philosophy, insofar as it is founded on a contemplation—even if this is taken over by reflective knowledge—is in the same boat as Art?

All these aporias are further exacerbated in dealing with the question of music. We have already seen that it cannot be reduced to the cognitive definition of art; it is a direct *expression* of the will and not a representation of the Ideas. More than other arts, it is hard to reconcile with the definition of art as an activity leading to detachment from life. In fact, according to the theory of harmony Schopenhauer defends, every musical composition must end by a return to consonance, and thus by the expression of a satisfaction of the will. But if music is the direct expression of the structuration of the will according to the differing levels of its objectifications and if at the same time it always ends in a consonance, hence in the

expression of a satisfaction, then the expression of the essence of things (insofar as it is homologous, let us not forget, with philosophical knowledge) does not in any way lead to the negation of the will to live: it leads at least to an indifference (pleasure residing in pure contemplation) or, more probably, to an affirmation of this will (why turn away from life, if desires are represented as being ultimately satisfied?). Moreover, Schopenhauer occasionally sees in the dissonances a simple necessary ingredient making even stronger the contentment that arises from the final consonance. Dissonance would thus no longer be the expression of irreducible conflicts within the will, but simply a retarding factor, and thus an amplifying factor, of the final satisfaction: "A succession of merely consonant chords would be satiating, wearisome, and empty, like the languor produced by the satisfaction of all wishes. Therefore dissonances must be introduced, although they disquiet us and affect us almost painfully, but only in order to be resolved again in consonances with proper preparation."[67] Thus suspension is "clearly an analogue of the heightened satisfaction of the will through delay."[68]

In reality, Schopenhauer's conception of music seems to require as its complement, not his pessimistic philosophy, but rather Nietzsche's philosophy.[69] That is, moreover, what was to happen: Nietzsche took over Schopenhauer's conception of music, but made it independent of the theory defining Art as detachment, and more generally separated it from the pessimistic philosophy of its creator. In Nietzsche's work, music becomes the emblem of the will's self-affirmation (which will moreover no longer be the simple will to live—that is, to survive, Nietzsche would say—but the will to power, that is, the will to aggressive self-affirmation): "even the ugly and the disharmonic are part of an aesthetic game that the will in the eternal amplitude of its pleasure plays with itself. But this primordial phenomenon of Dionysian art is difficult to grasp, and there is only one direct way to make it intelligible and grasp it immediately: through the wonderful significance of *musical dissonance*. Quite generally, only music, placed beside the world, can give us an idea of what is meant by the justification of the world as an aesthetic phenomenon. The joy aroused by the tragic myth has the same origin as the joyous sensation of dissonance in music. The Dionysian, with its primordial joy experienced even in pain, is the common source of music and tragic myth."[70]

Thus, instead of *a* metaphysics of Art, Schopenhauer develops three different conceptions: a cognitive conception, connected with the theory of the contemplation of the Ideas and illustrated by the visual arts; an ethical conception (the effect of detachment), connected with the theory of the negation of the will to live and illustrated by tragedy; and finally an expressive conception, connected with the theory of the will as thing-in-itself and illustrated by music. Each conception no doubt has its own merits,

but it is clearly impossible to bring them together into an overall theory of Art, for the simple reason that in some of its consequences each of the three is opposed to the other two.

Why this attempt at an impossible combination of three different conceptions? I do not think the origin of this attempt is to be sought in some internal incoherence in Schopenhauer's metaphysics. Rather, it results from his will to introduce the speculative theory of Art into his own philosophical system. We have seen that the speculative theory of Art and the sacralization of Art that it implies are linked to a theological view of the world, and more precisely to a celebration of Being. Schopenhauerian pessimism, on the contrary, requires of Art that it disillusion us regarding life, and therefore it ultimately implies a condemnation of Being. However, as soon as Art is defined as the contemplation (in the visual arts) or the expression (in music) of Being, it inevitably becomes a source of pleasure; Schopenhauer himself admits that Being *contemplated* is a source of pleasure. In other words, it is hard to see how Being could be *aesthetically* condemned. In all rigor, the claim that the arts induce an attitude of detachment and eventuate in a negation of life cannot be reconciled with an *aesthetics*, but at most with an *ethics* of Art (art as a lesson in wisdom). The fact that Schopenhauer finds it impossible to think about the arts except according to the tradition of the speculative theory of Art, even though the central onto-theological theses of that theory are incompatible with his pessimistic philosophy, clearly shows how apparently self-evident the theory had become during the first half of the nineteenth century.

The Fiction of Truth and the Truth of Fiction (Nietzsche)

It is relatively easy to present Schopenhauer's theory of art; he is the author of a single book, and his ideas, at least in their main lines, scarcely changed between the first and third editions of his *magnum opus*. The same cannot be said of Nietzsche: he was a prolix writer, and his ideas were constantly in movement. Movement or contradiction? The answer is not obvious; there is, to be sure, a certain development in Nietzsche's thought, but within a single work one sometimes finds contradictions that no diachrony suffices to resolve. Must we agree with Karl Jaspers that "self-contradiction is the fundamental characteristic of Nietzsche's thought"?[71] Must we even go so far as to see in this characteristic the peculiar style of Nietzsche's philosophy, a style that is necessary because the ideas he defends are inexpressible within the framework of logic, and more generally of conceptual thought?[72] In fact, at least insofar as the problem of the theory of Art is concerned, many of the contradictions one discovers seem to be the result of conflicts between concurrent conceptions that have not been overcome rather than of agonistic positions assumed as such.

These conflicts result fundamentally from the fact that Nietzsche, while he accepts the thesis of the ecstatic and speculative character of Art, tends to replace the pathos of the truth by a theory of schematizing fictions and, starting with *Human, All Too Human*, to reject the dualistic ontology of being and appearance. Now, one may ask whether these two elements are not inseparable from the speculative theory of Art. In fact, if there is no longer a world beyond, if appearance *is* being, or if truth is nothing but a fiction necessary for life, what place can there still be for an ecstatic knowledge?

However, these issues are far from simple. In the first place, to the extent that the fate of Art is closely linked to that of philosophical knowledge, this destabilization *also* concerns philosophical discourse; if there are only appearances, if all discourse is fiction, what legitimacy can a discourse that asserts the two preceding propositions have? Hasn't Nietzsche fallen victim to self-referential inconsistency, that is, hasn't he made his own assertion impossible? Two answers are possible. One can postulate an ecstatic status for the discourse that denies all ecstatic knowledge, in other words, endow with a meta-ontological status the assertion that every ontological assertion is a fiction.[73] Or one can maintain inversely that by reducing truth to (fictionalizing) interpretations, Nietzsche does not contradict himself: his own assertion according to which all truth is only an interpretation (assertion 1) is itself only an interpretation (assertion 2).[74] The two solutions have their disadvantages: the first, by resorting to a metaphilosophy, falls into a *regressus ad infinitum*, since the status of this metaphilosophy must itself still be established; the second falls into a vicious circle, since each of the two propositions is supposed in turn to legitimate the other. However, whatever one thinks of these solutions, if the reversal operates on philosophy, it also operates on Art, which can thus recover its speculative status, even if it is reversed: if truth is only a useful fiction, then Art, by consciously assuming its fictive status and offering itself explicitly as a construction, *is the truth of fiction and thus unveils being*. In a parallel way, if the opposition between essence and appearances is void, if appearances are what "is," then Art, which is the assumed figuration of appearance, utters the truth of being.

In the second place, this inversion is accompanied by an extension of Art beyond the spheres of artistic activity proper. When Nietzsche says that truth is fiction, that also means that what man has up to now taken to be knowledge dictated by things is in reality a kind of creation; the world in which man lives is the one he has created through activity that is fictionalizing and thus artistic, secular. Artistic activity in the strict sense of the term is only a particularly striking exemplification of this general creativity. We must add that the creation of a worldview is in turn only an aspect of a more fundamental creativity of which man is no longer the subject but one of the products: universal life itself, the romantics' *menstruum univer-*

sale, is a Dionysian game, the interaction of *quanta* of the will to power, the permanent creation and destruction of apparent figures.

The conceptual field I have just sketched out appears more clearly in the texts of Nietzsche's maturity. But in a certain way it is active, and seeks to express itself, even in the earliest writings, and it does so in opposition to elements of Schopenhauerian origin that at that time still largely dominate Nietzsche's world. It would therefore be pointless to try to deny the evolution of his ideas and the ruptures that punctuate it: 1. the Schopenhauerian aestheticism of *The Birth of Tragedy* (1872); 2. the "positivist" critique of morality, religion, philosophy, and art inaugurated by *Human, All Too Human* (1878–1880) and continuing (despite obvious shifts of emphasis) up to *The Gay Science* (1882); 3. the reinterpretation of the question of art within the framework of the theory of the will to power and the eternal return in *Thus Spake Zarathustra* (1883–1884), in certain of the later texts, and more generally in the posthumously published fragments written between about 1883 and 1889, the year of his collapse.

I shall follow the line traced by these three stages of Nietzsche's evolution. But we shall soon discover that in fact one constantly encounters the same problems, even though they take different forms: the problems of adapting the speculative theory of Art to an ontological horizon that is basically foreign to it. We have already noted this phenomenon in Schopenhauer, but in Nietzsche it becomes far more acute. The tensions that result from it, from the very fact that Nietzsche never ceases to reformulate them, and never ceases to try to reduce them, once again provide striking proof of the apparent self-evidence the speculative theory of Art had acquired.

ART AS A FUNDAMENTAL METAPHYSICAL ACTIVITY

Nietzsche's first writings, from *The Birth of Tragedy* to *Wagner in Bayreuth* (*Thoughts out of Season*, IV), are put under the double sign of aestheticism and the Schopenhauerian legacy. However, at the same time one can already find in them the elements of an ontology radically incompatible with Schopenhauer's view: many of the uncertainties and ambiguities of *The Birth of Tragedy* seem to me to be explained by this conflict between two worldviews that imply conceptions of art that are also mutually exclusive.

Through aestheticism, the young Nietzsche's thought connects up in fact with the aesthetic utopianism of Jena romanticism. However, if we concentrate on the question of the utopian function of Art, there is no doubt that Nietzsche reactivates romantic pathos: the same belief in a sublimation of life through its aestheticization, and thus through a revolution in Art; the same promotion of ideal figures, for the romantics, Goethe, for

Nietzsche, Wagner; the same heuristic function granted to ancient art, which is supposed to serve as a means for determining the present tasks of Art. It goes without saying that by the simple introduction of this historical pathos, which is evident in his interpretation of Wagner's art, for example, Nietzsche is unfaithful to the lessons of his master Schopenhauer, for whom history was merely an epiphenomenon without philosophical worth, since he denied time any function of essential differentiation.[75]

Of course, the two utopias retain their own specificities.[76] Thus the young Nietzsche's admiration for Wagner is more absolute than was the romantics' admiration for Goethe. The author of *Werther* was only one of the figures announcing the aesthetic-ontological revolution to come, whereas Wagner carries on his shoulders virtually alone all the weight of the redemption of the Nietzschean world. To be sure, the young Nietzsche enlists Kant and especially Schopenhauer as well in his program of re-demption. But it is on the artist, on Wagner, that the historical task essentially falls. This comes out particularly clearly in *Wagner in Bayreuth* (1876). For example: "This new art is a prophet which sees the end approaching for other things than the arts."[77] In other words, the revolution brought about by Wagnerian music is not limited to the musical domain, or even to the vaster domain of the arts: it portends a fundamental change in man's being-in-the-world. Wagnerian opera is a song of farewell: "To us, Bayreuth signifies the morning consecration on the day of battle. We could not be done a greater injustice than if it were assumed we were concerned only with art: as though it were a kind of cure and intoxicant with the aid of which one could rid oneself of every other sickness."[78] As in Schlegel, the new art is the Archimedean lever that will make it possible to transform the world. Wagner's music sounds the funeral knell of the old world: "everything in our modern world is so dependent on everything else that to remove a single nail is to make the whole building tremble and collapse. . . . It is quite impossible to produce the highest and purest effect of which the art of the theatre is capable without at the same time effecting innovations everywhere, in morality and politics, in education and society. Love and justice grown mighty in one domain, in this instance that of art, must in accordance with the law of their inner compulsion extend themselves into other domains and cannot return to the inert condition of their former chrysalis stage."[79]

Concerning the heuristic role of ancient art, the Nietzschean point of view is obviously not the same as that of the romantics. For the latter, the ancient model was the opposite of the art to come, whereas for Nietzsche it remains the model to be reactivated. The reason for this difference lies in the fact that in Nietzsche Christianity is a foil. Making a striking parallel, he claims that Kant, Schopenhauer, and Wagner leapt over Christianity and Socraticism (which is merely a Christianity that misunderstands

itself) to reconnect directly with their Greek homologues: "Thus there are between Kant and the Eleatics, between Schopenhauer and Empedocles, between Aeschylus and Richard Wagner, such approximations and affinities that one is reminded almost palpably of the very relative nature of all concepts of time: it almost seems as though many things belong together and time is only a cloud which makes it hard for our eyes to perceive the fact."[80] Schopenhauer's conception of time as solely phenomenal, which Nietzsche adopts here with certain reservations (since he limits himself to saying that "it almost seems," *beinahe scheint es*), is clearly not consistent with the idea that the present age has entered into a decisive crisis: if time is only an illusion, then there can be neither privileged moments nor decisive crises. That is one of many examples showing how much Nietzsche still hesitates between the theories of his master and what will be his own thought. Obviously, he will have to free himself from this radically negative conception of time in order to develop his own philosophy, in which historicity conceived as the flux of life plays a central role.

Another point on which Nietzsche moves away from the romantics is the choice of the art that is supposed to announce, or rather to inaugurate, this general revolution: it is no longer poetry, but music. However, this difference is not fundamental. Nietzsche's legitimation of the superiority of music repeats that given by the romantics for poetry: like them, he opposes the abstract communication of conceptual language to pure expression. In other words, he adopts the distinction between poetic language and prosaic language, simply replacing the first term by music and the second by language as such, or rather by the current degenerate language: music alone, which is hostile to all convention, is a direct expression of human feeling. A natural language, even the language of nature, it is opposed to verbal language which, because of the importance that concepts have acquired in it, has become incapable of expressing interiority: "Man can no longer express his needs and distress by means of language, thus he can no longer really communicate at all: and under these dimly perceived conditions language has everywhere become a power in its own right which now embraces mankind with ghostly arms and impels it to where it does not really want to go. As soon as men seek to come to an understanding with one another, and to unite for a common work, they are seized by the madness of universal concepts, indeed even by the mere sounds of words, and as a consequence of this incapacity to communicate, everything they do together bears the mark of this lack of mutual understanding, inasmuch as it does not correspond to their real needs but only to the hollowness of those tyrannical words and concepts: thus to all its other sufferings mankind adds suffering from *convention*, that is to say from a mutual agreement as to words and actions without a mutual agreement as to feelings."[81] Yet music and poetry are related: poetry as the romantics conceived it was supposed to be a sort of music;[82] as for Nietzsche, he thinks poetry is the

state of language when the latter is touched by the grace of music. Whence the choice of Wagner as herald of the coming age: he is the prototype not only of the Dionysian musician, but also of the poet-musician who regenerates verbal language and makes it recover its originary state—a state in which it was not yet conceptual language, but indifferently poetry, image, and feeling, in other words, authentic expression: "Wagner has forced language to return to an original state in which it does not yet think almost anything by concepts, in which it is itself still poetry, image, and feeling."[83]

Wagner's crucial importance lies in the fact that he reactivates the great art of the Greeks, tragedy, the union of the Dionysian (music) and the Apollonian (action in dialogue). Wagnerian art is thus a total art, achieving the synthesis of the world of hearing and the world of vision, and it is the "mediator and conciliator of apparently opposed spheres, the restorer of the unity and totality of artistic power that can be neither divined nor deduced, but only shown through action."[84]

What Nietzsche's text on Wagner asserts in a programmatic mode, *The Birth of Tragedy* had already presented in a theoretical form; one would miss the essential intention of this text if one failed to situate it within the utopian aestheticism nourished by Wagnerian art. In fact, under the cover of a historical study of ancient tragedy, Nietzsche is elaborating his aesthetic-ontological program. In this text, the encounter with romanticism is not located solely at the level of aesthetic utopianism, but more fundamentally at that of ontology: it is the aesthetic categories that serve to formulate the question of being, in the sense that, as Eugen Fink notes, "the aesthetic theory of ancient tragedy elucidates . . . the essence of being in general."[85] In fact, the two fundamental principles of Greek art, the Dionysian and the Apollonian, as well as their conflictual interactions, make it possible clearly to discern the eternal combat of the two basic ontological forces constituted on one hand by the hidden *Urgrund* of being, and on the other by the equally irrepressible tendency of being toward individualization in the multiplicity of phenomena. If Apollo creates the world of man's dreams and the world of beautiful forms, he also creates the world itself in its phenomenal manifestations. Dionysus, for his part, while he annihilates men's individuality in the pure expression of the will constituted by music, also always thrusts the world of individualized phenomena into the depths of being. Thus, as in the romantics, as in the young Schelling, art is the *organon* of philosophy.

A reading of a multifaceted text like *The Birth of Tragedy* is far from easy, if only because instead of a single definition of Art we find at least four:

a) a cognitive definition: Art is an ecstatic knowledge of the inner being of the world, of its Dionysian heart;

b) an affective-ethical definition: Art is a consolation (*Tröstung*) that allows us to go on living;

c) an ontological definition: Art is a semblance, a *Schein*, an illusion;

d) a cosmological definition: Art is the game that the universe plays with itself.

Among these differing conceptions two seem difficult to reconcile, namely the first and the third: how can Art be both an ecstatic knowledge and an illusion? The most immediate answer is obviously that there is art and art, in other words, that there exist arts that are on the side of ecstatic truth, and others that are on the side of illusion. But this implies, in all rigor, that the concept of Art ceases to be a definition of essence, since it has as its referent arts having mutually exclusive finalities. Moreover, Nietzsche himself emphasizes the fact that contrary to other authors, he does not derive the arts from a single principle, but from *two* principles, giving rise to two artistic worlds "differing in their intrinsic essence and in their highest aims."[86] Yet aesthetic utopianism seems to require a unitary theory of Art. Whence a certain number of difficulties that arise in the central distinction between the Dionysian and the Apollonian.

In order to structure the opposition between the Apollonian and the Dionysian, Nietzsche uses Schopenhauer's opposition between the world of representation and the world of the will. The Apollonian is the domain of the principle of individuation, of phenomenal being, of appearances; the Dionysian, on the other hand, is the site of the unity that is beyond all representation, beyond any object and any subject. Before being artistic poles, the Apollonian and Dionysian are the two great cosmological principles. Whence a close link between human art and the universe's aesthetic game: the artistic staging of the battle between the two principles is only an aspect of the cosmic battle they are fighting against each other. The cosmic level of the battle is moreover also reflected in the world of myths: the universe of Olympian gods corresponds to the Apollonian principle, that of the Titans to the Dionysian principle. However, this battle does not oppose two independent principles; in reality, the Apollonian, the principle of the phenomenal world, *is produced* by the Dionysian, which is the sole principle of being. The Dionysian *original ground* wants to look at itself in the world of Apollonian representation, in other words, it wants to give birth to its opposite.

It is not hard to see that the difficulties will arise precisely from the attempt to identify the opposition between the Dionysian arts (music) and the Apollonian arts (representational arts) with that between the two cosmic principles defined by Schopenhauer. In the latter's work, the cosmic opposition was not identical with the distinction between the representational arts and music; thanks to the theory of the Ideas, the representational arts were also on the side of essence. Nietzsche, in contrast, to the extent that he directly identifies Apollonian art with the world of representation and does not accept the theory of the Ideas (whose *ad hoc* character

in Schopenhauer he had early on discovered), is inevitably led to diametrically oppose the two types of art. Whence, as we shall see, the difficulty of arriving at a unitary determination of tragedy, which is supposed to be a synthesis of the Dionysian and the Apollonian. Whence also, more generally, the opposition between the two conceptions of Art, according to whether the point of view is that of Apollonian art or that of Dionysian art.

But before moving on to discuss the theses concerning the arts, we must first ask how one can move from the cosmic level to the artistic level. The passage takes place, as it always does in Nietzsche, through man's affective life, *pathos* being the way he directly expresses his participation in cosmic life. In the human soul, the Apollonian is the oneiric principle, the Dionysian the principle of drunkenness. There again, the Dionysian is the central term. In drunkenness, man destroys his individuality in order to become one with the cosmos: "Under the charm of the Dionysian not only is the union between man and man reaffirmed, but nature which has become alienated, hostile, or subjugated, celebrates once more her reconciliation with her lost son, man."[87] Through Dionysian drunkenness, man becomes the receptacle into which Being as *original ground* operates. In this sense, one can say that the first work of human art is none other than man himself when he delivers himself up to Dionysian drunkenness: "He is no longer an artist, he has become a work of art: in these paroxysms of intoxication the artistic power of all nature reveals itself to the highest gratification of the primordial unity."[88]

It is from this Dionysian state, from this drunken dance, that the arts developed, and first of all music, the pure Dionysian art, the direct expression of "the inmost ground of the world,"[89] and then the different mixed arts and those that are purely Apollonian.

The specific status accorded music, its definition as a direct expression of the will, or of the originary pain (*Urschmerz*), are borrowed, to be sure, from Schopenhauer. But we can discern a number of differences: on one hand Nietzsche introduces dance alongside music; on the other, since his musical ideal is Wagnerian opera, he has to justify its recourse to language. Thus he claims that pure music would threaten to destroy us if it did not pass through the filter of language, of myth.

The art most closely related to music is lyric poetry; it arises directly from it and seeks, so to speak, a linguistic metaphor capable of expressing it. However, as soon as there is language, there is representation. In this sense lyric poetry is no longer a pure Dionysian art and includes a certain Apollonian element: "In the first place, as a Dionysian artist he has identified himself with the primal unity, its pain and contradiction. Assuming that music has been correctly termed a repetition and a recast of the world, we may say that he produces the copy (*Abbild*) of this primal unity as music. Now, however, under the Apollonian dream inspiration, this music

reveals itself to him again as a *symbolic dream image* (*in einem gleichnis-artigen Traumbilde*). The inchoate, intangible reflection of the primordial pain in music, with its redemption in mere appearance, now produces a second mirroring as a specific symbol or example (*Exempel*)."⁹⁰

Next comes tragedy: it achieves the absolute synthesis of the Dionysian and the Apollonian, of music (the chorus) and representation (dialogue), of the expression of the original heart of being and the figuration of the world of appearances. But there again, by virtue of the privileged status accorded the Dionysian, the world of Apollonian appearances is in the service of the revelation of the Dionysian truth: it is the unity of man with the originary heart of the universe that is revealed through the dream image on the tragic stage. Tragedy is thus the Apollonian figuration of the Dionysian truth.

Finally, there are the purely Apollonian arts, that is, epic poetry and the visual arts. The unification of epic poetry and the visual arts under a single category may at first seem preposterous. Just as one can easily understand that the visual arts might be qualified as purely Apollonian arts, since they are the arts of vision and of "semblance" par excellence, so the idea that epic poetry is a purely Apollonian art may at first seem arbitrary. In what way is it so different from lyric poetry, or especially from dramatic poetry? Nietzsche indicates that epic imitates "the world of appearances and images," that is, the intramundane actions of the heroes and the Olympian gods. But that is also what tragedy does, and later on we learn that the scene, dramatic action, is the properly epic aspect of drama.⁹¹ The difference would thus lie in the fact that epic is a tragedy without the Dionysian element, that is, without chorus and song. Unfortunately, we shall have occasion to see later that Nietzsche also maintains that the dramatic action itself participates in the Dionysian, namely through its catastrophe, which destroys the individuality of its heroes and thus returns them to the originary essence of being. The difference must thus also concern the level of the action: epic action is purely Apollonian, whereas in dramatic action the Apollonian element ultimately rejoins the Dionysian essence. But in that case, the Apollonian could no longer be purely and simply identified with representation as such; it would be determined by the specific nature of the action represented.

We have seen that the Dionysian world corresponds to the essence of being, and thus to truth, whereas the Apollonian world is the world of appearances. But then what happens to the cognitive function of Art, which is so important in the tradition of the speculative theory of Art to which the young Nietzsche belongs?

In many passages of *Birth of Tragedy*, Nietzsche undeniably defends a cognitive theory of Art. More precisely, he defines it, in accord with the tradition of the speculative theory of Art, as ecstatic knowledge. Thus as

	Dionysian	Apollonian
ontological level	will to be	representation appearance
mythological level	world of the Titans	Olympian gods
psychological level	drunkenness	dream
artistic level	(dance) music	visual arts
	lyric poetry	epic
	drama	
	chorus	dialogue

early as the preface addressed to Richard Wagner, he tells us that Art is the "truly metaphysical activity."[92] If that is the case, it must reveal a truth of an ontological order. But what art is capable of attaining this ecstatic knowledge? The purely Apollonian arts are excluded at the outset, if it is true that the Apollonian is the domain of semblance and illusion. *A priori* it is music, the pure Dionysian art, that should be the paradigmatic art. But here we encounter the same difficulty as in Schopenhauer: (pure) music can hardly be described as knowledge, since it has no genuinely representational dimension. Rather than knowledge of what constitutes the essence of being, it is its ineffable expression, the "inchoate, intangible reflection of the primordial pain."[93] Lyric poetry, which is representative, seems to lend itself better to a cognitive definition, and Nietzsche emphasizes that it expresses not the artist's subjectivity but rather the truth of being. The lyric genius sees "the basis of things":[94] "The 'I' of the lyrist therefore sounds from the depth of being."[95] But the art that is truly central from the cognitive point of view is tragedy: it is "the fundamental knowledge of the oneness of everything existent, the conception of individuation as the primal cause of evil, and of art as the joyous hope that the spell of individuation may be broken in augury of a restored oneness."[96] Tragedy is thus indeed a cognitive activity, and the "tragic knowledge" (*tragische Erkenntnis*) it transmits is of an ontological order, since it reveals the essence of Being. To the extent to which Nietzsche conceives the opposition between unity of being and individuation as an opposition between essence and appearance, it is not surprising that his interpretation

of the cognitive significance of the tragic catastrophe coincides with Hegel's: "The misfortune in the nature of things, which the contemplative Aryan is not inclined to interpret away—the contradiction at the heart of the world reveals itself to him as a clash of different worlds, e.g., of a divine and human one, in which each, taken as an individual, has right on its side, but nevertheless has to suffer for its individuation, being merely a single one beside another. In the heroic effort of the individual to attain universality, in the attempt to transcend the curse of individuation and to become the *one* world-being, he suffers in his own person the primordial contradiction that is concealed in things, which means that he commits sacrilege and suffers."[97]

The problem here, as the reader will have noted, is that this determination of the arts according to their cognitive function is very hard to reconcile with their division according to the two poles of the Dionysian and the Apollonian. Whence a certain number of ambiguities, particularly as regards the definitions of music and tragedy.

Let us begin with the situation of music. As I have already said, while the Dionysian represents the pole of being and the Apollonian the pole of appearances and illusion, it is music that is supposed to be the speculative art par excellence. And in fact Nietzsche sometimes opposes music to drama: "music is the real idea of the world, drama is but the reflection of this idea, a single silhouette of it. . . . Even if we agitate and enliven the figure in the most visible manner, and illuminate it from within, it still remains merely a phenomenon from which no bridge leads us to true reality, into the heart of the world."[98] Only music can speak (*reden*) of "the most universal facts."[99] Yet because of its proximity to the essence of being, it is both ineffable (*bild und begrifflos*) and—when it is not mediated by speech—unbearable. It thus needs speech, not only so that it can be borne by man, but also in order to explain and exemplify itself. To become speculative knowledge in the strong sense of the term, the Dionysian has to resort to Apollonian representation: it if is beyond all representation, it is nevertheless only through representation that it can know itself. It is in this sense that the supreme art is not pure music, but rather tragedy, it being understood that for Nietzsche the musical element constitutes the foundation and heart of tragedy, as is shown by the complete title of the first edition of the text we are currently discussing: *The Birth of Tragedy from the Spirit of Music* (*Die Geburt der Tragödie aus dem Geiste der Musik*).[100]

What is the precise relation between the Dionysian and the Apollonian in tragedy? Initially, Nietzsche maintains that the two elements correspond to two different components of drama: dialogue is on the side of the Apollonian, the chorus on the side of the Dionysian. But if drama is supposed to be a synthesis, the two elements have to interact; it is through the

final catastrophe, and thus through an element of the action, that this interaction takes place. More generally, the Dionysian makes use of the Apollonian to arrive at a representation of itself: the chorus disburdens (*entladet*) itself in the world of the Apollonian image, and thus in dialogue. Tragedy's overall effect is thus Dionysian rather than Apollonian in nature: "In the total effect of tragedy, the Dionysian predominates once again. Tragedy closes with a sound which could never come from the realm of Apollonian art. And thus the Apollonian illusion reveals itself as what it really is—the veiling during the performance of the tragedy of the real Dionysian effect: but the latter is so powerful that it ends by forcing the Apollonian drama itself into a sphere where it begins to speak with Dionysian wisdom and even denies itself and its Apollonian visibility."[101] The tragic action "leads the world of phenomena to its limits where it denies itself and seeks to flee back again into the womb of the true and only reality."[102] Or, as Nietzsche also puts it, the scene with its action is only a vision produced by the Dionysian chorus, a vision through which it represents what is beyond all representation.

The idea is repeated in another form when Nietzsche is discussing Wagnerian drama, the contemporary form of tragedy. Here, myth is the central idea. We already know that myth's function is to protect us against the destructive force of music as pure Dionysian expression. But at the same time the latter transmits to it its metaphysical dimension: "The myth protects us against the music, while on the other hand it alone gives music the highest freedom. In return, music imparts to the tragic myth an intense and convincing metaphysical significance that word and image without this singular help could never have attained."[103] Thus we can bear Dionysian expression only through the image—the *Gleichnis*—of tragic myth, which tears us away from the unbearable reflection and echo (*Widerklang*) of the *universalia ante rem* or of Being, which is music.[104]

The central function of tragic arts thus seems to be a kind of ecstatic knowledge. It no doubt also has an affective dimension, but this does not consist in an illusory consolation such as that provided by the Apollonian veil that conceals "the horrors of the night."[105] On the contrary, it is ecstatic knowledge itself that has a consolatory function: the truth consoles us because it shows us that the flux of life is indestructible, that it is only the particular, apparent figures that are destroyed: "Dionysian art, too, wishes to convince us of the eternal joy of existence: only we are to seek this joy not in phenomena, but behind them. We are to recognize that all that comes into being must be ready for a sorrowful end; we are forced to look into the terrors of the individual existence—yet we are not to become rigid with fear: a metaphysical comfort tears us momentarily from the bustle of the changing figures. We are really for a brief moment primordial being itself, feeling its raging desire for existence and joy in existence."[106]

However, at other moments Nietzsche emphasizes instead the existence of an opposition between the Apollonian and the Dionysian within tragedy. The Apollonian is not only the necessary mediation of tragic knowledge, it *battles against* the Dionysian element: it seeks to "restore the almost shattered individual with the healing balm of blissful illusion."[107] The "blissful illusion" consists in the fact that where in reality it is the will as *original ground* that is acting, we see only individual actions: "thus the Apollonian tears us out of the Dionysian universality and lets us find delight in individuals."[108] This function of the Apollonian element is particularly obvious in the purely Apollonian art of the visual arts: "here, Apollo overcomes the suffering of the individual by the radiant glorification of the eternity of the phenomenon: here beauty triumphs over the suffering inherent in life; pain is obliterated by lies from the features of nature."[109]

In any case, man needs the "sovereign illusion" of the Apollonian in order to live: "This is the true artistic aim of Apollo in whose name we comprehend all those countless illusions of the beauty of mere appearance that at every moment make life worth living at all and prompt the desire to live on in order to experience the next moment."[110] Now, this tendency is also active in the art of tragedy. Thus we learn that tragic knowledge, that is Dionysian revelation, can be endured only on the condition that it is accompanied by the "remedy and . . . preventative" of art.[111] This reminds us of the assertion according to which music can be endured only if it passes through myth, through representation in language. The problem is that Nietzsche has earlier maintained that the Dionysian dimension of tragedy, and thus the revelation of ecstatic truth, is itself a source of pleasure and consolation: why then in this case does it still need the remedy and preventative provided by the Apollonian element?

The ambiguity of the status of the Apollonian element in tragedy lets us discern two opposed conceptions: Art as ecstatic knowledge and Art as consolatory illusion. To be sure, Nietzsche tries to reconcile the two by referring them to different arts. But insofar as he identifies ecstatic knowledge with the Dionysian and illusion with the Apollonian, and especially insofar as the Dionysian is the truth, but ineffable, whereas the Apollonian is the representation, but illusory, the place where *the truth would manifest itself* becomes very difficult to determine, since it has to combine truth and representation, and thus exclude the ineffable aspect of the former and the illusory aspect of the latter. The theory of tragedy is nothing other than an attempt to resolve this problem and to find this contradictory place.

That is not all: as if the situation were not already murky enough, Nietzsche defends a third conception according to which *only illusions exist.* He distinguishes three principles of illusion: the Socratic pleasure of knowledge, which hopes (in vain) to be able to heal the "eternal wound of

existence"; the arts, "those veils of beauty"; and finally, the metaphysical consolation that makes us believe that "beneath the whirl of phenomena eternal life flows on indestructibly."[112] According to this conception, the opposition between the visual arts and tragedy or music collapses, since even the pleasure connected with the Dionysian discovery of the indestructible nature of life is only an illusion. But in that case the opposition between the Dionysian and the Apollonian ceases to be pertinent, or at least it can no longer be interpreted as an opposition between the world of essence and the world of appearances.

This conception, according to which the opposition between essence and appearances is inoperative because in any case the world *as such* is only a fictionalizing construction of the will, prefigures the theses Nietzsche was to defend with particular vigor at the time of *Thus Spake Zarathustra* and the fragments devoted to the will to power.

There are at least three reasons for all these ambiguities. One is properly theoretical: Nietzsche is caught between a Schopenhauerian ontology that implies a dualism of appearance and essence, on one hand, and on the other, his own later position according to which the opposition between appearance and essence is meaningless: the world is what appears and there is nothing beyond it. The second reason, although connected with the first, is of an axiological order: in Schopenhauer's ontology the world of appearances is devalorized with respect to the true world, which is that of the unpresentable will; but from *The Birth of Tragedy* onward, Nietzsche tends on the contrary to valorize the world of appearances against the "worlds-beyond" postulated by the metaphysical tradition. Finally, the third reason: in at least one passage he outlines what will be his most radical thesis of the 1880s, namely that there is no reality, nor any truth that could correspond to it, and that there are only the will's fictionalizing interpretations.

The speculative theory of Art, in the strict sense of the term, is possible only if the Dionysian domain is that of the ultimate truth of being and if the arts have access to this domain. An initial difficulty thus arises from the fact that some arts are connected with the Apollonian world, which is the world of appearances. The distinction between a cognitive and an affective-ethical conception of art makes it possible to escape this difficulty at a first level, at the price of sacrificing the unity of Art. But at the same time a new difficulty arises: because of his aestheticism, Nietzsche valorizes Art as such, and thus Apollonian art as well, and consequently the domain of appearance and illusion. What counts from this point of view is now less the consolatory function of Apollonian illusion than its creative aspect. Nietzsche has only to definitively abandon Schopenhauer's ontological dualism in order to valorize fiction and illusion as such, that is, as works of art. The Dionysian nonetheless does not yield to the Apollonian:

it will cease to be interpreted as the essence of being that has to be known through ecstatic knowledge; under the name of the "will to power" it will be transformed into an energetic principle of the production of Apollonian fictions. Whence a paradoxical renascence of the speculative theory of Art, as we shall see later on. Between these two stages there is a period, often described as "positivist," during which Nietzsche totally abandons the identification of art with the principle of truth, reserving the latter for scientific knowledge. Concomitantly, he rejects Schopenhauerian dualism in favor of a unitary, phenomenal view of being. It is to this intermediary period that we must now turn our attention.

<div align="right">THE GENEALOGY OF ART</div>

In *Human, All Too Human* (1878–1880) and the writings that followed it, Nietzsche inaugurated his great critique and destruction of values. We must add that this was a critique of established values, and not a battle against value as such, since to the values he rejects he opposes others that he promotes. Morality, religion, metaphysics, and art: these are the idols elevated to the pinnacle by the history that he sets out to destroy by describing their anthropological and psychological genealogy. Later on he ends up suspecting that truth itself is merely the supreme idol, and this introduces a final, fundamental upheaval in his thought. But at the time with which we are concerned here, he is not yet formulating such suspicions; on the contrary, disinterested truth has never been exalted more than in *Human, All Too Human*.

It is by virtue of this pathos of truth that art is manhandled, along with the belief in universal and intangible moral values, belief in God, and the postulate of metaphysical worlds beyond. In other words, Nietzsche strips art of its cognitive function. At the beginning of *Human, All Too Human* he puts us on notice: "It is probable that the objects of religious, moral, and aesthetic sensations belong only to the surface of things, while man likes to believe here at least he is in touch with the world's heart."[113] This probability will soon turn into a certitude: "with religion, art, and morality we do not touch upon the 'nature of the world in itself'; we are in the realm of ideas, no 'intuition' can take us any further."[114] And a little further on he opposes religion and art to *Science*, explaining that "These [religion and art] are, to be sure, a blossom of the world, but they are certainly not *closer to the roots of the world* than the stem is: they provide us with no better understanding of the nature of things at all, although almost everyone believes they do. It is *error* that has made mankind so profound, tender, inventive as to produce such a flower as the arts and religions. Pure knowledge would have been incapable of it."[115]

To gauge the upheaval thus brought about in relation to *The Birth of*

Tragedy, it suffices to see the status henceforth accorded to music: it completely loses its hermeneutic function as a direct expression of the essence of being. From now on, it is a simple formal arrangement of sounds: the pleasure it gives us is connected with this arrangement. If in spite of everything we assume that music has a symbolic content, that is because, given its secular link with the art of speech, we associate musical traits with the poetic contents that usually accompany them. These associations end up becoming so strong that they persist even when music dispenses with words: "'Absolute music' is either form in itself, at a primitive stage of music in which sounds made in tempo and at varying volume gave pleasure as such, or symbolism of form speaking to the understanding without poetry after both arts had been united over a long course of evolution and the music form had finally become entirely enmeshed in threads of feeling and concepts. . . . In itself, no music is profound or significant, it does not speak of the 'will' or of the 'thing in itself'; the intellect could suppose such a thing only in an age which had conquered for musical symbolism the entire compass of the inner life. It was the intellect itself which first *introduced* (*hineingelegt*) this significance into sounds."[116] However, Nietzsche continued to acknowledge the spellbinding power of Wagnerian music. But this spell, far from leading to Dionysian drunkenness, merely diminishes manly strength: "'*Cave musicam*' is to this day my advice to all who are man enough to insist on cleanliness in things of the spirit; such music unnerves, softens, feminizes, its 'eternal womanly' draws *us*—downwards!"[117]

This overthrow of the speculative theory of Art implies a fundamental ontological reorganization. To be sure, at first Nietzsche's position is still equivocal. In some aphorisms, while denying art access to an *original ground*, he continues to maintain that there *exists* such a transcendent originary foundation, and thus a duality between appearance and essence. If, as he asserts in one of the aphorisms quoted above, the objects of aesthetic feeling belong to the "surface of things" (*Oberfläche der Dinge*), there must also exist a dimension deeper than this surface. Similarly, when he says that art is far from the roots of the world, he goes on: "Anyone who unveiled to us the nature of the world would produce for all of us the most unpleasant disappointment. It is not the world as thing in itself, it is the world as idea (as error) that is so full of significance, profound, marvelous, and bearing in its womb all happiness and unhappiness."[118] All these assertions presuppose an ontological dualism, and if they reflected Nietzsche's true perspective, they would in fact constitute a simple reversal of the terms within an ontology that would itself remain fundamentally dualistic.

In reality, this dualistic Schopenhauerian ontology proves to radically irreconcilable with his new conception of truth, which he no longer sees as

speculative knowledge bearing on worlds beyond, but on the contrary a critical analysis of phenomena as they are given to us. In the later section entitled "The Wanderer and His Shadow" we read: "We must again become *good neighbors to the closest things* and cease from gazing so contemptuously past them at clouds and monsters of the night."[119] Countless other aphorisms in *Human, All Too Human*, *Daybreak*, and *The Gay Science* hammer home the same idea: the only truth is that of things near us, of this world, because this world is the only one that exists. It is a changing world, in constant movement; if there is no transcendent world there can be no absolute truth, either: "everything has become: there are *no eternal facts* [*Tatsachen*], just as there are no absolute truths."[120] Thus there is no longer any place for ecstatic artistic knowledge, for privileged access to a transcendent world; the Schopenhauerian theory of aesthetic intuition amounts only to "ecstatic reveries."[121] In order for art to be ecstatic knowledge, certain "metaphysical postulates" would have to be accepted, for example, the one concerning the constancy of objects and characters and especially the one that claims that our visible world is merely apparent: "These presuppositions are, however, false."[122] The supposedly ultimate "world" revealed by art is not a transcendent reality but a fiction, a mirage that counterfeits the real—that is, the phenomenal—world.

The scientific ideal in accord with which Nietzsche wants to govern his own analyses is thus the ideal of the positive sciences, that of "truths that are the outcome of cautious reasoning"[123] and "simple and sober methods and results."[124] Thus metaphysical, moral, and religious speculation must be replaced by a genealogical anthropology and psychology, that is, by an analysis of the genesis and foundation of these speculations. It is no longer a matter of sounding the abyss of transcendence, but rather of analyzing how men have come to postulate such an abyss. The analysis proposed is a genealogy *ab inferiori*:[125] Nietzsche maintains in fact that the ultimate foundation of all values and all transcendent worlds is found in the reality of human drives, in human vital needs. They do not arise from intelligence but from need (*Bedürfnis*). But "Hunger is no proof that the food that would satisfy it *exists*, although it desires the food."[126] That holds not only for moral and religious propositions, but also for more elementary metaphysical propositions that have become so useful and even indispensable for us that we no longer even question their status. There are errors that are necessary for us to live, such as the following elementary beliefs: "that there are enduring things, that there are equal things; that there are things, substances, bodies; that a thing is what it appears to be; that our will is free; that what is good for me is also good in itself."[127]

This vital necessity of errors also reveals *a contrario* to what extent the concern for truth runs counter to human nature: what leads men to elaborate world views is pleasure and displeasure—two motivations that accept error and illusion very willingly.[128]

The desire for truth is born much later than the generic capacity to interpret the world. And for Nietzsche, the battle between the two principles is far from over, even if the desire for truth has also turned out to be a "life-preserving power": "Compared to the significance of this fight, everything else is a matter of indifference: the ultimate question about the conditions of life has been posed here, and we confront the first attempt to answer this question by experiment. To what extent can truth endure incorporation? That is the question; that is the experiment."[129]

Along with religion, morality, and metaphysics, art is one of the activities that postulate transcendent worlds beyond, to which they claim to have privileged access. But since there are no worlds beyond, these activities merely construct imaginary worlds. Thus the genealogical method must also be applied to art: "In the case of everything perfect we are accustomed to abstain from asking how it became: we rejoice in the present fact as though it came out of the ground by magic. . . . The science of art has, it goes without saying, most definitely to counter this illusion and to display the bad habits and false conclusions of the intellect by virtue of which it allows the artist to ensnare it."[130]

This genealogy of art has three main aspects: an analysis of its vital function, an analysis of its evolutionary function, and a psychology of the artist.

a) The function of art is not cognitive, but purely affective: its goal is to reduce our vital power. It goes about this in three ways.

In the first place, it presents reality to us other than it is. It makes it more attractive by concealing it behind the veil of beauty: "Art makes the sight of life bearable by laying over it the veil of unclear thinking."[131] But it also confers on it a greater depth and endows it with an imaginary meaning. It thus protects us against truth: "*What one should learn from artists.* —How can we make things beautiful, attractive, and desirable for us when they are not? And I rather think that in themselves they never are. Here we could learn something from physicians, when for example they dilute what is bitter or add wine and sugar to a mixture—but even more from artists who are really continually trying to bring off such inventions and feats. Moving away from things until there is a good deal that one no longer sees and there is much that our eye has to add if we are still to see them at all; or seeing things around a corner and as cut out and framed; or to place them so that they partially conceal each other and grant us only glimpses of architectural perspectives; or looking at them through tinted glass or in the light of the sunset; or giving them a surface and skin that is not fully transparent—all this we should learn from artists while being wiser than they are in other matters. For with them this subtle power usually comes to an end where art ends and life begins; but we want to be the poets of our life—first of all in the smallest, most everyday matters."[132]

In the second place, in its ludic character, art is a "cult of the untrue"

that is no longer imposed but freely accepted. This leads us to accept more easily the inevitability of the false in life, when scientific knowledge causes us to discover it: "If we had not welcomed the arts and invented this kind of cult of the untrue, then the realization of the general untruth and mendaciousness that now comes to us through science—the realization that delusion and error are conditions of human knowledge and sensation— would be utterly unbearable. *Honesty* would lead to nausea and suicide. But now there is a counterforce against our honesty that helps us to avoid such consequences: art as the *good* will to appearance. . . . As an aesthetic phenomenon existence is still *bearable* for us, and art furnishes us with eyes and hands and above all the good conscience to be *able* to turn ourselves into such a phenomenon."[133] In other words, by giving us an example of a free acceptance of the untrue, art suggests that we consider our life as a work of art in turn. What Nietzsche here still invites us to conceive only as sort of *"als ob"* in analogy to art, so that we might not be disgusted by the inevitability of the untrue, will soon be transformed—within the framework of the theory of the will to power—into a positive characteristic of life: life is the creation of fictions.

Finally, a third characteristic connected with the representative nature of the arts: the arts lead us to look disinterestedly on things, to detach ourselves from them and to experience them solely as spectacle. In this sense art is after all a preparation for the purely observational state of mind that is that of the scientific thinker: "it [art] has taught us for thousands of years to look upon life in any of its forms with interest and pleasure, and to educate our sensibilities so far that we at last cry: 'life, however it may be, is good!' This teaching imparted by art to take pleasure in life and to regard the human life as a piece of nature, as the object of regular evolution, without being too violently involved in it—this teaching has been absorbed into us, and it now reemerges as an almighty requirement of knowledge. One could give up art, but would not thereby relinquish the capacity one has learned from it. . . . The scientific man is the further evolution of the artistic."[134]

b) From the point of view of its evolutionary function, art corresponds to the childhood of humanity, the stage of magical thought in which people saw gods and demons all around them and endowed nature with a soul.[135] Its function was to beautify nature as long as humanity was not yet strong enough to face up to it. In this sense it is still turned toward the past, and is opposed to the *Aufklärung* achieved by the scientific mind. More specifically, Nietzsche asserts that art still has a tendency to take up the torch of religion when the latter is in decline: "Art raises its head where religions relax their hold. It takes over a host of moods and feelings engendered by religion, lays them to its heart and itself grows more profound and soulful, so that it is now capable of communicating exultation and

enthusiasm as it formerly could not."[136] The view that sees ecstatic knowledge in art is thus intimately connected with a body of erroneous beliefs, and when these beliefs are no longer accepted, art itself loses its metaphysical function: "the artists of all ages . . . are the glorifiers of the religious and philosophical errors of mankind, and they could not have been so without believing in the absolute truth of thee errors. If belief in such truth declines in general, if the rainbow-colors at the extreme limits of human knowledge and supposition grow pale, that species of art can never flourish again which, like the *Divina Commedia*, the pictures of Raphael, the frescoes of Michelangelo, the Gothic cathedrals, presupposes not only a cosmic but also a metaphysical significance in the objects of art. A moving tale will one day be told how there once existed such an art, such an artist's faith."[137] This is also the case for modern music, from Palestrina to Wagner: born of the Counter-Reformation, it put itself in the service of religious transcendentalism and thus constitutes a genuine Counter-Renaissance.[138] Thus art, or at least Art (that is, art insofar as it is assumed to have a metaphysical function) is a thing of the past, and Nietzsche—like Hegel—announces its death: *"Evening twilight of art.* —Just as in old age one remembers one's youth and celebrates festivals of remembrance, so will mankind soon stand in relation to art: it will be a moving recollection of the joys of youth. Perhaps art has never before been comprehended so profoundly or with so much feeling as it is now, when the magic of death seems to play around it."[139] However, the two philosophers do not give the same reason for this death: whereas for Hegel the metaphysical function of Art is taken over by philosophy, Nietzsche maintains that speculative Art dies because metaphysical thought itself is henceforth impossible. Of course, the fact that the arts' metaphysical function and more generally their cognitive function have been revealed to be illusory, does not cause them to lose all function, since it is solely on that condition that they can be practiced and experienced for what they are: fictional games magnifying life.

c) The genealogy is also a psychology of the artist. From the point of view of its informational content, art is not a direct expression of the *original ground*, it is not an *organon* of metaphysical knowledge, but rather "the artist's self-presentation."[140] At the same time that he emphasizes the psychological dimension of art, Nietzsche turns away from questions concerning the nature of the different arts or genres. This is because general notions no longer have any ontological reality for him: there are only individual works produced by individual artists. Whence the importance of the psychological genealogy as the *ratio essendi* of the works. Yet works are not what primarily occupies him: he is especially interested in the psychological mechanisms of creation and the specific psychological type represented by the artist.

The analysis of artistic creation passes by way of a critique of the cult of genius and the concomitant idea of a specifically aesthetic intuition: "The belief in great, superior, fruitful spirits is not necessarily, yet nonetheless is very frequently associated with that religious or semireligious superstition that these spirits are of suprahuman origin and possess certain miraculous abilities by virtue of which they acquire their knowledge by quite other means than the rest of mankind. One ascribes to them, it seems, a direct view of the nature of the world, as it were a hole in the cloak of appearance, and believes that, by virtue of this miraculous seer's vision, they are able to communicate something conclusive and decisive about man and the world without the toil and rigorousness required by science."[141] The necessity of resorting to a faculty of mystical intuition becomes superfluous as soon as one ceases to maintain that art provides speculative knowledge. *All* human activities are complicated and astonishing, and not only the artist's, which moreover does not differ essentially from that of the inventor, the astronomer, the historian, or the military strategist. In every case, the mental aptitudes are the same: an ability to concentrate for a long time on a single object, the patient search for the appropriate means, learning from models of excellence, etc.[142] Thus Nietzsche emphasizes the artisanal aspect of artistic creation: talent is the result of work, of a "workman's seriousness" (*Handwerker-Ernst*). He gives the example of the short story: to write good short stories presupposes not so much innate talent as long practice with a view to mastering the craft.[143] Just as important is the activity of judgment that allows the artist to sift through his ideas or combine them: "In reality, the imagination of a good artist or thinker is productive continually, of good, mediocre and bad things, but his *power of judgment*, sharpened and practiced to the highest degree, rejects, selects, knots together; as we can now see from Beethoven's notebooks how the most glorious melodies were put together gradually and as it were culled out of many beginnings."[144] As for a work's degree of unity, this results not from any internal organic necessity but from rational calculation. Thus the formal necessity of a work is never more than relative: "The forms of a work of art which express the ideas contained in it, its mode of speech that is to say, always have something easy-going about them, like all forms of speech."[145]

Whereas the analysis of creative procedure leads to a critique of the theory of genius, the analysis of the artistic personality seeks to explain such a theory by reference to the psychological characteristics artists tend to adopt, and also to explain why they are so quick to believe in a metaphysical function of art. It is because—just as art corresponds to the childhood of humanity—the psychology of the artist is an infantile psychology: "The artist is himself already a retarded being, inasmuch as he has halted

at games that pertain to youth and childhood";[146] "he has remained a child or a youth all his life, stuck at the point at which he was first assailed by his drive to artistic production; feelings belonging to the first stages of life are, however, admitted to be closer to those of earlier times than to those of the present century. Without his knowing it, his task becomes that of making mankind childlike; this is his glory and his limitation."[147]

In conclusion, it seems clear that the ideas Nietzsche defends at this period not only collide directly with the fundamental premises of the sacralization of Art, but are also determined to destroy them (through the genealogical analysis of the artistic world). That said, this rejection of the speculative theory is only a secondary aspect of a broader critique that is essentially concerned with morality and metaphysics. More fundamentally: the rejection of the sacralization of Art is only one of the consequences of the rejection of the dualistic ontology of appearance and essence whose principal victims are religion, morality, and metaphysics. Whence a fundamental ambiguity: one is not always sure whether Nietzsche is criticizing the speculative theory of Art—that is, a certain conception of art—or art itself.

The problem arises from the fact that the association of religion, ethics, metaphysics, and art is itself one of the basic assumptions of the speculative theory. Now, in his critiques, Nietzsche never challenges this association, which is nevertheless extremely suspect, since it amalgamates three (assertive or prescriptive) discourses with a set of creative practices. Not realizing that the first fatal step taken by the speculative theory of Art resides in this reduction of the arts (and their ontological, semiotic, and functional multiplicity) to a discursive structure concurrent with or complementary to discourse on the World, God, or the Good, Nietzsche does not always succeed in disengaging himself from it. To be sure, the amalgam of the speculative theory of Art and art, of the discourse on the object and the object of which it speaks, is not permanent: often, as we have seen, Nietzsche distinguishes between the function accorded to art (by one theory or another) and actual artistic activities. But in many aphorisms he attacks art, whereas in reality his criticisms bear solely on the speculative theory. Thus the idea according to which the worlds created by art are supposed to be truer than the world of appearances in which we live is a postulate of the speculative theory of Art, and not an assertion intrinsically inseparable from artistic practice. Moreover, for several centuries artistic practices got along very well with the contrary theory, according to which the worlds created by art are less real than the world in which we live. The ambiguity is also found in the genealogical analysis of the evolutionary function of art: Nietzsche projects the speculative theory of Art onto the art of the past, that is, against all historical evidence he presupposes that in

the past art was unanimously considered and practiced as an ecstatic cognitive activity, which leads him to think that it is art that has to be reformed rather than the speculative theory that has to be abandoned. But the most serious consequence of this ambiguity lies in the fact that he can free himself from the speculative theory of Art only by inverting it, that is, by maintaining that art is a travesty of reality. Yet it is the very notion of Art as a permanent object, identical with itself through the different arts and through time, having a fixed natural function, that should be the object of the genealogical critique of general terms.

Thus in this "positivist" period Nietzsche does oppose the speculative theory of Art, but insofar as he continues to use uncritically *the notion of Art*, he remains a prisoner of its problematics. He cannot displace it, but only overthrow it. The fact that it triumphs anew—even if in a paradoxical form—in the writings devoted to the will to power is thus not so surprising as it at first glance appears.

<div align="right">ART AND THE WILL TO POWER</div>

The period inaugurated by *Human, All Too Human* was put under the sign of *Science* and of the truth at any price; whence the denunciation of idols. However, at the beginning of the fifth book of *The Gay Science*, entitled "We Fearless Ones," Nietzsche sets forth a thesis that is full of consequences for his future orientations: "science also rests on a faith; there simply is no science 'without presuppositions.' The question whether *truth* is needed must not only have been affirmed in advance, but affirmed to such a degree that the principle, the faith, the conviction finds expression: '*Nothing* is needed *more* than truth, and in relation to it everything else has only second-rate value.' "[148] What is the source of this will to truth? Does truth arise from the will to avoid misjudging (reality), not to go astray or be mistaken, or does it arise from the will not to lead others into error, not to deceive anyone? If the will to truth is simply a will not to be mistaken with regard to reality, science is in fact only an exercise in prudence. But in that case the will to truth could not be absolute, since some errors are vital. Nevertheless, the demand for truth is presented as absolute. Therefore it must be governed by the second motive, the will not to deceive anyone (including oneself). In other words, it is governed by a *moral* motive. Hence the suspicion attached to any moral value will also be attached to this one: why will the truth rather than illusion? Isn't the truth one of the powers directed against life, isn't it a will to death?[149]

To some extent, this suspicion had long haunted Nietzschean thought. But over the years it made its weight increasingly felt. We must note that in itself it does not imply any epistemological challenge to the concept of truth, but concerns only its *utility*. At the time of *Human, All Too Human*

we have even seen it serve to praise truth, the grandeur of which was supposed to lie precisely in its antinatural character, in opposition to the spontaneous tendency to useful illusions. The change thus concerns the valorization alone: henceforth life is given priority over truth.

However, alongside this "vitalist" suspicion with regard to the will to truth there arises a second suspicion that is new and much more devastating, since it concerns truth's epistemological status. At the time of *Human, All Too Human* Nietzsche had certainly rejected the distinction between appearance and essence, but he did so in order to identify the true world with the world of appearance: the real world is the world in which we live, and there is no other. This conclusion was imposed by the absolute will to truth that refuses to allow itself to be deceived or to deceive others. In other words, this conception did not challenge the distinction between reality and illusion, between reality and fiction; whence also the possibility of opposing art *qua* fiction to the truth revealed by *Science*. The refutation of the distinction between essence and appearance amounts in fact to a negation of essence, to its identification with appearance. The first suspicion, the one concerning the moral foundation of truth, does not challenge this distinction between reality and fiction, but limits itself to simply questioning the value of truth for life. The second suspicion, on the other hand, attacks the very notion of reality: there might not be any true reality, reality might be nothing other than a fictionalizing construction. Consequently, the concept of truth itself might be only a fiction, and the will to truth only a disguised will to illusion; criticizable as a moral demand opposed to life, it would also be completely illusory. Of course, Nietzsche has a specific conception of truth in mind, namely the theory of correspondence according to which truth is a belief defined propositionally as the equivalence between a predication and a state of affairs.[150] He refuses to accept the fundamental presupposition of this theory, namely that there exist independent and irreducible states of affairs. He maintains on the contrary that every state of affairs is already an interpretation: "Against the positivism that remains at the level of the phenomenon, maintaining that 'There are only the facts,' I should object: no, there are no facts, only interpretations."[151] The value of different interpretations can no longer be determined with respect to an objective benchmark (the being that is supposed to be given), but only relative to their vital function: "Truth is the type of error without which a certain species of living beings cannot live. It is what is a value from the point of view of life that is ultimately decisive."[152] The true is that which, for a given person, produces an increased sense of power: "The criterion of truth lies in the increase of the sense of power."[153] Every belief that leads to a weakening of this will to power must therefore be considered harmful, "erroneous," even if it is one of the established "truths." In other words, the traditional dichotomy between truth

and error is abolished and replaced by a distinction, which is not congruent with the first one, between the beliefs that strengthen the will to power and those that weaken it. The evaluation of a worldview depends upon its expressive function: Nietzsche supports worldviews that express strength, health, and the affirmation of life and opposes those that express weakness, sickness, and the negation of life.

The critique of truth (*Wahrheit*) is a critique of a specific conception of truth, truth as correspondence; however, this critique itself is carried out in the name of a requirement of truthfulness (*Wahrhaftigkeit*[154]) behind which we can discern a new conception of truth as authenticity. To be sure, all truth is only an interpretation, and the assertion of this thesis is itself only an interpretation; but there exist authentic interpretations and inauthentic interpretations, that is, there are interpretations in which the will to power presents itself transparently to itself, and others in which it presents itself in derivative, indirect forms. I therefore do not believe that in his late writing Nietzsche erased every requirement of truth in favor of an absolute relativism; the very fact that he continues to use terms such as "fiction," "illusion," and "lie" to qualify the epistemological status of propositions claiming to be objective and objectal clearly shows this. If every idea of truthfulness were meaningless it would no longer be possible to speak of lies or illusions.[155]

The essential problem with Nietzsche's later conceptions on the subject of the arts resides in the fact that they are sometimes based on a critique of truth as a moral demand—without challenging its epistemological status—and sometimes on the radical destruction of the very concept of truth-as-correspondence, a destruction that is formulated in the theory of fictions. But the status of the arts cannot be the same in both cases.

Within the framework of the critique of truth as a moral demand—and from the moment that the rejection of the distinction between appearance and essence is accompanied by the abandonment of the idea of an ecstatic truth—the arts are resituated on the side of the forces of illusion. This position was already established in the genealogy of art presented in *Human, All Too Human*: it leads to the overthrow of the speculative theory of Art. The later reflections on this topic thus bring nothing new: they still unveil "the falsity of art, its immorality,"[156] since "For a philosopher it is shameful to say: 'the good and the beautiful coincide'; if he also adds that 'the same goes for the truth,' he deserves a thrashing. The truth is ugly. We have art in order to avoid dying from the truth."[157] At the most one can note a more clearly positive valorization of this illusion-producing power of Art, which is connected with an unequivocal acceptance of life and hence with the depreciation of truth as an ascetic demand opposed to life: thus, rereading *The Birth of Tragedy*, Nietzsche observes that art is more valuable than truth, and that is because it is "the great means that

makes life possible, the great seducer that draws us into life, the great stimulant to live."[158] This valorization is nevertheless accompanied by reservations: at the time of *Human, All Too Human*, one of the criticisms against art had emphasized its connections with religion and morality, and thus its complicity in activities depreciating the world in which we live in favor of a transcendent world. Nietzsche continues this criticism, but instead of directing it against art as such, he formulates it against a specific conception of art, that of art for art's sake: "in this way a false antinomy is introduced into things—which leads to a slander on reality ('idealization' in the sense of ugliness). As soon as one isolates an ideal from reality, one depreciates the real, impoverishes it, slanders it. . . . Art, knowledge, morality are so many means: instead of recognizing in them the intuition aiming at intensifying life, they are made to correspond to the contrary of life, to 'God'—as revelations, so to speak, of a superior world that appears here and there through these revelations."[159] In all logic, this criticism is addressed less to artistic practices than to a specific conception of art, namely the speculative theory of Art. But here again we encounter the ambiguity discussed earlier. Sometimes Nietzsche distinguishes between artistic theories and artistic practices, but sometimes he also asserts that in fact there are *two forms of art*; on one hand there is the art of decadence and nihilism, the art of the weak who dare not confront life, namely romantic art, which postulates that it accedes to ecstatic knowledge of a transcendent universe; on the other hand there is the art that deifies life, namely the Dionysian art of classical tragedy, which celebrates terrestrial life in both its marvelous and horrible aspects: "Is Art the result of *a lack of satisfaction with the real*? Or is it an expression *of gratitude for the happiness* one has enjoyed? In the first case, romanticism, in the second, halo and dithyramb (in short, the art of apotheosis)."[160]

This distinction between two forms of art is perfectly compatible with the radical destruction of the notion of truth that Nietzsche proposes in some of his late texts and fragments. At the same time, Art can no longer be on the side of illusion, since if there is no longer any truth, there cannot be any illusion either. If we never relate to a world that exists as an independent given, if the world is always our creation, then the very idea that there might be truthful images and false images of this world must be abandoned. But we have also seen that Nietzsche's theory does not entail the abandonment of any criterion of truth. Hence the arts, beyond their function as a stimulus to life, paradoxically recover a kind of cognitive bearing: if being is always something created, if the world is a projection or effectuation of the will to power, then the arts, insofar as they present themselves overtly as creations, are the most transparent mode of the projective activity. Whence a paradoxical resurgence of Art. To be sure, Art does not teach us anything about being in its ultimate truth, because there

is no ultimate being; on the other hand it shows us how worlds are born: through man's creative, projective activity. Therefore to understand Art is to understand the will to power, because it is in Art that the will to power embodies itself in its absolute transparency. In other words, Art once again becomes the organon of philosophy, since it reveals the structure of the world as a fiction.

Thus the work of art is the transparent emblem of the creative activity of the cosmic will to power: "The work of art, when it appears without an artist, for example as body, as organization. . . . The world as work of art engendering itself."[161] The work of art's mode of being is the mode of being of the universe, that is the mode of being of every being. Artistic activity in the strict sense of the term is only one of the forms of cosmic *poïesis*: life itself is "the fundamental artistic phenomenon."[162]

In the framework of these views Nietzsche develops the thesis that human art develops in three stages: first there is the hermit, the man who shapes his own life; then comes the artist in the strict sense of the term, who creates artifacts; finally comes the "philosophical artist,"[163] whose vocation is to shape future humanity. This third stage implies in fact a reactivation of the historical-social utopia of the speculative theory of Art: the social domain is supposed to be the field of creative activity par excellence. At least that is what is affirmed by a fragment that—retrospectively—sends a chill down our backs: "Henceforth the initial conditions will be favorable to the formation of vaster organisms of domination, such as have heretofore never existed. And that is still not the most important thing; it has become possible for international eugenic societies to appear that would take as their task the raising of a race of masters, the future 'masters of the earth'—a new and prodigious aristocracy, founded on the most severe self-legislation, in which the will of violent men endowed with philosophical sense and of artist-tyrants will endure for thousands of years: a type of superior men who, by virtue of the dominance of their will, their knowledge, their wealth and their influence, will use democratic Europe as their most docile and most supple instrument for taking into their hands the destinies of the earth, in order to work as artists to shape 'the man himself.'"[164] Whereas according to the utopianism of *The Birth of Tragedy* the artistic revolution was to overthrow the social and political situation, now the political field itself becomes the site of a specific artistic activity.[165]

But the work of art is not only the exemplifying revelation of the fictional, interpretive structure of reality; it also reveals the inner functioning of cognitive activity, insofar as the latter is merely a fictionalizing activity that is not aware of itself: instead of praising the truth we ought to praise the "strength of construction, of simplification, of formation, of invention."[166] The will to truth is only a form of the will to create, it is the

"formative will," because "We can understand no world other than the one we have ourselves made."[167] The world is our creation: "In a certain sense, man projects his drive to truth, his 'goal,' outside himself as a *being* world, or a metaphysical world, a 'thing-in-itself,' or already existing world. His need as a creator invents in advance the world on which he is working, anticipates it. His anticipation ('this belief' in truth) is his support."[168]

Within the framework of a worldview that is certainly very different, Nietzsche thus rediscovers the most radical conceptions of the speculative theory of Art, the ones defended by Novalis and the young Friedrich Schlegel. The idea that the universe is a work of art, the assertion that we know only what we make, the aestheticization of politics, the conception of artistic activity as a model of cognitive activity—these theses had already been formulated, often in terms very close to Nietzsche's, by the Jena romantics. This rebirth is paradoxical, since the notion of truth, which is so central in the speculative theory of Art, is abandoned and replaced by the idea that reality is a fictionalizing creation. Moreover, contrary to the romantics, Nietzsche emphasizes the hermeneutic content of Art less than the activity that gives rise to it: the content of the presentation matters less than the presenting activity, and more precisely the strength, the power, that are asserted through it. The question of truth as content is thus essentially voided. But for the romantics as well, the profound truth of the work of art was ultimately irreducible to its representational content: the work of art is speculative not only because it reproduces ultimate truths but also and especially because it creates worlds, and in that way its mode of being is an extension of the mode of being of the universe. Moreover, while Nietzsche rejects truth-as-correspondence, the question of truthfulness, as we have seen, remains pertinent: in Art the will to power accedes to a very special authenticity and transparency. Now, for the Jena romantics, as their thesis regarding the intransitive nature of the work of art shows, the truth of the work is no longer assertive, but resides rather in the authenticity of its internal structuration, that is, in its own cosmic nature, in the fact that in it the universal creative principle manifests itself overtly.

The incompatibility between the romantics' idealist ontology and Nietzsche's worldview nonetheless remains fundamental. Thus the authenticity envisaged is not the same in the two cases: on one hand, the manifestation of the infinite and theological-metaphysical One and All; on the other, the mobilization of the will to power as physical and physiological strength. Whereas romanticism elevated aesthetics toward theology, Nietzsche wants to reduce it to physiology: "The aspiration to art and beauty is an indirect aspiration to the ecstasies of the sexual instinct that transmits them to the *cerebrum*."[169] But as Eugen Fink points out, this

physiology in turn is only "a theology without God . . . that justifies exis-
tence as an aesthetic phenomenon, that sees in the brilliance of the beauti-
ful the felicity of the world, that is, the artist's religion of the playful God,
Dionysus."[170]

Art as the Thought of Being (Heidegger)

Dᴏᴇs ᴛʜᴇ Heideggerian conception of Art mark a break with respect to the speculative tradition of Art? *The Origin of the Work of Art* (1935–36)[1] is the only text in which Heidegger deals with art *as such*. His other studies in the domain of aesthetics bear on specific arts, that is, with few exceptions,[2] on poetry: thus his discussions of Hölderlin in *Commentaries on Hölderlin's Poetry*[3] remain indispensable for clarifying and concretizing our comprehension of the theses developed in *The Origin of the Work of Art*.

By taking *The Origin of the Work of Art* as my central reference point, I bracket the question of the later evolution of Heidegger's thought. But this fact, which would surely skew the analysis if its object were the overall philosophy of the author of *Being and Time*, is unimportant from the point of view that interests me here: the evolution of Heidegger's discourse over the years hardly affects the status accorded to Art. At most one can note that the program of a dialogue between thought and poetry is realized in the most radical manner in the texts of the 1950s, for example the first studies in *Commentaries on Hölderlin's Poetry*. This gradual "poetizing" of his own discourse only brings Heidegger closer to the romantic ideal of the poet-thinker (*dichtender Denker*).[4] This amounts to saying that from the point of view of the speculative theory of Art, the later development only reinforces the leading schema set in place in *The Origin of the Work of Art*.

On the other hand, it is indispensable to recall briefly the conception of art found in texts that preceded *The Origin of the Work of Art*, and more specifically in *Being and Time*.[5] In fact, the first thing one notices when one comes from the later texts is how small a role art plays in Heidegger's first book. Nevertheless, the pertinent passages—which all concern poetry—are interesting, for in the light of a more attentive reading they seem to maintain two different conceptions.

According to the first conception, poetry is an ex-plication that is pre-ontological (that is, naïve and spontaneous) of Being, and for that very reason a pre-ontological "self-ex-plication" of *Dasein* (and thus of man). As such, it is lumped together with philosophical psychology, anthropol-

ogy, ethics, "politics,"[6] biography, and history—all discourses whose object is the behavior, faculties, strengths, possibilities, and destinies of *Dasein*.[7] Their philosophical function is to serve as documents (*Zeugnisse*) that philosophy brings into the framework of the existential analytic. Their role is twofold: they show that existential interpretation is not an invention (*Erfindung*) of the philosopher but rather a construction grounded in *Dasein*'s spontaneous self-explication; hence philosophical interpretation becomes the site of their essential revelation.[8] It is thus philosophical discourse that articulates what the literary work "really" means, by translating it into the appropriate philosophical categories. Poetry therefore has no privileged position among Dasein's various self-explications; moreover, poetic discourse is unaware of its own truth: only philosophical interpretation can reveal it. Such a conception of interpretation obviously presupposes that a poetic text always means something other than what it explicitly says; here we rediscover the romantic move that postulates the allegorical or symbolic nature of poetry. While the type of interpretation Heidegger defends is of romantic origin, the status he accords poetry is still situated beyond the horizon of the speculative theory of Art, since it denies poetry any autonomous capacity for ontological revelation.

In competition with this first conception we find the idea that poetry itself can have existential worth, and that it can be, like philosophical discourse, an ontological interpretation in the full sense of the term. That at least is how I read a passage in § 34 that deals with language as a fundamental existential category. "The communication of the *existential* possibilities of availability (*Befindlichkeit*), that is, the discovery of existence, can be the end sought by speech that 'says as a poem.'"[9] Now if the communication (*Mitteilung*) of *Dasein*'s existential possibilities can be the proper goal of poetry, its status coincides with that of philosophy. In fact, unlike *existentiel* determinations, *existential* determinations belong to the domain of fundamental ontology, and more precisely to that of the analytic of *Dasein*.[10] To be sure, *Being and Time* offers us no hint concerning the possible nature of this gnoseological relationship between poetry and fundamental ontology. But it is nonetheless a conception that already belongs to the speculative theory of Art.

To characterize briefly the position Heidegger develops in *The Origin of the Work of Art*, one can say that in it he abandoned the first conception in favor of the second: the object of this text will in fact be the analysis of the essence of the work of art as an existential category (even if Heidegger abandons the vocabulary of existential analysis and of fundamental ontology). In other words, we find ourselves wholly within the tradition of the speculative theory of Art. And more precisely, we witness a rebirth of the romantic theory of Art. To be sure, the question of the relationship be-

tween poetry and philosophical discourse is taken up only incidentally in *The Origin of the Work of Art*, but we already find outlined in this work the conception of a dialogue between thought and poetry that was to occupy a preeminent place in the texts devoted directly or indirectly to poetry. Heidegger thus follows in the opposite direction the path that had led from Jena romanticism to Hegelianism: starting out from a conception that sees in art material for philosophical reflection, he ends up at the romantic thesis of a parallel development of both of them. But in doing so he also reproduces the constitutive aporia of Jena theory: if Art and thought say the Same (*das Gleiche*), this fact cannot be the object of an assertion on the part of thought, for the latter would then say *more* than Art. Now, it is in fact thought that says it: as in Jena romanticism, it is a matter of a dialogue delimited by a previous philosophical decision, the one that predetermines Art as an ontological discourse.

HEIDEGGER AND ROMANTICISM

Heidegger's general philosophy obviously does not share romanticism's positions, which are those of early German idealist philosophy. One could even say that much of his reflection is devoted to the attempt to distinguish himself from this philosophical horizon, in which he sees the fulfillment of the terminal phase of Western metaphysics (the phase inaugurated by Descartes and Leibniz). This terminal phase is supposed to be erected on the doctrine of subjectivity conceived as the foundation of the truth of beings, in which respect it constitutes the ultimate and extreme stage in the neglect of being and of ontological difference, a neglect that defines metaphysics as such. With respect to this tradition, Heidegger conceives his own thought as being a sort of return to the buried origin: he wants to recover—without relying on the constructions of metaphysics—the thought of Being that makes them possible just as they neglect it.

It is therefore important to discuss briefly the points of disagreement between Heidegger's philosophy and romantic metaphysics; the undeniable continuity in the domain of the theory of Art will only appear the more clearly.

The simplest way to begin is with the dichotomy between metaphysics and what Heidegger calls "the thought of Being." Metaphysics, whose history coincides with that of the West, is the age of the forgetting of Being:[11] its birth signals the confusion of being (*Seiendes*) and Being (*Sein*), and hence the forgetting of the ontological difference between what is and the "fact" that there is anything at all. From ancient Greece onward, metaphysics has confused the analysis of present beings with the question of presence as an event. To the question: "Why is there something rather than nothing?" it replies by seeking a supreme being, a *causa sui* that

would constitute the foundation of all other beings at the same time that it would be the being that most is: God. Or else it seeks to define what determines the Being of beings, that is, the universal condition that makes a being a being: Platonic ideas, Kantian categories, etc. In both cases, it forgets to ask the originary question concerning the "there is" as an absolute event situated before any causal determination or general definition. However, it is this event of Being that makes possible all questions concerning beings, even if it is forgotten: "It [metaphysics] thinks Being as a being. Wherever it is asked what Being is, Being as such remains in view. Metaphysical representation owes this view to the light of Being. Light, that is, what such a thought experiences as light, itself no longer enters into the view of this thought."[12]

But Heidegger goes further: the forgetting of Being is not fortuitous or due to a lack of intelligence; it is part of the fate of Being, part of its *Geschick*. If the history of metaphysics is a history of the forgetting of Being, this is not an error that has to be corrected, but a fate that has to be thought, and that one can now think because metaphysics is coming to an end. Since for Heidegger the history of metaphysics coincides with the history of the West, the fate of the West *is* the fate of metaphysics. The latter "dominates" the succession of different periods and gives to each of them its leading principles: "In the course of Metaphysics a meditation on the essence of being is carried out, at the same time as the mode of truth's happening is decided in a determining manner. Metaphysics also founds an era, giving it, through a determinate interpretation of being and a determinate acceptation of truth, the principle of its essential configuration. This principle governs entirely all the characteristic phenomena of that era."[13] To each historical configuration of metaphysics corresponds a specific configuration of the forgetting of Being. In conformity with traditional historiography, Heidegger distinguishes three eras: antiquity, the Middle Ages, and modern times. This tripartite distinction is oriented directionally, since it rests on the idea that the forgetting of Being becomes graver from one period to the next: modern times are the period of supreme distress, but for that very reason they may announce a decisive reversal. The possibility of this reversal indicates that in reality the triad has a double supplement, a sort of ante-historical and post-historical aura: on one hand, pre-Socratic thought as originary thought; on the other, post-metaphysical thought that rejoins the originary thought by passing through the historical density of metaphysics.

The least that can be said is that—abstracting from the hegemonic role accorded to metaphysics—this schema is not new, since it governs the whole of historicist thought since the romantics at least. Thus it seems to me that it would be a mistake to contrast Heidegger with historicism: while it is true that he rejects the idea of *determinism* (because it seems to

him to be dominated by the metaphysical notion of the principle of reason) in favor of a conception of *fate*, the latter nonetheless takes on other essential traits of historicism, such as messianic pathos, the prominence accorded the contemporary period as the decisive one, the idea of a structuration of periods according to unifying principles, the postulate of a meaning underlying the series of different periods, and especially the fundamental presupposition that historical facts have to be related to an underlying, hidden logic. Basing himself on this last presupposition, which seems to me to lie at the heart of historicism, Heidegger distinguishes, as had Hegel before him, between a superficial historicity and deep history, what he calls *historicality*. Moreover, the conception of fate is even more fatalist than the determinist conception, since for a causality that remains at least apprehensible it substitutes an "event" that is both indeterminate and inevitable.

Here I shall discuss only the modern period, since romantic philosophy is situated within this framework, and Heidegger simply identifies romantic philosophy with absolute idealism,[14] and hence with the result of the metaphysics of modern times. This metaphysics locates the Being of beings in representation (*perceptio, idea*, judgment, etc.) and defines truth as subjective certainty. It has a double ancestry: in Descartes the subject is made the foundation of truth, the latter's criterion being the certainty that accompanies the representation; in Leibniz being as representation is organized according to the principle of sufficient reason. From this time on only what can be grounded in the certitude of an equivalence and can "explain," that is, be inserted into a causal chain, is accepted as being. Being is what is representable and calculable: "Being in its totality . . . is taken in such a way that it is truly and simply being only to the extent that it is fixed by man in representation and production."[15] The promotion of *Dasein* to a subject goes along with the constitution of beings as objects: the subject-character of *Dasein* dominates the objectivity of the "World" and "Nature." The metaphysics of modern times is thus that of the challenging of beings (including man): its essence is technology, whose most striking aspect is science.

Of the consequences entailed by this general characterization, I shall examine only one, which touches directly upon our subject: the birth of aesthetics. This birth results from the conjunction of the dualism of the representing subject and the represented object (typical of modern metaphysics) with the dichotomy (as old as Western metaphysics) between the sensuous and the rational, between the *aistheton* and the *noeton*.[16] This opposition between what is given and what manifests itself through the given is formulated by romantic philosophy with the help of the concepts of symbol and allegory: in the work of art, appearance becomes the sign of a spiritual truth. But in conformity with its historical determination, ro-

manticism conceives this dichotomy within the framework of a metaphysics of representation: it is the imagination as a productive faculty of the representing subject that posits the work as symbol, informs its matter, gives a *morphè* to the *hylè*. The work of art is thus the expression of the artistic will of the representing subject. Since the Being of beings resides in their representation, the work of art, by expressing the subject, also represents this being.

Aesthetics thus conceives the work of art as proceeding from the artistic subject's autonomous creative activity. On the side of the reception of the work we find the corresponding notions of "experience" (*Erlebnis*) and "culture" (*Kultur*). The receiving subject posits the work as an enrichment of his representation, of his *Weltbild*, and brings together (*versammeln*) the whole of the works of the past as so many objects forming the circle of culture available to him. Thus aesthetics reduces the work of art to the status of an object at the disposition of the creative subject and the receiving subject.

This critical attitude in no way prevents Heidegger's work from being permeated by the romantic *doxa*:[17] it is found not only in the field of his theory of art but also in his general philosophical orientation, with its explicit or implicit valorizations. Its most prominent and most massive manifestation is certainly a deep cultural pessimism. It is accompanied by a rejection, often bitter and even scornful, of modernity in its social, political, scientific, etc. aspects. This attitude emerges particularly in his definition of modern times as a period of the supreme forgetfulness of Being, as the time of the greatest danger (*Zeit der höchsten Gefahr*), and thus as a period presaging a decisive reversal of which Heidegger's work claims to be both the decoding and the *Vor-blick*, the announcement. The triadic historical schema we have encountered obviously must be situated in the framework of this cultural pessimism, whose obligatory pendants are the exaltation of the origin and the announcement of a decisive upheaval.

Under the rubric of cultural pessimism we find several interrelated themes:

a) The theme of inauthenticity, a Heideggerian variant of the theory of alienation. It plays a strategic role in the definition of Art as an event of truth and an ecstatic mode of being: Art causes us to move beyond inauthenticity. However, at the same time Heidegger maintains that in order to have access to Art, we must already have somehow abandoned the inauthentic mode of being. Thus he complains (in his 1934–35 seminar) that "our *Dasein* is mired in the banality of an everyday life that completely excludes it from the sphere of the power of art."[18]

b) The theme of the violation of nature, of its exploitation by technology. Heidegger's comments on this subject become increasingly apocalyptic, especially after the Second World War. It does not seem to me a matter

of indifference that he sees the emblem of this in the nuclear threat, rather than in the Nazi or Stalinist death camps (which he could nonetheless have easily related to his thesis of the challenging of man). In any case, the romantic legacy is clear, since the depreciation of science, and even its rejection in the name of the mysteries of *physis*, is undeniably a romantic theme. It suffices to recall Goethe's polemics against Newtonian mathematical and experimental physics and his arguments in favor of a new contemplative physics. To be sure, Heidegger, remembering these polemics, asserts that Goethe did not at all succeed in moving beyond the horizon of subjectivist metaphysics, which his criticisms could therefore not really affect.[19] This is one example among many of the small but decisive difference he assiduously cultivates: it cannot cause us to forget that in this case his own condemnation of science as a "denaturing"[20] power is governed by exactly the same ethical reflex as the one that guided Goethe.

c) The theme of science as an inferior form of knowledge (as compared with philosophy). For Heidegger, science is merely the theoretical side of technological challenging. It is therefore subject, in its very possibility, to the historical principle of subjectivist metaphysics: it can never challenge it, because it feeds upon it. *A fortiori*, it cannot enter into dialogue with the thought of being: science does not think.[21] This devalorization also affects the so-called human sciences; thus the dialogue between thought and poetry is sheltered from the outset from any interference with the history of art or philology.

d) The theme of the decadence of language (*Sprachverfall*), the bogey of the speculative theory of poetry; in Heidegger, the thesis is reformulated within the framework of inauthenticity and the forgetting of being. Whereas in *Being and Time* the decadence of language is connected with the inauthenticity of everyday life (the realm of the "They"), the later writings situate it in a historical perspective: language falls to the status of a means of communication; in other words, the *Sprachverfall* becomes one of the powers of technological challenging: "The decadence of language, of which there has been so much talk recently, and very tardily, is nevertheless not the reason, but already a consequence of the process in which language, in the grip of the modern metaphysics of subjectivity, goes almost irresistibly beyond its element."[22]

e) The hypostasis of the origin,[23] which is the other side of the cultural pessimism. In *The Origin of the Work of Art*, the origin is presented as a threefold foundation, a *Stiftung*: the foundation of the work of art is an "origin" (*Ursprung*) that is unfounded, neither explicable nor deducible from preexisting beings, and in this sense it is a gift (*Schenkung*); it is thus the seminal beginning (*Anfang*) of a historical period or of a "historical humanity" and in this sense it is a foundation (*Grund*): finally, it is a leap forward (*Sprung*) beyond everything the historical period keeps in reserve.

Speaking of the thought of the origin amounts to speaking of the thought of unity. But we have to distinguish between numerical unity (there is always *one* historical principle) and unity as totalization (the principle unifies a whole period and organizes it in all its manifestations). In these two aspects, the thought of unity subordinates the diversity of empirical temporality in its dispersion: the theory of the threefold origin not only guarantees the dictatorial permanence of the same principle throughout the historical period it governs, but also its legibility, its transparency (for the authentic thinker or authentic poet), from the first moment onward.

Such a conception of unity comes down in fact to choosing, among the multiplicity of historical phenomena, paradigms that are supposed to unify them: every period thus has its adequate paradigm, which can only be—and this is not surprising—a philosophical concept. This is the paradigm that legitimates the translation of history (*Historie*), that is, the whole of the phenomena of the empirical historical tradition, into history (*Geschichte*): a translation that "reveals" that *Geschichte* is fundamentally the history of thought, and thus in the case of the West, the history of metaphysics.[24]

However, this statement requires qualification: The *Origin of the Work of Art* still acknowledges that there are other privileged representatives on the side of thought, other beings in which "the openness takes its stand and attains its constancy."[25] Heidegger in fact distinguishes five essential ways in which the truth can come about: the thinker's questioning; the work of art; the foundation of a state; "the proximity of what is no longer simply a being, but the most being in the being," that is, religion; and finally, essential sacrifice.[26] This does not really contradict the earlier analyses: we have to distinguish between the possibilities of instituting the truth *as such* (which are in fact five in number) and the foundation of an "*epochal*" truth. Now, metaphysical concepts are always epochal and determine *only* the history of metaphysics, that is, the "super-epoch" characterized by the forgetting of Being. Within these limits all other forms of the happening of truth are subjected in some way to the "law" of metaphysics, even if as authentic modes of the happening of truth their source ultimately escapes it. Here we must recall the distinction between the concealment (*Verbergung*) and the dissimulation (*Verstellung*) of truth. To be sure, truth is never "whole," because the opening of Being is always also its concealment (*Verbergung*); but what constitutes the specificity of the concealment of Being in the epoch of metaphysics is dissimulation (*Verstellung*). In other words, the "epochal" truth, as a going astray, always dissimulates the truth of Being as it comes about in the five essential ways Heidegger distinguishes.

In fact, this conception of epochal principles also raises problems for

Heidegger's theory of Art. If metaphysical principles determine *all* the phenomena of a period, they should *also* determine Art. Hence, insofar as metaphysics is a dissimulation of Being, it must also make impossible any foundation of artistic truth in the periods it governs. In any case, a passage in *The Origin of the Work of Art* asserts that there is a close connection between artistic foundation and metaphysical principles: "Always when that which is as a whole demands, as what is, itself, a grounding in openness, art attains to its historical nature as foundation. This foundation happened in the West for the first time in Greece. What was in the future to be called Being was set into work, setting the standard. The realm of beings thus opened up was then transformed into a being in the sense of God's creation. This happened in the Middle Ages. This kind of being was again transformed at the beginning and in the course of the modern age. Beings became objects that could be controlled and seen through by calculation. At each time a new and essential world arose. At each time the openness of what is had to be established in beings themselves, by the fixing in place of truth in figure. At each time there happened unconcealedness of what is. Unconcealedness *sets itself into work*, a setting which is accomplished by art."[27] The passage seems clear: the happening of truth in Art comes about in accord with the modalities of the metaphysical historicality of the period it opens. Art must thus always participate in the specific dissimulation of a given metaphysical epoch. And yet, in his famous analysis of a pair of peasant shoes painted by Van Gogh, Heidegger asserts that this picture expresses a truth that escapes the metaphysical horizon, since it is supposed to reveal "the equipmental being of equipment" in its *nonmetaphysical* truth. Now, the nineteenth century is entirely governed by modern metaphysics, the final stage in the forgetfulness of being: how can Van Gogh's picture escape the "law" of that forgetfulness? It is hard to see how the two perspectives, that of the metaphysical *Verstellung* and that of artistic truth, can both be maintained.

Heidegger uses the thesis of the hegemony of metaphysical principles as a weapon against all the enterprises he considers to be possible "rivals" to his "questioning," essentially science, and to a lesser extent, theology. Conversely, the thesis of the nonmetaphysical truth revealed by the work of art is foregrounded when he wants to establish a dialogue between the thinker's "questioning" and Art. The texts that develop his version of speculative theory of Art belong chiefly to the second perspective, but he is not always willing to give up the advantages of the first. Thus when he analyzes Rilke's poems, he finds them only partially satisfactory; immediately the thesis of metaphysical determination rises up from his poetic utterance, and this thesis is supposed to legitimate the discords between the poetic "propositions" of the author of the *Duino Elegies* and the theories of the thinker of Being. Conversely, the "appropriation"[28] of Van

Gogh's painting, which is supposed to reveal the truth of being-produced, makes no reference to any metaphysical determination of this truth: and for good reason, since the painting is supposed to show what the thinker of Being thinks, and therefore a truth that escapes metaphysical determinations. The position occupied by Hölderlin is clearly the most revealing: according to Heidegger, his poetic enterprise certainly sets out from absolute idealism, but in his later work—to which the philosopher devotes his full attention—he "leaps" beyond this metaphysical horizon toward the *poïesis*, the *Dichtung* of Being. Therefore he is supposed to be the privileged interlocutor of the thinker who finds himself in a related situation, since he thinks the beyond-metaphysics on the basis of its end (and, in both cases, through a return to Greek origins).

The determination of Art as *absolute* origin is resolutely situated in this perspective of the foundation of an essential truth escaping metaphysical historicality. As soon as the work of art is conceived solely as a particular historical origin (that is, the origin of a given epoch), its status becomes ambiguous: *Art* might fall to the status of *art*. To be sure, it retains a privileged role, since it constitutes a historical beginning: "Whenever art happens—that is, whenever there is a beginning—a thrust enters history, history either begins or starts over again."[29] But the birth of a new metaphysical principle is also a historical thrust and nothing guarantees that in opening the world of a given epoch, art escapes the metaphysical concealment that characterizes that epoch. It is thus solely in the form of an *absolute* origin that *art* is *Art*, that is, a nondissimulating revelation of Being.

ART AND TRUTH OF BEING

Heidegger develops his conception of the work of art in the framework of a distinction between the thing (*Ding*), equipment (*Zeug*), and the work (*Werk*). He states that it is essential to free these terms from metaphysical conceptions that make impossible any genuine apprehension of their respective essences. Metaphysics conceives the thing and the work in accord with the paradigm of equipment: it misunderstands their own natures. It thus arrives at a faulty apprehension of the being-equipment of equipment. Three pairs of metaphysical determinations are responsible for this double misunderstanding: the distinction between *hypokeimenon* and *symbebekos* (which will lead, in its Latin translation, to *substantia* and *accidens*), the one between *aistheton* and *noeton* (which we have already encountered), that is, between *hylè* on one hand and *eidos* and *morphè* on the other (thus the distinction between matter and form-figure). This last pair proceeds directly from the metaphysical determination of being-equipment, and it is this pair that Heidegger's discussion privileges, even though the two others are never entirely lost from view.

These metaphysical determinations prevent us from seeing the essential and differential characteristics of the three fields grasped in their specific truths: "This long-familiar mode of thought preconceives all immediate experience of beings. The preconception intercepts[30] reflection on the being of any given entity. Thus it comes about that prevailing thing-concepts obstruct the way toward the thingly character of the thing as well as toward the equipmental character of equipment, and all the more toward the workly character of the work."[31]

The Heideggerian triad does not function as an opposition among terms that are mutually exclusive. Each one participates in the two others in one of its aspects, while at the same time distinguishing itself form it in its specific configuration:

> A piece of equipment, a pair of shoes for instance, when finished, is also self-contained like the mere thing, but it does not have the character of having taken shape by itself like the granite boulder. On the other hand, equipment displays an affinity with the art work insofar as it is something produced by the human hand. However, by its self-sufficient presence the work of art is similar rather to the mere thing which has taken shape by itself and is self-contained (*dem eigengewüchsigen und zu nichts gedrängten blossen Ding*). Nevertheless we do not count such works among mere things. . . . Thus the piece of equipment is half thing, because characterized by thingliness, and yet it is something more; at the same time it is half art work and yet something less, because lacking the self-sufficiency of the art work. Equipment has a peculiar position intermediate between thing and work, assuming that such a calculated ordering of them is permissible.[32]

Thus the piece of equipment is supposed to constitute the median term between the thing and the work. But in a more fundamental sense, the true central term [rather than a median term of a "calculated ordering," an ordering that—as the adjective *verrechnend* ("calculating") indicates—comes from the metaphysical horizon] is indeed the work of art. The *median* term according to the metaphysical is not the *central* term according to the thought of Being: the work blurs the calculated ordering.

Let us try to describe more precisely the privileged place occupied by the work of art: it is a place that has the ability to reveal Being, to name the Being of beings. To put this in the Heideggerian vocabulary: the being-work brings about the truth of the Being of beings, including its own. Through a circular procedure Heidegger arrives at the central thesis of the speculative theory. He begins by saying that to understand the being-work of this being that is the work, as to understand the being-thing of the thing or being-equipment of equipment, we must first think the Being of the being; "What matters is a first opening of our vision to the fact that what is workly in the work, equipmental in the equipment, and thingly in the

thing comes closer to us only when we think the Being of beings."[33] But the analysis undertaken in the second part of *The Origin of the Work of Art* shows that this thought of Being is itself possible only within the horizon of the work of art, since only the work of art makes the piece of equipment *appear* in its truth, so that it is only in it that the thinker can discover this truth. We must therefore read the passage on Van Gogh, which precedes the imperative to think the Being of beings, in order to accede to the Being of the work, as a sort of premonition or *Vorwegnahme* of what will be developed in greater detail in the second part, namely the idea that it is in reality the work of art that founds the truth of the being and thus makes it possible to think the Being of the being.

The passage on Van Gogh's painting reproduces the circular movement that guides the general procedure, and is worth analyzing in detail. Heidegger introduces the picture after having demonstrated the inability of various metaphysical concepts to think the being-equipment of the piece of equipment, etc. In view of this failure of metaphysics, he proposes to approach the problem from a phenomenological perspective (even if he does not use the term, that is what it amounts to), that is, to try to describe the equipmentality of equipment by taking as an example (*Beispiel*) "a common sort of equipment—a pair of peasant shoes. We do not even need to exhibit actual pieces of this sort of useful article in order to describe them.[34] Everyone is acquainted with them. But since it is a matter here of direct description, it may be well to facilitate the visual realization (*Veranschaulichung*)[35] of them. For this purpose a pictorial representation suffices. We shall choose a well-known painting by Van Gogh, who painted such shoes several times."[36]

At first it seems this picture can tell us nothing we don't already know: it is a representation of a pair of peasant's shoes, or rather of a peasant woman's shoes,[37] and thus of a piece of equipment defined by its use. But the reversal is not long delayed: "And yet . . . " (*Und dennoch*). This rhetorical signal introduces the Heideggerian "reading" of the picture, which is already oriented in advance, it must be emphasized, by the identification of the shoes as those of a peasant woman. This reading is well-known: the picture reveals to us the equipmental being of the equipment as stretched-out between the earth to which it belongs and the world of the peasant woman that shelters it: "From out of this protected belonging the equipment itself rises to its resting-within-itself."[38] This repose is that of reliability (*Verlässlichkeit*), a term that expresses "the abundance of an essential being of the equipment": "By virtue of this reliability the peasant woman is made privy to the silent call of the earth; by virtue of the reliability of the equipment she is sure of her world (*ist sie ihrer Welt gewiss*). World and earth exist for her, and for those who are with her in her mode of being, only thus—in the equipment. We say 'only' and therewith fall

into error; for the reliability of the equipment first gives to the simple world its security and assures to the earth the freedom of its steady thrust."39

Thus Van Gogh's painting reveals to us that the essential being of equipment is not to be found in its mere usefulness alone, a usefulness that "awakens the impression that the origin of equipment lies in a mere fabricating that impresses a form upon some matter,"40 but in its reliability, its *Verlässlichkeit*. But how has this truth been discovered?

> Not by a description and explanation of a pair of shoes actually present; not by a report about the process of making shoes; and also not by the observation of the actual use of shoes occurring here and there; but only by bringing ourselves before Van Gogh's painting. This painting spoke. In the vicinity of the work of art we were suddenly somewhere else than we usually tend to be.
>
> The art work let us know what shoes are in truth. It would be the worst self-deception to think that our description, as a subjective action, had first depicted everything thus and then projected it into the painting. If anything is questionable here, it is rather that we experienced too little in the neighborhood of the work and that we expressed the experience too crudely and too literally. But above all, the work did not, as it might seem at first, serve merely for a better visualizing of what a piece of equipment is. Rather, the equipmentality of equipment first genuinely arrives at its appearance through the work and only in the work.41

I have cited this passage at length because it illustrates some of the most debatable aspects of Heidegger's procedure. Let us recall that we started out from the use of Van Gogh's picture as a pictorial representation that was supposed to simplify the intuitive presentation of a pair of shoes. The latter in turn were supposed to serve as a basis for a phenomenological description of the equipmentality of the piece of equipment. Now, in this initial stage a certain number of implicit identifications and shifts occur. Thus it is decided at the outset that Van Gogh's painting can represent only a *peasant's* shoes. From this we move without the slightest justification to a *peasant woman's shoes*. Thus before the reading of the picture begins, Heidegger has already established in the most authoritarian way the denotative identifications that in all logic (but we know that logic belongs to the metaphysical horizon . . .) should have been *one of the things at stake* in the description of the picture. In any case, before we're done we find that far from being a simple illustration that is supposed to simplify the description, the work of art brings out the equipmental being of the piece of equipment: to be sure it reveals this being in accord with the modalities proper to the workly character of the work, but that is precisely the only mode, along with that of contemplative thought, in which the truth can reveal itself.

What is the basis for this reversal? Nothing other than an unargued decision whose textual sign is the ellipsis implied by: "And yet . . . " The reversal thus decreed is never related to the public characteristics of the work, that is, to characteristics that are also accessible outside the postulates of the thought of Being. This comes out clearly in the central passage of Heidegger's interpretation:

> From the dark opening of the worn insides of the shoes the toilsome tread of the worker stares forth. In the stiffly rugged heaviness of the shoes there is the accumulated tenacity of her slow trudge through the far-spreading and ever-uniform furrows of the field swept by a raw wind. On the leather lie the dampness and richness of the soil. Under the soles slides the loneliness of the field-path as evening falls. In the shoes vibrates the silent call of the earth, its quiet gift of the ripening grain and its unexplained self-refusal in the fallow desolation of the wintry field. The equipment is pervaded by uncomplaining anxiety as to the certainty of bread, the wordless joy of having once more withstood want, the trembling before the impending childbed and shivering at the surrounding menace of death.[42]

Among the admirers of this reading (and they are many) none seems to have noticed that while it presents us with particularly talkative shoes, the picture itself is practically mute: the reading has, in fact, hardly any grounding in the pictorial characteristics. The first sentence still has a minimal anchorage in the work, since it starts out from "the dark opening," a description in which the adjective does in fact refer to an observable pictorial feature; but the interpretation of this darkness as revealing "the toilsome tread of the worker" is an extrapolation possible only on the basis of the "a priori" decree that has identified the shoes as a peasant woman's shoes. The same mechanism is at work in the second sentence: if "the stiffly rugged heaviness" of the shoes is a characterization that can be derived from the "look" of the painted shoes, one surely cannot say the same about the interpretation of this pictorial feature, namely the way in which it is grounded in "the accumulated tenacity of her slow trudge through the far-spreading and ever-uniform furrows of the field." Starting with the third sentence, the description becomes that of a visionary, or rather it constitutes a set of agreed-upon and inevitable elaborations that are no longer based in any way on the pictorial properties of the painting: they follow directly from the identification of the shoes as a peasant woman's shoes and from Heidegger's personal ideology (that is, from his belief in the existence of a peasant *Lebenswelt* and from his specific view of the latter).

In reality, Van Gogh's painting functions only as an evanescent relay in an analysis whose functioning depends on the presupposition that the work is absolutely transparent, literally made to disappear by Heidegger's

interpretation. When he says, "This painting spoke," he identifies the
work with the voice of the oracle. But we know that the voice of the Pythia
was in reality that of the priestess of the cult. When Heidegger says: "It
would be the worst self-deception to think that our description, as a sub-
jective action, had first depicted everything thus and then projected it into
the painting," he describes exactly what he has just done.

Heidegger emphasizes that art never reveals the truth of a particular
empirical being, but always the truth of the *Being* of that being and the
truth of the world that is its horizon. Thus Van Gogh's picture brings out
the truth of the being "equipment," and thus its Being, namely
Verlässlichkeit. But at the same time it reveals the peasant woman's world,
that is, a particular field of the Being of the being. We must add that the
artistic revelation of the Being of the being occurs on the basis of and with
a view to Being and not in the perspective of beings, as is the case in the
conceptualizations of metaphysics. *Verlässlichkeit* is not the essence of
equipment (in the metaphysical sense of "universal substratum"), it is its
mode of coming into the open, which as such is always concealed by open
beings. We will encounter this characteristic again later on: the work of art
is always the opening of a world, that is, its foundation. To be sure, artistic
revelation, at least in the visual arts, has its own specificity: the happening
of truth occurs in the mode of appearance, of *Scheinen* insofar as the clear-
ing appears, shines, *qua* artistic beauty (*das Kunstschöne*). The status of
poetry is obviously more complex, and also more ambiguous: when he
wants to distinguish Art from thought, Heidegger resorts to the theory of
appearance, and then he uses the visual arts as the paradigm; when on the
contrary he wants to stress the dialogue between Art and thought, he re-
sorts to the theory of artistic saying and the paradigm of verbal art. This
is a tactic that is not specifically Heideggerian, since we have already
found it in Hegel, in a slightly different form. In any case, beyond their
specificities, Art and thought are linked by a fundamental family relation-
ship, since both of them are concerned not with particular beings, nor with
beings in the numerical totality (what Schlegel called the extensive grasp
of the One and All through a linear discursivity), nor with beingness in its
generality, but with what *founds* Being *as such*—that is, the fact that they
are situated in an ecstatic dimension: "Thus in the work it is truth, not
only something true, that is at work. The picture that shows the peasant
shoes, the poem that says the Roman fountain, do not just make manifest
what this isolated Being as such is—if indeed they manifest anything at all;
rather, they make unconcealedness as such happen in regard to what is as
a whole. The more simply and authentically the shoes are engrossed in
their nature, the more plainly and purely the fountain is engrossed in its
nature—the more directly and engagingly do all beings attain to a greater
degree of being along with them. That is how self-concealing being is illu-

minated."[43] Just as the essential thought is not the study of beings but rather meditation on the "there is," that is, the event, the opening up of Being as such, the work of art does not represent a being (through drawing, speech, etc.) but is rather the setting into work of the clearing of Being.

ART AS HISTORICAL FOUNDATION AND AS ECSTATIC DEVIATION

Like Hegel, Heidegger connects Art indissolubly with history. Thus he maintains that Art is always united with the historical destiny of the period in which it emerged:

> The Aegina sculptures in the Munich collection, Sophocles' *Antigone* in the best critical edition, are, as the works they are, torn out of their own native sphere. However high their quality and power of impression, however good their state of preservation, however certain their interpretation, placing them in a collection has withdrawn them from their own world. But even when we make an effort to cancel or avoid such displacement of works—when, for instance, we visit the temple in Paestum at its own site or the Bamberg cathedral on its own square—the world of the work that stands there has perished.
>
> Work withdrawal and world-decay can never be undone. The works themselves are no longer the same as they once were. . . . The whole art industry, even if carried to the extreme and exercised in every way for the sake of works themselves, extends only to the object-being of the works. But this does not constitute their work-being.[44]

However, Heidegger goes further: the historicity of Art is not limited to the fact that it is always connected with a given historical world, that is, that it is always contextually anchored (which no one denies); we have seen that its specificity lies instead in the fact that it has a *foundational* function with respect to this world. Saying that the work of art opens a world amounts to saying that it opens the historical destiny of a people. In this connection, Heidegger gives the example of the Greek temple: "It is the temple-work that first fits together and at the same time gathers around itself the unity of those paths and relations in which birth and death, disaster and blessing, victory and disgrace, endurance and decline acquire the shape of destiny for human being. The all-governing expanse of this open relational context is the world of this historical people. Only from and in this expanse does the nation first return to itself for the fulfillment of its vocation."[45] And a little farther on he adds:

> But men and animals, plants and things, are never present and familiar as unchangeable objects, only to represent incidentally also a fitting environment for the temple, which one fine day is added to what is already there. We

shall get closer to what *is*, rather, if we think of all this in reverse order, assuming of course that we have, to begin with, an eye for how differently everything then faces us. . . .

The temple, in its standing there, first gives to things their look and to men their outlook on themselves. This view remains open as long as the work is a work, as long as the god has not fled from it.[46]

I have already said that this thesis of the historical function of Art sometimes seems difficult to reconcile with the thesis that Art has an ontological function. Thus, let us repeat, it is hard to see how Van Gogh's painting can be endowed with a historical foundational function, since it was painted while its world was (if one accepts Heidegger's claim that these are a peasant woman's shoes) collapsing, being supplanted by technological challenging. And it is probably not accidental that Heidegger's analysis of it contains no reference to the historical function of Van Gogh's work.

We must therefore ask whether art *as such* has a historical foundational function, or whether this is a function that art can fulfill only in certain periods. Heidegger himself asks this question at the end of the *Origin of the Work of Art* and in the "Epilogue" he appended to it: can art still be a historical foundation for our age, or must we agree with Hegel, who saw in it a manifestation of absolute Spirit that has been transcended? This passage shows that it is to artistic revelation *as such* that Heidegger accords a historical foundational function: in fact, when he asks himself the Hegelian question, he identifies it with the question as to whether art *as such* is not dying, which means that for him to question the historical function of art is to question its nature or its essence. Moreover, we encounter the claim again, this time applied to poetry, in the seminar given in the winter of 1934–35: "the historical *Dasein* of peoples, their rise, their apogee, and their decline, arise from poetry, and . . . so does authentic knowledge in the sense of philosophy; and both at the same time arise from the state's actualization of the *Dasein* of a people *qua* people—politics. This original, historical time of peoples is consequently the time of poets, of thinkers and founders of the state, that is, of those who in fact found and justify the historical existence of a people. They are the true creators."[47] In this passage, the absolute foundational value of poetry is clear: to be sure, the poet, the thinker, and the founder of the state are all three described as creators and founders of the historical existence of a people, but it remains nonetheless that poetry is absolutely primary, since it precedes the thinker and the latter precedes the founder of the state.

There is nevertheless a close connection between the poet, the thinker, and historicity. Now, in the period of metaphysics, the "thinker" is the metaphysician. Thus we come back to our question: how can we avoid making Art indissociable from metaphysical dissimulation, if this dissim-

ulation is said to determine the period in question? How can Art still be a revelation of Being if it is situated in a period of the forgetting of Being and if it is historically indissociable from the deepest essence of that period? That is a question to which one can find no answer.

The second conception of the work of art, the one that defines it as ecstatic knowledge, and thus as distance with respect to endoxical being-in-the-world, does not encounter the same problems. It is centered on the opposition between the piece of equipment and the work with regard to their relationships to their materials. Heidegger formulates the problematics of the relationship between the materials and the object produced or created in a famous passage—which is particularly esoteric—devoted to what he calls the battle (within the work) between earth and world. To reformulate the problem in more usual terminology, one could say that "earth" refers to *physis* and more precisely to the matter, the materials of the work of art, while "world," as we know, designates the representational function of the work. Now it seems that the relationship between the piece of equipment and earth is not the same as that between the work and earth: the piece of equipment uses up earth and aims at making it disappear into its usefulness. The material as such is taken into account only insofar as it is adequate to the intended use. In the work of art, in contrast, earth is thematized as such: to be sure, it is not part of the Open (of the world), since by definition it is that which holds itself in reserve; and yet it emerges, it enters into the Open, but it does so as that which withdraws into itself. The work lets earth be what it is: it does not subordinate it to an external finality, nor does it try to penetrate it (as science does—in vain).[48] It is precisely because it lets earth be what it is that it can make it happen as that which withdraws. For that reason the work not only opens a world, but establishes the battle between earth and world: it brings earth, as that which withdraws into itself, into emergence (*Ragen*) in the world, while at the same time restoring the latter to earth, that is, leading it to base itself on it. For earth and world are locked in indissoluble combat, and because the work establishes the indissolubility of this combat it is also the happening of truth, since truth is nothing other than the play of withdrawal and clearing: "Earth juts through the world and world grounds itself on the earth only so far as truth happens as the primal conflict between clearing and concealing."[49]

All these considerations are supposed to ground the existential value of Art, namely its ability to constitute a shock (*Stoß*) and an impact (*Anstoß*). The shock is the revelation that the work *is*: a revelation not as a retention of its being created, but as an always present happening of that being. The sole "theme" of being a work is the simple "fact" that it is: "In a work . . . this fact, that it is a work, is just what is unusual. The event of its being created does not simply reverberate through the work; rather, the

work casts before itself the eventful fact that the work is as this work, and it has constantly this fact about itself. The more essentially the work opens itself, the more luminous becomes the uniqueness of the fact that it is rather than is not. The more essentially this thrust comes into the Open, the stronger and more solitary the work becomes."[50] Several themes intersect in this passage. Thus the definition of the work's being-created as the event of its Being (and thus as thematization of the fact that it is) is directly related to its ontological status. What matters in the work is neither, in contrast with equipment, that in view of which it is (whether the "in view of" is understood as relating to a cause or to a goal), nor, in contrast to communicational signs, that for which it substitutes, but solely the simple fact that it is. Now to the extent to which it thematizes its own being as event, it can at the same time reveal Being as such, since Being is event.

This conception obviously recalls the theory of the Jena romantics, and more specifically two of their central theses concerning the work of art, namely that in the work we witness a coalescence of meaning and being (whence its autotelic nature), which makes it an exemplification of the very structuration of Being. To be sure, Heidegger, as we have seen, rejects the romantic conception of the symbol, but what he proposes concerning the work, both as regards the "thematization" of its own Being as constituting its sole true "subject," and as regards its ability to grasp the essence of Being in and through a singularity (its own), circumscribes exactly the same field as the Jena romantics' theory of the symbol.

But the passage quoted above is also interesting in another respect: it marks the transition from the conception of distance as difference between the work and the piece of equipment to that of a distance between the work and inauthentic everyday life. In fact, the work of art is always strange and solitary: "*To submit to this displacement means: to transform our accustomed ties to world and to earth and henceforth to restrain all usual doing and prizing, knowing and looking, in order to stay within the truth that is happening in the work.* Only the restraint of this staying lets what is created be the work that it is. This letting the work be a work we call the preserving of the work. It is only for such preserving that the work yields itself in its createdness as actual, i.e., now: present in the manner of the work."[51]

If the difference between the work and the piece of equipment concerns the mode of creation, the difference between the work and everyday existence relates to its reception, to its "preservation." Before the shock provoked by the work, being in its totality (and ourselves insofar as we are involved in it) appears reassuring to us. The work, by opening a world, makes us discover that the reassuring appeared as such only because we were mired in the everyday mode of existence, that is, in inauthenticity.[52] This is a double function already proposed by Novalis: the work of art as

revelation of the One and All simultaneously reveals to us that empirical existence in its particularism is merely an illusion. In Heidegger the vocabulary is different, and the definition of the two domains opposed cannot be confused with the romantic dualism between the finite and the finite; nonetheless, the functional structure remains exactly the same. Art gives us access to a different "reality," at the same time revealing the "falsity" of everyday life.

The Heideggerian thesis of the ecstatic nature of Art thus takes a threefold form: on the cognitive level, artistic "knowledge" *qua* revelation of Being is opposed to endoxical knowledge; on the level of the mode of being, the work of art as an autotelic entity is opposed to the heterofinalized piece of equipment; finally, on the functional level, the work of art as inducing a state of ecstasy is opposed to the inauthentic being-in-the-world of everyday life.

It is clear that the two conceptions, that of the historical function of Art and that of its ecstatic status, are wholly independent of each other. In this sense, while the theory that defines Art as an ecstatic distance in relation to inauthenticity in fact makes it possible to escape the problems encountered by the thesis that Art has a historical foundational function, it is at the price of changing from one concern to another: Art is no longer defined in opposition to metaphysics but in opposition to the inauthenticity of everyday life. In other words, the initial problem still has not been resolved: Heidegger simply limits himself to shifting terrain in order to escape the inevitable contradiction arising from the conjoint assertion of the absolute reign of metaphysical dissimulation and the ontological function of the work of art.

POETRY AND THOUGHT

In the course of my analysis of romanticism, I drew attention to the extent to which Art is connected with the postulated specificity of an artistic "language" possessing qualities lacking in other human semiotic activities. I distinguished two aspects: on one hand the nonverbal arts are not granted the dignity of Art insofar as they are translatable into a representational structure of a hermeneutic type; on the other hand, verbal art, identified with poetry, becomes the paradigmatic art, because in it the essence of Art is realized in the most adequate way. In *The Origin of the Work of Art*, Heidegger develops considerations of the same kind.

The notion of *Dichtung* is introduced at a strategic point in the text, namely in the third part, which returns to the fundamental question of the essence of art. This question is taken up on the basis of the definition of the work as the happening of truth. This happening of truth is none other than

its Poem, its "poïetizing," its *Dichtung*: "Truth, as the clearing and con-
cealing of what is, happens in being composed, as a poet composes a poem.
All art, as the letting happen of the happening of the truth of what is, is,
as such, *essentially poetry*. The nature of art, on which both the art work
and the artist depend, is the setting-itself-into-work of truth. It is due to
art's poetic nature that, in the midst of what is, art breaks open an open
place, in whose openness everything is other than usual."[53]

The presentation of *Dichtung* as the essence of Art has a double corol-
lary: on one hand, poetry occupies a privileged place among the arts as a
whole; on the other hand, the nonverbal arts are conceptualized in accord
with the linguistic paradigm. In a central passage, Heidegger, while deny-
ing the subjection of the other arts to poetry, underlines the latter's special
place: "If all art is in essence poetry, then the arts of architecture, painting,
sculpture, and music must be traced back to poesy. That is pure arbitrari-
ness. It certainly is, as long as we mean that those arts are varieties of the
art of language, if it is permissible to characterize poesy by that easily
misinterpretable title. But poesy is only one mode of the lighting projection
of truth, i.e., of poetic composition in the wider sense. Nevertheless, the
linguistic work, the poem in the narrower sense, has a privileged position
in the domain of the arts."[54] This passage raises a double question: in what
sense does poetry occupy a special place among the arts, and how can it be
connected with the other arts, it being understood that the latter could
never constitute simple derivative classes?

The answer to the first question resides in the thesis of language as the
dwelling of Being: language is the unconcealment of Being insofar as it
"happens." This thesis is already found in the analysis of the "disposition"
(*Befindlichkeit*) of *Dasein* proposed by Heidegger in *Being and Time*:
there being-in-the-world is grasped in the double modality of understand-
ing (*Verstehen*) and ex-plication (*Auslegen*). In *The Origin of the Work of
Art* the importance of language is still greater, since it is directly linked
with the "project" as the correlate of "thrownness": language is the very
act of the projection of the Open, an act through which it is determined
how the being will be opened and how Being will be concealed in its open-
ing. The Open is possible only in and through language, which implies, of
course, the rejection of any communicational definition of the latter:

> To see this [that is, to see how poetry occupies a special place], only the right
> concept of language is needed. In the current view, language is held to be a
> kind of communication. It serves for verbal exchange and agreement, and in
> general for communicating. But language is not only and not primarily an
> audible and written expression of what is to be communicated. It not only
> puts forth in words and statements what is overtly or covertly intended to be

communicated; language alone brings what is, as something that is, into the Open for the first time. Where there is no language, as in the being of stone, plant, and animal, there is also no openness of what is, and consequently no openness either of that which is not and of the empty.[55]

The rejection of a communicational definition is linked to an essentially nominative conception of language. Religious in origin, in Heidegger it ends up in the theory of "essential words" on which he bases his hermeneutic practice when he is reading poetic works: "Language, by naming beings for the first time, first brings beings to word and to appearance. Only this naming nominates beings *to* their being *from out of* their being. Such saying is a projecting of the clearing, in which announcement is made of what it is that beings come into the Open *as*. Projecting is the release of a throw by which unconcealedness submits and infuses itself into what is as such."[56] Such a conception of language inevitably implies an atomism of meaning that takes no account of syntactical structures or, of course, the pragmatic dimension:[57] as Heidegger conceives it, language is reducible to a dictionary, even if it is a dictionary of "the fundamental words of Being." I shall come back to this point later on in analyzing Heidegger's interpretive practice.

During the 1930s and up to the end of the Second World War, particularly in *The Origin of the Work of Art* and the first studies on Hölderlin, this conception of language is closely connected with the theory of historicity. Language is always the historical language of a specific people, that is, it is the terrain on which a people's historical destiny is established, decided, and played out: "Actual language at any given moment is the happening of this saying, in which a people's world historically arises for it and the earth is preserved as that which remains closed. Projective saying is saying which, in preparing the sayable, simultaneously brings the unsayable as such into a world. In such saying the concepts of an historical people's nature, i.e., of its belonging to world history, are formed for that folk, before it."[58]

Thus the first steps are taken for an identification of language with *Dichtung* as the essence of Art, since both are defined simultaneously by their onto-logical function and by the historical status. But Heidegger adds this reservation: "Poetry is thought of here in so broad a sense and at the same time in such intimate unity of being with language and word, that we must leave open whether art, in all its modes from architecture to poesy, exhausts the nature of poetry."[59] This reservation may at first seem surprising; in reality, it prepares the ground for the thesis of the fundamental unity of the Poem (*Dichtung*) and thought (*Denken*) that one finds in the analyses of Hölderlin's poetry.

It is because language itself is Poem that that poetry, the art of lan-

guage, can be described as "the most original form of poetry in the essential sense."[60] This in turn makes it possible to define its relation to the other arts: "Language is not poetry because it is the primal poesy; rather, poesy takes place in language because language preserves the original nature of poetry. *Building and plastic creation, on the other hand, always happen already, and happen only, in the Open of saying and naming. It is the Open that pervades and guides them.* But for this very reason they remain their own ways and modes in which truth orders itself into work. They are an ever-special poetizing within the clearing of what is, which has already happened unnoticed in language."[61] Thus if the other arts are not derived from poetry, they are still less original than it is, because they are pervaded and guided by the Open of saying and naming that happens in language.

However, if the nonverbal arts always already presuppose the clearing of Being as it happens in language, how can one still describe them as *Dichtung* if the latter is defined precisely as the happening of that clearing? Let us recall that science was denied an original relation to the question of Being because it never occurs except in a clearing that has already happened; it is hard to see how the nonverbal arts can escape the same judgment. And yet they do escape it, since we have seen that the Greek temple was explicitly identified with the act of opening a world, and thus with the happening of the clearing, of the truth of the Greek world. And Heidegger, far from seeing the slightest contradiction in this, asserts on the contrary that this is precisely because (*deshalb*) the other arts are pervaded and guided by the Open that has "happened" in saying and thinking that they remain "their own ways and modes in which truth orders itself into work." In fact, in spite of this bold assertion, Heidegger confronts the same difficulty as most of the other representatives of the speculative theory of Art: that of bringing into a single theory both verbal art and the nonverbal arts, it being understood that the theory in question is logocentric (in this case the epithet is not abusive), that is, it has a tendency to situate the essence of Art in its hermeneutic function and to conceive the latter as overtly or covertly linguistic. And Heidegger is scarcely more successful in avoiding this difficulty than were his predecessors, since he provides no clear indication as to *how* the "secondary" character of the nonverbal arts with respect to poetry can be reconciled with the nonetheless originary character of the clearing that is supposed to precede them.

The promotion of poetry to a paradigmatic art is also closely connected with its assigned function of entering into dialogue with thought. It can moreover be said Heidegger's theory of Art culminates in the thesis of this dialogue.

As early as our analysis of Jena romanticism, we saw that the relation

between poetry as a paradigmatic art and thought could be adequately grasped only if it was read within the framework of the Art-philosophy-science triad. The Heideggerian pair *Dichtung/Denken* must also be resituated in a triad: *Dichten/Denken/Wissen* (poetizing/thinking/knowing), the latter term being related both to the sciences and to the metaphysics that is their foundation. Heidegger thus undertakes a shift with regard to the Jena romantics, a shift concerning philosophy: for the Jena romantics, the latter was one of the terms of the privileged pair (poetry and philosophy) opposed to science as the nonoriginary term; in Heidegger it becomes the site of the excluded term, a site that now includes two terms, because it includes both metaphysics and the sciences. But the structure itself remains rigorously the same: two privileged terms and a third term that functions as a foil. Just as in the romantics the unity of poetry and philosophy was based on the "expulsion" of the "empirical" sciences, in Heidegger the dialogue between *Dichten* and *Denken* occurs at the expense of science and metaphysics. This exclusion of sciences and metaphysics from the sacred domain is the corollary of the sidelining of the modalities of language linked with the forgetting of Being. Poetry and thought, *Dichten* and *Denken*, can enter into dialogue because each of the two terms is conceived as difference with respect to its respective endoxical discourse: communicational language on one side, scientific and metaphysical discursivity on the other. The difference between poetry and thought, which established the possibility of their union (Jena romanticism), or of their "dialogue" (Heidegger), is pertinent only against the background of this initial "sameness" entailed by their difference with regard to endoxical discourses.

What is the exact nature of the dialogue between the Poem and thought? Heidegger's reply varies according to whether he is asking the question *in abstracto* or in a historical perspective. In the first case, he seems to maintain the idea of an implicit priority of the Poem, and more concretely of poetry. Thus in "Hölderlin and the Nature of Poetry" we read (on the subject of the elegy "Bread and Wine"): "In it is said poetically what could here be *only* set forth by thought."[62] There it is clear that this statement repeats the romantic thesis opposing poetry to philosophical exposition. It is again in this perspective of the self-sufficiency of poetic saying that we must interpret the hermeneutic ideal of a perfect transparency of commentary with regard to the plenitude of the work: "For the sake of what happens as a poem, the interpretation must seek to make itself superfluous. The final but also the most difficult step in all interpretation consists in the latter's disappearance along with all its explanations before the pure presence of the poem."[63] This ideal is in perfect accord with the thesis of the paradigmatic function of poetry in the development of the dialogue between poetry and thought, a thesis that seems moreover

to become more accentuated as the years go by, since the concluding text in *Commentaries on Hölderlin's Poetry* (which dates from 1968) asserts: "The way of speaking of a poem that is in conformity with the poem can only be poetic saying. In this saying, the poet speaks neither about the poem nor of the poem. He poetizes (*dichtet*) what is proper to the poem."[64] This assertion, whose immediate theme is the question of the relationship between Hölderlin's poems and his theoretical texts, holds *mutatis mutandis* for commentary on the text, in this case Heidegger's, which can be adequate to the poem only if it in turn is transformed into *Dichtung*.

The priority of poetry seems moreover to be related to its function as an absolute historical origin. In the seminar held in Thor in 1966, René Char remarks that the semantic multiplicity of Heraclitus's saying makes him akin to the poet. Heidegger responds that that is so because the Greek language had a noncalculating relationship to nature, that is, it allowed Being to happen in its double movement of opening and concealing. This implicitly signifies that poetry, for its part, maintains a similar relationship to nature, and thus that it always remains originary. That is, moreover, what he says explicitly a few pages further on. Asserting that thought's task consists in thinking the fate of Being, he explains that in this enterprise the Poem constitutes a sort of *organon* for thought: "For poetry has not become unfaithful to the site of the originary opening up, whereas the becoming-philosophy of thought—and of the world—determines the path we are currently following."[65] Poetry has never left this native ground that thought has to reconquer through the deconstruction of the metaphysical tradition and through dialogue with poets.

However, when poetry is no longer conceived as an absolute historical origin or in accord with its nontemporal essence, but rather as emerging in a concrete historical period, the relation with thought can be inverted. We encounter again here the question of whether an artistic revelation of Being is possible in the period of fully achieved metaphysics. Whence the questions raised in the concluding lines of *The Origin of the Work of Art*, to which I have already referred: "whether art is or is not an origin in our historical existence, whether and under what conditions it can and must be an origin."[66] In the Epilogue he resituates these questions in the perspective of Hegel's verdict that Art is a completed and transcended figure of the becoming of absolute Spirit. This verdict, Heidegger says, is that of an epoch of Being that identifies truth with the certainty of the absolute: the very position that Art occupies in the Hegelian system is granted it by this historical principle of truth. Obviously, one might object that the Jena romantics, as well as the Schelling of *The Philosophy of Art*, saw in the fulfillment of Art, on the contrary, a future end of philosophy. However, they incontestably belong to the same historical period as Hegel. The Heideggerian conclusion, namely that the Hegelian verdict can be questioned

only from a point of view other than that of metaphysics, thus seems by no means inevitable.

Yet if one accepts the Heideggerian conclusion, the latter clearly implies that Art can no longer be an origin for our historical period, because this period's conception of truth (and hence of Being) prevents it from being such an origin. It can become an origin again only once it leaves this period. This exit is "in the hands" of the fate of Being, but the thinker can prepare the way for it. Thus the thought of the essence of Art "is the preliminary and therefore indispensable preparation for the becoming of art. Only such knowledge prepares its space for art, their way for the creators, their location for the preservers."[67] Thus it is no longer Art, in its poematic essence and in its special figure—poetry—that guides groping philosophy: it is on the contrary thought that prepares for Art's (re)becoming-origin (this is, with a slight difference in vocabulary, the position defended by Schelling in *The Philosophy of Art*).

If we leave the historical questioning and situate ourselves at the level of the gnoseological status of Art (that is, of poetry), we can say that Heidegger oscillates between the position of the Jena romantics and that of Hegel: Art is more than thought, Art is less than thought. His conceptual motivations are in both cases irreducible to those of the Jena romantics or Hegel, but the result with regard to the status of Art is the same. The commentators generally maintain that the two conceptions correspond to different stages in Heideggerian thought. And in fact, all the passages I have cited to illustrate the first conception were written after 1936. It is also true, as I have repeatedly pointed out, that the celebration of the paradigmatic role of poetry becomes more emphatic in the texts after the Second World War; and moreover the thesis of the necessity of meditating on the essence of Art as an autonomous task of the thinker and the possible preparation for a (re)becoming-origin of Art is hardly mentioned any more. It nonetheless remains that *both* conceptions are already found in *The Origin of the Work of Art*, where they correspond to two different perspectives: that of absolute establishment (the Greek origin or the essence *in se* of Art) and that of epochal establishment. In the latter perspective, metaphysics, and consequently also the deconstruction of metaphysics by the thought of Being, take priority over Art. In other words, Heidegger's evolution can also be read as a temporal projection of this duality of the perspectives present as early as *The Origin of the Work of Art*.

A final question concerns the manner in which Heidegger explains the difference between poetic discursivity and thought. In fact, for a dialogue to be possible, poetry and thought have to both say the same thing and say it in a different way. They have to say the same thing, for it is only against the background of this sameness that thought can clarify (*erläutern*) poetry. They have to say it differently, for otherwise the dialogue would be

absorbed into pure redundancy. The sameness in content and the alterity of the saying guarantee the mutual translatability of the two idioms. We already know that the sameness that is basic to poetic saying and thought—their common "theme"—is nothing other than the truth of Being. But Heidegger is much less prolix when it is a question of explaining how the two activities differ from each other. In the 1943 postface to *What Is Metaphysics?* we read:

> Obedient to the voice of Being, thought seeks the Word through which the truth of Being may be expressed. . . . Of like origin is the naming of the poet. But since like is only like insofar as difference allows, and since poetry and thinking are most purely alike in their care of the word, the two things are at the same time at opposite poles in their essence. The thinker utters Being. The poet names what is holy.
>
> We may know something about the relations between philosophy and poetry, but we know nothing of the dialogue between poet and thinker, who "dwell near to one another on mountains farthest apart. As for knowing how, if it is thought on the basis of the essence of Being, poetic saying, thanking and thinking refer to one another and at the same time they are distinct, the question must here remain open. It is likely that thanking (*Danken*) and poetic saying arise differently from original thought, of which they make use without for all that being able being a thought for themselves."[68]

It will be observed first that this passage contradicts the thesis that poetic saying is the originary language, since here Heidegger admits the hypothetical possibility that poetry is descended from the originary thought. A little earlier he notes: "Thought's reply is the origin of human speech, a speech that alone gives rise to language as the divulging of speech in words."[69] But in "Hölderlin and the Essence of Poetry" (1936) he asserts on the contrary that "it is poetry that begins by making language possible. . . . The essence of language must be understood on the basis of the essence of poetry."[70]

In any case, in the first passage, Heidegger distinguishes between the *naming* of the *sacred* by poetry and the *saying* carried out by thought. The terminological distinction is not always clear: in the texts on Hölderlin he sometimes uses both the verbs "name" (*nennen*) and "say" (*sagen*) in referring to the poetic utterance. In "Hölderlin and the Essence of Poetry," for example, *Dichtung* is determined as being the "original *naming* of the gods"; the commentary on "Wie wenn am Feiertage" speaks on the contrary of the poetic utterance as "the saying that establishes": similarly, the commentary on "Andenken," defines poetry as "the *saying* of the sacred."[71] In fact, the essence of the distinction does not have to do with the verbs but with the complements: Being on one side, the sacred (and the gods) on the other. By virtue of the postulated sameness, this difference

can obviously not have to do with the content, but solely with the "how?": poetry says Being *as* sacred, as divine, while thought says it *as* Being. But if one tries to see in a more concrete way what this difference includes, one finds hardly any elements of a reply, other than a few indirect hints that are difficult to evaluate. In the texts on Hölderlin the poet is described—according to a traditional *topos* that had been reinvigorated by romanticism—as a mediator between gods and men, and more precisely between the gods and a historical people. To name the gods, to name the sacred, would be to establish the historical fate of the people as it is revealed to it in divine signs. To be sure, the thinker's questioning cannot be conceived outside historical determinations, but it nevertheless seems that Heidegger accords it a different place in the temporality of this historical destiny: it comes, either *before* the poet, in order to prepare his arrival, or *after* him, in order to clarify his saying and thus to preserve it in its initial brilliance. It is thus somewhat marginal to the destiny of the people to which the poet, on the contrary, is very closely connected through his act of establishment: "And thus poetic questioning is of a very different kind from that of thought, which ventures forth in what is essentially worth questioning, and there, it engages in a test quite different from that of saying the Sacred. The thinker allows his thought to become outlandish, not because he wants merely to traverse what is outside the homeland, but because to be outside the homeland is for him to be at home. On the contrary, the question addressed by the poet's faithful thought (*das andenkende Fragen*) is another way of saying poetically what it means to 'be in the homeland.' . . . It is simply that the poet questions as a poet. The revelatory appearance of the question is still a concealing."[72] The end of this passage seems to indicate still another way of conceiving the distinction between poetry and thought, namely as an opposition between a veiled appearance and a direct questioning. On this interpretation, the gods, and more abstractly, the sacred, would constitute veil of Being. However, the idea of this kind of distinction between poetry and thought is scarcely compatible with Heidegger's central thesis that concealment is *constitutive* of Being.

All these hesitations and uncertainties can be read as so many indications that the distinction between poetic naming and the thinker's saying has only a tactical function in Heidegger's thought, which is always countered by an inverse movement postulating their originary unity: the originary establishment of the essential utterance is both thought *and* poetry. This essential and "unified" utterance precedes any distinction (even that between poetry and thought). It constitutes both the content of the dialogue and its most secret, forever ineffable dynamics. Hölderlin, we learn, *thinks poetry* in his poems, that is, his poetry is at the same time thought. And in "On the Way to Language" we read: "All reflective thinking is poetic, and all poetry in turn is a kind of thinking."[73]

In reality, in Heidegger's work—as in that of many other representatives of the speculative theory of Art—the different forms taken by the dialogue and the rivalry, the oscillation between the precedence accorded to one or the other of the terms involved, the perpetual movement between the establishment of differences and their immediate recuperation into an originary indifferentiation, escape any rational analysis. To evaluate their true value, it would probably be necessary to make them resonate in unison with the pathos of an existential experience that imposes itself with absolute clarity on those who share it, but that it is difficult to reconstruct in a convincing manner outside that horizon.

An Interpretive Practice

Heidegger's interpretive practice derives from his conception of the relations between thought and poetry. This conception is ambiguous: one would not be surprised to find the same ambiguity when it comes to a definition of interpretive practice. On one hand, Heidegger states that what poetry says, it alone can say, so that any ex-plication by thought is merely a makeshift. The corresponding interpretive ideal involves the disappearance of commentary, leaving only the text commented on, so that "we let the poem itself tell us what its own particularity consists in and on what it is based."[74] Thus we end up with a critical mimeticism whose ideal is a minimal paraphrase. But Heidegger also defends a concurrent conception, according to which it is up to thought to bring to light what the poem means (*meinen*) without saying it explicitly. Interpretation should experience (*erfahren*) the unspoken in the poem: "There would then be no moment in which to make a contrived myth out of the figure of the poet. There would then be no occasion to misuse his poetry as a rich source for a philosophy. But there would be, and there is, the sole necessity, by thinking our way soberly into what his poetry says, to come to learn what is unspoken."[75] The interpretive practice corresponding to this conception is translation: the commentary translates the poetic "saying," and especially the unspoken, into a philosophical concern, in this case the thought of Being.

A third characteristic is added to paraphrase and to translation: the privileged attention accorded to "fundamental words," generally at the expense of the utterances in their syntactical unity. Whence a basically paratactic method that is doubtless the most obvious characteristic of Heidegger's literary analyses. This method plays an important role in the translation of poetic saying into thought of Being, since by isolating "fundamental words" it makes it possible for interpretation either to recombine them syntactically in the interpretive metalanguage, or to use them as starting points for autonomous conceptual developments. In "Hölderlin

and the Nature of Poetry," Heidegger thus seeks to develop Hölderlin's conception of poetry on the basis of five key-words (*Leitworte*), that is, on the basis of five utterances drawn from the most diverse parts of the corpus of Hölderlin's works. Starting from these materials, he constructs his theory of the essence of poetry. For example, the second "key-word" is "That is why the most dangerous of all goods, language, was given to man . . . : so that he might bear witness that he is." In the context of the poem from which it is extracted, this passage refers to one of the characteristics of man (alongside free will and "superior power of ordering and accomplishing"). Heidegger disassociates it from this context and uses it as a translation of his own theory of language. Once this theory has been developed, he returns to another "key-word," on the basis of which he develops his theory of historicity, and so on. Hölderlin's texts have in reality only one function: to serve as punctual relays for considerations that are peculiar to Heidegger the interpreter.

Of course, by choosing to devote most of his analyses to Hölderlin, Heidegger turns to a poet who in fact shares a certain number of his preoccupations and conceptions. Among the common points—aside from their very strong attachment to Swabia—the most incontestable are: the relationship to Greece as a lost origin and the relationship to the German fatherland as an origin to come; the conviction that they are living in an intermediary period; the reference to the same philosophical tradition, Hölderlin being the ambivalent witness to its birth, whereas Heidegger, situated at the other end of the development, tries to preserve its fundamental impulse while at the same time setting out to deconstruct it. Finally, in the most general and diffuse manner, both authors share a common disposition: if Hölderlin is a poet-thinker, Heidegger is a thinker-poet. Because of this spiritual commonality, Heidegger's interpretation of Hölderlin is partly well-suited to him: Heidegger is incontestably the most important interpreter of the author of *Hyperion*. His analytical methods nonetheless remain questionable and lead more than once—even in the case of Hölderlin—to unilateral interpretations.

The questionable character of Heidegger's procedure is sometimes masked by the fact that he devotes very elaborate interpretations to isolated poems, which can give the impression of a detailed, respectful analysis of the poetic text. But as soon as one examines the actual interpretive practice, one discovers that it proceeds above all by leaps from one "fundamental word" to another, the connection between the different words being achieved by translational paraphrases or by autonomous developments, and often by a combination of the two. Thus, when he analyzes the first two stanzas of the hymn "Die Fahrt" he notes only the fundamental words "hearth" (*Herd*) , "rays," "origin," and "fidelity," on the basis of which he constructs an autonomous interpretive development that moves,

for example, from *Herd* to *Werkstatt* (workshop, forge)—this latter term not being present in the poem—or from rays to clearing. In other words, Heideggerian interpretation creates alongside the poem analyzed a philosophical metapoem to which he devotes the majority of his "clarifications."

Heidegger is well aware that the utilization of the principle of "fundamental words" in literary interpretation may well elicit reservations. Thus he takes care to ensure the autonomy of his questioning in relation to philology and literary theory. The preface to the fourth German edition (1971) of *Erläuterungen zu Hölderlins Dichtung* warns: "these *clarifications* do not claim to be contributions to literary history or to aesthetics. They proceed from a necessity of thought."[76] Moreover, he limits his poetic corpus to the domain of what he calls the "exceptional poem" (*das ausgezeichnete Gedicht*),[77] or, as he says in analyzing a poem by Rilke, the "valid poem" (*das gültige Gedicht*).[78] A valid poem is one that, at least in our historical period, poetizes the essence of poetry. Heidegger thus notes only what the romantics had called the reflective practice of literature, that in which it takes itself as the "object" of its saying. The poem, when it is grasped in its essence, is the "saying" of Being: the interpretive translation of poetic "saying" into thought of Being is thus justified, since the thinker limits himself to interpreting poems that poetize the essence of poetry and since the essence of poetry resides in its onto-logical function.

Another way of guaranteeing the autonomy of philosophical reading consists in refusing to consider the poem as an act of language on the part of a socially or psychologically concrete individual, thereby linking it to the facticity of a particular existence. Thus when he interprets Hölderlin's "Andenken," he observes: "The title lets us know that here the nature of future poets' thought, a thought that is poetry, is said. And that is something quite different from the 'poetizing' of Hölderlin the tutor's journey."[79] To be sure, a purely biographical reading of a poem is impoverishing, if it is conceived as an attempt to *replace* the poem by the emotions it expresses and the events it describes, or to *reduce* it to them. Nonetheless, "Andenken" *was* written by the tutor Hölderlin and describes the landscapes of southern France that he *did* pass through. Moreover, it is not called "Andenken" ("Memory") for nothing, even if Heidegger decides to see in memory, *An-denken*, only a fundamental term of the thought of Being and categorically refuses to take its usual sense into account. In reality, it is hard to see just how one could deny that "Andenken" refers to events in Hölderlin's life. One can go even further: every interpretation of the poem has to be compatible with the fact that it refers to such private events. Obviously, that does not mean that its essential interest is biographical in nature, or that its meaning can be reduced to its referential import; but on the other hand, neither is it clear why its philosophical import should exclude its biographical reference.

Another important characteristic of Heidegger's analyses resides in the fact that they never take into account the properly poetic aspect of the texts interpreted. It is at least paradoxical that a thinker who postulates the essential character of *poetic* saying takes absolutely no account of poetic techniques, and more generally of formal issues. Heidegger's analyses in fact bear purely on the content. But at the same time he implicitly accepts the delimitation of the textual corpus by formal characteristics, since his analyses as a whole suggest that for him poetic saying is connected with the criterion of versification: he analyzes no text in prose as an example of poetic saying, and when he discusses Hölderlin's letters or theoretical writings he takes care to emphasize that their function is only to prepare for the clarification of the poem. His procedure is thus incoherent: for the constitution of his corpus, he implicitly relies on a formal criterion, but at the same time this criterion is never thematized as such in specific analyses. Hölderlin's texts are poems because they are the saying of Being; however, we never learn why this saying, aside from being the saying of Being, is a *poetic* saying (in the generic sense of the term). Thus the theory of the dialogue between poetry and thought, while it postulates an abyssal (*abgründig*) difference between the two, takes into account solely the characteristics of the poem that are reducible to thought, and which are therefore not specifically poetic: for Heidegger's purposes, the poems might just as well be in prose.[80]

Paraphrase, translation, dismantling of the syntax, making the text autonomous with regard to the concrete subject who utters it, absolute silence concerning the poetic form: to these five characteristics we must add hermeneutic authoritarianism. The latter is legitimated by the very principle of translational interpretation, which postulates an opposition between what the poem seems to say and what it really means. This opposition is brought into play every time a poem being analyzed seems to run counter to the onto-logical interpretation in which the interpreter is engaged: Heidegger carelessly uses the pair *bedeuten/meinen*, the first term referring to the commonly received meaning or the "apparent" contextual meaning, the second to the "authentic" meaning, that is, the one advanced by the thinker of Being. The pair may vary: thus in the interpretation "And the Nature of Poetry" *bedeuten* (to mean) is replaced by *erinnern an* (to recall). Since the passage in question is exemplary of the procedures Heidegger employs, I shall analyze it in detail. First, here are the verses that are dealt with by the interpretation, that is, the sixth stanza and the beginning of the seventh:

> Then promptly moved, the soul, long
> Known to the infinite, trembles
> With memory and, fired by the sacred ray,
> The fruit born from love, the work of gods and men,

The song, that he might witness to both, succeeds.
Poets say that since she visibly
Desired to see the God, his lightning bolt fell on Semele's house,
And mortally wounded ash [she] bore
The storm's fruit, holy Bacchus.

And therefore now the sons of earth
Drink the heavenly fire without peril.
Yet it is fitting that we poets stand
Under God's storms, with our heads bare,
To seize the Father's ray itself with our own hand,
And concealed in a song,
Give the people the heavenly gift,

This passage, at least with the German text alongside it,[81] does not pose too many problems so far as the semantic interpretation is concerned: it contrasts the sons of the earth who have only an indirect and safe access to the celestial fire with the poets who confront the Father's lightning bolts directly and try to grasp them with their hands. The poets are then compared with Semele: just as through her son Bacchus she gave men wine, the poet gives them song. But this first parallel, which has to do with the gift, raises the possibility of a second parallel concerning the destiny of the givers: Semele was destroyed; how will the poet fare? In other words, does the parallelism of their gifts imply a parallelism in their fates? Heidegger, instead of seeing that this question is raised by the very structure of the semantic parallelism, refuses to consider it. By virtue of his conception of poetic saying, it is taken for granted from the outset that there could be no parallelism between Semele's fate and that of the poet, since the poet bears witness to the sacred (which is not the case when Semele wants to see the god "in a human way"): the poet is the one who establishes the world in which the "sons of the earth" live, and he alone mediates between gods and men. Thus the "heavenly fire" drunk by the sons of the earth can no longer refer to wine: "the word 'drink' does indeed recall (*erinnert an*) the god of wine, but it really means (*meint jedoch*) the reception of the other fruit, men's hearing of the spirit that breathes in the successful hymn."[82] In other words: "the heavenly fire" apparently designates wine, but in reality it designates song. At first sight one might think that in making this claim, Heidegger simply means that we must interpret wine as a metaphor of poetic song. In reality he refuses to consider that the passage about "the heavenly fire" could be related to the story of Semele and Bacchus because he has decided to oppose Semele to the poet: "The eagerness to see the god in a human way carried Semele off in the ardent passion of the lightning unleashed. She who conceived forgot the sacred. . . . Semele's fate shows negatively how only the presence of the sacred ensures the song's true

success. *The allusion . . . to Semele's fate is inserted into the poem only as a counter-theme.*"[83] This being the case, Heidegger has to claim that the beginning of the seventh stanza is not situated in a continuation of the story of Semele, but in reality connects up with the middle of the sixth stanza, that is, with the definition of sacred song: "That is why the beginning of the following stanza connects, not with the end of the sixth, but with its middle."[84] Therefore we are to understand that the sons of the earth can henceforth drink the heavenly fire without peril because the sacred song has been established by poets, an establishment that Semele's "human way" of seeing had been unable to achieve. Men drink the heavenly fire without peril because they live in the world opened by poets. From the point of view of the syntactical organization of the poem, this interpretation is at least risky: it is much more plausible that the "That is why" at the beginning of the seventh stanza refers to the immediately preceding passage, that is, to the story of Semele. Instead of analyzing the poem as it presents itself and instead of asking the questions its semantic structure makes it possible to ask, Heidegger postulates as a prior principle that it coincides with an overall structure of interpretation capable of bringing to light a coherent conception. He does not analyze the poem as it is, but as it would be if it were a successful transposition of the overall interpretation he proposes: "The text used for the present commentaries is based, after being revised in accord with the handwritten drafts, on the explication that we shall attempt."[85]

But the poem in question is *unfinished*, and Heidegger is well aware of this. Instead of taking this unfinishedness into account, he has decided to treat the text as if it were completed: "The poem is unfinished in many respects. The ordering of the end in particular, which Hölderlin himself once chose, remains indeterminable. But every kind of unfinishedness is here only the consequence of the superabundance that wells up from the innermost beginning of the poem and requires a rigorous conclusion. Every attempt to follow the structure of the final stanza can have as its aim only to awaken those who can hear what the 'word' of this poem is."[86] The "rigorous" conclusion demanded by the interpreter consists in celebrating the historical role of the poet as the one who establishes a people's fate and as a mediator between the gods and men. To be sure, this interpretation is undeniably in accord with Hölderlin's conception of the function of the poet. But that does not mean that it is in accord with the poem analyzed: if one cannot reduce a poem to its biographical substance, neither can one reduce it to its philosophical substance. An interpreter as concerned about respecting the specificity of poetic "saying" as Heidegger claims to be owes it to himself to analyze precisely the differentiated development of this substance in the very movement of the poem. Now an important aspect of the properly poetic movement of "Wenn wie am Feiertage" is revealed by

the fragments of an eighth stanza. Heidegger does not take this fragmentary stanza into account, even though he could consult it in the editions available to him. It is not hard to discover the reason for this silence: this fragmentary eighth stanza operates a genuine reversal with respect to the preceding stanzas. The poet moves from his confidence in the nondestructive character of the "Father's fire," and thus from the hope of escaping Semele's fate, to an anguished cry, that of the "false priest" thrown down "far below the living" and serving them as a warning:

Woe is me!

And even if I say

That I had approached, to contemplate the Celestial ones,
They themselves threw me down deep below the living,
The false priest, in the shadows, so that I
Might sing to the docile the warning song
There.

This reversal fits perfectly into the parallel sketched out in the sixth and seventh stanzas. If it constitutes a possible alternative to the certainty expressed in the seventh stanza, the reason resides in the semantic pressure exercised by the parallel between Semele's gift and the poets' gift; the parallelism of the gifts opens the *possibility* of a parallelism in their fates. Just as Semele was punished for having tried to see the god, does not the poet, who claims to be the intermediary between the gods and men, risk being punished for his pride? And what if the intermediary were only a "false priest"? By this point at least, it is the voice of the "tutor Hölderlin" that breaks in. It is easy to see why Heidegger prefers not to take into account the eighth stanza, thus missing an important aspect of the poem: for the break brought about by the semantic logic of a paradoxical parallelism (depending on whether it is developed with regard to the gift or to the giver), for the emergence of the personal voice of the tutor Hölderlin that breaks into the hymnic discourse, Heidegger substitutes a "conclusive" ending. To be sure, the latter saves the Hölderlinian *and* the Heideggerian conception of *Dichtung*, but a high price is paid: it does violence to the poem, for the poem, in the reversal sketched out in the eighth stanza, shows precisely that it is not reducible to the theoretical program of its own author (and of his interpreter).[87]

The procedures I have just analyzed,[88] which one can easily also find in the (rare) studies that Heidegger devoted to poets other than Hölderlin,[89] are fully within the tradition of the speculative theory of Art. They draw in fact their legitimation from the thesis of the onto-logical nature of poetic "saying": if the essence of the poem resides in its power of philosophical revelation, it seems legitimate to reduce it to the philosophical substance

that constitutes its material. In Hölderlin's poems, the philosopher focuses not on the poem but on its philosophical substance. In spite of himself, Heidegger acts in the same way as the denigrated interpreter who reduces the poem to its biographical material: in both cases the poem functions as a document from which is "distilled" what is transposable into the meta-discourse considered pertinent.

To be sure, we must remember that the relationship between Heidegger and Hölderlin is not an ordinary relationship. Since the philosophical substance poetized by the author of *Hyperion* is nothing other than one of the inaugural formulations of the speculative theory of Art, Heidegger's analyses of Hölderlin constitute a genuine revival of the speculative theory of Art. The circle is closed: the theory has finally found its object, but this object is nothing other than itself, since it evacuates from it everything that might differentiate it from itself, namely its poetic specificity. If Hölderlin is *the* poet, it is because he is *also* one of the theoreticians of the speculative theory of Art, and because the interpreter reduces him to being only that.

More generally, one can say that Heidegger pushes to its limits the logic inherent in the very project of the speculative theory of Art, a logic that cannot help neutralizing the artistic and aesthetic specificity of the works he analyzes; just as poetry is nowhere to be found in Heidegger's analysis of Hölderlin, painting is nowhere to be found in his analysis of Van Gogh. If the arts are reducible to Art, if the essence of Art is poetry, and if poetry "says the same" as philosophy, there is nothing more to be done with either the arts or the particular art of poetry. Thus Art ends up devouring the arts, and the speculative theory, having become specular, no longer reflects anything but itself.

What the Speculative Tradition
Misunderstood

Novalis, Schlegel, Hegel, Schopenhauer, Nietzsche and Heidegger: these six names are obviously far from circumscribing, in the modern age, the historical destiny of the speculative theory of Art. But they do sum it up: insofar as one can identify the "inventors" of the speculative tradition, Novalis and Friedrich Schlegel are certainly the most plausible candidates for this role; as for the other four authors whose works I have analyzed, they are all philosophers in the most demanding sense of the term. We have seen that in reality the speculative theory of Art constitutes philosophy's seizure of control over the theory of art and also in part—as we shall see—over artistic practices. These six authors are the essential sources drawn upon by countless critics, essayists, and artists who—during the nineteenth century and the first half of the twentieth—have made the speculative theory of Art the dominant artistic conception, if not in the West as a whole, at least in Europe.

Understanding this omnipresence of the speculative theory of Art at the very heart of the artistic life of the nineteenth and twentieth centuries allows us to measure the effects and the consequences of this tradition on our relationship to art. For the most part, these consequences seem to me negative, and a profound reorientation of our way of thinking about the arts and approaching them is indispensable. That at least is what I hope to show in these concluding pages. Three aspects of the speculative tradition have had the most damaging consequences on our current conception of the arts.

First of all, there is the epistemological confusion of the descriptive approach with the evaluative approach. I have already discussed this in the chapter on Kant, but I should like to reformulate the problem in more concrete terms, because our cognitive relation to the arts suffers so grievously from this confusion. The latter finds its strongest expression in the historicist paradigm; we have traced its emergence in Friedrich Schlegel. What concerns me here is its adoption by artists, especially in the domain of the visual arts, where it has served as a justification for avant-garde

modernism. But the historicist paradigm bars our access to other artistic traditions that have never known it; it oversimplifies the complex history of modernism itself. Giving it up would allow us a more diversified and more fecund perspective on works—beginning with the very ones that the historicist project relies upon.

Then there is the distinction between the aesthetic sphere and the artistic sphere. It was emptied out by the speculative theory of Art, in the name of a reduction of art to its creative aspect. This problem has repercussions: we must finally recognize the composite character of the domain of aesthetic objects and even of that of the products of "art" (in the etymological sense of the term). This is an important point, because it allows us to reinsert art in the highest meaning of the term into the broader field of which it constitutes the richest form: the work of art is a product of human creative behavior, but it is not the only one, nor is it hermetically sealed off from other human works.

Finally, the most important stake in the debate—if not theoretically, at least socially— is the question of pleasure, and thus that of the aesthetic attitude. The compensatory function of the sacralization of art is linked to an exacerbated Puritanism that has led us to cut the work of art off from the gratification it provides. What is involved here is not so much a matter of justifying pleasure as of recognizing the specific logic of aesthetic behaviors—a logic that is misunderstood when one claims to sever it from its hedonic dimension.

THE SPECULATIVE THEORY OF ART IN THE MODERN "ART WORLD"

What is called "artistic modernity"—whether its genesis is situated in romanticism, in Baudelaire, or in Symbolism—is inseparable from the conceptual framework provided it by the speculative theory of Art. More than any other period in the history of the arts—with the possible exception of the Renaissance—the age of "modern art" is that of a philosophy of art as much as of an artistic practice. Since I cannot here reconstitute in detail the historical line of development—a development with many intersections and delaying effects—of a theory that, at first glance, seems far removed from properly artistic problems, I shall limit myself to a few particularly revealing samples.

As the site of the genesis of the sacralization of Art, the romantic movement is in a way the indirect source of *all* its later forms. Contrary to the other incarnations of the speculative theory of Art that I have analyzed, romanticism is—by birth—both a philosophical theory and an self-representation of the artistic world: if the Schlegel brothers are above all theoreticians (even though they "committed" a few literary works), Novalis is

also an important poet. One might extend this observation to other representatives of the romantic movement: Hölderlin is both one of the greatest German poets and a theoretician; painters like Runge and Carus are romantic thinkers as much as artists.[1] By virtue of this "mixed" nature, both philosophical and artistic, romanticism is the matrix of most of the artistic movements to come—and particularly the avant-garde movements at the beginning of the twentieth century.

Moreover, it has long been demonstrated that most if not all the European romantic movements borrow their theoretical baggage from the Germans, essentially from the Schlegel brothers and from Schelling: among the chief mediators are Mme de Stael for all of Europe, Coleridge for England, Victor Cousin for France, Manzoni for Italy.[2] Hence the speculative theory of Art spread at the same time as European romanticism and it is found, in a more or less degraded form, in the work of most romantic and post-romantic artists. We can take as an example Baudelaire's theory of the imagination, a central component of Symbolist poetics. A reading of chapters 3 and 4 of the *Salon de* 1859 shows that Baudelaire borrows his theory of the "queen of the faculties," and particularly the important distinction between fantasy and creative imagination, from Poe (more precisely, from "The Poetic Principle," a text that he had moreover already used two years earlier in the "New Notes on Edgar Poe" that precede his translation of Poe's tales) and from Mrs. Crowe's *The Night Side of Nature.* These two authors only repeat the theses developed by Coleridge in his *Biographia Literaria,*[3] inspired by A. W. Schlegel, Schelling, and Fichte, who, as we have seen, reinterpret the Kantian "productive imagination" in order to make it the poetic faculty by which Art is able to accede to the Absolute. The direct influence of theoretical romanticism on the arts and on artistic reflection does not cease, to be sure, with the end of the romantic movements; the writers of German Expressionism, and also Rilke, and closer to us, Maurice Blanchot, draw directly on the writings of the Jena romantics.

The historical destiny of Hegel's aesthetics is a perfect example of a delayed effect: its impact on the artistic life of its period was certainly less than that of the romantic movement, because, among other reasons, it was an abstract philosophical doctrine that could hardly hope to act directly on the world of art; but the indirect effect of its conceptions was only all the greater, in two quite different modalities. The first is that of its triumph in the universities. This triumph certainly experienced historical eclipses (for example, at the end of the nineteenth century) but these were always provisional. The fact that Hegel's aesthetics often attracted teachers is not surprising: after all, it *is* an academic exposition and its systematic framework—its closed and complete character—made it an ideal and conven-

ient course program. In any case, handed down in this way through several generations of intellectual "elites" that adapted it to the needs of the moment, it gradually became an element of the West's communal consciousness. This movement was amplified by the second channel through which it was transmitted, namely Marxism. Strange as it might seem, given the crude sociological determinism often professed by Marxism, it succeeded in developing its own variant of the speculative theory: Art—or rather "great art," and thus the art of the past as well as socialist art—is supposed to reveal the economic and social structure, that is, nothing less than the fundamental reality of the human world. We know the historical fate of Engels's claim that the works of Balzac reveal in a pitiless manner the nature of society in his time; against his wishes—because he is a great artist—Balzac shows the inevitability of the (provisional) triumph of the bourgeoisie and the historical bankruptcy of the aristocracy, the class with which he nevertheless sympathized. By generalizing this thesis, part of Marxist aesthetics came to postulate that great art, or at least great literature (but we know that the speculative theory of Art likes to extrapolate on the basis of a specific art), has an ecstatic cognitive power: outside Marxist philosophy, art is the only cognitive activity that is able—under certain conditions determined by Marxism, and thus by philosophy—to escape the alienated vision of reality that is inseparable from any class society.[4] In orthodox communism, these attempts at sacralizing Realist art were often thwarted: when they had as their object a pre-Socialist art, they ran counter to the monism of the theory of alienation; if they concerned Socialist art, they then constituted a potential danger to the cognitive monopoly of the Party, and through it to Marxist philosophy.

Critical Marxists, like Benjamin or Adorno, also exploit the commonplaces of the sacralization of Art. The puritanical polemic against "culinary art" or the "culture industry" that is omnipresent in all the aesthetics inspired by the Frankfurt School takes on its full meaning in the perspective of the postulate of the intrinsically critical and subversive power of the "true" art that is supposed to lay bare man's social alienation. Theodor Adorno's *Aesthetic Theory*,[5] for example, is in part a reformulation of the speculative theory in the perspective of "negative dialectics." The compensatory function of Art is particularly striking: as "the unconscious writing of history," Art is an irreducible protest against a generally bad reality, and thereby the promise of a utopian reconciliation. We know that for Adorno, Schönberg's twelve-tone scale was in fact an unconscious manifestation of the social process: by their rejection of the established norms of public acceptance, Schönberg's compositions criticize the alienated consciousness and the fetishistic character of music conceived as a commodity; thereby they reveal the real social contradictions and participate in a transcendence of bourgeois art. Adorno obviously defends an evaluative definition of the work of art: "The concept of the work of art

implies the notion of success. Botched art is no art at all."[6] He also defends
a radical conception of the reducibility of the arts to their philosophical
"truth": "Philosophy and art overlap in the idea of truth-content. The pro-
gressively unfolding truth of a work of art is none other than the truth of
the philosophical concept. . . . Truth-content is not what art works denote,
but the criterion which decides if they are true or false in themselves. It is
this variant of truth content in art and this variant alone which is suscepti-
ble of philosophical interpretation, because it corresponds to an adequate
concept of philosophical truth. . . . Aesthetic experience must pass over
into philosophy or else it will not be genuine."[7] We can once again see the
point to which the promotion of the arts to the level of an ecstatic knowl-
edge in reality seals their subjection to philosophical discourse.

Schopenhauer's influence on modern aesthetics is generally underesti-
mated, particularly in France, where, for complex reasons, this philoso-
pher often receives bad press. Hence it is all too easy to forget that during
the second half of the nineteenth century, when even Hegel sank into tem-
porary oblivion, Schopenhauer's philosophy triumphed more or less all
over Europe. Yet his pessimism is inconceivable without the compensation
provided by aesthetic ecstasis, a genuine redemption that allows man to
escape the evils of the will to survive. Schopenhauer's thesis of salvation
through art is no doubt the one of the philosophical formulations of the
speculative theory of Art that enjoyed the greatest historical success.[8] To
be sure, Schopenhauer having been *the* philosopher in the fin-de-siècle
salons, it is often difficult to tell how much his influence is due to actual
reading of his works. But the way in which his ideas spread is of little
importance; the essential point is that the central theses of his aesthetics
are found in some of the most important artists of the second half of the
nineteenth century and the beginning of the twentieth: in Wagner, of
course, but also in Huysmans, Gauguin and the Nabis, Proust,[9] or Male-
vitch and Mondrian.[10] I shall limit myself to France: as is shown by
Valéry's text cited as an epigraph to this book, the end of the nineteenth
century is characterized by a powerful return of the sacralization of Art;
and it is chiefly the Schopenhauerian variant that dominates, both by its
pessimistic vision of the world (adopted in particular by the Naturalists[11])
and especially by his claim that Art is the revelation of the Ideas. Thus in
1881, the Symbolist critic Albert Aurier wrote that Gauguin's art is "Plato
interpreted visually by a savage genius": his works express eternal Ideas.
The assertion seems paradoxical, considering Plato's condemnation of
painting; but Platonism is here identified with its reinterpretation by
Schopenhauer—which in turn takes its place in the heritage of Plotinus's
theory of the Beautiful. The interpretation of Gauguin's pictorial project in
Neoplatonic terms proposed by Aurier is in no way eccentric: according to
Maurice Denis, the Nabis based their theory of Art on Plotinus, Poe,

Baudelaire, and Schopenhauer.[12] It is certainly not clear that Gauguin had read Schopenhauer, but Mark A. Cheetham[13] has shown convincingly that his artistic practice—like that of Paul Sérusier, moreover—was governed by a Neoplatonic legitimation. It is found especially in his rejection of the analytical procedure of the Impressionists in favor of the synthetic construction that was supposed to express the "pure idea,"[14] in his emphasis on the importance of inner vision (whence the pictorial motif of closed eyes), and also in his small regard for sense perception (an attitude connected with his injunction to painters to paint their subjects from memory rather than *de visu*).

At first, Nietzsche's influence prolonged Schopenhauer's, but his affirmative reinterpretation of the notion of "will" quickly opened a chasm between his theory of Art and that of his master. His aesthetics of the "will to power" was to play a central role in most of the avant-garde movements of the early twentieth century: the artistic-political activism of Expressionism, Futurism, Neo-Plasticism, and Constructivism owes a great deal to the Nietzschean conception of Art as an expression of the elementary vital force and to Aloïs Riegl's proposed reinterpretation of the will to power as a will to art. To differing degrees, we thus find the Nietzschean legacy in Le Corbusier, van Doesburg, Mondrian, the representatives of the Bauhaus, Mies van der Rohe, et al.[15] The omnipresence of the expression: "We will . . ." and its typographical emphasis is a striking characteristic of the avant-garde manifestos of the period. We find it, for example, in Malevitch's manifesto OUNOVIS (1919–1920), which begins this way: "WE WILL modernity to become the life of the form of our strength. WE WILL our energy to be devoted to the creation of our new forms."[16] Similarly, in Oskar Schlemmer's programmatic text for the first Bauhaus exposition (1923), we read: "We are! We will! And we create!"[17] The notion even serves as a title for a publication, the review *Vouloir* ("Will"), to which Mondrian among others contributed. This almost obsessive voluntarism is connected with the idea that the avant-garde artist is the "new man,"[18] the prefiguration of the Nietzschean Overman; some people saw in the mass death during the First World War the bloody upheaval that according to Nietzsche was to accompany the birth of the Superman. Finally, the idea of an aestheticization of reality—an idea central to avant-garde projects because it allowed them to establish a link between their artistic programs and social revolution—also derives from Nietzsche's philosophy and in particular from his claim that reality is justified only as an aesthetic phenomenon.

Nonetheless, the connection of the avant-garde movements with the tradition of the speculative theory of Art cannot be limited to Nietzschean philosophy. Their fundamental utopian impulse, which was both spiritual

and aesthetic in nature, reactualizes just as much the originary moment of the sacralization of Art, namely the dreams of Jena romanticism: the very project of an artistic avant-garde, an eminently historicist project, sinks its roots into the depths of the tradition we have analyzed. Thus we find in many forms of avant-gardism—especially in Suprematism or in Mondrian—the double orientation so typical of the speculative theory: the idea that the ultimate goal of Art is to bring to light its own essence and the messianic utopianism of an aestheticization of reality in which the arts would end up disappearing.

For Malevitch, for example, there are two types of painting: the old—representational—and the new—nonrepresentational. Between the two there is an unbridgeable gap: "The innovators of the contemporary age must create a new age. An age such that it is not contiguous with the old one on any side."[19] This radical rupture is legitimated by the fact that only the new painting—Cubism, Futurism, and their Suprematist outcome—is in search of the essence of art: "art has divided itself into two basic parts: some [artists] have become representational (Concretists), easel painters and reflectors of the mode of life without having illuminated the essence of art; others have become nonrepresentational (Abstractionists) after having illuminated the essence of art and having abandoned portraiture and reflecting the mode of life."[20] Contrary to traditional artists, the new artist "expresses not the illusion, but the new real Reality,"[21] which is the "fusion of the world with the artist"[22] made possible when painting becomes autotelic, or a "pictorial self-cause."[23] As an ontological revelation, Suprematist art is thus a philosophical art: "This system, hard, cold, without a smile, is set in movement by philosophical thought, or rather it is in this system that its real strength henceforth moves."[24] Thus Suprematism is carried beyond art, toward philosophy, but also—and for that very reason, given the *topos* of the foundational character of philosophical discourse for the human community—toward the transformation of life: "Our ateliers no longer paint pictures, they construct the forms of life."[25]

The metaphysics that Malevitch's art claims to reveal is largely inspired by Schopenhauer. His claim that the "real Reality" to which the Suprematist painter accedes is the "world-without-object" situated beyond the schism between the subjective and the objective is directly inspired by Schopenhauer's conception of aesthetic vision as an abolition of the schism between subject and object. Troels Andersen, the editor of the English translations of Malevitch's texts, even thinks that some of them derive directly from the subdivisions of *The World as Will and Idea*: in the case of the fragmentary autobiography, the numbering of Malevitch's manuscript is supposed to correspond to that of the relevant paragraph in Schopenhauer's book.[26] Just as interesting is the relationship between Malevitch's conceptions and Heidegger's: in their prefaces to the French translations of Malevitch's writings, Jean-Claude Marcadé and Emmanuel

Martineau have no difficulty in establishing connections between Male-
vitch's philosophy of the "nothing" and the negative theology of the "con-
cealment of Being" promoted by Heidegger.[27] Martineau concludes that
Malevitch discovered in advance "what Heideggerian phenomenology
later put into words."[28] For my part, I doubt that Malevitch's reflections
really gain much by being compared with the philosophically much more
powerful work of Heidegger; I even fear that thereby they lose much of
their true interest, that is, their complex but primordial relation with
Malevitch's pictorial practice. The relationships are undeniable, but
Martineau and Marcadé discover no less close links between Malevitch and
Nietzsche, Schelling, and Jakob Boehme, and this is equally revealing:
these three authors are also important sources of inspiration for Hei-
degger, which seems to me to show simply that Heidegger and Malevitch
participate in the same *doxa*, that of the speculative theory of Art.

Malevitch's case shows that the artistic theories of the avant-gardes are
literally "over-determined" by the tradition of the sacralization of Art, to
the point that the search for precise sources is probably illusory in many
cases: one is confronted by an immense textual patchwork. Mondrian, for
example—but one can say the same of Kandinsky—draws most of his
philosophy from theosophy, particularly from the writings of Blavatsky
and Steiner. Now theosophy is a syncretic mysticism that cheerfully mixes
conceptions deriving from Nietzsche (the theory of the new man), Hegel
(evolutionism), the romantics, the Illuminists (Jakob Boehme), and the
Neoplatonists. The fact that we find in Mondrian—and more generally in
the writings of the *De Stijl* movement—echoes of the thought of Schopen-
hauer, Nietzsche, and Hegel thus does not necessarily prove that he actu-
ally read these philosophers. In the first issue of the review *De Stijl* we read
for example this quotation from Plotinus—which could just as well be
taken from Schopenhauer: "Art is above nature, because it expresses the
ideas of which objects in nature are only the defective simulacra. The art-
ist, relying solely on his own resources, rises above capricious reality."[29]
Similarly, when Mondrian dedicates *Elementary Visualism* (1921) to "fu-
ture men," he incontestably adopts a Nietzschean perspective: but the lat-
ter is so much "in the air" at the time that we are not in any way obliged
to conclude that he had read the philosopher's works.

As for Kandinsky, we know that he was familiar with theosophy, and
also with Schopenhauer's works. Thus his theory of colors is largely in-
spired by that of Schopenhauer (who in turn goes back to Goethe's
Farbenlehre); in the same way, the term "internal necessity," which plays
a central role in his essentialist theory, is undoubtedly borrowed from the
author of *The World as Will and Idea*. However, when he says that "the
effect of internal necessity, and therefore the development of art, is a
progressive exteriorization of the objective-eternal into the subjective-

temporal,"[30] he combines Schopenhauer's concept with another, indebted to Schelling or Hegel, of historical evolution (for Schopenhauer history is only pure superficial appearance and not the progressive exteriorization of internal necessity). Should one conclude from this that Kandinsky had read the German idealists? There seems to be no direct proof that he had, and Cheetham quite rightly observes that he could very well have encountered Hegelian dialectical evolutionism in "one of its countless derivative embodiments"[31] that are found in the aesthetic writings around the turn of the century.

The family resemblance between Malevitch, Mondrian, and Kandinsky is not limited to their common philosophical-mystical horizon. It can be shown more precisely that these three artists—whose pictorial works are so dissimilar—legitimate their practices by means of shared principles that are part of the "stock" of the speculative theory of Art. Five of these seem to me particularly important:

a) The finality of artistic activity resides in the realization/discovery of the essence of art. I have already cited Malevitch, who claims that nonrepresentational artists are guided by the essence of painting. Similarly, Kandinsky defines abstract art as the will "to represent . . . only the Internal Essence, through the elimination of all external contingency."[32]

b) The essence of art resides in its self-referential elements: in the case of painting, this "pictorial self-cause" (Malevitch) is composed of light, the forms and colors in their purely pictorial reality, independent of any representational function. In his "An Analysis of the Basic Elements of Painting" (1913), Kandinsky defines painting as a language that has its own vocabulary (the basic pictorial elements) and grammar (the laws of composition).[33] And Theo van Doesburg was to write in 1930: "The picture must be entirely constructed with purely visual elements, that is, with planes and colors. A pictorial element has no other meaning than 'itself,' and hence the picture has no other meaning than 'itself.'"[34]

c) Paradoxically—as in the romantics—this self-referentiality of artistic language makes it capable of revealing "real Reality." According to Kandinsky, the new artist touches, "under *nature's skin*, its essence, its 'content': by becoming self-referential, painting reveals *natura naturans*, for "the two domains produce their works in an identical way"[35] Mondrian, for his part, maintains that his painting makes the Universal sensuous, and more precisely that his oppositional system (at the level of forms and colors) realizes the equilibrium of the fundamental dualities of this Universal, for example the duality of masculine and feminine, that of material and immaterial, and so on.[36]

d) Art's discovery and realization of its own essence are necessary evolutionary facts, in other words, the history of art is governed by a teleological evolution. Arp and Lissitsky's influential book, *The Isms of Art*,

published in 1924 in a trilingual English-German-French edition, thus proposes a history of modern art conceived as a series of movements taking their place in a continuous progress. The idea is also found in most of the avant-garde artists: the supposed progress from Impressionism to abstract art by way of Cubism is a veritable commonplace of the period, as is the more general historical schema that postulates a progress from representation to nonrepresentation—the latter progress being conceived, of course, as a fundamental rupture, not only in art, but more generally in the spiritual evolution of humanity.

e) Artistic evolution culminates in an eschatology that brings about an absolute synthesis of society and art. According to Malevitch, as we have seen, the new artists create forms of life rather than pictures. And Mondrian writes in 1919–1920: "The pure plastic vision must construct a new society, just as in Art it has constructed a New Plasticity."[37] And for Kandinsky, "the great period of abstract art that has just begun, the fundamental revolution that turns the history of art upside down, counts among the most important forerunners of the spiritual revolution that I once called the period of the Great Spiritualists."[38] It is through this messianism that for a few years the artistic avant-gardes thought they could identify themselves with the program of a social revolution that was fed by a dream of the same kind. This misunderstanding was quickly dissipated, and artists found themselves called upon to choose between their art and communist doctrine: it is to the credit of Kandinsky and Mondrian, for example, that they never abandoned their artistic demands, though they had to scale them back a bit so far as their messianic hopes were concerned.[39]

If this last aspect of the avant-garde program quickly collapsed, the first four continued to nourish the history of modern art up until at least the 1960s, for example in the very influential writings of Clement Greenberg. And in a certain way, minimalist art and conceptual art still adhere to this program. Moreover, if the syncretism and eclecticism that have invaded the art world since the 1960s are actually associated with what Yves Michaud has called the "paradigm of disorientation,"[40] the fact that the art world continues to "advance" through "movements," even if they are increasingly ephemeral, shows that the evolutionist paradigm continues to function, even if in a void: works are always situated in the framework of a strategy of historical action. It is just that we no longer find ourselves in a teleological motion but rather a Brownian motion.

Finally, what was Heidegger's role in the penetration of the art world by the speculative theory of Art? His influence was and continues to be considerable, at least in France, directly through his writings, but just as much or even more through the adoption of his ideas by other philoso-

phers (the deconstructionist trend that exacerbates the Heideggerian idea of a dialogue between thought and Art), by critics (for example, Maurice Blanchot[41]), and even poets (for example, René Char[42]). Moreover, Heideggerian philosophy is often used to reformulate artists' indigenous theories: I have noted that Martineau and Marcadé proposed a translation of Malevitch's conceptions into the Heideggerian idiom, at the risk of privileging the commonplaces at the expense of more concrete—and, from the pictorial point of view, more interesting—aspects. By doing so, they are moreover only repeating Heidegger's appropriation of a Hölderlinian legacy—with the same result: a celebratory discourse that neglects the actual complexity of the relations between the theoretical project and the work. But rather than dilating on this illusory *aggiornamento* of the speculative theory constituted by its earlier formulations in Heideggerian vocabulary, I prefer to focus on the relations—which are far more interesting—between Heideggerian thought and the conceptions of René Char.

These relations are complex, for Char was not influenced by Heidegger: it is rather a matter of an encounter in the common terrain of the sacralization of poetry. In fact, the situation is exemplary so far as the hegemony of the speculative theory of Art in the artistic domain is concerned. Char's poetic work owes practically nothing to Heidegger: Char was already an accomplished poet when he first became acquainted with the philosopher's ideas.[43] But it is nonetheless clear that on many points his preoccupations *coincide* with those of the German author: hostility with regard to science and technology,[44] the conception of truth as a revelation escaping any kind of calculation, and the importance accorded Heraclitus's philosophy and Nietzsche's thought. It is true that on other points—and this shows that each writer's thought is independent of the other's—they are moving in very different directions: Char accords no importance to history and nothing indicates that he shares Heidegger's fascination with Greece; inversely, one cannot find in Heidegger's writings the slightest trace of the Sadian philosophy that plays such a great role for the French poet.

We encounter the same complex situation in the more specifically poetic domain. Thus the basic orientation of Char's poems is far removed from Hölderlin's preoccupations—in which Heidegger situates the very essence of poetry: the search for the (Greek) origin, tragic historicism, and the painful consciousness of living in a transitional period, the theme of the poet at the establisher of a people's historicity— all these aspects that the philosopher emphasizes in Hölderlin are virtually absent in Char's work. In other respects, however, the image of poetry that emerges from Char's work is very close to that proposed by Heidegger: an "unexpected and fifth element,"[45] it is a revelation of the truth,[46] it precedes action,[47] it subordinates itself to the divine by accepting the latter's concealment, it says the sharing-out, the division of Being, it dwells in the lightning flash, "the

heart of the eternal,"[48] that causes an "entirely satisfactory presence" to rise up, "the inextinguishable, uncreated real."[49] For Char as well, poetry is an ecstatic revelation of an ontological order. To be sure, as Éric Marty rightly observes, this ontological revelation is itself recuperated in a still more fundamental revelation, of a hermetic order: beyond a meditation on Being and the concealment of Being, it emerges in an alchemical and kabbalistic reflection on Creation, "on the foundational rift of the being as creature."[50] But if these hermetic concerns distance the author of *La Nuit talismanique* from Heidegger, they only anchor him all the more strongly in the tradition of the speculative theory of Art: hermetic thought was a central preoccupation of the latter's originary phase, the romanticism of Jena (we have only to think of Novalis's conception of poetry as a "secret code"). Finally, by including the Heidegger-inspired interpretation of his poetry by Jean Beaufret among the "Études critiques" ("Critical Studies") collected in his *Oeuvres complètes*, Char obviously invites the reader to read him from the viewpoint of the author of *The Origin of the Work of Art*. There is no need to add that, given Char's importance, these conceptions have largely determined modern French poetry's self-representation.

We could prolong indefinitely the list of twentieth-century artists and writers who place themselves in the heritage of the tradition that we have just analyzed: I sought only to show that the sacralization of Art has more or less imbued a large part of modern artistic and literary life, constituting a sort of theoretical horizon of expectations for the art world for almost two hundred years.

The Speculative Theory of Art as a Persuasive Definition: Concerning "Modernist" Historicism

Whatever one thinks of the speculative theory of Art as an artistic ideal, it must also be judged as an aesthetic theory: as a definitional procedure, it *also* has cognitive pretensions, and these pretensions deserve to be evaluated with respect to their own value. We have been able to see that the definitions of essence it proposes are in reality always hidden evaluative propositions: far from describing the arts, the speculative theory constructs an artistic ideal. In other words, the term "Art" does not refer to a descriptive object: it is the correlate of an evaluative ideal. Now in the case of an ideal (as in that of a norm), the question is not whether it is true or false, but whether it is desirable or not. One therefore commits a category error when one seeks to accord a *constitutive* status (for the arts) to evaluative principles thus developed. The most prominent symptom of this error in categorization is that the authors I have analyzed are all obliged to undertake massive exclusions, to distinguish between "true art" and "false art," between works that *deserve* to be called "work of art" and

those that do not, and which will therefore be excluded from the domain thus delimited—even though from a descriptive point of view (for example, from the point of view of a semiotic, institutional, historical, or functional analysis) the excluded works actually belong to the *same* domain as the privileged works.

To bring out a little more clearly the difference that separates a descriptive theory from an evaluative theory, I shall use Charles L. Stevenson's notion of "persuasive definition."[51] Generally speaking, a persuasive definition has two characteristic traits: first, it expresses a feeling (an attitude) with respect to the object, and hence it implies an evaluation; secondly, its descriptive component has a persuasive function, in the sense that it seeks to make others share the evaluative attitude adopted. Now this seems to me to be the status of the speculative theory of Art:

a) Its first step consists in using the term "art" in an evaluative sense and in endowing it with a laudatory function: this is what I have called the "sacralization of Art." The term thus takes on an emotive signification: it expresses the speaker's positive attitude with regard to objects to which the term is attached. The oppositions between Art and the sciences, or between Art and empirical life, have no function other than providing a basis for this laudatory function of the term. The same goes for the close connections postulated between Art and religion (among the romantics and in Hegel), between Art and wisdom (Schopenhauer) or the will to power (Nietzsche), between Art and "thought" (Heidegger): in all these cases it is a matter of anchoring the term in a valorized and valorizing field. Adorno's assertion that only successful works *are* works of art transforms this confusion into an explicit principle.

b) The second step is more decisive: by claiming to reduce the descriptive meaning of the term "art" to the evaluative definition it proposes, the speculative theory of Art *in fact* proposes to endow the term with a *new denotation*, its extension being henceforth limited to works that show themselves to be in conformity with the evaluative definition. The extensional domain of the arts is thus abusively identified with the field of the works, the genres, and the types of art to which the theoretician accords a *positive* aesthetic value. Whereas a descriptive definition of the arts ought to *analyze* the *usual* definition of the term by bracketing the scale of values peculiar to the analyst, the speculative theory of Art *proposes* a new terminological *convention* based on an evaluative definition. In other words, the denotative—descriptive—dimension of the definitions proposed is determined by an antecedent evaluation. Through its attempt to make its interlocutors accept the change in linguistic usage it proposes, the speculative theory of Art tries to make them share the attitude that its laudatory use of the term "Art" expresses, that is, to develop in them the specific artistic ideal in the light of which it thinks works should be evalu-

ated. That artists make use of definitions in this way is understandable: they want to promote their project, and all means to that end are good— even those that lead the art world into error. One cannot say the same of those whose goal is—or should be—cognitive.

Saying that the speculative theory proposes an evaluative definition does not imply that it lacks any descriptive component. In analyzing Kant's aesthetics, I emphasized the fact that aesthetic judgment is not descriptively empty: when I assert that "x is beautiful," I express a certain attitude, to be sure, but if someone contradicts me or asks me why I find the object in question beautiful, the reasons I will give will be in general this or that property that the work actually possesses, or at least that I believe it possesses. More concretely, the descriptions associated with my evaluative judgment can *show* others which objectal traits are the cause of my pleasure, just as they can *reveal* to others properties they had not perceived, and which once discovered may lead them to share my judgment. But we have also seen that none of the associated descriptions can endow the evaluative judgment with a general cognitive legitimacy, since the properties noted as pertinent are not chosen with a view to description, but as justifying an evaluation: they serve as *a posteriori* reasons explaining or legitimating my attitude with regard to the object. This is shown by the commonplace fact that my interlocutor can *both* acknowledge that the work possesses the properties in question *and* nonetheless continue to deny that it is beautiful or successful: the evaluation is never reducible to the justifying description, even if the latter has no functional value except in relationship to it.

The speculative theory of Art therefore commits a double error: on one hand its descriptive basis is not neutral but functionally dependent on a prior evaluation; on the other hand, contrary to an implicit presupposition, its evaluation is not reducible to a justifying description, since even while accepting the latter one can still deny the former. If one wants to describe the nature of art, one cannot reduce it to a subset chosen by virtue of an evaluative criterion: "unsuccessful" works, that is, ones that are not in conformity to the evaluative criterion selected (whatever it is), participate in the nature of art (belong to the same "making") just as much as do the "valid" works (to adopt Heidegger's term). If an artistic ideal is proposed we enter into another discursive practice, that of aesthetic judgment—and the latter is irreducible to any descriptive judgment, and *a fortiori* it cannot ground a description of the essence or nature of art.

However, in this form the opposition oversimplifies the actual relations between description and evaluation. Artistic practices are complex cultural activities, and their complexity is due in part to the easily self-referential character of their theorization: any descriptive analysis can be transformed into a project or program, for human behaviors are often

modeled to some extent on the socially accepted theories of these same behaviors. Theory thus becomes a pragmatic horizon of expectation, and it may—under favorable circumstances—become a self-fulfilling prophecy. This phenomenon is moreover strengthened by the fact that every description cannot help but be partial (and that also goes, of course, for my own reconstruction of the speculative theory of Art): there is no cognitive transparency, and we can approach the world only by choosing a perspective, which is always particular, limited, and unilateral. Now this perspective is itself often particularly motivated by our attitude (or our desires) with regard to actual reality (in our domain, this can be for instance an artistic ideal that one would like to promote, or artistic problems with which one is confronted). When our inquiry concerns intentional facts, its self-referential potential (and thus the fact that our present behavior may be modeled on the description of the past, whether to extend it or to break with it) may change the illocutionary force of the explanatory model, which ceases to be descriptive and becomes prescriptive: when this change in the illocutionary force is overlooked, a theory can consider (mistakenly) that it has predictive force, and thus find itself strengthened (equally mistakenly) so far as its retrospective pertinence is concerned.

The constructions of the history of modern art that have accepted the paradigm of the speculative theory of Art have pushed this self-referential drift (and the misunderstandings it implies) to its maximum intensity. Indeed, they all postulate an *internal history* of art and claim that Art is determined in and through its relation to a history that is supposed to be an essential reflexive dimension in artistic *creation* itself.[52]

By "internal history," I mean a history that guides the activity of its subjects, according to a teleological and self-referential dynamics. For an artistic activity to have a history of this kind, it is therefore not enough for it to have a past. What is at stake here is a very special reflexive relation to this past: it is established as a narrative capable of both legitimating and constraining present practice (positively or negatively) insofar as the pertinence of its own subjects is concerned. The past has to be seen as having a constraining power *qua history*, and thus *qua* directional narrative (and not, for example, as a simple positive or negative model). In addition, we find the idea of a historical *progress* and more precisely of an artistic autoteleology, and thus of an internal goal: for example, we have seen how romanticism postulates that the object of literature is literature itself, and that therefore its ultimate goal, which guides the history of its progress, resides in the realization of its internal essence—each generation being called upon to take its place in this historical task and to carry it further than the preceding generation.

Only such an autoteleological historicism makes possible the establishment of an internal history as a motivating factor for artistic practice. As

soon as an art is taken up into such an internal eschatology, the possibilities that are open to the individual artist tend to be circumscribed by how far the art he practices has advanced historically: the motto "we can no longer do what we used to do" becomes an absolute imperative, because it is linked to a mission that believes itself constrained by the "objective" essence of the art in question. At the same time the complex, multiple, contradictory, and differential historicity of artistic practices is reduced to the linear history of a collective project that the community of artists sets for itself and in the resolution of which everyone is called upon to participate. Every art that develops in accord with such a collective historical project obviously has a very specific evolutionary curve, characterized by the existence of a great internal tension.

One might object that the visual arts at least were already governed by this kind of model before the birth of the tradition I have analyzed—namely in the art of the Italian Renaissance described by Vasari.[53] One might also note that the Aristotelian conception of the evolution of Greek tragedy is governed by the same paradigm of a teleological history that happens to be fulfilled in the realization of the "nature" of the genre (achieved by Sophocles). But in these two cases the situation differs from that of "modernist" essentialism. On one hand, Aristotle's point of view, like Vasari's, is retrospective; they base their conclusions on an evolution that they believe has reached its end. On the other hand, in "modernist" historicism the prospective dimension is essential: the past is not a completed model, it only represents the first steps of a future evolution. To be sure, this prospective dimension is not always present in the speculative theory of Art, since the Hegelian vision is retrospective. It is, however, present as soon as the theory functions in the modern art world: an artist can do nothing with a retrospective theory; what interests an artist is an artistic *project*. A second difference is still more important: Vasari and Aristotle defined the nature of painting (and of tragedy) by a relational function, *mimesis* (the visual representation of reality, or imitation of human actions). The supposed "nature" of painting or tragedy resided in a cognitive ideal dictated by an external horizon of expectations (the visual world, human actions), functioning as independent data to which art is supposed to be "faithful." The essentialism of the pictorial avant-gardes, on the other hand, ended up in an autoteleological purism that tried to reduce art to what were taken to be its fundamental *internal* components. This kind of attempt could have no other outcome than the evanescence of the pictorial object itself: the "components" of an intentional object can be fundamental (or secondary) only in relation to the *function* (whether this is representational, decorative, or something else) it is supposed to fulfill. As soon as one denies all such functions (which was the case in the most radical variants of the abstractionist project), one is in-

volved in an endless movement, for an intentional object has no purely internal essential (or secondary) properties—since its "nature" *is* functional. Hence every "minimalism" can be pushed further: for Mondrian, the essence of painting can be reduced to horizontals and verticals as well as to pure colors; Malevitch reduces it to the monochrome surface; conceptual art, for its part, makes it evaporate into a pure object of thought.

Let me make it clear that I am not in any way questioning the pictorial quality of Mondrian's or Malevitch's works, nor the interest of certain conceptual works: what is at issue here is the logical viability of the legitimation that governs them. At the risk of repeating myself, I remind the reader that a work cannot be reduced to its legitimations:[54] the confection of a picture, a text, or a musical work has to do with a processual intentionality inseparable from the artist's encounter with the medium worked in; it cannot be reduced to a preceding intention that the work is supposed to realize more or less successfully.[55] This being the case, an incoherent theoretical motivation may very well enter into the confection of a great work: even when it constitutes *the* initial motivation of the artist, it will be only one of many causal factors that interact in the actual creation.[56] Simply, it will then be found that the artist turns out to have created (at least in part) something other than what he had intended to create (and thought he was creating). To relativize the causal power of theory does not amount to denying it, especially in its trans-individual functioning, that is, insofar as it governs the connections among works: for example, I am persuaded that it is because of its historicist autoteleology that modern painting did not come to a halt, stuck in academicism (as happened after Vasari, whose conceptions were codified by the Academies), but rather sought its self-dissolution—masterfully dramatized by Marcel Duchamp[57]—at the very moment when the avant-garde utopias were strongest.

Another point is just as important: this evolutionary model has no general value. Svetlana Alpers, for example, notes very rightly that the conception of an essentially progressive art (she is thinking of Vasari, but this is even more true of the historicism of the speculative theory of Art) is an exception rather than the rule: "Most artistic traditions mark what persists and is sustaining, not what is changing, in culture."[58] Thus even the canonical arts, that is, those whose recent development is governed by the schema of internal historicization, are far from having always been so governed: we need only to think of Dutch painting, literature when it was governed by the principle of *imitatio*, or tonal music. Moreover, as soon as one moves even slightly away from the beaten paths and accepts the obvious but too-often forgotten truth that the anthropological domain of artistic practices is not limited to the canonical arts (in fact, canonized in the nineteenth century), the model of a teleological evolution is completely inadequate: artistic practices as important as landscape gardening, pot-

tery, clothing design, and others—in fact, all the applied and decorative arts—have never been governed by this model. The same can be said about art outside Europe; think of the historical evolution of the Japanese print, one of the great achievements of engraving on wood. Its history extends over some three centuries: moving from Moronobu's crudeness to Harunobu's compositional mastery, then to Utamaro's sensuality, Hokusai's powerful draftsmanship, or Hiroshige's poetic atmosphere, the practice of the *ukiyo-e* underwent many changes, and even experienced a major technical and aesthetic shift with the perfecting of the polychrome print toward the middle of the eighteenth century. And yet it does not include autoteleological reflexivity in the historicist sense of the term: the properly artistic evolution of *ukiyo-e* results from the conjoint interaction of multiple factors, particularly the variability of the public's demands, of the artists' temperaments and tastes, of the refinement of printing techniques, and so on. In other words, it is an evolution with multiple motivations, dispersed over a vast social, aesthetic, and ideological field without any effort on the part of the artists or art-lovers to wrench it away from this "impurity" and to anchor it in an internal teleological history.

But examples lie closer to hand: the art of photography has an evolutionary profile of the same type. We know that for several decades it has become increasingly museum-ized. Since this embalming is in general done by museums of modern art, the strategy of legitimation is often that of "modernist" art. "The Invention of Art," an exposition covering the first fifty years of photography organized at the Pompidou Center in Paris, is a perfect example of this procedure intended to anchor photography in the domain of the visual arts and of its teleological historicity. That is no doubt why the organizers chose to introduce the visitor to their own exposition by making him first pass through a room devoted to Peter Galassi's famous exposition *Before Photography*—which seeks to demonstrate "evidence" to support the claim that there is a continuity between the analytical view in painting and the photographic image. However, the thesis is debatable; its "demonstration," as Rosalind Krauss has pointed out, is based on the biased choice of paintings and photographs considered pertinent.[59] By choosing other photographs (from the same period), it would have been just as possible (and even easier) to prove the opposite thesis. As for the exposition devoted to the history of photographic art proper, it lent an extreme privilege to the photographic projects connected with avantgarde movements in the domain of the canonical arts—whence also the implicit claim that contemporary photography blends into the visual arts—illustrated by the fact that in museums the "contemporary" rooms were largely devoted to the works of artists using the medium of photography. In other words, the exposition had room only for facts consistent with

the model of a teleological history leaning on that of the visual arts. Within the period covered by "The Invention of an Art," the choices were completely biased and there was a notable total absence of the pictorial movement, of American landscape photography, the French "realistic" school, the great works associated with the Magnum agency, and so on. Far from bearing fair witness to the actual evolution of the artistic practices of photography, the exposition sought to rewrite history, the end being clearly to annex photography, to absorb it into "modern art."

In reality, the historicity of the artistic practice of photography is certainly closer to that of the *ukiyo-e* than to that of avant-garde Western painting. To study it historically requires us to abandon the model that has governed the recent history of the institutionalization of the canonical arts in the West. If it is possible to read the history of painting in the nineteenth and twentieth centuries in part as the story of a series of movements and avant-gardes taking their place in a progressing teleology, this kind of attempt is doomed to fail in the case of photography: the domain of the images and the works considered aesthetically pertinent forms an irremediably heterogeneous (or even miscellaneous) field. One factor that has no doubt opposed its autoteleological historicization is the constraining power of its particular semiotic and pragmatic status. This power is such that even when the photographic image is integrated into a pictorial composition, as sometimes happens in the works of artists using the medium of photography, it continues to dominate: it makes a solid mass in its pictorial surroundings. Now let us not forget that this semiotic status has remained the same since the beginning of photography.[60] Thus we can place side by side an image from the 1840s and a contemporary snapshot without experiencing a basic historical gap: the two images easily fit into a single semiotic horizon, and the one hundred and fifty years that separate them do not force us to accommodate our vision differently in passing from one to the other. On the other hand, in the pictorial domain, the last two centuries are filled with so many profound ruptures that one cannot approach in the same way a canvas from the beginning of the nineteenth century and a contemporary picture: between the two dates, the system of the visual arts' coordinates and the hermeneutic coordinates have undergone several successive revolutions. Looking side by side at Goya's "3 May 1808" and one of the pictures in Robert Motherwell's series "Elegies to the Spanish Republic," or a sculpture like Rodin's "Thinker" and Richard Serra's "Tilted Arc" implies in each case a complete revolution in our way of seeing, in our expectations and modes of approach, whereas a picture like Gustave Le Gray's "Étude d'arbres" could easily take its place alongside a landscape photo from our own time. There would certainly be significant differences—technical, aesthetic, and others—between the two

pictures. One cannot confuse them, or ignore the historical duration that separates them: but these differences operate within a stable semiotic horizon, whereas it is not the same for the paintings and sculptures mentioned.

An additional confirmation of nonhistoricist evolution can be found in the fact that the development of photography is not characterized by a progression, but rather by a series of oscillations, due particularly to the constantly renewed tension between the pictorial element and straight photography. It seems to me very difficult to see in this a teleological evolution going from a more or less naïve realism toward a sort of meta-photography that would eventually absorb photography into the visual arts. That does not mean that there is no evolution or maturation in the art of photography. For instance, contrary to what was still the case in the pictorialism of the beginning of the century, today photographers no longer believe—and neither does their public—that in order to achieve artistic status they have to "beautify"; this liberates photography from the imitation of academic painting. But this evolution, if it bears witness to a maturation of the artistic reflection, is also in large part an indirect effect of technical progress: the increased sensitivity of films and automatization and motorization have led to a major acceleration in the taking of photographs; hence the photographer's conscious examination often comes after the image, which distances the photographic act from the phantasm of "beautiful" pictorial composition.

In view of the current decline of the historicist and essentialist model in the canonical arts, the art of photography, which used to seem atypical and even deficient, reveals itself to be more "normal" than it appeared, especially if we finally agree to enlarge the artistic horizon to include the "minor" creative practices that were marginalized by the historicist perspective. Hence the question of its status with respect to the canonical arts loses its importance. It was too long believed that belonging to a canonical art was synonymous with a particular artistic dignity: in other words, it was hoped that the question of artistic value could be reduced to that of the historical-institutional status of works. Confronted with a photo, as by any other sort of work, the important question is not so much whether it is art, but whether it is a photo (a painting, a poem, etc.) that is worth spending some time on—and we must answer this question for ourselves.

AESTHETICS AND ART

The reader will probably object that I have just carelessly used the term "art of photography," applying it to practices (for example, to the images made by reporters) whose status is ambiguous to say the least. Criticizing Galassi's interpretation of nineteenth-century topographical photography as a continuation of the analytical pictorial view, Rosalind Krauss notes:

> In deciding that the place for nineteenth-century landscape photography was in museums, that the genres of aesthetic discourse could be applied to it, and that the model of art history was well suited to it, contemporary specialists in photography went much too far, much too fast. First, they concluded that certain images were *landscapes* (rather than views, that is, photographic images) and henceforth no longer had any doubt as to the kind of discourse to which these images belonged or what they represented. Next . . . they determined that it was possible to apply to the visual archive other fundamental concepts of aesthetic discourse. These concepts include that of the *artist*, along with the associated idea of the kind of continuous, intentional progression that we call a *career*. Another of these concepts is the possibility of a coherence and meaning that are supposed to emerge from this collective corpus, and that would in this way constitute the unity of an *oeuvre*.[61]

This objection is connected with a more general problem that was taken up by Kant but forgotten by the speculative theory of Art: that of the distinction between aesthetic facts and artistic facts, as well as that of the possible relationships between them. Krauss does not seem to me to give a really satisfying reply. Saying that nineteenth-century photographs hanging today in museums were not motivated by an artistic intention in the institutional sense of the term does not settle the question of their aesthetic status—Krauss herself refers to the "great formal beauty"[62] of the images made by the landscape photographer Auguste Salzmann. In fact, she does not distinguish clearly enough between the aesthetic dimension and the artistic dimension, it going without saying that this distinction itself must be refined to do justice to the complexity of aesthetic facts.

In a preliminary way, one could say that the notion of art refers to a human activity that produces specific objects or events—the problem obviously being to determine what this specificity consists in. As for the aesthetic domain, one may say that it is that of an emotive and evaluative attitude: we can adopt such an attitude with regard to works of art, but also with regard to other sources of perceptual and intellectual stimulation. This distinction might be extended by that between aesthetic judgment (which bears on a stimulus independently of any concern with its intentional or "natural" status) and artistic judgment in the strong sense of the term (implying that an intentionality and the relations between that intentionality and the object are taken into account). That is roughly the result at which I arrived in my assessment of Kant's *Critique of Judgment*.

In reality, the situation is more complicated, essentially because the notion of "art" is not unequivocal. Here we might adapt and generalize Gérard Genette's fruitful distinction between constitutive literariness and conditional literariness.[63] The term "literariness" refers to the aesthetic functioning of linguistic structures. The literariness of fiction and of poetry

is constitutive since every fictive work and every poem is literary by virtue of belonging to the cultural category "fiction" or "versified poetry"—and hence independently of any question of evaluation. In contrast, conditional literariness occurs when readers valorize aesthetically any text, independently of its cultural function. The literariness of, say, historical works, philosophical texts, private letters, essays, is conditional to the extent that the decision as to whether to consider them as literary works is made case-by-case and depends on an evaluation—on the part of the reader—of the quality of the text in question. Of course, this conditional literariness is not, by necessity, purely individual: in many cases it is based on a consensus. The logical distinction between conditional and constitutive literariness is nonetheless preserved: Michelet's *The Sorceress* is not considered a literary work because it belongs to the category of the historical essay (many historical essays are not read as works of art but solely as documents or testimonies), but because for some readers it possesses certain qualities that make it worth approaching aesthetically; inversely, *Goldfinger* is a literary work because of the simple fact that it is a fictional narrative, that is, it is situated within an established aesthetic usage—independently of any positive or negative evaluation. To be sure, we must add that if the expression "work of art" is reserved for works with aesthetic finality—and this seems to be the way it is generally used—it is all the more important not to identify it with the notion of "creation" as such, or with that of symbolic creation (in Cassirer's or Goodman's sense), since many symbolic creations—and still more creations without any qualification—have no aesthetic finality.

The categorially literary status of fiction and poetry does not depend on a theoretical postulate: it simply happens that writing a fictional text or a poem involves situating oneself within a practice that *is* functionally aesthetic; the fact that readers of Ian Fleming are not (always) readers of Joyce, Musil, or Proust does not change the fact that the two types of works fulfill the same function, even if in accord with different modalities or for different publics.

It is clear that this distinction can be applied as well to other artistic domains. Thus we can say that music is constitutively aesthetic whereas the status of painting and photography is mixed. Most pictorial genres are constitutively aesthetic, including most of those—such as icons—that fulfill a non-aesthetic function, insofar as their creative aim is to produce an effect that is not one of pure referential information, but linked to a contemplation of properties intrinsic to the image (considered independently of their denotative function). No doubt there also exist genres, if not pictorial at least graphic, whose aesthetic character is purely conditional: think of topographic views, or the plates illustrating eighteenth-century encyclopedias, whose function was purely denotative—and this does not pre-

vent us from often finding aesthetic qualities in them. In the case of photography, the proportion is inverted: most genres are situated within an intentional function that is purely denotative and informational, and only a few images are governed by a purely aesthetic intention (for example pictorialist works). Moreover, the situation prevailing in photography again draws attention to the fact that a product that belongs to a constitutively aesthetic activity does not necessarily have greater aesthetic power than one whose aesthetic status is conditional: many of us find the photojournalist Robert Capa's pictures much more interesting from the point of view of photographic aesthetics than Robert Demachy's pictorialist exercises. The distinction between constitutive and conditional facts does not imply an evaluative hierarchy.

Genette connects this distinction with two different aesthetic systems, one intentional, the other attentional. The former depends on a creation with an aesthetic aim and the latter on an aesthetic reception that can be exercised even in the absence of a corresponding creation: no one can forbid you to read Hegel's *Phenomenology of Spirit* as a novel (fairly abstract, it is true) or to plunge with delight into Bossuet's prose (even if the Christian faith the Bishop of Meaux propagates in his writings remains alien to you). The same thing can be said about scientific photography, and also for products in everyday use that draw our aesthetic attention: a milk pitcher, a plowshare, etc.

The distinction between an intentional aesthetic function and a solely attentional aesthetic function is not, however, always congruent with the distinction between what is constitutively aesthetic and what is only conditionally aesthetic. Thus, an essay has a conditional aesthetic function in that its communicational finality is denotative and not aesthetic, but that in no way prevents it from including an intentional aesthetic dimension, on the level of style, for example. It is just that this dimension is subordinated to a communicational finality that is not aesthetic in nature. Inversely, finding aesthetic qualities in a police report depends on a purely attentional aesthetic system, since we may suppose that the policeman did not take aesthetic considerations into account in writing his report (this supposition may be mistaken . . .). The same situation is found in photography. Finding aesthetic qualities in a scientific photo representing a clump of bacteria no doubt depends on a purely attentional aesthetics. But in the case of nineteenth-century landscape photographers, the situation is far more complicated. We now see clearly in what sense the fact of observing that their work was not situated within an artistic project only half solves the problem: can we assert with certitude that for this reason the aesthetic force of their images is purely attentional? Nothing is less certain: even if the photos are not the result of a constitutively aesthetic project (and thus artistic in the institutional sense of the term), they were none-

theless *composed* by human individuals for whom a photographic image was a visual composition; this being the case, it seems difficult, once such a photo attracts us aesthetically, to refuse to see in it the result of the operation of an aesthetic sensibility. Instead of saying that we must abandon the categories derived from aesthetics when we approach such images—as Rosalind Krauss seems to suggest—I would prefer to say that we must broaden these categories. In other words, I believe that we must accept the idea that the pertinence of intentionalist aesthetic categories is not limited to objects that are situated in a constitutively artistic aim. After all, O'Sullivan or Atget were quite capable of pursuing a nonartistic project and yet showing a great concern for aesthetics: the absence of an artistic project in the institutional sense does not automatically exclude the presence of aesthetic concerns. The same goes for many common objects of everyday life which, although functional, testify to a clear aesthetic concern. And it seems to me that many architectural creations have the same status.

Things become still more complicated if we notice that attentional aesthetic reception means two quite different things: we may be referring to the fact that the receiver valorizes aesthetically properties that do not result from any aesthetic consideration on the part of the creator (for example, in the case of a plowshare whose form—aesthetically pleasing, at least to me—is governed by purely functional considerations), but that nonetheless depend on techniques intentionally made use *of* by the producer. However, we may also be referring to the fact that the receiver valorizes aesthetically either elements of a human product that escape any intentional influence (thus in Japan pottery lovers accord great aesthetic value to certain "defects" accidentally produced in firing),[64] or—and this is a more familiar case—a natural object. Here we come back to the domain of natural beauty, even though it is not coextensive with this sphere.

The difference between these two situations is clear. In the first case, aesthetic attention valorizes structures that, even though they are not aesthetic, are nonetheless intentional: it is just that the receiver adopts an aesthetic point of view with regard to elements encoded in a different perspective. When we take aesthetic pleasure in a plowshare, we endow the object with a function that it did not have, but we take pleasure in it as a human product. This aestheticization easily takes place in all the domains of human creativity: it suffices to bracket the object's "utilitarian" function in order to appreciate it in itself, *qua* "worked" form. The second situation is very different, since here the reception cancels the more fundamental distinction between what is worked or wrought—and thus depends on an intentional structure—and what is without any intention. It is here that the attentional dimension of aesthetics is the strongest: the receiver is the creator or inventor of the object that he appreciates.

The distinctions I have just introduced are very rough, but they suffice to show that the simplistic opposition the speculative theory of Art establishes between the domain of works of art and that of equipment (to use Heideggerian terminology) does not account for a reality that is infinitely more complex and moreover historically changing.

The conclusions that can be drawn from this are of several kinds. First, it is clear that a serious study of art cannot be limited to the domain of the five arts selected as canonical in the eighteenth century: architecture, sculpture, painting, music, and poetry (or literature). This is all the more important because it is impossible to determine abstractly which human activities are capable of becoming valorized by an art, and thus by an aesthetic production or reception. The tea ceremony and flower arrangement have thus been major arts in Japan, on the same level as poetry or painting. The case of the tea ceremony is particularly revealing, since it shows that even one of the humblest, most everyday human activities can be stylized into a complex art capable of producing a very refined experience of pleasure.

Thus we can see why the distinction between major arts and minor arts is both inevitable and unstable: it depends essentially on the aesthetic importance a given society accords to a type of specific objects or activities. What is a minor art in one place may be a major art elsewhere: pottery is considered a minor art (a craft) in the West, whereas it is a major art—even though utilitarian—in China and in Japan; in the same way, if in the West calligraphy has hardly gone beyond the level of an auxiliary decorative activity, it is an autonomous art in Arabic, Chinese, and Japanese civilizations. What is a minor art today was sometimes a major art in the past: that is perhaps the case of tapestry in the West. What was a minor art may become a major art: this is the case with the novel, and more recently, with film. A clue that can almost always be relied upon is the degree of symbolic differentiation, which in general faithfully reflects the depth of our engagement with intentional objects: the Zen Buddhist sand garden is an object of formal differentiation and hermeneutic meditation that is no less intensive than Hölderlin's poetry, Shakespeare's theater, or Cezanne's painting in the West. Naturally, such a hierarchy of the arts always also has a self-referential component and can easily become a self-fulfilling prophecy: it is in part because it is highly valorized that an artistic activity becomes the object of increasingly complex symbolic structurations. From the point of view of aesthetic experience the institutional hierarchy is assuredly only secondary: a successful work belonging to a minor art may be far more interesting than a mediocre work belonging to a canonical art.

The distinction between utilitarian objects and art objects, which has often distorted debates on the relationships between art in the institutional sense and other human creative activities, loses much of its edge: there is

no incompatibility between being an art object (in the true sense of the term "art") and being a utilitarian object; the fabrication of a utilitarian object may very well also be governed by aesthetic considerations. The question as to whether such an object is or is not a "work of art" in the institutional sense of the term is not very important for determining its aesthetic power, and thus its aesthetic value—I therefore think that Genette's observation that "the intentional (and thus artistic, *stricto sensu*) character of a text is less important than its aesthetic character"[65] is generally valid. Similarly, an aesthetic reception of an object can very well accompany the most utilitarian use of it: I can address my prayers to a painting representing a saint while at the same time appreciating the aesthetic qualities of the work; I can study Michelet to learn about the history of witchcraft while taking aesthetic pleasure in his text. If it is sometimes difficult to engage in both activities at the same time, one can in any case easily move from one to the other, which would no doubt not be the case if the practical function were incompatible with the aesthetic experience.

Approaching works of art from the aesthetic angle thus allows them to be functional and allows utilitarian objects to possess an intentional (and, of course an attentional) aesthetic dimension. That does not mean that everything is equally valuable. But categorial distinctions do not allow us to constitute an aesthetic hierarchy according to the types of objects (or of events) concerned: the (attentional) aesthetic value of an nonartistic object can be greater, as we have said, than that of an intentional work of art. The decision depends on the individual object (whatever category it may belong to), and also on the sensibility of the person approaching it from an aesthetic point of view. But it is nevertheless no accident that in general (but not always, nor by virtue of an intrinsic necessity) it is works of art in the strong sense of the term that provide us with the most intense aesthetic satisfaction: after all, they were created with an aesthetic aim.

On Aesthetic Pleasure

The notion of (aesthetic) pleasure, which is still central in Kant, is almost wholly absent from the various versions of the tradition of the speculative theory of Art. Pleasure is also often denigrated by critics, and even by some artists, who are persuaded that the hedonic dimension of aesthetic experience is incompatible with the art work's dignity. In Hegel, for example, pleasure is what remains of art when it has lost all historical-speculative function: thus, in the period of fully realized philosophical science, the work is limited to producing pleasure; abandoned by the god it sheltered, the temple becomes an object of purely aesthetic delight. The Hegelian devalorization of pleasure paradoxically indicates an important fact: pleasure is not really a *function* (in the sense of what something "does,"

what it is "good for") of art. Yet, since it remains when all function has disappeared, pleasure is perhaps the condition on which a work can fulfill a function (whatever it might be). Or, to be both more restrictive and more prudent: pleasure is the condition of a work's being able to fulfill a function (whatever it might be) *as an aesthetic object.* This proposition would delimit two extreme poles between which our ways of dealing with art may oscillate: on one hand the absence of any functionality (in the transitive sense of the term, defined above), on the other, a function (for example, documentary) exercised without the mediation of an aesthetic experience. If pleasure is not a function of art, neither is it a function of aesthetic experience, but for another reason: it *is* that experience, or rather its positive version, since displeasure may be present in the encounter as well.

If this is the case, the fact that aesthetic experience is an experience of pleasure in no way prevents art from fulfilling all sorts of cognitive, moral, social, religious, political, or existential functions. Works no doubt usually fulfill diverse functions, and one may even maintain that they should always do so: it suffices to concede that they can fail do so without thereby ceasing to be aesthetic objects. The same thing holds, of course, for our aesthetic experience of the natural world: Kant considered it linked to a moral interest, but he granted that it could be self-sufficient.

The medieval preacher who introduced an anecdote or fable into his sermon put *delectare* in the service of *prodesse*, pleasure in the service of function: the *exemplum* had to please in order to edify. If it did not, the preacher risked being less successful than if he had abstained from trying to mobilize pleasure. We are often highly displeased when a promised pleasure is not experienced: we grumble as we leave the movie theater or we throw down a book.

To be sure, our preacher ran still another risk: there was always the danger that the anecdote would limit itself to pleasing (thus the ecclesiastical authorities counseled prudence in making use of this indirect means of persuasion). *Prodesse* is not automatically induced by *delectare*: the functions of art are extrinsic to aesthetic experience (which does not mean that they are extrinsic to the work of art). But there is more, at least if Kant is right when he says that the causality proper to pleasure—let us add: whatever it might be—resides in the fact that a person who finds himself in this state wants to remain there "without ulterior aim"[66]: pleasure is not only self-sufficient, but even tends to perpetuate itself. By replaying the pleasurable anecdote in their heads, the faithful risk not attending to the moral the preacher wanted to draw from it. The theory of art for art's sake has thus brought to light a fundamental virtuality of aesthetic experience, or rather it would have done so had it not felt obliged to stylize aesthetic pleasure into a mystical experience. This explains why puritans—beginning with Plato—have often looked on art with a jaundiced eye, and also

why the speculative theory of Art thought it could ensure the dignity of the arts only by getting rid of pleasure (and thus of aesthetic experience).

To be sure, one may think that all pleasures are not equally valuable, and it is certain that they do not all manifest themselves in the same way. Nonetheless, they have too many traits in common for it to be possible to radically oppose them to each other: we seek them for themselves, they reside in a state of well-being, and we try to maintain ourselves in that state as long as we can. This holds for aesthetic pleasure as well as for the most physical pleasure. Anyone who denigrates pleasure as such has to engage in all sorts of contortions if he still wants to save the aesthetic attitude.

Assuredly, to approach art through pleasure is to approach it from the art-lover's side. This therefore amounts to a point of view that is very partial in both senses of the word. Nothing requires that the creative artist have a corresponding experience. Just as the poet (or the actor) has no need to experience the feeling that his poem (or his performance) expresses, his creative act is not necessarily an experience of pleasure: creation, it is said, is sometimes suffering (but artists are great deceivers). Neither does the artist necessarily create his work *in order* that it please. His motivations are often quite different; his goals may be expressive, cognitive, moral, and so on. In addition, sometimes he would no doubt find it very difficult—as would all of us—to say why he did what he has done. The artist is not even obliged to take into account the pleasure that the work must produce, since it is art itself, as a reality that is always institutional and historical, that takes it into account in his stead. An artist never creates *ex nihilo*: his work is situated in the context of acknowledged artistic practices; and they are acknowledged as such above all because they have been appreciated, because they have been sources of pleasure (this holds for the contents, the forms, the genres, the media, etc.).

It is true that the question of the causal relationships between pleasure and established artistic practices is to some extent a chicken-and-egg question. Thus it probably does not admit of a single answer. Aristotle thought men were so constituted that they took pleasure in mimetic activities. And in fact, practically all civilizations have developed mimetic arts; moreover, we can easily (that is, without going through complicated processes of learning) take pleasure in the mimetic works of cultures very distant from our own; and finally, this is a pleasure to which one has access at almost any age. Mimetic pleasure is connected with a process of learning; but up to a certain point (rather rudimentary, to be sure) the latter seems to follow related paths in most civilizations (we have only to think of tales, myths, fables, or witticisms). Other practices, in contrast, are clearly "acquired tastes." They are connected with a specific civilization and can produce pleasure only after a long process of learning: the tea

ceremony or calligraphy make the neophyte yawn with boredom, and certain recent forms of the visual arts in the West, for example conceptual art, are in a related situation. Similarly, every work that makes an artistic rupture with tradition can be appreciated only to the extent that one is capable of situating one's own aesthetic experience in a specific historical culture: this is the case of many avant-garde works (but not all). However, all this does not in any way prove that a "spontaneous" pleasure is necessarily more intense than one connected with complicated learning.

All pleasure taken in a work of art is not necessarily aesthetic: the earliest lovers of novels may have favored them because they thought they were *truer* than epics. I do not think the possible pleasure connected with this conviction can be qualified as aesthetic. Hence it is not certain that we should postulate a specific *type* of pleasure that is aesthetic. It seems to me simpler to seek the nature of the aesthetic attitude in the particularity of the relationships that we entertain with the objects that elicit pleasure. Thus we are not obliged, at the outset, to oppose aesthetic pleasure to other kinds of pleasure, or to reduce it to one of them.

I should say—and in doing so I am only repeating what Kant said on this point—that any pleasure elicited by a representational activity exercised on an object (a human product or a natural object) counts as aesthetic pleasure. This already permits us to distinguish it from sexual pleasure or culinary pleasure, in which—if everything goes well—the representational activity is never more than an anticipation of the passage to the (bodily) act itself. In aesthetic pleasure, it is the representational activity as such (as an autonomous activity) that is a source of pleasure, so that we are led to maintain ourselves in this state rather than to transcend it toward a different act. To be sure, the borderline between an autonomous activity and a heterofinalized activity is not always easy to determine, but in general the distinction does not seem to me problematic.

Yet we must not misunderstand its significance: a bodily activity can in turn become the object of a self-sufficient representational activity exercised upon it. Thus eating or erotic activity can become the source of a second, aesthetic pleasure if they induce a pleasing representational activity exercised on the occasion of the bodily act (and no longer leading to this act). The Kantian opposition between the pleasure of an attraction and that of aesthetic contemplation is acceptable if we read it as proposing a distinction between the pleasure taken in representational activity and that taken in the object of the activity, but it leads us into error if we read it (and perhaps Kant himself read it this way) as a distinction between objects that can become a source of aesthetic pleasure and others that are supposed to be incapable of doing so (because they are too "physical"): there is a culinary aesthetics as well as an erotic aesthetics.

Kant strongly emphasizes the idea that aesthetic pleasure is supposed to

be disinterested, whereas other pleasures, for example culinary or sexual pleasure, are supposed to be interested: in the latter cases it is the existence of the object that interests us and not its mere representation. And we know what an important role this thesis played in the sacralization of Art, particularly in Schopenhauer, according to whom aesthetic contemplation is supposed to free us from the agony of the will to live.

The distinction—in its Kantian form—seems to me acceptable if it means that in aesthetic pleasure representational activity is cultivated for its own sake and not with a view to other ends—sexual, for example, but also moral or cognitive (with a view to acquiring knowledge of the work of art as an artifact). This does not, however, make aesthetic pleasure more disinterested than other pleasures. Santayana notes—in opposition to Kant—that *all* pleasure is disinterested, since it is sought for its own sake and tends to maintain itself.[67] Inversely, all pursuit of pleasure is just as interested: the esthete seeking a sublime painting is no less interested than the fetishist seeking a foot—or a shoe—that suits him (which does not mean that the two interests are equivalent—but that is another problem). Which brings us back to the fundamental characteristic formulated earlier: in aesthetic experience, representational activity is a source of autonomous pleasure.

However, Kant also maintains that, contrary to the pleasure elicited by an attraction, whose uniquely personal value we willingly acknowledge, aesthetic pleasure gives rise to a judgment that claims universality. He even sees in this the decisive clue indicating that aesthetic judgment has a transcendental foundation. It is true that in the domain of art we generally want others to share our personal evaluation. But I am not sure that the Kantian interpretation of this fact is the only one possible, or the most plausible. First of all, when natural beauty is concerned, we easily accept the fact that our friend or companion does not appreciate the same things we do: a given landscape that I find sublime may not please another person, and we easily accept this difference in our reactions. According to Kant, natural beauty is the canonical domain of aesthetic feeling: the claim to universality should be particularly strong in this domain. On the other hand, if I expect everyone to share my feeling with regard to a novel, a painting, or a film, this expectation is not necessarily due to the fact that my pleasure seems to me disinterested, not linked to personal preferences. Santayana observes that our real motives are perhaps less philosophical and more interested:

> We take, for instance, a certain pleasure in having our own judgments supported by those of others; we are intolerant, if not of the existence of a nature different from our own, at least of its expression in words and judgments. We are confirmed or made happy in our doubtful opinions by seeing them ac-

cepted universally. We are unable to find the basis of our taste in our own experience and therefore refuse to look for it there. If we were sure of our ground, we should be willing to acquiesce in the naturally different feelings and ways of others, as a man who is conscious of speaking his language with the accent of the capital confesses its arbitrariness with gayety, and is pleased and interested in the variations of it he observes in provincials.[68]

It is therefore not certain that our desire to see others share our aesthetic judgments is an indication of the latter's transcendental foundation: it is perhaps due simply to our inveterate conformism. In any case, in the aesthetic domain an ideal of universality does not seem in any way desirable: if aesthetic experience were limited to being—as Kant maintains—that of an indeterminate harmony of the mental faculties, and if I could suppose that this was similar in everyone, it would be likely to be very meager, for what is similar in everyone is rarely complex and differentiated.

Kant, to be sure, rejects any aesthetic conformism, since he denies that there can be a principle of the beautiful, and—in a passage I have quoted—goes so far as to say that when someone tries to give me reasons to persuade me that my judgment is erroneous, "I stop my ears: I do not want to hear any reasons or any arguments about the matter. I would prefer to suppose that those rules of the critics were at fault, or at least have no application." But someone who has the courage to stop his ears with regard to the established norms also no longer has any reason to insist that others share his evaluation; inversely, someone who claims that his pleasure and his judgment are universal often does so because in reality they are not his own. It is therefore possible to account for the facts advanced by Kant without seeing in them indications of a transcendental foundation of the aesthetic sphere.

An important problem is that of the relationship between the autonomy of aesthetic pleasure and the question of its possible conceptual determination. I should like to return here in more general terms to the reflections sketched out at the end of my analysis of the *Critique of Judgment*. Kant, let us recall, makes much of the thesis that the beautiful pleases "without concept" even though the pleasure has a claim to universality; it is in this paradoxical character that he sees the distinctive mark of the aesthetic domain. But in so doing—as I have already said—he underestimates the actual role of the conceptual dimension in the genesis of aesthetic pleasure.

To be sure, at a first level the thesis may appear to be simply a reformulation of the principle that aesthetic pleasure is aesthetic only insofar as it is autonomous, that is, not determined by heteronomous reasons—for example, by moral norms, or even by artistic norms: if a work pleases me because I think it is going to strengthen the moral cohesiveness of society, it does not please me aesthetically; similarly, if it pleases me *because I*

think it is perfect (according to some given artistic norms), it is not a source of pure aesthetic pleasure. The precise scope of this principle has to be defined: nothing prevents a work from pleasing me *because it is* perfect (in accord with these same norms), but the knowledge of this (possible) causal relation must *motivate* neither my pleasure nor my evaluation of the work. Up to this point the principle seems to me entirely defensible.

However, we have seen that Kant means something quite different by the idea that the work of art must please "without concept": pleasure must be elicited by an *indeterminate* representational activity, by an indefinite harmony of the faculties (of imagination and understanding). More precisely, he seems to mean that pleasure must be produced by the conformity of a perception (of a natural object or a work of art) with an indeterminate representational activity. To this conception, I have already objected that, to the extent that all our perceptions are categorized (according to cultural specificities as well), it is hard to see how a representational activity could remain indeterminate: if an Inuit differentiates among many different nuances of white that are for me the same, he does so by virtue of a discriminatory capacity that is indissolubly perceptual and conceptual. Thus, a painting entitled *White Square on White Background* might for him be a highly differentiated object from the point of view of its color, and this differentiation, which is aesthetically pertinent, will be conceptual as well as perceptual.

Kant does not, of course, deny that aesthetic judgment is intellectual in nature (like all judgment). We have even seen that he asserts that judgment precedes and grounds pleasure, which can scarcely be doubted insofar as aesthetic pleasure is a pleasure taken in a representational activity and that any representational activity is saturated with acts of judgment, even if they are often not explicit. But this act of perceptual judgment is inevitably determined, since it always includes multiple acts of identification and predication. Moreover, our relationship to art cannot be reduced to a perceptual relationship, or *a fortiori* to a visual relationship (whereas that is Kant's implicit model): there are arts that proceed through a mode of perception other than visual (music, for example), or in which perception as such plays only an indirect role (literature); finally, in every kind of art, categorizations other than those connected with perception are involved. Generally, no object presents itself "spontaneously" as an aesthetic object; we have to constitute it as such, that is, we have to approach it in a certain way, distinguish between the properties that are pertinent and those that are not (thus in general the back-panel of a painting is aesthetically nonpertinent—except in the case of an altarpiece), etc. It goes without saying that if aesthetic pleasure is pleasure taken in a representational activity cultivated for its own sake, then the maximization of the

conceptual differentiation of this activity can only increase our pleasure, since it enriches our reaction.

Therefore in aesthetic experience intellectual activity is not limited to providing us with norms of evaluation (otherwise it would be actually extrinsic, even heteronomous). It is solely through intellectual activity that we can constitute, or construct, the aesthetic object. We can agree with Kant when he asserts that no regulative norm must determine our pleasure and our judgment; but at the same time it is clear that we cannot get along without the constituting categories that determine the pertinent properties in relation to which an object can be identified and structured as a specific aesthetic and artistic object: a sonata rather than a symphony, an English garden rather than a Chinese or Japanese garden, a photograph rather than a painting, etc. The requirement that aesthetic pleasure (and the activity of judgment connected with it) not be conceptually determined thus makes sense only if it is interpreted to mean that this pleasure cannot be legitimated in relation to a finality other than itself. On the other hand, it makes hardly any sense to require that aesthetic pleasure not be determined by the specificity of a representation that is conceptually saturated, but only by an indeterminate harmony among our mental faculties.

All this shows that it is necessary to clarify the notion of aesthetic judgment, an expression that can designate two very different acts between which Kant does not sufficiently distinguish. It can designate the whole set of judgmental activities that elicit, nourish, and maintain representational pleasure: the act of reading a novel maintains itself as a pleasant state only insofar as it resides in a constant activity of judgment (including imaginative judgment) that is repeatedly renewed and made more complex, and that is exercised for its own sake, that is, with a view to its own perpetual renewal and not to its culmination in a different activity. But the expression can also designate evaluation proper, evaluation that leads me to say that the novel in question is successful or not, and possibly to give reasons in support of this judgment. It seems to me that fundamentally the Kantian requirement that aesthetic judgment not be conceptually determined is not acceptable insofar as it concerns evaluative judgment: the latter must be only the sanction for the pleasing judgmental activity through which we constitute and structure the aesthetic object (our pleasure residing in this judgmental activity).

The preceding considerations leave many questions open. They do not explain why we take pleasure in a representational activity pursued without regard to any ulterior end. I admit that I cannot even start to answer this question. But it seems to me that the problem here arises not so much from the aesthetic attitude as from the generic character of pleasure: why do we take pleasure in making love, in physical exercise, in playing with

our children—without regard to any ulterior end? Neither have I satisfac-
torily described wherein resides the judgmental activity through which
aesthetic pleasure "circulates." That is because it is always individual (rel-
ative to the object and to the subject who approaches it): trying to reconsti-
tute it in a general form would be as utopian as trying to determine a
universal form of the creative act. All we can do is to describe the struc-
tural characteristics of the work of art that can guide the receiver's judg-
mental activity—or that bear witness to the artist's creative act. In actual-
ity, the multiplicity of the interpretations proposed for a single work of art
would suffice to demonstrate the singularity of each aesthetic experience.
Our representations are culturally shared, to be sure, but the possibilities
of combining them, contrasting them, etc. are so multitudinous, the posi-
tive or negative investments are so variable, the points of view so unfore-
seeable, that we cannot predict whether a given object will please, or how
it will please, or by virtue of what it will please, or whom it will please.

That certainly does not mean that all experiences are equally valuable,
nor that all do equal justice to the works: but an aesthetic experience that
misunderstands some or even most of a work's characteristics nonetheless
remains an aesthetic experience. Neither do I claim that the properties of
a work change with the receivers: the work is what it is, but all receivers do
not activate the same properties: some receivers misunderstand a certain
number of these, others "add" some, etc. All this is hardly mysterious:
when we enter into an aesthetic relationship with an object, its "native"
properties often matter less than the functional properties with which we
"endow" it in the context of a particular receptive strategy. To be sure,
knowing certain of the "native" qualities (physical, phenomenological, in-
tentional, "categorial" in Watson's sense, etc.) generally allows us access
to more complex, more successful usages—even though this is perhaps not
always the case: we must not underestimate the potential aesthetic rich-
ness of "errors" in identification and attribution.

Connecting aesthetic experience with the judgmental activity exercised
on a representation does not in any way imply its "intellectualization" and
a misunderstanding of the function of the emotions, if only because the
pleasure taken in the judgmental activity *is* an emotion. The work capti-
vates us, fascinates us, or more modestly, simply interests us. That is also
why, as Yves Michaud observes, the only latent defect of a work of art is
to produce a feeling of boredom: "It seems to me that one can tolerate
many things in art, that it is difficult, vulgar, shocking, mannered, blas-
phematory, intellectual, pornographic, picturesque—and even pleasant,
beautiful, sublime, seductive. It seems to me on the other hand absolutely
contrary to its concept that it should make us die of boredom. When art is
no more interesting than a conversation at an art opening, it would be
better to take an interest in something else."[69]

To be sure, this conception of aesthetic pleasure is very liberal: any kind of idea (a mathematical proof as well as a painting, a stone as well as a tragedy, a gesture as well as a symphony) can be approached in an aesthetic perspective, since what matters is not the type of object but the type of activity exercised on it. This conception therefore cannot be the foundation for a theory of art: at most, it outlines the domain of human experience in which art finds its place (alongside other activities). But that is also all we ask of it: the descriptive theory of the arts belongs to semiotics or the theory of symbols in Goodman's sense.[70] What matters is that this conception of the aesthetic attitude is in no way incompatible with taking into account the cognitive and hermeneutic richness of works of art; on the contrary, if the description I have sketched out is correct, aesthetic pleasure is inseparable from a cognitive (perceptual *and* conceptual) attitude and thus also from sustained attention to what the work of art can teach us—it going without saying that the knowledge transmitted by works is of the most diverse kinds, depending on the work, the genres, and the arts. Finally, this knowledge that finds its source in the arts is not different (neither superior nor inferior) from that at which we arrive by the other cognitive routes, whether it is a matter of everyday experience, philosophical reflection, or scientific knowledge: that is precisely why it is important to us and can enrich our lives.

In order to disqualify the aesthetic, it is often said to have been born ("only") in the eighteenth century; thus it is supposed to be essentially an "expression" of subjectivism and "modern" (or "bourgeois") individualism, and consequently to have no general descriptive value for the study of humanity's multiple relationships with the arts. Nevertheless, although the study of other periods or other civilizations teaches us that art has been cultivated with a view to diverse functional goals, it also shows us that the valorization of aesthetic gratification, and hence of "gratuitous," purely artistic pleasure, is in no sense a vice of modern Western civilization: we find much evidence leading in the same direction in Muslim, Indian, Chinese, and Japanese civilizations, as well as in classical antiquity, whether Greek or Roman. The aesthetic dimension is indeed a general given of art—the atmosphere that is indispensable for its life. This truth will no doubt appear trivial; but for the past two hundred years, many of those who have reflected on the arts have so thoroughly forgotten it that it must be now rediscovered.

We have now moved beyond the limits of the present work: it has not been my intention to study the different domains of investigation that should replace the imaginary field of Art as it has been constructed by the tradition of the sacralization of the arts. Perhaps I have at least succeeded in showing that our relation to art works and our comprehension of the arts

have everything to gain from giving up a body of received of ideas whose historical prestige cannot indefinitely conceal their eminently preconceived character.

One cannot be simultaneously the cult's priest and the ethnologist who seeks to understand it: in this sense, my analysis, like any exterior point of view, might occasionally have been too severe. But when a belief collapses and we must bid it farewell, critical distance is no doubt the best attitude we can adopt with regard to it. In the present case it shows us that when all is said and done, the sacralization of the arts has been no more than a local convention and not humanity's final word regarding aesthetics and the arts.

Notes

INTRODUCTION

1. Whose cultural pessimism Lyotard, like Derrida and most of the post-Heideggerians, shares: to be convinced of this it suffices to read the opening pages of *The Differend: Phrases in Dispute*, trans. George Van Den Abbeele, Minneapolis: University of Minnesota Press, 1988).

2. Jean-François Lyotard, *The Inhuman: Reflections on Time*, trans. Geoffrey Bennington and Rachel Bowlby (Stanford: Stanford University Press, 1991), 135–43.

3. If Luc Ferry thinks Kantian aesthetics may have reached its high point in the theory of the sublime, this shows that what interests him in Kant is not the aesthetic problematics in the strict sense of the term but rather the function of the aesthetic sphere in a social theory of individuality. See Ferry's *Homo Aestheticus: The Invention of Taste in the Democratic Age*, trans. Robert de Loaiza (Chicago: University of Chicago Press, 1993).

4. But let's first clean up our own act: my attempt—in *L'image précaire* (Paris: Seuil, 1987), 161 ff.—to apply the theory of the sublime to a certain type of photographic images is open to the same objection, despite my acknowledgement that the "problematics concerns primarily the objects of sensuous intuition and not artificial images."

5. *Homo Aestheticus*.

6. I borrow these two terms from Arthur Danto, "Deep Interpretation," in *The Philosophical Disenfranchisement of Art* (New York: Columbia University Press, 1986), 47 ff.

7. This in no way prejudices the status of hermeneutic interpretation as a branch of the history of art—here it is a matter only of interpretation as a critical tool. Is it necessary to add that there are exciting and illuminating "deep interpretations"—and that that is not the question?

8. On this distinction, see Svetlana Alpers, *The Art of Describing: Dutch Art in the Seventeenth Century* (Chicago: Chicago University Press, 1983).

9. As Antoine Compagnon does in *Five Paradoxes of Modernity*, trans. Franklin Philip (New York: Columbia University Press, 1994).

10. Wassily Kandinsky, *Concerning the Spiritual in Art, and Painting in Particular*, trans. M.T.H. Sadler, rev. F. Golffing, M. Harrison, and F. Ostertag (New York: Wittenborn, 1970).

11. In the sense of a teleological nature, and without precluding the possible existence of works of art having universal characteristics—which is quite a different question.

12. That does not mean that works of art cannot have cognitive pertinence, that they can tell us nothing about the world or ourselves. I am criticizing solely the thesis that a kind of ecstatic knowledge is involved that cannot be related to our

scientific or practical knowledge of the world. In fact, this amounts to misunderstanding the sometimes very fruitful relationships between the arts and positive knowledge, such as the connections between the Italian Renaissance perspectivist works and the mathematical representation of space, or those between Dutch painting and Francis Bacon's program for an empirical science. I would add that this cognitive dimension in no way cancels the aesthetic (and thus hedonic) dimension of the work, since the latter realizes its presentative mediation.

13. Heidegger, for example, limits his conception of poetry to what he calls the "valid poem" (*das gültige Gedicht*), that is, to a poem that lends itself to philosophical translation: whence the privilege he accords to Hölderlin, the philospher-poet par excellence. Adorno, despite his hostility to Heidegger, agrees with him on this point, since he maintains that philosophy and art converge in their truth content.

14. Jean-François Lyotard, *The Inhuman.*

15. G.W.F. Hegel, *Aesthetics: Lectures on Fine Art*, trans. T. M. Knox (Oxford: Clarendon, 1975), 1: 7. Henceforth cited as *AES*. This translation is based on the second edition (1842).

16. Martin Heidegger, *The Origin of the Work of Art*, in *Poetry Language Thought*, trans. Albert Hofstadter (New York: Harper and Row, 1971), 76–77.

17. Paul Valéry, "Propos sur la poésie," *Oeuvres* (Paris: Gallimard, 1957), I: 1381.

18. Matthew Arnold, "The Study of Poetry," in *Essays in Criticism*, 2d series (London: MacMillan, 1911), 2–3.

19. Joseph Kosuth, quoted by Nicolas Bourriaud, "Joseph Kosuth, entre les mots," *Artstudio* 15 (Winter 1989): 95, and by Joel Rudinow, "Duchamp's Mischief," *Critical Inquiry* 7 (1981): 747.

20. I shall return in the conclusion to the historical importance of the speculative theory of Art within the art world in the strict sense of the term, that is, in the projects of artists or artistic movements as well as in critical writings.

21. Of course the investment of the world of art by the market economy does not begin with romanticism: it suffices to think of Dutch painting in the seventeenth century or certain literary genres, such as the novel, which have always contributed to a market economy. But it can probably be said that this movement of economic integration is generalized and accelerated in the nineteenth century. It is moreover not enough to explain the compensatory function of the speculative theory: after all, seventeenth-century Dutch painters had no problem seeing their paintings put on sale as one kind of merchandise among others. But—and all historians agree about this—these painters lived in a universe whose religious and ethical worldview was wholly stable; romanticism, in contrast, had to respond to a radical disintegration of the traditional cosmos, in the religious and philosophical domains as well as in the political and social domains.

CHAPTER ONE
KANTIAN PROLEGOMENA TO AN ANALYTIC AESTHETICS

1. Jürgen Habermas connects the birth of eighteenth-century aesthetics with the more general phenomenon of the dissociation of modern rationality into diverse spheres of autonomous competence and discursivity, a dissociation that gave

rise to the concepts of art, politics, and science considered as activities with their own logic and internal legitimation. See Habermas, "La modernité—un projet inachevé," trans. Gérard Raulet, in *Critique* 37 (October 1981). Luc Ferry's *Homo Aestheticus* defends a thesis of the same general kind. Ferry's work is governed by a different perspective from mine, since he studies aesthetics as the place where the modern theory of individuality is embodied: his investigation belongs to the realm of social philosophy much more than to that of the theory of art and aesthetics proper.

2. Alexander Gottlieb Baumgarten, *Metaphysica*, § 533: "Scientia sensitive cognoscendi et proponendi est AESTHETICA (Logica facultatis cognoscitivae inferioris, Philosophia gratiarum et musarum, gnoseologia inferior, ars pulchre cogitandi, ars analogi rationis)." In Baumgarten, *Texte zur Grundlegung der Ästhetik* (Hamburg: Felix Meiner, 1983), 16.

3. All references to this work cite *The Critique of Judgement*, trans. James Creed Meredith (Oxford: Clarendon, 1928; rpt. 1952).

4. Alfred Baeumler, *Das Irrationalitätsproblem in der Ästhetik und Logik des* 18. Jahrhunderts (1923; rpt. Darmstadt: Wissenschaftliche Buchgesellschaft, 1967).

5. See ibid., 2.

6. ibid., 13–14.

7. See for example his introduction to the French translation, *Critique de la faculté de juger*, trans. A. Philonenko (Paris: Vrin, 1965), 7–16. See also Ernst Cassirer, *Kants Leben und Werk* (1921; rpt. New Haven: Yale University Press, 1977), 327–41. Ferry, *Homo Aestheticus*, adopts the same perspective.

8. See below, n. 40.

9. Kant says it could claim at most a de facto generality based on an accidental identity of sensations: thus there would be not communication but simply superimposition of identical physiological determinisms.

10. "Accordingly he will speak of the beautiful as if beauty were a quality of the object and the judgment logical (forming a cognition of the Object by concepts of it); although it is only aesthetic, and contains merely a reference of the representation of the object to the Subject." *Critique of Judgement*, 1: 50, § 5.

11. *Critique of Judgement*, 1: 51, § 6.

12. This reading of Kant is defended by Paul Guyer in his *Kant and the Claims of Taste* (Cambridge, MA: Harvard University Press, 1979), and more recently in "Pleasure and Society in Kant's Theory of Taste," in Ted Cohen and Paul Guyer, eds., *Essays in Kant's Aesthetics* (Chicago: University of Chicago Press, 1982), 21–54.

13. Guyer, *Kant and the Claims of Taste*, 35.

14. *Critique of Judgement*, 1: 62, § 11.

15. For a discussion of this dilemma, see Ralf Meerbote, "Reflections on Beauty," in Cohen and Guyer, eds., *Essays in Kant's Aesthetics*, 81–85.

16. See Kant, *Critique of Judgement*, 1: 60, § 9.

17. The Kantian theory of the faculties is not always unequivocal, and it has given rise to divergent interpretations. By according the central place to the faculty of transcendental imagination, I follow Heidegger's interpretation [*Kant and the Problem of Metaphysics*, trans. Richard Taft (Bloomington: Indiana University Press, 1990)], which is not universally accepted. But here the correctness of these points of details matters little: even if the status and function of the transcendental

imagination are interpreted somewhat differently, this in no way affects the prob-
lems that concern us here.

18. *Kants Gesammelte Schriften* 8 (Akademieausgabe), 404, quoted by R.
Verneaux, *Le Vocabulaire de Kant* (Paris: Aubier-Montaigne, 1967), 90, which has
been very useful in my discussion of form in Kant's work.

19. *Kritik der reinen Vernunft*, quoted by Verneaux, *Le Vocabulaire*, 100.

20. Verneaux, *Le Vocbulaire*, 99.

21. See Luc Ferry, *Homo Aestheticus*, Chapter 3, "The Kantian Moment."

22. This relationship to the supersensuous, to the absolute, which in the sphere
of beauty is realized by the finality without representation of a specific end, is also
found, with even more power, in the realm of the sublime. In fact, what the judg-
ment of the beautiful realizes in relation to knowledge, the judgment of the sublime
realizes, even though in different modalities, in relation to moral judgment. If I do
not linger here on the question of the sublime, it is because the analysis of aesthetic
judgment refers solely to the beautiful. This is hardly surprising since the finality
without representation of a specific end, the theory's central mechanism, operates
in only in the realm of the beautiful.

23. As soon as one moves from the singular judgment "This rose is beautiful"
to the (logically) universal judgment "Roses are beautiful," one moves from the
domain of aesthetic judgments to that of logical judgments, even if in this case the
logical judgment is based on the comparison of a certain number of (singular)
aesthetic judgments. Aesthetic judgment is necessarily singular because it is the
direct expression of a feeling, even if the latter is universalizable.

24. *Critique of Judgement*, 1: 58, § 9.

25. Ibid., 2: 151, § 40.

26. Ibid., 1: 83, § 21.

27. David Hume, "Of the Standard of Taste," *Essays Moral, Political, and
Literary* (London: Longmans, 1898), 278.

28. *Critique of Judgement*, 2: 226, Appendix, § 60.

29. Ibid., 2: 140, § 33.

30. Ferry, *Homo Aestheticus*, 75–87.

31. *Critique of Judgement*, 1: 85, § 22.

32. For an exemplary analysis of this problem, see Antony Savile, *Aesthetic
Reconstructions* (Oxford: Blackwell, 1987), 152–60.

33. *Critique of Judgement*, 1: 41, n. 1; § 1.

34. Ibid., Introduction, 32; § 7.

35. Ibid., 1: 188, § 51.

36. Ibid., 1: 80, n. 1; § 17.

37. Ibid., 2: 158, § 42.

38. Ibid., 1: 72–73, § 16.

39. Ibid., 1: 72, § 16.

40. Ibid. Kant is far from always coherent on the subject of music: if music
without a text is an example of free beauty, it should clearly fall into the domain of
the judgment of pure taste. However, at several points in the *Critique of Judgment*
Kant hesitates as to the position to be accorded music: is it an art of the beautiful
or simply an agreeable art? Is it a *beautiful* play of sensations or a simple play of
agreeable sensations? Its undecided status is moreover like that of colors: "we

cannot confidently assert whether a color or tone (sound) is merely an agreeable sensation, or whether they are in themselves a beautiful play of sensations, and in being estimated aesthetically, convey, as such, a delight in their form" (*Critique of Judgement*, 2: 189, § 51). In the case of music, the the answer seems to depend on the importance accorded to mathematical proportions in the pleasure it provides. However, in his *Anthropology from a Pragmatic Point of View* [1798; trans Mary J. Gregor (The Hague: Nijhoff, 1974]) he defends a more categorical position, since in this work the devalorization of music is wholly unambiguous: "For it is only because music serves as an instrument for poetry that it is *fine* (not merely pleasant) *art*" (§ 71B, 114). In other words, instrumental music is not part of the fine arts, but rather of the agreeable arts. To be sure, because it does not represent anything, it is "pure" in the sense that it cannot be referred to an intentional goal, but the aesthetic judgment made on it can only be pure, that is, empirical, since it is only an agreeable art. Yet free beauty as such cannot be identified with empirical aesthetic judgment; on the contrary, it is only in its domain that a pure aesthetic judgment, in the sense of a judgment not determined by a precise final intention, is possible. Now, a pure aesthetic judgment must be both undetermined by a subjective empirical sensation and not subject to the regulation of a concept. One can only note here once again the ambiguity of the notion of "pure aesthetic judgment" in Kant's work.

41. See Jacques Derrida, "Parergon," in *Truth in Painting*, trans. Geoff Bennington and Ian McLeod (Chicago: University of Chicago Press, 1987).

42. *Critique of Judgement*, 2: 167, § 45. (Emphasis supplied.)

43. *Anthropology from a Pragmatic Point of View* § 57, p. 94.

44. *Critique of Judgement*, 2: 169, § 46.

45. Ibid., 2: 176, § 49.

46. Ibid., 2: 175–76, § 49.

47. See above, 35–37.

48. *Critique of Judgement*, 2: 169, § 48.

49. Ibid., 2: 171, § 48.

50. Ibid., 2: 181, § 49. (Emphasis supplied.)

51. Ibid., 2: 171, § 47. (Emphasis supplied.)

52. Ibid.

53. *Critique of Judgement*, 2: 182–83, § 50.

54. See Antony Savile, "Beauty: A Neo-Kantian Account," in T. Cohen and P. Guyer, eds., *Essays in Kant's Aesthetic*, 115–47. Savile distinguishes clearly between natural and artificial beauty and thinks Kantian aesthetics cannot be coherent unless one refuses to introduce finality without representation of a specific end into the problematics of the work of art.

55. According to this initial categorization, the domain of the fine arts might be defined as a *mixture* of elements belonging to finality without representation of a specific end and elements that appeal to human intentionality, i.e., that imply a specific end or goal. I must say that the idea of this kind of mixture does not seem to me very clear: to the extent to which finality without representation of a specific end and specific finality are two diametrically opposed concepts, an object can hardly present a mixture of the two without losing all internal coherence. If it is not a matter of a mixture, then what is it? Kant never takes up this question.

56. See Kendall Walton, "Categories of Art," *Philosophical Review* 79 (1970):

334–67. Walton shows convincingly that a work of art exists only within a categorial horizon, generally connected with the institution of art.

57. See Timothy Binkley, "'Piece': Against Aesthetics," *Journal of Aesthetics and Art Criticism* 35 (1977): 265–77.

58. Hegel formulates the same thesis explicitly: in comparing poetry and music, he qualifies the "sensuous mode of presenting" taken on by the former, that is, "the tempo of words and syllables, rhythm, and euphony, etc.," as a "rather accidental externality" as compared with sound in music; in poetry, "spirit becomes objective to itself on its own ground and it has speech only as a means of communication or as an external reality out of which, as out of a mere sign, it has withdrawn into itself from the very start." *AES* 3: 963–64.

59. *Critique of Judgement*, 2: 191–92, § 53.

60. Thus Friedrich Schlegel notes: "The difference between prose and poetry resides in the fact that poetry seeks to present (*darstellen*), whereas prose seeks only to communicate. . . . It is the indeterminate (*das Unbestimmte*) that is presented so that each presentation is something infinite; inversely only what is determinate can be communicated. The sciences as a whole seek not the indeterminate but the determinate." *Kritische Friedrich-Schlegel-Ausgabe* (Paderborn: Schöningh, 1975), 3: 48.

61. Even the "painters of ideas" whom Kant prefers in pictorial art are obliged to submit to this principle.

62. *Critique of Judgement*, 2: 178, § 49.

63. On this question in general, see Donald W. Crawford, *Kant's Aesthetic Theory* (Madison: University of Wisconsin Press, 1974), chaps. 5–8.

64. *Critique of Judgement*, 2: 221–22, § 59.

65. *Anthropology from a Pragmatic Point of View*, § 38, p. 65.

66. *Critique of Judgement*, 2: 226–27, § 60.

67. Immanuel Kant, *Critique of Pure Reason*, trans. Norman Kemp Smith (1929; rpt., New York: St. Martin's Press, 1965), 276 (A 260).

68. This can be seen as one of the consequences of the "under-determination" of our theories by experience. See W. O. Quine, *From a Logical Point of View* (Cambridge, MA: Harvard University Press, 1953).

69. See Ralf Meerbote, "Reflection on Beauty," in Cohen and Guyer, eds., *Essays in Kant's Aesthetic*, 75.

70. Schiller, *Kallias-Briefe*, in *Werke in drei Bänden* (Munich: Hanser, 1966), 2: 352.

71. *Critique of Judgement*, 1: 71, § 15..

72. Ibid., 1: 55, § 8.

73. Ibid., 1: 75, § 17.

74. See Kendall Walton, "Categories of Art."

75. See Michael J. Parsons, *How We Understand Art* (Cambridge: Cambridge University Press, 1987), 35.

76. In his *Essai critique sur l'esthétique de Kant* (Paris: Alcan, 1896), Victor Basch had already reproached Kant for not having acknowledged several levels "in the aesthetic sphere" (196). He added: "for us, pure aesthetic judgment is inadmissible. It is an organ that does not exist, and cannot exist. Every aesthetic judgment is in fact an aesthetic-teleological judgment" (510).

CHAPTER TWO
THE BIRTH OF THE SPECULATIVE THEORY OF ART

1. Among the general works devoted to an exhaustive study of the (German) romantic revolution, we must cite H. A. Korff, *Geist der Goethezeit. Versuch einer ideellen Entwicklung der klassisch-romantischen Literaturgeschichte*, 8th ed. (Berlin: Koehler & Amelang, 1966), and especially R. Ayrault, *La genèse du romantisme allemand* (Paris: Aubier, 1961–76).

2. Friedrich Schlegel, for example, long led the unstable and aleatory life of a "free" writer with the accompanying lack of financial and statutory security. Let us also not forget that the great publishing venture of Jena romanticism, the periodical *Athenaeum*, came to a close in 1800, essentially for financial reasons connected with the failure to find a commercial publisher. On this subject see Ernst Behler's postface to the reprint of issues of the romantic periodical in the modern journal *Athenaeum. Eine Zeitschrift* (Darmstadt: Wissenschaftliche Buchgesellschaft, 1973) 3: 5–64.

3. See Friedrich Novalis, *Schriften*, ed. P. Kluckhohn and R. Samuel (Stuttgart: Kohlhammer, 1960), 2: 485–99 and 3: 507–24 (3rd ed., 1983). Henceforth cited as *SCH*, followed by the volume, page, and in some cases, between parentheses, the number of the fragment.

4. See for example Hans Wolfgang Kuhn, *Der Apokalyptiker und die Politik. Studien zur Staatsphilosophie des Novalis* (Freiburg-im-Breisgau: Rombach, 1961), 150.

5. See the exemplary study of the romantic theory of the symbol in Tzvetan Todorov, *Theories of the Symbol*, trans. Catherine Porter (Ithaca, NY: Cornell University Press, 1982), as well as the introductory texts in Philippe Lacoue-Labarthe and Jean-Luc Nancy, *The Literary Absolute: The Theory of Literature in German Romanticism*, trans. Philip Bernard and Cheryl Lester (Albany, NY: State University of New York Press, 1988). We must also mention the already old study by Walter Benjamin, *Der Begriff der Kunstkritik in der deutschen Romantik* (1920; rpt. Frankfurt-am-Main: Suhrkamp, 1973).

6. Rüdiger Bubner, "De quelques conditions devant être remplies par une esthétique moderne," in Rainer Rochlitz, ed., *Théories esthétiques après Adorno* (Paris: Actes Sud, 1990), 87: "The appearance of a reciprocal elucidation (of art and philosophy) is misleading, for the fundamental question of truth is secretly dominated by philosophy."

7. Friedrich Schlegel, *Kritische Ausgabe* (Paderborn: Schöningh, 1959 ff.), 3: 99. Henceforth cited as *KA*, followed by the volume, page, and when appropriate, the number of the fragment.

8. In 1829 Friedrich Schlegel gave a series of lectures under the title of "Philosophy of History." In them he develops a theological conception of history, centered on the fall of man and his movement toward salvation (see *KA* 9: 3–428). But as early as 1798 he had asserted in a fragment in *Athenaeum*: "The revolutionary desire to realize the kingdom of God is the springboard of progressive culture and the beginning of modern history. Anything unrelated to the kingdom of God plays only a secondary role" [*KA* 3: 201 (222)].

9. I refer here solely to the first formulations of Fichte's philosophy, that is,

essentially *Über den Begriff der Wissenschaftslehre* (1794) and *Grundlage der gesamten Wissenschaftslehre* (1794, 1795), which are the texts to which Novalis devotes most of his notes.

10. In fact, Fichte himself later distances himself from the Kantian critical perspective, as early as the *Bestimmung des Menschen* (written in 1798 and published in 1800), which reintroduces *being* as a term transcending knowledge, the latter being reduced to a simple knowledge of appearance. Here Fichte returns to the notion of the "thing in itself" in order to delimit the place of being, that is, he abandons the radical criticsm of his first writings. But the texts written in 1794 and 1795 are not yet really subject to this kind of ontological pressure, and it took the atheism debate to bring Fichte back to views more acceptable to an intellectual public that had meantime become largely hostile to the Enlightenment tradition.

11. *SCH* 2: 106 (3).

12. *SCH* 2: 143 (70, 71).

13. *SCH* 2: 157 (151).

14. *SCH* 2: 257 (490).

15. *SCH* 2: 257 (492).

16. *SCH* 2: 269–70 (566).

17. F. Hemsterhuis, *Alexis ou de l'âge d'Or*, in *Oeuvres philosophiques* (Paris, 1792), 2: 154.

18. *SCH* 2: 372 (32).

19. *SCH* 2: 390 (46).

20. *SCH* 2: 386 (44).

21. F. W. J. Schelling, *Philosophische Briefe über Dogmatismus und Kritizismus*, in *Schriften von 1794–1798* (Darmstadt: Wissenschaftsliche Buchgesellschaft, 1975), 199.

22. *SCH* 2: 417–18 (17).

23. *SCH* 2: 390 (45).

24. *SCH* 2: 386 (44). On the transformation of Kantian notion of practice into a notion of poïesis, see H. J. Mähl's introductory remarks in *SCH* 2: 337–39.

25. See *SCH* 3: 289 (275), 404 (710), 572 (121).

26. Quoted by H. J. Mähl, in *SCH* 2: 316.

27. See *KA* 2: 312.

28. *SCH* 3: 527 (17).

29. *SCH* 3: 396 (684).

30. *SCH* 3: 406 (717). In the same fragment Novalis calls this union of the poet and the philosopher the "Goethean thinker."

31. *SCH* 3: 563 (36).

32. See *SCH* 2: 524–25 (13).

33. *SCH* 3: 533 (32).

34. *SCH* 3: 276–77 (210).

35. See *KA* 18: 146 (280).

36. *SCH* 3: 88.

37. *SCH* 3: 685–86 (671).

38. *SCH* 3: 638 (502).

39. *SCH* 2: 650 (481).

40. *SCH* 3: 298 (327).

41. See *Critique of Pure Reason*, 144 (A 121), and above, 41.

42. *SCH* 3: 430 (826).

43. See *Critique of Pure Reason*, 144 (A 120).

44. *Ibid.*, 182 (A 140, B 180).

45. See Martin Heidegger, *Kant and the Problem of Metaphysics*, trans. James S. Churchill (Bloomington: Indiana University Press, 1962), § 35. I shall not enter into the controversial question of whether Kant suppressed these pages in the second edition of the *Critique of Pure Reason*.

46. Kant, *Critique of Pure Reason*, 186 (A 146, B 185).

47. See chapter 1, 50.

48. Immanuel Kant, *Anthropologie*, in *Werke in 10* Bänden, 10: 466, § 25.

49. The romantic theory of poetic language is in a way only one of the stages in the long history of mimological linguistic theories. See Gérard Genette, *Mimologics*, trans. Thaïs E. Morgan (Lincoln: University of Nebraska Press, 1995).

50. See Tzvetan Todorov, *Theories of the Symbol*, chap. 6. Todorov presents the whole spectrum of romantic and para-romantic positions, from Karl Philipp Moritz to Schelling by way of the Schlegel brothers, Novalis, Wackenroder, Goethe, Ast, et al., and his analysis brings out very clearly the fundamental affinity of all these authors beyond their individual differences.

51. Ibid., 146–64.

52. Panofsky, in his analysis of the importance of Plotinus's ideas in the Mannerist period, emphasizes the close connection between the theory of the symbolic function of art and hierarchical and spiritualist worldviews. In particular, he shows to what extent this conception is opposed to the ancient theory that beauty is defined by the equilibrium of proportions and the symmetry of the parts. He adds that it acknowledges as an implicit postulate that the Idea of Beauty that is found in the artist's mind is superior to its material realization in the art work—characteristics that we also find in romantic theory. See Erwin Panofsky, *Idea: A Concept in Art Theory*, trans. Joseph J. S. Peake (New York: Harper & Row, 1968), 55 ff.

53. Here are a few particularly striking definitions: "The true symbol is one in which the particular represents the universal, not as a dream or a shadow, but as a living and instantaneous revelation of what cannot be explored" [Goethe, *Maximen und Reflexionen*, no. 314, in *Sämtliche Werke* (Artemis Verlag/DTV, 1977), 9: 532]; "the beautiful is a symbolic representation of the infinite; for in this way it becomes at the same time clear how the infinite can appear in the finite. . . . How can the infinite be brought to the surface, to appearance? Only symbolically, in images and signs" (A. W. Schlegel, *Die Kunstlehre*, in *Vorlesungen über schöne Literatur und Kunst* [Stuttgart: Kohlhammer, 1963], 2: 81–82). If the underlying theory is fundamentally the same in all these authors, the terminology is sometimes puzzling: thus Goethe and Schelling, for instance, oppose symbol to allegory (the latter being a representation in which the singular signifies the universal without fusing with it), whereas Friedrich Schlegel uses the term "allegory" in place of the term "symbol": "All beauty is allegory. The most lofty is ineffable and can be expressed only through allegory" (*KA* 18: 4 (663). At the same time Schlegel rejects conventional allegory, which "limits itself to translating abstract concepts . . . into emblems" (*KA* 4: 23). Later on, Schopenhauer ends up completely confusing mat-

ters: while defining art as an intuitive realization of the Idea (and in this he comes back to the romantic definition of the artistic symbol), he rejects not only allegory (except in poetry) but even more the symbol, in which he sees no more than a conventional allegory. See Arthur Schopenhauer, *The World as Will and Idea*, trans. R. B. Haldane (London: Kegan Paul, 1896), 1: 305–37.

54. *SCH* 3: 123.

55. Sometimes this theory, which might seem to allow a symbolic interpretation of *any* figurative practice, is interpreted in a very restricted sense: thus Friedrich Schlegel, in his *Ansichten und Ideen einer christlichen Kunst*, maintains that only historical-allegorical paintings can claim the status of true works of art (see *KA* 4: 106–7). It goes without saying that this kind of reduction of the symbolic function to the historical genre is not in any way required if one defines the symbol as Novalis does here. It is nonetheless interesting to note that Novalis's practice of the novel also has a tendency to confine itself to an allegorical coding that is anything but discreet.

56. *SCH* 2: 562 (185). The paradoxical idea of a self-referential symbolism is already prefigured in Karl Philipp Moritz: "True beauty consists in the fact that a thing signifies nothing but itself, designates only itself, contains only itself, that it is a whole realized in itself" (quoted by Todorov, *Theories of the Symbol*, 161).

57. See for example *SCH* 2: 672–73; 3: 451 (953).

58. See Bubner, "De quelques conditions,," 87.

59. Pindar: "Prophesy (*manteueo*), Muse, and I will be your interpreter (*prophateuso*)," frag. 137, trans. D. A. Russell and M. Winterbottom, *Ancient Literary Criticism* (Oxford: Oxford University Press, 1972), 4. Democritus: "What a poet writes with enthusiasm (*enthousiasmos*) and divine inspiration (*pneuma*) is most beautiful," frag. 18, Diels/Krantz, *Fragmente der Vorsokratiker* (Berlin: Weidmannsche Verlagsbuchhandlung, 1960), 2: 146; translation taken from Kathleen Freeman, *Ancilla to the Pre-Socratic Philosophers: A Complete Translation of the Fragments in Diels* (Cambridge, MA: Harvard University Press, 1957), 97. The passages in Plato (in *Ion* and *Phaedo*) are too famous to be quoted here. Let us simply note that in the *Ion* Plato explicitly compares poetic inspiration to the delirium of the Korybantes and to the Bacchantes, and asserts that the divinity, having stolen away their spirits, makes them vaticinate and transforms them into soothsayers (*Ion*, 534). But this valorization of poets is very ambiguous, for it also allows Plato to deny them all *techne*, all art.

60. See P. Klopsch, *Einführung in die Dichtungslehren des lateinischen Mittelalters* (Darmstadt: Wissenschaftliche Buchgesellschaft, 1980), 20–36.

61. Plato, *Republic*, 484C:5-D:3.

62. Aristotle, *Poetics*, 51B:5–10. See also 51B:27–33.

63. *Ibid.*, 51B:27–29. There is a passage in book B of the Physics (II, 8 199A) in which Aristotle maintains that art has the power to achieve what nature by itself is incapable of realizing, but this thesis in no way endows art with a function of ontological revelation.

64. See Ernst R. Curtius, *European Literature and the Latin Middle Ages*, trans. Willard R. Trask (Princeton: Princeton University Press, 1967). It is true that one finds passages in ancient authors, particularly in certain Latin authors, that present the poet as founding reality: thus in Ovid, *Fastes* 6:21, the goddess

Juno calls the poet *vates, Romani conditor anni*. But all these passages can be interpreted within the framework of rhetorical conventions (brachylogy and *evidentia*), and it seems to me erroneous to see in them signs of the conception that poetry is a kind of ontological revelation as, in a vaguely Heideggerian perspective, Godo Lieberg does in *Poeta Creator* (Amsterdam: J. C. Gieben, 1982), 30.

65. Plato, *Republic* 10, 607B.

66. For all these details I have made use of E. R. Curtius, *European Literature*, and P. Klopsch, *Einführung in die Dichtungslehren*.

67. Curtius, *European Literature*, 215 ff. Elsewhere, Curtius notes that "The twelfth century Renaissance commonly equated poetry and philosophy (Baudri of Bourgueil, Walter of Chatillon). Natural science is accounted a part of philosophy. Lucan is praised for having dealt with 'philosophical questions' such as the nature of tides" (207).

68. Klopsch, *Einführung in die Dichtungslehren*, 88 ff.

69. "*Grammaticalia scis, sed naturalia nescis, nec logicalia scis.*" Reproduced by Klopsch, *Einführung in die Dichtungslehren*, 87–88.

70. Curtius (*European Literature*, 547 ff.) notes for example that the sacralization of poetic activity must also be situated in the tradition of discourses in praise of the arts and sciences, a topos that could also be applied to eloquence, agriculture, history, music, etc.

71. To avoid any misunderstanding, I propose to distinguish between literary history (the study of literature in a historical perspective) and the history of Literature, which is the romantic variant of the speculative theory of Art.

72. Thus Schelling: "History as a whole is a progressive, gradually self-disclosing revelation of the absolute" [*System of Transcendental Idealism*, trans. Peter Heath (Charlottesville: University of Virginia Press, 1978), 211].

73. See Paul Veyne, *Writing History: An Essay on Epistemology*, trans. Mina Moore-Rinvolucri (Middeltown, CT: Wesleyan University Press, 1968), 161–63, and 313 n. 19. On many points my remarks merely develop ideas defended by Veyne and earlier by Karl Popper.

74. See Karl R. Popper, *The Poverty of Historicism* (Boston: Beacon, 1957), and *The Open Society and Its Enemies* (London: Routledge, 1945). For a good presentation of the present state of the discussion, see Jürgen Habermas, *On the Logic of the Social Sciences*, trans. Shierry Weber Nicholson and Jerry A. Stark (Cambridge, MA: M.I.T. Press, 1988), 1–42.

75. See Ernst Cassirer, *Die Logik der Kulturwissenschaften* (Darmstadt: Wissenschaftliche Buchgesellschaft, 1984), 98.

76. This causality is transcendent even in the immanentist versions of historicism, for example in the Hegelian conception of history as the self-realization of absolute Spirit. Spirit is indeed realized in history, but behind men's backs (through the so-called "cunning of Reason"). In other words, if the dialectical "laws" are immanent in history, that does not prevent history as such from being transcendent with regard to factual empirical causality. In Hegel there are thus two kinds of history: conceptually determined evolution on one hand, and the multiplicity of empirical facts on the other.

77. By its evolutionary component, historicism differs, of course, from certain current determinist conceptions that seek "structural" historical laws that are sup-

posed to function as abstract models of repeatable historical facts. These conceptions need not be discussed here, since they are fundamentally different from historicism.

78. The fact that a scientific law may lead to the prediction of a particular event does not contradict Popper's notion that laws are always conditional and do not posit the existence of the facts to which they refer. If the sun exists, it will be extinguished in accord with the physical law involved, but the fact that it exists is not entailed by the law (even though at other times it may be linked).

79. J. G. Droysen, *Historik: Vorlesung über Enzyklopädie und Methodologie der Geschichte*, quoted in H. R. Jauss, "The History of Art and Pragmatic History," in Jauss, *Toward an Aesthetic of Reception*, trans. Timothy Bahti (Brighton, Sussex: Harvester Press, 1982).

80. See A. C. Danto, "Analytical Philosophy of History" (1965), rpt. in *Narration and Knowledge* (New York: Columbia University Press, 1984), 143–61.

81. See H. R. Jauss, *Toward an Aesthetic of Reception*, 220. For his part, Danto (*Narration and Knowledge*, 141) points out the inseparability of the *post hoc* from the *propter hoc* in testimonial narrative: "A narrative describes and explains at once." See also Paul Veyne's *Writing History*, which develops convincingly the essentially narrative character of historical discourse.

82. Whether the characters of the narrative are physical persons or on the contrary collective or abstract persons, the testimonial status of historical narrative remains, of course, unchanged. Even a nonscholarly testimonial account is governed by these distinctions. This does not mean that the construction of collective or abstract individuals does not pose specific problems. The more the metaphor of the individual is relied upon, the more crucial these problems become, as in the case of organicism.

83. I have presented my critique of historicism without referring to the postulate of human freedom because that would involve me in an endless debate. That said, I am persuaded that when we speak of historical causality, we must include therein the effects that flow from human deliberations.

84. J. Winckelmann, *Geschichte der Kunst des Altertums* (Darmstadt: Wissenschaftliche Buchgesellschaft, 1982), 9.

85. Hans Ullrich Gumbrecht, "History of Literature—Fragment of a Vanished Totality," *New Literary History* 16 (1985): 469.

86. *Poetics*, 47A: 8–9.

87. Ibid., 49A: 13 and 49A: 14–15. According to Aristotelianism, tragedy evolves toward its nature: once the latter is achieved, once the potentiality is realized, tragedy ceases to evolve.

88. See *Physics* II, 1, 192A: 18.

89. I have offered a more detailed analysis of the Aristotelian conception of poetry in *Qu'est-ce qu'un genre littéraire?* (Paris: Seuil, 1989), 10–25.

90. And inversely, Novalis points out, nature is Art: "Nature possesses an artistic instinct—the distinction between nature and art is therefore only empty talk." *SCH* 3: 650 (554).

91. The criticism of abstract philosophical determinations is omnipresent in all the thinkers I shall have occasion to analyze here. Thus according to Hegel abstract definitional determination is the least essential determination; Nietzsche, as we

know, never ceases to oppose the complexity of life to philosophical ratiocination; while Heidegger emphasizes that conceptual determinations cannot grasp the essence of the work of art.

92. Quoted by Claus Uhlig in "Literature as Textual Palingenesis: On Some Principles of Literary History," *NLH* 16 (1985): 492.

93. For the preceding quotations, see *KA* 9: 6–7, 8, 10, 14.

94. Ibid., 9.

95. Ibid.

96. Ibid.

97. On this crisis, see the closing pages of Ernst Behler, "Friedrich Schlegel's Theorie der Universalpoesie," *Jahrbuch der deutschen Schillergesellschaft* 1 (1957): 211–52, rpt. in *Friedrich Schlegel und die Kunsttheorie seiner Zeit* (Darmstadt: Wissenschaftlich Buchgesellschaft, 1985), 194–253.

98. See *KA* 6.

99. In his introduction to Schlegel's text (*KA* 6: xi–l), H. Eichner stresses the fact that this is the first example of a history of literature in the modern sense of the term, essentially by virtue of the fact that it takes into account the evolutionary dimension of literature. In reality, what is involved is not a simple taking into account of the evolutionary perspective, but rather an evolutionary doctrine, in the form of an organicist historicism. In my opinion, the truly positive aspects of the history of Literature are situated rather in the extension of philological rigor to texts other than ancient ones, in the interest shown in noncanonical literary traditions (for example, in the works of Camoëns, or in the poetry of the troubadours rediscovered by Friedrich Schlegel several years before the publication of Raynouard's famous anthology), as well as in the attempt to situate and understand each literary tradition within its own historical horizon. These advances were facilitated by historicist ideology; but it nonetheless seems necessary to distinguish between the two phenomena.

100. Quoted by Eichner in the introduction to *KA* 6: vi.

101. *KA* 1: 3.

102. *KA* 1: 274.

103. *KA* 2: 290.

104. *KA* 1: 398 (emphasis supplied).

105. Kant, *Werke* 9: 33–50.

106. "Was heisst und zu welchem Ende studiert man Universalgeschichte?" Schiller, *Werke* 2: 20–21.

107. *KA* 1: 626–27.

108. *KA* 1: 629 (emphasis supplied).

109. *KA* 1: 630–31.

110. Walter Benjamin, *Der Begriff der Kunstkritik in der deutschen Romantik* (Frankfurt-am-Main: Suhrkamp, 1973), 47.

111. *KA* 2: 410.

112. *KA* 2: 411.

113. The process of selecting works according to their pertinence in the overall organism of Literature is repeated in the generic subdivisions. There, too, the historicist approach to literature limits generic evolution to a collection of canonical works expressing the essence of a given genre. Canonical literary works thus grad-

ually become the historical representatives of their generic definitions. This is quite clear in Gustave Lanson, who, speaking of the epic songs of medieval France, lets the cat out of the bag: "The (epic) cycles are in large part factitious: literary criticism should destroy frameworks in which swarming mediocrity conceals the masterpieces. When everything was to be exhumed, everything had to be examined; but today the goal must be to let nine-tenths of the epic songs gently sink back into the beneficent oblivion that has received nine-tenths of the tragedies. Everything tedious and extravagant must perish once again: what deserves to live on will be all the more free to do so, and the *Song of Roland*, two or three other poems, a dozen episodes discreetly detached from a hundred poems or so will only gain when they alone represent French epic, and French epic will gain even more." *Histoire de la littérature française*, 14th ed. (Paris: Hachette, 1920), 45. In Lanson, literary history is not so much knowledge of literary facts as a monument of the national literary past, just as in Schlegel the history of Literature is the monument of humanity's literary past.

114. *KA* 18: sect. 3, 477.

115. *KA* 2: 140–41.

116. *KA* 2: 414.

117. *KA* 11: 6.

118. *KA* 2: 327. However, in his *Geschichte der europäischen Literatur*, Schlegel asserts that contrary to the epic or dramatic poem, the lyric poem does not possess organic unity: "This completely fragmentary form, deeply based on its essence, this complete absence of totality, is a characteristic sign of lyric poetry. The unity that prevails in it is homogeneity—to be compared to the unity of metals. It is the unity of tone" (*KA* 9: 63). Schlegel is an exceptional critic, and he is well aware of an important difference in structure between narrative and dramatic poetry on one hand, and lyric poetry on the other. But this difference is not one between organic structuration and unity of tone: it has to do rather with the fact that narrative and dramatic poetry is mimetic, which is not the case with expressive lyric poetry (the only kind Schlegel considers properly lyrical). See Käte Hamburger, *The Logic of Literature*, trans. Marilynn J. Rose (Bloomington: Indiana University Press, 1973).

119. See Michel Charles, *L'Arbre et la source* (Paris: Seuil, 1985), 102–6. Charles contrasts the contextual organization of memory, like that of a material library, with the linguistic, intertextual, and pragmatic organization of memory, which is like that of the imaginary library of rhetoric.

120. *KA* 3: 7. Considering that philosophy is the *organon* of poetry, Schlegel reverses an assertion made by Schelling, who had said in his *System of Transcendental Idealism* (1801) that art was "the only true and eternal organ and document of philosophy" (231). This contrast is a fine example of Hegel's "old quarrel" with romanticism.

121. *KA* 2: 373.

122. Conclusion to the essay on Lessing, *KA* 2: 410.

123. See *KA* 2: 413. The opposition between *Tendenz* and *Absicht* is already found in fragment 239 of the *Athenaeum*: "The love Alexandrian and Roman poets had for dry and not very poetic subjects is nevertheless based on this great thought:

everything must be poeticized; not at all as an intention on the part of the artist, but as a historical tendency of the works" (*KA* 2: 205).

124. *Ideen*, no. 95 (*KA* 2: 265). Similarly in the "Dialogue on Poetry": "All the poems of antiquity are connected with each other, grow organically, and ultimately form a whole. Everything is closely related and everywhere one and the same spirit reigns, differing only in its expression. Thus it is not to indulge in a hollow image to say that ancient poetry is a single, indivisible, and accomplished poem" (*KA* 2: 313).

125. Ibid. (my emphasis).

126. *KA* II: 5.

127. *KA* 2: 410–11.

128. *KA* I: 231.

129. Ibid., 228.

130. See ibid., 232.

131. See *KA* 9: 155.

132. See Peter Uwe Hohendahl, ed., *Geschichte der deutschen Literaturkritik* (Stuttgart: Metzler, 1985), esp. 19 and 132.

133. Figures given by Wolf Lepenies, *Das Ende der Naturgeschichte* (Munich: Hanser, 1976), 23.

134. Hohendahl, *Geschichte*, 81.

135. From the point of view of the capital invested, book publication constituted one of the most important industrial activities in Germany during the second half of the eighteenth century.

136. Thus Cyprian in the *Epistula ad Donatum*: "Turn your eyes from these [i.e., from the gladiatorial games Cyprian has just condemned] toward the no less deplorable result produced by a quite different spectacle. In theaters as well what you shall see will cause you pain and shame. The tragic buskin causes ancient crimes to file past in poetry. The ancient horror with regard to parricide and incest is repeated in a truthful action, so that through the centuries what was committed in the past might not cease to be committed. The audience of each age is thus reminded that what has already happened can still happen (*fieri posse quod factum est*)" (reproduced in Lieberg, *Poeta Creator*, 145).

137. See H. R. Jauss, "Schlegel und Schiller's Replik auf die 'Querelle des Anciens et des Modernes,'" in *Literaturgeschichte als Provokation der Literaturwissenschaft*, 67–106.

138. See for example the preface (1797) to *Die Griechen und Römer* (in which Schlegel also adopts the Schillerian term "sentimental"): "The characteristic elements of sentimental poetry are the interest it takes in the realization of the Ideal, the reflection on the relationship between the Ideal and reality, as well as its relationship to an individual object of the idealizing imagination on the part of the poetic subject" (*KA* I: 211).

139. Ibid., 255.

140. Ibid., 253.

141. Schiller, "Naïve and Sentimental Poetry," in *Naïve and Sentimental Poetry and On the Sublime: Two Essays*, trans. Julius A. Elias (New York: Ungar, 1967), 154.

142. Ibid., 156.

143. The idea is not entirely absent in Schiller's work, since in his *Letters on Aesthetic Education* he distinguishes three moments (*drei Momente*) in the evolution of humanity: the physical moment, the aesthetic moment, and the moral moment. However, the last two are not real historical moments, but only Ideas: neither beauty (the aesthetic moment) nor the good (the moral moment) can ever be embodied in reality. This separation, Kantian in inspiration, between the phenomenal and the noumenal, is opposed to the development of a historical dialectic, whatever the ambiguity of some of Schiller's statements.

144. *KA* 1: 214.

145. See "Herders Humanitätsbriefe," *KA* 2: 49.

146. Schiller, *Werke*, 2: 554 (emphasis supplied).

147. See ibid., 558.

148. *KA* 1: 273.

149. See Schiller, *Werke*, 2: 514.

150. *KA* 1: 207.

151. Ibid., 219.

152. Ibid., 224 (emphasis supplied).

153. *KA* 18: sect. 5, 421.

154. Ibid., 7: 72.

155. Gérard Genette's *Introduction to the Architext*, trans. Jane E. Lewin (Berkeley: University of California Press, 1992), reformulates the debate.

156. Thus *KA* 18: sect. 4, 439. "Epic = chemical; lyric poetry = mechanical; drama = organic. Ancient poetry begins in the middle"; or again, 4: 500, where a four-part analogy is proposed: "Epic = Ideal; lyric poetry = elementary; tragedy = systematic; comedy = absolute: an abstract four-part analogy."

157. *KA* 11: 12.

158. *KA* 2: 305.

159. Ibid., 305 and 306.

160. *KA* 3: 58.

161. *KA* 11: 83.

162. *SCH* 2: 589–90.

163. See *KA* 1: 5–15.

164. *KA* 11: 30–31.

165. *KA* 2: 291 (emphasis supplied).

166. Ibid., 154.

167. *KA* 16: 134 (5: 587).

168. *KA* 1: 308.

169. *KA* 2; 158 (*Lyceum-Fragment* 91).

170. Introduction to *KA* 4: xiii.

171. Only in part, because from the *Studium-Aufsatz* on, Schlegel had defined modern poetry by its subordination to designs provided by the understanding, that is, by a gnoseological dimension. He called this art *darstellende Kunst*, "presentative art," and opposed it to the art of the beautiful (see *KA* 1: 242–43).

172. *KA* 16: 85 (5: 5).

173. Ibid., 84 (5: 24).

174. *KA* 2; 252 (*Athenaeum-Fragment* 434).

1. As previously mentioned, I quote here T. M. Knox's translation (*AES*).
2. Friedrich Wilhelm Joseph Schelling, *System of Transcendental Idealism*, trans. Peter Heath (Charlottesville: University Press of Virginia, 1978), 230.
3. Ibid., 231.
4. F.W.J. Schelling, *Schriften* 1799–1801 (Darmstadt: Wissenschaftliche Buchgesellschaft, 1975), 627
5. See Dieter Jähnig, *Schelling. Die Kunst in der Philosophie* (Pfullingen: Neske, 1966) 1: 9–19.
6. *Schriften 1799–1801*, 629.
7. F.W.J. Schelling, *The Philosophy of Art*, trans. Douglas W. Scott (Minneapolis: University of Minnesota Press, 1989), 11.
8. Ibid., 14.
9. Ibid., 16.
10. Ibid.
11. Ibid., 32.
12. For a discussion of the place of art in Schelling's philosophy, see Jähnig, *Schelling*, esp. vol. 2, *Die Warheitsfunktion der Kunst.* For a general discussion of Schelling's philosophy, see Jean-François Marquet, *Liberté et existence. Étude sur la fonction de la philosophie de Schelling* (Paris: Gallimard, 1973).
13. We know that in Schelling, for example, the historical dimension is merely secondary, not only in the period of the philosophy of identity but also in that of transcendental philosophy. Thus in the *Philosophy of Art* the temporal oppositions are simply formal (16) and thus do not have the same status as the distinctions among the different arts. It is only from about 1809 on (that is, from *Über das Wesen der menschlichen Freiheit*) that he reintroduces the historical dimension as a philosophical-theological category, but he is no longer very interested in art: that is not surprising, since for him history is not, as in Hegel, the self-realization of Reason but just as much its degradation (by Evil). As for Solger, even though he asserts that "the Idea is always embodied in a historical form" (*Vorlesungen über Ästhetik*, 1819; rpt. Darmstadt: Wissenschaftliche Buchgesellschaft, 1973, 120), his systematic deduction of Art makes hardly any reference to the historical dimension.
14. See G.W.F. Hegel, *Enzyklopädie der philosophischen Wissenschaften im Grundriss* (1830 edition) (Hamburg: Felix Meiner, 1969), § 556. See also Rüdiger Bubner's commentaries, "Hegel's Aesthetics: Yesterday and Today," in *Art and Logic in Hegel's Philosophy* (Sussex: Harvester Press, 1980), especially 31: "For Hegel, only what can be translated into an authentic philosophical idea . . . can become a subject of aesthetics."
15. It goes without saying that Hegel uses the notion "symbol" in a sense different from the one given it by romanticism or by Goethe. For Goethe, for example, the symbol is precisely the embodiment of the spiritual in the sensuous, their intimate symbiosis, whereas the Hegelian symbol implies that the sensuous signifier and its spiritual signified are exterior to each other, that it corresponds to what the romantic tradition called allegory. The opposition between Hegel and his predecessors is thus essentially terminological.

16. *Enzyklopädie*, § 131.

17. The determining role played by artistic consciousness in Beauty's sublation of sensuous reality explains why natural beauty can play only a minor role in Hegel. The beauties of nature are not conscious products of spirituality, and thus only very deficient embodiments of Spirit. Therefore "everything spiritual is better than any product of nature" (*AES* 1: 29).

18. See *AES* 1: 40.

19. *AES* 1: 9.

20. *AES* 1: 20–21.

21. The Divine in its universality is *bildlos*, imageless (see *AES* 1: 175).

22. *AES* 1: 174–279.

23. "Das endliche Dasein," *AES* 1; 230.

24. *AES* 1: 205, 219.

25. *AES* 1: 219.

26. Ibid.

27. *AES* 1: 232.

28. *AES* 1: 9.

29. *Enzyklopädie*, Introduction, § 3.

30. Hegel, *Der Geist des Christentums*, in *Theorie Werkausgabe*, 1, *Frühe Schriften* (Frankfurt-am-Main: Suhrkamp, 1971): 288: "die Wahrheit ist die Schönheit."

31. On Hegel's early writings, see Jacques Taminiaux, "La Pensée esthétique du jeune Hegel," *Revue philosophique de Louvain* 56 (1958): 222–50, and Robert Legros, *Le Jeune Hegel et la naissance de la pensée romantique* (Brussels: Ousia, 1980).

32. *Phänomenologie des Geistes*, ed. Hoffmeister (Hamburg: Meiner, 1952), 473–520. See also Jean Hyppolite, *Genèse et structure de la Phénoménologie de l'esprit de Hegel* (Paris: Aubier, 1946), 521.

33. Hegel, *Phänomenologie*, 485.

34. Ibid., 523.

35. "Fragment de système de 1800," in Hegel, *Werke* 1: 422–23.

36. There are three editions of the abridged *Enzyklopädie* (1817, 1827, and 1830), edited by Hegel himself, each containing important revisions that do not, however, concern the question of the relationships among Art, religion, and philosophy. The edition usually reprinted is the third one, but the 1817 edition is reproduced photomechanically in Glockner's *Jubiläumsausgabe* of Hegel's works (1927 ff.). I always cite the 1830 edition.

37. *Enzyklopädie*, § 562.

38. See *Enzyklopädie*, § 554: "Absolute Spirit is both an identity that is eternally in itself and an identity that returns and is returned to itself . . . *Religion— that is, the way in which one may designate this supreme domain as a whole— must be considered*, as not only emanating from the subject and being in it but also as emanating objectively from absolute Spirit, which, *qua* Spirit, is in the communion" (emphasis supplied).

39. G.W.F. Hegel, *Introduction to the Lectures on the History of Philosophy*, trans. T. M. Knox and A. V. Miller (Oxford: Clarendon, 1985), 22.

40. *AES* 1: 8.

41. Israel Knox notes in this regard that the thesis that Art has come to an end is directly connected with the speculative function Hegel accords it: "art is merely the sensuous expression of the Idea—its first expression. Therein lies its glory and therein lies its tragedy. If its concern were not the same as that of philosophy—the Absolute, truth—if it dealt with some inferior realm of being and knowledge, it could be spared, it would have a permanent function to fulfill. But since its function is metaphysical, its historico-cultural role has been accomplished." *The Aesthetic Theories of Kant, Hegel, and Schopenhauer* (rpt., New York: Humanities Press, 1978), 97–98.

42. "Unmittelbarer Genuß." *AES* 1: 11.

43. Ibid.

44. Ibid.

45. Ibid.

46. *AES* 1: 63.

47. *AES* 1: 25.

48. *Enzyklopädie*, § 562.

49. This difficulty had already been encountered by Kant (see above, chap. 1, n. 40). Only the irrationalists Schopenhauer and Nietzsche have a positive attitude toward this art that resists any representational translation.

50. *AES* 3: 627.

51. Ibid.

52. Sometimes described as "nur historisch" ("solely historical"). See for example *AES* 2: 708.

53. *AES* 3: 780.

54. Ibid. (emphasis supplied).

55. *AES* 3: 799.

56. *AES* 3: 800 (emphasis supplied).

57. *AES* 3: 799.

58. Ibid.

59. One might think music is the most interior art, since, realizing itself in abstract pure temporality, it coincides with the (abstract) essence of subjectivity (of consciousness), Time. But compared with poetry, the interiority of music lacks concrete determinations. For more details concerning Hegel's conception of music, see below, 169–71

60. See *AES* 1: 378–426. In addition to conscious symbolism and unconscious symbolism, Hegel also acknowledges the existence of a symbolism of the sublime, represented essentially by pantheism and mysticism (Christian, Indian, or Islamic), as well as by the Hebrew religion. It is characterized either by the disappearance of sensuous particularities into the Absolute (for example in Indian pantheism) or by the exaltation of the Absolute and the annihilation of the finite world (Hebrew poetry).

61. We must add that not only is the pyramid incapable of presenting the interiority that inhabits it, but even this interiority itself is not that of the living soul, but rather that of death. See *Phänomenologie*, 486, and *AES* 1: 356.

62. Thus the colossi erected by Memnon of Amenophis III near Thebes are "motionless, the arms glued to the body, the feet firmly fixed together, numb, stiff, and lifeless" (*AES* 2: 358).

63. *AES* 2: 505.

64. *AES* 2: 528.

65. Hegel sees an indication of this transformation within art itself: the sculpted and painted representations of Christ are made without any regard for beauty, and do not recoil before even the ugliness of a painful crucifixion. That is because the spiritual content has been detached from the sensuous figure, which becomes perfectly indifferent.

66. See *AES* 3, The System of the Arts, Section 3: the Romantic Arts; chap. 1: Painting; chap. 2: Music; chap. 3: Poetry.

67. *AES* 3: 960.

68. *AES* 3: 966–67..

69. *AES* 1: 82.

70. Ibid.

71. See for example *AES* 1: 73, 3: 613–14.

72. See *AES* 1: 73.

73. Stephen Bungay, *Beauty and Truth: A Study of Hegel's Aesthetics* (Oxford: Oxford University Press, 1984), 53–54.

74. We know that Hegel's attitude toward humor, a category he considered typically romantic, was ambivalent. However, his conception of comedy as the self-dissolution of art (*qua* substantial representation) owes much to this category. The two authors connected with objective idealism that most exploited the category of humor were Solger (*Vorlesungen über Ästhetik*), and later on, Karl Rosenkranz, *Ästhetik des Hässlichen* (1853; rpt. Darmstadt: Wissenschaftliche Buchgesellschaft, 1973). Rosenkranz is the sole author of this period (so far as I know) who sets out from the fact that to the extent that aesthetic categories refer to values, negative determinations are just as much part of them as are positive determinations. Implicitly, this obviously means that Art cannot be defined by the category of beauty.

75. *AES* 3: 621.

76. See Paul O. Kristeller, "The Modern System of the Arts," *Journal of the History of Ideas* 12 (1951): 496–527, and 13 (1952): 17–46.

77. Here some qualification is necessary. We have seen that in the *Phänomenologie* dance still had canonical status: it was at the center of one of the three fundamental categories of the work of art, that of the living work of art (a category that no longer exists in the *Ästhetik*).

78. The correspondence Hegel establishes between the arts and the forms of art had already been criticized very early on, notably by Christian Hermann Weisse, in a review of the *Ästhetik* in *Hallische Jahrbücher für Wissenschaft und Kritik*, 1–7 September 1838, 1695. He thinks that the correspondence between the two orders of facts is inconsistent (*haltlos*) and arbitrary (*willkürlich*). See Bungay, *Beauty and Truth*, 55.

79. *AES* 3: 967.

80. *AES* 3: 614.

81. *AES* 2: 631.

82. *AES* 3: 1045.

83. *AES* 3: 892–93.

84. *AES* 3: 892.

85. *AES* 3: 896.

86. *AES* 3: 902.

87. The fact that Hegel, contrary to the requirements of his system, is led to deny music any content, shows that his systematic orientation does not blind him to reality, at least if Stravinsky is right in saying: "I consider music, in its essence, to be powerless to express anything at all: a feeling, an attitude, a psychological state, a natural phenomenon." [quoted by Françoise Escal, *Contrepoints. Musique et littérature* (Paris: Méridiens Klincksieck, 1990), 16.]. Stravinsky's statement is no doubt peremptory, but music is clearly not a hermeneutic system in the sense in which Hegel conceives it. For a subtle and learned discussion of the relationships between music and signification, see Françoise Escal, *Contrepoints*, esp. 105 ff. Escal shows in particular that Stravinsky's thesis must be qualified in light of undeniable expressive connotations (historically more or less stable) produced by the cultural context of musical practice.

88. *AES* 2: 636.

89. *AES* 2: 660.

90. *AES* 2: 656.

91. *AES* 2: 657.

92. *AES* 3: 968.

93. *AES* 3: 964.

94. *AES* 3: 968.

95. *AES* 3: 966–67.

96. *AES* 3: 964.

97. Ibid.

98. Ibid.

99. *AES* 3: 965.

100. *AES* 3: 964.

101. *AES* 3: 968.

102. *AES* 3: 960.

103. *AES* 3: 1037.

104. *AES* 3: 1158.

105. See *AES* 2: 622–23.

106. I have discussed Hegel's theory of genres in *Qu'est-ce qu'un genre littéraire?*, 36–47. Here I shall limit myself to a succinct summary of its basic problems.

107. *AES* 3: 1037.

108. *AES* 3: 1044–45.

109. See *AES* 3: 155–56.

110. See G. Genette, *Mimologics*, 36–41.

111. In the French translation of the *Ästhetik* the single term *drame* is used to designate, depending on the context, dramatic poetry and the subgenre of drama.

112. Like many Hegelian ideas concerning the evolution of the arts, this thesis is also one of the commonplaces of his time, and it is already found in particular in Schelling, *Philosophie der Kunst*, 364, and Solger, *Vorlesungen über Ästhetik*, 176.

113. See *AES* 3: 1202–4.

CHAPTER FOUR
ECSTATIC VISION OR COSMIC FICTION?

1. See Jörg Salaquarda, "Schopenhauers Einfluß auf Nietzsches 'Antichrist,'" in *Schopenhauer*, ed. J. Salaquarda (Darmstadt: Wissenschaftliche Buchgesellschaft, 1985). Heidegger maintains on the contrary that Nietzsche's mature writings are basically independent of Schopenhauer, perhaps because the latter is one of the ancestors that he refuses to acknowledge. See Martin Heidegger, *Nietzsche*, trans. David F. Krell, 4 vols. (San Francisco: Harper and Row, 1979–87), vol. 1, *passim*.

2. See Arnold Gehlen, "Die Resultate Schopenhauers," in *Theorie der Willensfreiheit und frühe philosophische Schriften* (Neuwied and Berlin: Luchterhand, 1965), 312–38.

3. Arthur Schopenhauer, *The World as Will and Idea*, trans. R. B. Haldane, (London: Kegan Paul, 1896), 3: 224–25. Henceforth cited as *WWV*.

4. *WWV* 3: 223.

5. *WWV* 3: 225.

6. Friedrich Nietzsche, "On the Uses and Disadvantages of History for Life," *Untimely Meditations*, trans. R. J. Hollingdale (Cambridge: Cambridge University Press, 1983), 113.

7. Ibid., 120.

8. Ibid., 61.

9. Ibid., 110.

10. According to Martin Seel, *Die Kunst der Entzweiung* (Frankfurt-am-Main: Suhrkamp, 1985), 47, the aesthetic theories issuing from romanticism tend to oppose art to reason, either through a positive exaggeration (art is the ultimate fulfillment of reason) or by a privative exaggeration (art escapes reason). Schopenhauer's attitude falls into the second category. I would add that when art escapes reason, that is still a way of transcending it.

11. Quoted by A. Philonenko, *Schopenhauer* (Paris: Vrin, 1980), 115.

12. *WWV* 3: 141.

13. *WWV* 3: 468..

14. *WWV* 1: 46 .

15. *WWV* 1: 72.

16. *WWV* 1: 75.

17. Quoted by Philonenko, *Schopenhauer*, 177.

18. *WWV* 1: 199.

19. *WWV* 1: 230.

20. See *WWV* 1: 35–36.

21. *WWV* 1: 231.

22. *WWV* 1: 226.

23. *WWV* 1: 220.

24. *WWV* 1: 252.

25. *WWV* 3: 123.

26. On this point I disagree with Clément Rosset, *L'Esthétique de Schopenhauer* (Paris: Presses Universitaires de France, 1969), who identifies will and the world, that is, who conflates the categories of the will in itself, of the ideas and of

the phenomenal world in order to postulate a "shadowy precursor," an X anterior to the will, the ultimate essence of being. Rosset's solution makes it possible to resolve certain inconsistencies in *The World as Will and Idea*, but it makes Schopenhauer say the opposite of what he actually says.

27. See J. S. Clegg, "Logical Mysticism and the Cultural Setting of Wittgenstein's *Tractatus*," *Schopenhauer Jahrbuch* 59 (1978): 29–47.

28. *WWV* 1: 235.

29. *WWV* 1: 239.

30. *WWV* 1: 240.

31. *WWV* 3: 138.

32. *WWV* 3: 178.

33. See *WWV* 1: 272–73.

34. *WWV* 1: 273.

35. *WWV* 1: 272.

36. See *WWV* 1: 278–79.

37. *WWV* 1: 272.

38. See *WWV* 3: 142–43.

39. See *WWV* 1: 313.

40. *WWV* 1: 330.

41. Ibid.

42. *WWV* 1: 331.

43. *WWV* 1: 332.

44. Clément Rosset, *L'Esthétique de Schopenhauer*, whose close analysis clearly shows the paradoxical character of music in Schopenhauer's work, proposes—as we have seen—to relate it not to the will but to something "before" the will, to a "shadowy precursor." But Schopenhauer does not acknowledge anything beyond the will; he explicitly asserts that the status of music parallels that of the Ideas.

45. *WWV* 1: 333; emphasis supplied.

46. *WWV* 3: 242.

47. *WWV* 1: 339.

48. See Ulrich Pothast, *Die Eigentliche Metaphysische Tätigkeit. Über Schopenhauers Ästhetik und ihre Anwendung durch Samuel Beckett* (Frankfurt-am-Main: Suhrkamp, 1982), 101–3.

49. *WWV* 1: 333; emphasis supplied.

50. *WWV* 1: 339.

51. *WWV* 1: 333. It is in order to avoid these contradictions that Rosset (*L'Esthétique de Schopenhauer*) proposes to relate music to something beyond the will.

52. See *WWV* 1: 231, where knowledge of the Ideas is said to have as its object solely "the *what*" (*einzig und allein das Was*).

53. *WWV* 3: 176.

54. *WWV* 3: 177.

55. *WWV* 3: 177–78.

56. *WWV* 3: 121.

57. *WWV* 3: 176.

58. *WWV* 3: 212–13.

59. *WWV* 3: 214.

60. *WWV* 3: 215.

61. *WWV* 3: 189.

62. Ibid.

63. *WWV* 3: 193.

64. *WWV* 3: 209–10.

65. *WWV* 1: 326.

66. *WWV* 1: 346.

67. *WWV* 3: 243.

68. Ibid.

69. See Rosset, *L'Esthétique de Schopenhauer*, 110–17 for considerations leading in the same direction.

70. *The Birth of Tragedy*, trans. Walter Kaufmann (1967; rpt., New York: Vintage, n.d.), 141.

71. Karl Jaspers, *Nietzsche: Einführung in das Verständnis seines Philosophierens* (Berlin and Leipzig: Walter de Gruyter, 1936), "Einleitung."

72. This is one of Rüdiger S. Grimm's central theses in *Nietzsche's Theory of Knowledge* (Berlin and New York: Walter de Gruyter, 1977).

73. See Jean Granier, *Le Problème de la vérité dans la philosophie de Nietzsche* (Paris: Seuil, 1966).

74. Grimm, *Nietzsche's Theory of Knowledge*, 46: "There are only interpretations, and this proposition itself is an interpretation."

75. See Eugen Fink, *Nietzsches Philosophie* (Stuttgart: Kohlhammer, 1968).

76. See Karl Joël, *Nietzsche und die Romantik* (Jena and Leipzig: Eugen Diedrich, 1905).

77. "Richard Wagner in Bayreuth," in *Untimely Meditations*, trans. R. J. Hollingdale (Cambridge: Cambridge University Press, 1983), 199.

78. Ibid., 212.

79. Ibid., 209–10.

80. Ibid., 208.

81. Ibid., 214–15.

82. See Joël, *Nietzsche und die Romantik*, 36–37.

83. Ibid., 147.

84. Ibid., 131.

85. E. Fink, *Nietzsches Philosophie*.

86. *The Birth of Tragedy*, 99.

87. Ibid., 37.

88. Ibid.

89. Ibid., 38.

90. Ibid., 49.

91. Ibid., 31.

93. Ibid., 49.

94. Ibid., 50.

95. Ibid., 93.

96. Ibid., 74.

97. Ibid., 70.

98. Ibid., 129.

99. Ibid., 127.

100. The first edition dates from 1872. When he republished the book in 1884, Nietzsche changed the title: *The Birth of Tragedy, Or Hellenism and Pessimism*. As for the original title—if I am correctly interpreting the silence on this subject maintained by the editors of the critical edition—it seems to have been kept but placed after the "Attempt at a Self-criticism" with which Nietzsche makes this new edition begin. At least it is in that form that the titulary apparatus of *The Birth of Tragedy* appears in the critical edition.

101. *Birth of Tragedy*, 130.

102. Ibid., 131.

103. Ibid., 126.

104. Ibid., 127.

105. Ibid., 118.

106. Ibid., 104.

107. Ibid., 127.

108. Ibid., 128.

109. Ibid., 104.

110. Ibid., 143.

111. Ibid., 97.

112. Ibid., 109–10.

113. *Human, All Too Human*, 1, § 4.

114. Ibid. 1, § 10.

115. Ibid., 1, § 29.

116. Ibid., 1, § 215.

117. Ibid., 1, Preface, § 3.

118. Ibid., 1, § 29.

119. Ibid., 1 (2), § 16. See also *Daybreak*, § 44: "*The more insight we possess into an origin the less significant does the origin appear: while what is nearest to us*, what is around us and in us, gradually begins to display colors and beauties and enigmas and riches of significance of which earlier mankind had not an inkling."

120. Ibid., 1, § 2.

121. *The Gay Science*, § 99. In this aphorism, Nietzsche maintains that Germans, and Wagner in particular, have noted only "Schopenhauer's mystical embarrassments and subterfuges," notably his theory of aesthetic intuition.

122. *Human, All Too Human*, 1, § 222.

123. Ibid., 1, § 131.

124. Ibid., 1, § 146.

125. See E. Fink, *Nietzsches Philosophie*.

126. *Human, All Too Human*, 1, § 131.

127. *The Gay Science*, § 110.

128. See *Human, All Too Human*, 1, § 34.

129. *The Gay Science*, § 110.

130. *Human, All Too Human*, 1, § 145.

131. Ibid., 1, § 151.

132. *The Gay Science*, § 299. See also *Human, All Too Human*, § 148.

133. *The Gay Science*, § 107.

134. *Human, All Too Human*, 1, § 222.

135. See ibid., 1, § 159.

136. Ibid., 1, § 150.

137. Ibid., 1, § 220.

138. See ibid., 1, § 219.

139. Ibid., 1, § 223. See also ibid., 1, § 234, where—echoing Hegel and Plato—he maintains that in a perfect state art could only disappear.

140. E. Fink, *Nietzsches Philosophie*.

141. *Human, All Too Human*, 1, § 164.

142. See ibid., 1, § 162.

143. See ibid., 1, § 163.

144. Ibid., 1, § 155.

145. Ibid., 1, § 171.

146. Ibid., 1, § 159.

147. Ibid., 1, § 147.

148. *The Gay Science*, § 344.

149. See ibid.

150. See Grimm, *Nietzsche's Theory of Knowledge*, 43–65; Arthur C. Danto, *Nietzsche as Philosopher* (New York: Columbia University Press, 1980), 98–99.

151. Friedrich Nietzsche, *Sämtliche Werke, Studien Ausgabe* (Munich: DTV, 1980) 12: 7 (60).

152. *SW* 11, 34 (253).

153. Quoted by Grimm, *Nietzsche's Theory of Knowledge*, 18.

154. For this distinction between *Wahrheit* and *Wahrhaftigkeit*, see especially *SW* 12: 8 (1).

155. Thus I endorse the position expressed by Fink, for example (*Nietzsches Philosophie*) rather than that defended by Grimm (*Nietzsche's Theory of Knowledge*).

156. *SW* 13, 10 (24).

157. *SW* 14, 6.

158. *SW* 13, 11 (415).

159. *SW* 13, 10 (194).

160. *SW* 12, 2 (114). See also Nietzsche's *On the Genealogy of Morals*, trans. Walter Kaufmann (New York: Vintage, 1967). This opposition between the two forms of art refers to the distinction between affirmation and resentment as well as to that between the active and the reactive life. On this subject, see Gilles Deleuze, *Nietzsche and Philosophy*, trans. Hugh Tomlinson (New York: Columbia University Press, 1983).

161. *SW*, 12, 2 (114).

162. *SW* 10, 25 (438).

163. *SW* 12, 2 (66).

164. *SW* 12, 2 (57).

165. The historical fate of this project of aestheticizing life is well known: it was to be one of the central pivots of modernist movements from 1900 to 1933.

166. *SW* 10, 25 (470).

167. Ibid.

168. *SW* 13, 9 (91). On this ontological function of art within the framework of the theory of the will to power, see Heidegger, *Nietzsche*.

169. *SW* 12, 8 (1).

170. E. Fink, *Nietzsches Philosophie*.

CHAPTER FIVE

ART AS THE THOUGHT OF BEING (HEIDEGGER)

1. "Der Ursprung des Kunstwerkes," in *Holzwege*, 6th ed. (Frankfurt-am-Main: V. Klostermann, 1980); "The Origin of the Work of Art," in *Poetry, Language, Thought*, trans. Albert Hofstadter (New York: Harper and Row, 1971); henceforth cited as *OA*. The best discussion of Heidegger's theory of art, from an "internalist" point of view, is F. W. von Hermann, *Heideggers Philosophie der Kunst* (Franfurt-am-Main: V. Klosterman, 1980). In the same philosophical perspective, see also Joseph Sodzik, *Esthétique de Heidegger* (Paris: Editions Universitaires, 1963), and Arion L. Kelkel, *La Légende de l'être. Langage et poésie chez Heidegger* (Paris: Vrin, 1980). The most competent introduction to Heidegger's poetics in its relation to Hölderlin's poetry remains Beda Allemann's *Hölderlin und Heidegger* (Zürich: Atlantis, 1954).

2. For example, "Building Dwelling Thinking" (1952), in *Poetry, Language, Thought*, and *Die Kunst und der Raum* (St. Gallen: Erker, 1969), which, as their titles indicate, deal essentially with architecture and sculpture.

3. Fourth ed., Frankfurt-am-Main, V. Klosterman, 1971. I refer only marginally to the more detailed discussion of the reading of Hölderlin found in the texts of the seminars published as part of the complete edition of Heidegger's works; the seminars in question were held in the winter semesters of 1934–35 and 1941–42, and in the summer semester of 1942. The texts of these seminars limit themselves to explaining the theses defended in the *Erläuterungen zu Hölderlins Dichtung*, without introducing anything new: the method of reading in particular is strictly the same.

4. A companion piece to the thinker-poet (*denkender Dichter*) that Hölderlin is for Heidegger.

5. The German edition *Sein und Seit*, 15th ed. (Tübingen: Max Niemeyer Verlag, 1979); in English, *Being and Time*, trans. John Macquarrie and Edward Robinson (New York: Harper, 1962).

6. The quotation marks are Heidegger's; *Being and Time*, 37.

7. Ibid.

8. See the German, *Sein und Seit*, 197.

9. Ibid., 162 (emphasis supplied).

10. Allemann, *Hölderlin und Heidegger*, does not take into account the passage quoted, which leads him to the following conclusion: "In the whole of *Being and Time* there is not the slightest allusion to the fact that the poetic might be particularly well-suited to such an explanation" (117). The passage from the first conception to the second is connected with what is usually called the *Kehre*. On this shift—where what is involved is the replacement of the question of the meaning of Being by that of its (historical) truth, and hence the passage from Being to time that was already anticipated in *Being and Time*—see O. Pugliese, *Vermittlung und Kehre: Grundzüge des Geschichtsdenkens bei M. Heidegger* (Freiburg-im-Breisgau, 1965), as well as R. Schürmann, *Le Principe anarchie* (Paris: Seuil, 1982),

especially 245–80. Schürmann returns to the idea of an evolutionary triad, previ-ously defended by Otto Pöggeler in *The Paths of Heidegger's Life and Thought*, trans. John Bailiff (Atlantic Highlands, NJ: Humanities Press, 1996), the period of the question of the meaning of Being, that of the question of historical truth, and finally that of the topology of Being. According to Pöggeler, the second conception, to which *The Origin of the Work of Art* belongs, is romantic, whereas the third is supposed to escape from this tradition [see *Philosophie und Politik bei Martin Heidegger* (Freiburg and Munich: Karl Alber, 1972), 157]. This view overlooks the fact that the function of art, and in a privileged way the function of poetry, remain thoroughly in conformity with the speculative theory of Art, and that the idea of a dialogue between thought and poetry, an idea that plays an important role during this third period, adopts one of the central characteristics of romantic thought.

11. As early as *Being and Time*, Heidegger had said that the forgetting of Being could go so far as to forget the question of this forgetting itself, and hence as far as total erasure.

12. Introduction to "Was ist Metaphysik?" (1949; Frankfurt-am-Main: V. Klostermann, 1981), 7. Also, *The Question of Being*, trans. William Kluback and Jean T. Wilde (New Haven: College and University Press, 1958), 91: "It [oblivion] is an affair of Being itself, governs the fate of its essence." The distinction between metaphysical questioning and the thought of Being raises a terminological prob-lem. On one hand Heidegger distinguishes "the revelation of the Being of being" as it is realized in Art or as the thinker questions it, from the metaphysical question that bears solely on beings: but on the other hand, metaphysical questioning is also sometimes described as "questioning of the Being of being." In this second case, the term to be emphasized is "being," whereas in the thinker's questioning the focus is on Being, or to be more precise, on the difference between Being and beings, and thus on the ontological difference. Metaphysics does not discern this difference: when it questions Being, it questions it as it questions beings: it ques-tions the beingness (*Seiendheit*) of beings, rather than the Being (*das Wesen*) of beings. In my analysis of Heidegger's theory of Art, the expression "the Being of being" always refers to the thinker's questioning and not to metaphysical ontology.

13. *Holzwege*, 81.

14. Thus in *On the Way to Language* , 134, Heidegger writes, on the subject of Novalis and his theory of language, "Novalis understands language dialectically, in terms of subjectivity, that is, within the horizon of absolute idealism."

15. *Holzwege*, 87.

16. See *On the Way to Language*, 46.

17. Which Pierre Bourdieu rightly describes as "conservative romanticism." See "L'Ontologie politique de Martin Heidegger," *Actes de la recherche en sciences sociales* 5–6 (1975): 109–56, an article which, although very aggressive, brings back the ideological atmosphere in which the Heideggerian enterprise is situated. See also Jeanne Hersch, "Les Enjeux du débat autour de Heidegger," *Commentaire* no. 42 (summer 1988): 474–80, which in my view constitutes the best assessment of the relationships between Heidegger's philosophy, his antisemitism, and his adher-ence to Nazism.

18. Heidegger, *Hölderlins Hymnen Germanien und Der Rhein*, ed. Suzanne Ziegler (Frankfurt-am-Rhein: Klostermann, 1980).

19. See "Wissenschaft und Besinnung," in *Vorträge und Aufsätze* (Pfullingen: Günther Neske, 1954), 58–59: "[N]ature cannot be evaded insofar as objectness as such prevents the corresponding representations and demonstrations from ever restructuring nature's plenitude of being. That is what was ultimately haunting Goethe in his unfortunate conflict with Newton's physics. Goethe could not yet see that his intuitive representation of nature also moved within the medium consti-tuted by objectness, in the subject-object relation, and thus, in its principle, did not differ from physics and remained, metaphysically, the same thing as physics." In contrast, in *The Principle of Reason*, trans. Reginald Lilly (Bloomington: Indiana University Press, 1991), 126, Goethe is taken as a guide who makes it possible to open an "outer gate" leading beyond the reign of the principle of reason.

20. See *Hölderlins Hymnen Germanien und Der Rhein*: "All the sciences of nature—as indispensable as they might be within certain current limits, for exam-ple when it is a matter of making rubber or alternating current—leave us funda-mentally clueless on the essential question, in spite of their exactitude: because they 'denature' nature."

21. See for example "Letter on Humanism," in *Basic Writings*, ed. David F. Krell (New York: Harper and Row, 1977), 191 ff., and especially "What Is 'Think-ing'?" in *Vorträge und Aufsätze*, 127: "Science does not think." This means among other things that science cannot understand itself (see ibid., 61): only the thinker can understand it and say what its historical place is. Thus Jean Beaufret, the thinker, can tell physicists that "ontologically, physics is already complete" [see *Vier Seminare* (Frankfurt-am-Main: Klostermann, 1957), 56].

22. Ibid., 42.

23. Rainer Schürmann, *Le Principe anarchie*, 152–53, notes the relationship between the Heideggerian problematics of the origin and romantic conceptions: "The directive signification of the notion of beginning in Heidegger's work is doubtless taken from the German romantics: the original, the beginning par excel-lence, is ancient Greece. But as also in the romantics, this notion comes to designate not only what formerly was, but what we are awaiting rather late in the day, a new reversal; that is, it designates the very essence of human saying and doing."

24. For a critique of the Heideggerian distinction between history and histori-cality, see David Kolb, *The Critique of Pure Modernity* (Chicago: University of Chicago Press, 1986), 288 ff.

25. *OA* 61.

26. This last notion must be compared with the triad *Arbeitsdienst, Wehrdi-enst, Wissensdienst* develeoped in Heidegger's inaugural address upon becoming rector of the University of Heidelberg in 1933 in order to grasp all of its ideological significance, and to understand its disappearance from texts published after World War Two.

27. *OA* 76–77.

28. See Jacques Derrida, "Restitutions," in *Truth in Painting*, trans. Geoff Ben-nington and Ian McLeod (Chicago: University of Chicago Press, 1987). See also below, n. 37.

29. *OA* 77.

30. Heidegger uses the word "unterbindet" here. The English translator ren-ders this as "shackle"; this meaning is literal (though not common) and it seems to

me not appropriate here. The following phrase states that these concepts "obstruct the way," and this shows that "unterbindet" should be understood in the (common) sense of "to intercept, arrest."

31. *OA* 31.

32. *OA* 29.

33. *OA* 39. See also the 1956 *Zusatz*: "Reflection on what *art* may be is completely and decidedly determined only in regard to the question of *Being*. Art is considered neither an area of cultural achievement nor an appearance of spirit; it belongs to the *disclosure of appropriation* by way of which the 'meaning of Being' can alone be defined. What art may be is one of the questions to which no answers are given in the essay." *OA* 86.

34. *OA* 32–33. The German text is: *"Zu deren Beschreibung bedarf es nicht einmal der Vorlage Wirklicher Stücke dieser Art von Gebrauchzeug."*

35. Cf. Derrida, *Truth in Painting*, 295.

36. *OA* 32–33.

37. We will never discover how Heidegger knows this. Derrida, in his subtle text, dismisses both Heidegger and his critic Meyer Schapiro because both of them are supposed to have accepted in advance that the picture shows a pair of shoes rather than simply two shoes that may very well have come from two different pairs. It is clear that on the terrain of empirical conjectures where Schapiro situates himself, he is perfectly justified in granting that this is a pair of shoes, because that possibility is far more probable than the one devised by Derrida. His agreement with Heidegger concerning the fact that this is a pair of shoes thus deprives his critique of their identification as a pair of peasant woman's shoes of none of its pertinence. His own hypothesis, namely that these are a city-dweller's shoes, in this case Van Gogh's, certainly rests on a mimetic conception of art, as Derrida quite rightly points out, but we must not forget that in asking about their appurtenance he only places himself on the terrain already chosen by Heidegger. See Meyer Schapiro, *Theory and Philosophy of Art: Style, Artist and Society* (New York: George Braziller, 1994).

38. *OA* 34.

39. Ibid.

40. *OA* 35.

41. *OA* 35–36.

42. *OA* 33–34.

43. *OA* 56.

44. *OA* 40–41. The question Heidegger raises here is obviously important: it is that of the radical change in the pragmatic status of works of art following "Elginism" and the birth of the museum. But his position is in no way original: Walter Benjamin was defending it around the same time (in "The Work of Art in the Age of Mechanical Reproduction"); we have also found it in another form in Hegel; and in fact it had been vigorously defended at the turn of the nineteenth century by Quatremère de Quincy, in his *Lettres sur le projet d'enlever les monuments de l'Italie* (1796) and in his *Considérations morales sur la destination des ouvrages de l'art* (1815). On this subject, see Joan Borrell, *L'Artiste-roi* (Paris: Aubier, 1990), 311–21.

45. *OA* 42.

46. *OA* 42–43; emphasis supplied. The same holds for tragedy: it is not a pre-

senting (*aufführen*) or a representing (*vorführen*), but an enactment of the battle between ancient peoples and the new gods. See ibid., 43.

47. "Der Ursprung des Kunstwerkes," 58–59.

48. The opposition between the piece of equipment that "uses up" the earth and the work that respects it, even though it is a commonplace, has scarcely any real foundation. Let us take the case of painting: it is clear that the processes of transformation to which the mineral or vegetable pigments are subjected (leaving aside synthetic pigments, which Heidegger would probably reject because they are "industrial") are governed by the same heterofinality as the village potter's use of clay. Thus the preparation of lapis lazuli blue presupposes numerous mechanical manipulations: the pulverization of the stone, the mixing of the powder with pine resin in order to eliminate all the impurities deriving from the original rock, etc. In other words, the pure appearance of color already depends on a whole set of heterofinalized processes that, far from respecting the earth's reserve, "force" it no less than any given artisanal production.

49. *OA* 55.

50. *OA* 65–66.

51. *OA* 66. Emphasis supplied.

52. On this subject, see F. W. von Herrmann, *Heideggers Philosophie*, especially 286.

53. *OA* 72. Emphasis supplied. Cf. "Hölderlins Erde und Himmel," in *Erläuterungen zu Hölderlins Dichtung*: "Art, being the process of allowing the invisible to appear by showing it, is the genre of the highest sign. The base and summit of this kind of showing are deployed in Saying as poetic song" (162).

54. *OA* 73.

55. Ibid.

56. Ibid.

57. The pragmatic dimension, in both its communicational and expressive components, is in any case related to the decadence of language.

58. *OA* 74.

59. Ibid.

60. Ibid.

61. Ibid. Emphasis supplied.

62. My emphasis: "In ihr ist dichterisch gesagt, was hier nur denkerisch auseinandergelegt werden konnte" (*Erläuterungen zu Hölderlins Dichtung*, 48). The text dates from 1936.

63. *Erläuterungen zu Hölderlins Dichtung*, 8.

64. Ibid., 182.

65. *Vier Seminare* (Frankfurt-am-Main: V. Klostermann, 1977), 22.

66. *OA* 78.

67. Ibid.

68. *Was ist Metaphysik?* 12th ed. (Frankfurt-am-Main: V. Klosterman, 1981), 51. I forego here an examination of Heidegger's replacement, from one edition to another, of the term *Danken* by *Denken*. [The translation of this quotation is based partly on that in Werner Brock's selection from Heidegger's writings, *Existence and Being* (London: Vision Press, 1949).—Translator.]

69. Ibid., 50. So far as the priority of thought over poetry (in the generic sense

of the term) is concerned, "Der Spruch Anaximanders" (in *Holzwege*) is still more categorical: "thinking is poetizing (*Dichten*), and not only in the sense of poetry or song. The thought of being is the original mode of poetic saying. In it alone, above all, language comes into language, that is, into its essence. Thought says the dictation of the truth of Being. Thought is the original *dictare*. Thought is the original poetizing that precedes all poetry, but also precedes the poetic element in art, insofar as the latter comes into the work within the realm of language. All poetizing (*Dichten*) in both this broader sense and in the narrower sense is fundamentally thought. The poetizing essence of thought guarantees the reign of the truth of Being." (*Holzwege*, 324).

70. *Erläuterungen zu Hölderlins Dichtung*, 43.

71. Ibid., 42, 76, 103. Emphasis supplied.

72. Ibid., 111.

73. *On the Way to Language*, trans. Peter D. Hertz (New York: Harper and Row, 1971), 136. Allemann, *Hölderlin und Heidegger*, 232, tries to resolve the problem by asserting that poetry and thought are both originary, but according to differing points of view: "In a certain way thought precedes poetry; to the extent, in fact, that it 'ventures into what is essentially worthy of questioning' (*Erläuterungen zu Hölderlins Dichtung*, 129), that is, to the extent that it goes further than metaphysics. For its part, in a certain way poetic saying precedes thought, to the extent that the familiar, which is poetically uttered, always retains, in what it does not utter, a proximity to Being, toward which thought is never more than on its way." Poetry would thus be more originary in its silences, and thought more originary in its saying! That is no doubt why thought has to utter the ontological saying of the poem that the latter can only keep silent about.

74. *Erläuterungen zu Hölderlins Dichtung*, 182.

75. "What Are Poets For?" in *Poetry, Language, Thought*, 95–96. (*Holzwege*, 269–70.)

76. *Erläuterungen zu Hölderlins Dichtung*, 7. The italics are Heidegger's.

77. Ibid., 182.

78. "What Are Poets For?" in *Poetry, Language, Thought*, 98. (*Holzwege*, 270.)

79. *Erläuterungen zu Hölderlins Dichtung*, 84.

80. I know of only one passage in which a reference to the formal problem can be found. In the analysis of the fifth stanza of "Wie wenn am Feiertage" we read: "If one counts them up, a verse is missing in the fifth stanza. Thus we must insert a transition (*ein Zwischengedanke*) so there is a clear transition to the following stanza" (*Erläuterungen zu Hölderlins Dichtung*, 67). Even this formal consideration is mentioned only to the extent that the interpretation of the content encounters an obstacle.

81. Text as it appears in *Erläuterungen zu Hölderlins Dichtung*, 50:

> Daß schnellbetroffen sie, Unendlichem
> Bekannt seit langer Zeit, von Erinnerung
> Erbebt, und ihr, von heilgem Stral entzündet,
> Die Frucht in Liebe geboren, der Götter und Menschem Werk
> Der Gesang, damit er beiden zeuge, glükt.
> So fiel, wie Dichter sagen, da sie sichtbar
> Den Gott zu sehen begehrte, sein Bliz auf Semeles Haus
> Und Asche tödtlich getroffne gebahr,

Die Frucht des Gewitters, den heiligen Bacchus.

Und daher trinken himmlisches Feuer jezt
Die Erdensöhne ohne Gefahr.
Doch uns gebührt es, unter Gottes Gewittern,
Ihr Dichter! mit entblößtem Haupte zu stehen,
Des Vaters Stral, ihn selbst, mit eigner Hand
Zu fassen und dem Volk ins Lied
Gehüllt die himmlische Gaabe zu reichen. . .

82. *Erläuterungen zu Hölderlins Dichtung*, 70.

83. Ibid. Emphasis supplied.

84. Ibid.

85. Ibid., 51.

86. Ibid., 75. In general, Heidegger grants preference to the last state of the poems he is analyzing. But this is not a principle of philological rigor, since he abandons it when it ceases to be useful to him. This is the case here, when he refuses to take into account the draft of an eighth stanza in "As When on a Holiday." Similarly, when in the eighth stanza of the hymn "Der Rhein," he comes across the name of Rousseau, he gets rid of it by noting that Hölderlin wrote it only afterward, instead of that of Heinse (his friend). He adds: "The original interpretation of the stanza must therefore be rid of the reference to Rousseau." (*Hölderlins Hymnen Germanien und der Rhein*, ed. Susanne Ziegler [Frankfurt-am-Main: V. Klostermann, 1980]). This is clearly a decision that is at least debatable, especially since Hölderlin is also the author of a poem titled "Rousseau."

87. See Peter Szondi, "Der andere Pfeil," in *Hölderlin-Studien* (Frankfurt-am-Main: Suhrkamp, 1970). Szondi's arguments, based on a detailed comparative analysis of the whole of Hölderlin's hymns, lead to more or less the same conclusion as the purely "internal" analysis I have sketched here. I leave open the question as to whether the despair announced in the eighth stanza is supposed to concern solely the poet Hölderlin, who would thus acknowledge that he is not (yet) up to his task (that is Szondi's interpretation, and it seems convincing), or challenges the claims of poets as such to be intermediaries between the divine and the human.

88. I have not taken into account the etymological juggling in which Heidegger sometimes indulges in his analyses of poetic texts, because it seem to me not worthy of serious discussion.

89. It would in fact be easy to show that the same procedures are found in the analyses of Trakl (for example, "Language in the Poem," in *On the Way to Language*) or Rilke (for example, "What Are Poets For?" in *Poetry, Language, Thought*). In these analyses, which date from after the Second World War, the pan-Germanic nationalism that makes reading most of the texts on Hölderlin so painful becomes much more discreet.

CONCLUSION
WHAT THE SPECULATIVE TRADITION MISUNDERSTOOD

1. Runge, for example, developed a metaphysics of colors, in which the three "originary colors" (*Urfarben*) are analogues of the Trinity; as for Carus, he main-

tains that (visual) beauty is "the feeling (*Empfindung*) of the presence of the divine being in nature, and in the same way as the truth is the knowledge of this divine being" (*Neun Briefe über Landschaftsmalerei*, quoted after Gerhard Eimer, *Caspar David Friedrich. Auge und Landschaft* [Munich: Insel Verlag, 1974], 172). The mystical sources they allude to, for example Plotinus or Jakob Boehme, were moreover later remobilized by Kandinsky and Mondrian, who also reactivated philosophical speculations on colors.

2. See for example Fritz Strich, "Die Romantik als europäische Bewegung" (1924), reprinted in *Begriffsbestimmung der Romantik* (Darmstadt: Wissenschaftliche Buchgesellschaft, 1968), 112–34; René Wellek, "The Concept of Romanticism in Literary History," in *Concepts of Criticism* (New Haven: Yale University Press, 1963), 128–98.

3. Regarding Coleridge's theory of imagination, and more generally his relations with German philosophy, see Thomas McFarland, *Originality and Imagination* (Baltimore: Johns Hopkins University Press, 1985), chap. 6, "The Higher Function of Imagination."

4. See for example Georg Lukács, *The Historical Novel*, trans. Hannah and Stanley Mitchell (Boston: Beacon, 1963). On aesthetics, less simplistic but just as pervaded by the young Lukác's speculative theory of Art, see Rainer Rochlitz, *Le Jeune Lukács* (Paris: Payot, 1983).

5. See Theodor W. Adorno, *Aesthetic Theory*, trans. C. Lenhardt (London: Routledge & Kegan Paul, 1984)

6. Ibid., 269.

7. Ibid., 189–90.

8. Michael Podro points out that no aesthetic theory had more influence on the conceptions of modern art than Schopenhauer's philosophy. See *The Manifold in Perception: Theories of Art from Kant to Hildebrand* (Oxford: Clarendon Press, 1977), 92.

9. See Anne Henry, *Marcel Proust. Theories pour une esthétique* (Paris: Klincksieck, 1983). Henry maintains that Proust's aesthetics was indebted not only to Schopenhauer, particularly with regard to the theory of music and the idea of the redemptive function of art (46 ff), but also to Schelling (82 ff.). In fact, the speculative theory of Art pervades turn-of-the-century aesthetic conceptions to such an extent that it is often difficult to determine precise sources.

10. Regarding Malevitch and Mondrian, see below, 278–79.

11. See René-Pierre Colin, *Schopenhauer en France: un mythe naturaliste* (Lyons: Presses Universitaires de Lyon, 1979). It suffices to think of the pessimism of Huysmans—a naturalist who became an aesthete—in *À Rebours*, which derives directly and explicitly from Schopenhauer.

12. I am indebted for all this to Mark A. Cheetham, *The Rhetoric of Purity: Essentialist Painting and the Advent of Abstract Painting* (Cambridge: Cambridge University Press, 1991), 1–39.

13. Ibid.

14. In *Diverses Choses* Gauguin describes his painting "Pape Moe" as a materializing form of a pure idea (see Cheetham, *Rhetoric of Purity*, 158, n. 60).

15. See Jürgen Krause, *Martyrer und Prophet. Studien zum Nietzsche-Kult in der bildenden Kunst der Jahrhundertswende* (Berlin: Walter de Gruyter, 1984).

Nietzsche has been no less important in the domain of German literature: it suffices to think of the young Thomas Mann or the Expressionist poets. See for example the collective work *Nietzsche und die deutsche Literatur*, 2 vols. (Tübingen: Niemeyer, 1978).

16. Reproduced in Kasemir Malevitch, *Le Miroir suprématiste* (Paris: L'Âge d'Homme, 1977), 84.

17. Quoted in Fritz Neumeyer, Mies van der Rohe, *Das kunstlose Wort: Gedanken zur Baukunst* (Siedler, 1988), 175. Neumeyer studies in detail the ambivalent relation between Nietzschean philosophy and the avant-garde conceptions defended by Mies in the 1920s.

18. The expression is used by Kandinsky in *Du Spirituel dans l'art, et dans la peinture en particulier* (Coll. Folio Essais [Gallimard, 1989]); moreover, in this work he also refers to the Superman.

19. "Sur le musée" (1919), in *Le Miroir suprématiste*, 64.

20. "Le Peintre et le cinéma" (1926), in ibid., 107.

21. "Forme, couleur et sensation" (1928), in ibid., 114.

22. Ibid., 123.

23. "L'OUNOVIS" (1929), in ibid., 88.

24. "Le Suprématisme" (1919), in ibid., 83.

25. "De la part de l'OUNOVIS" (1919–20), in ibid., 86.

26. See Troels Andersen, "Preface" to Kasemir Malevitch, *The World as Non-Objectivity: Unpublished Writings 1922–1925* (Copenhagen: Borgen, 1976).

27. See for example Emmanuel Martineau, "Preface," to Malevitch, *Le Miroir suprématiste*, 7–33, and Marcadé, "Preface," to *La Lumière et la couleur* (Paris: L'Âge d'Homme, 1981), 7–36.

28. Martineau, "Preface" to Malevitch, *Le Miroir suprématiste*, 9.

29. Quoted by Cheetham, *Rhetoric of Purity*, 48–49.

30. Wassily Kandinsky, *Du spirituel dans l'art*, 136.

31. Cheetham, *Rhetoric of Purity*, 79.

32. Kandinsky, *Du spirituel dans l'art*, 52.

33. Wassily Kandinsky, *Complete Writings on Art*, 2 vols., ed. Kenneth C. Lindsay and Peter Vergo (Boston: G. K. Hall, 1982), 851–55.

34. Manifesto of the review *Art concret*, reproduced in Serge Lemoine, *Piet Mondrian et De Stijl* (Paris: Hazan, 1987), 67–69.

35. Kandinsky, *Complete Writings on Art*, 2: 760, 855.

36. See especially his "Réalité naturelle et réalité abstraite" (1919–20), published in *De Stijl*.

37. Quoted in Lemoine, *Piet Mondrian et De Stijl*, 30.

38. "Art abstrait" (1925), in *Écrits complets*, 2: 315.

39. Cheetham establishes parallels between Mondrian's and Kandinsky's purist essentialism and Nazi ideology, which was also obsessed with purity. This judgment on the basis of intent seems to me to show clearly the absurdities to which one can take a symptomatic reading inspired by deconstruction that allows itself to be guided by the drift of signifiers: on the pretext that Hitler sought racial *purity* and Mondrian and Kandinsky sought pictorial *purity*, Cheetham thinks he can conclude that there is a structural identity of thought, in this case a fascist one. Mondrian's and Kandinsky's works would thus have a great "potential for oppression"

and their condemnation by the Nazis is no more than an "irony of history" (136), because "If the opportunity had presented itself, can one be sure that Mondrian would have made a benevolent philosopher-king?" (135). This is clearly an absurd accusation: if there is one moral quality one cannot deny Mondrian and Kandinsky, it is surely their fundamental artistic and personal integrity: neither of them sought to become a "philosopher-king," and both were opposed to Nazi oppression. One should also recall that Kandinksy left the Soviet Union in 1921 even though he occupied an official position there; had he secretly desired to be a philosopher-king he would have been tempted to climb in the hierarchy of the new regime instead of giving up his post—which cost him his nationality.

40. Yves Michaud, *L'Artiste et les communistes* (Paris: Jacqueline Chambon, 1989), 19.

41. "La Littérature et l'expérience originelle," a text whose multiform influence on conceptions of literature in France is well known, recycles Heidegger's theories (at the level of vocabulary and style, as well). Blanchot starts out from the same question: "What should we say about art, what should we say about literature?" Like the German philosopher, he connects it with the Hegelian thesis of the end of art: "Is art a thing of the past?" Like Heidegger again, he opposes art to communication and defines it as an ecstatic relationship to Being. Similarly he maintains that the current task of art is to seek its own essence. Let us add that in the multiplicity of its sources (besides Heidegger and Nietzsche, we must mention Novalis, Hölderlin, and Rilke) and in its internal coherence, Blanchot's critical work is incontestably one of the most ambitious contemporary reformulations of the speculative theory of Art in the literary domain—which does not mean that it is only that. See Maurice Blanchot, *The Space of Literature*, trans. Ann Smock (Lincoln: University of Nebraska Press, 1982), 209–47.

42. Char is not the only great French poet close to the Heideggerian problematics: we could also mention Yves Bonnefoy, for whom poetry is "an experience of being and a reflection on being," as Jean Starobinski put it in his preface to the volume *Poèmes* (Paris: Gallimard, 1982).

43. Paul Veyne is right to emphasize the fact that Char's poetry and poetics develop independently of Heidegger's philosophy. See his *René Char en ses poèmes* (Paris: Gallimard, 1990), 302–13.

44. "Science can give devastated man no more than a blind searchlight, an emergency weapon, tools without instructions." René Char, "Les Apparitions dédaignées," in *Oeuvres complètes* (Paris: Gallimard/Bibliothèque de la Pléiade, 1983), 467.

45. Introduction to "Dehors la nuit est gouvernée *précédé de* Placard pour un chemin des écoliers," in Char, *Oeuvres complètes*, 85.

46. "The poet can then see the contraries—those punctual and tumultuous images—come to their end, their immanent line personify itself, poetry and truth, as we know, being synonymous" ("Seuls demeurent," in Char, *Oeuvres complètes*, 159.

47. In "Seuls demeurent," the poet is described as a "great Beginner" (ibid., 159). See also Char's interpretation of Rimbaud's thesis: "Poetry will no longer set the rhythm for action. It will precede" (ibid., 734–35).

48. "If we dwell in a lightning flash, it is the heart of the eternal," "Le poème pulvérisé," ibid., 266.

49. "Partage formel," ibid., 155.

50. Éric Marty, *René Char* (Paris: Seuil, 1990), 213.

51. Charles L. Stevenson, *Ethics and Language* (New Haven: Yale University Press, 1944), 67–71; "Persuasive Definitions," *Mind* 47 (1938); "Interpretation and Evaluation in Aesthetics," in Max Black, ed., *Philosophical Analysis* (Ithaca: Cornell University Press, 1950), 341–83; "On 'What is a poem?'" *The Philosophical Review* 66 (1957): 328–62.

52. We must of course distinguish between *historicity* and *history*: history (whether internal or brought in from outside) is always a narrativization of historicity, that is, a reflexive organization of historical phenomenality; the latter is never apprehensible other than in specific descriptions, but their (at least virtual) plurality allows (and even obliges) us to postulate that it "exists" before our constructions. Contrary to a fashionable sophism, the fact that a reality is apprehensible only as discursively organized does not in any way mean that there is *only* discursive reality.

53. See Hans Belting, *The End of the History of Art?*, trans. Christopher S. Wood (Chicago: University of Chicago Press, 1987), 65–94.

54. Antoine Compagnon observes that in Proust, for example, we find "a gap . . . between the redemptive problematics influenced by Schopenhauer—the theory set forth in *Le temps retrouvé*—and a novel that develops in a relatively autonomous way, but nonetheless requires this theoretical legitimation." *Five Paradoxes of Modernity*, 69.

55. See Michael Baxandall, *Patterns of Intention: On the Historical Explanation of Pictures* (New Haven, Yale University Press, 1985), chap. 2, for a subtle exposition of the problematics of intentionality in the artistic domain.

56. To what point can one take an artist's theories into account in approaching his works? The question is sometimes difficult to answer. In any case, no doubt there are few Kandinsky lovers who see his pictures in the light of his theory of colors, according to which green, for example, "corresponds to what is, in the society of men, the bourgeoisie: it is an immobile element, self-satisfied, limited in all ways. This green is similar to a big cow, healthy, lying down, immobile, capable only of ruminating while considering the world with its stupid and inexpressive eyes." *Du Spirituel dans l'art*, 151.

57. Compared with Duchamp, most of the current representatives of conceptual art cut a rather sorry figure. It doesn't help matters that, contrary to their spiritual father, they affect an immense seriousness.

58. See Svetlana Alpers, *The Art of Describing*, xxv.

59. Rosalind Krauss, *Le Photographique. Pour une théorie des écarts* (Paris: Macula, 1990), 40 ff.

60. To find a semiotic rupture within photography, we must turn to Coburn's, Moholy-Nagy's, or Man Ray's photograms: there it is in fact the semiotic and pragmatic status of the photographic sign that changes, since in this case the system of perspectivist representation, which is responsible for much of the analogical legibility of photographic images, is canceled.

61. Krauss, *Le Photographique*, 46.

62. Ibid., 48.

63. Gérard Genette, *Fiction et diction* (Paris: Seuil, 1990), 11 ff.

64. Thus the distinction between intention and attention may also be involved in the domain of constitutively aesthetic works, since it is a matter of distinguishing between the intentional structure as such (artistic *or* pragmatic-functional) of an object and its properties. This raises the thorny question as to which of the work's elements—for example, in the case of a poem—are pertinent from the point of view of its intentional structure, and which are not. Lévi-Strauss's and Jakobson's debate concerning the interpretation of Baudelaire's poem "Les Chats" shows the importance of this question—and the difficulty of concretely resolving it.

65. Genette, *Fiction et diction*, 39.

66. *Critique of Judgement*, 1: 64, § 12.

67. See George Santayana, *The Sense of Beauty* (1896; rpt. New York: Random House/Modern Library, 1955), 42.

68. Ibid., 45.

69. Michaud, *L'Artiste et les communistes*, 29.

70. See Nelson Goodman, *Languages of Art: An Approach to a Theory of Symbols* (Indianapolis: Bobbs-Merrill, 1968).

Index of Names

Adorno, Theodore Wiesengrund, 3, 276, 285, 310 n. 13, 315 n. 6, 342 n. 5
Aeschylus, 179, 212
Allemann, Beda, 335 nn. 1, 10, 340 n. 73
Alpers, Svetlana, 289, 345 n. 58
Andersen, Troels, 279
Aristotle, 93, 94, 101, 138, 288, 300
Arnold, Matthew, 11
Arp, Hans, 281
Atget, Eugène, 296
Auden, W. H., 101
Aurier, Albert, 277
Ayrault, Robert, 315 n. 1

Baeumler, Alfred, 18
Balzac, Honoré de, 276
Basch, Victor, 314 n. 76
Batteux, Charles, 29
Baudelaire, Charles, 5, 274, 275, 278
Baudri de Bourgeuil, 319 n. 67
Baumgarten, Alexander Gottlieb, 17, 58
Beethoven, Ludwig van, 228
Behler, Ernst, 315 n. 2, 321 n. 97
Belting, Hans, 345 n. 53
Benjamin, Walter, 112, 276, 315 n. 5, 321, n 10
Binkley, Timothy, 314 n. 57
Blanchot, Maurice, 275, 283, 344 n. 41
Blavatsky, Yelyena Petrovna, 280
Boccaccio, 95
Boehme, Jacob, 69, 117, 280
Bollack, Jean, 186
Bonnefoy, Yves, 344 n. 42
Borrell, Joan, 338 n. 44
Bossuet, 295
Bourdieu, Pierre, 336 n. 17
Bubner, Rüdiger, 315 n. 6, 318 n. 58, 325 n. 14
Bungay, Stephen, 165
Burke, Edmund, 58

Capa, Robert, 295
Carus, Carl Gustav, 275
Cassirer, Ernst, 18, 294, 311 n. 7, 319 n. 75
Cézanne, Paul, 297
Char, René, 261, 283–84

Charles, Michel, 116
Cheetham, Mark A., 278, 281, 342 nn. 12, 14, 343 nn. 29, 31, 39
Cicero, 94
Clegg, John S., 331 n. 27
Coburn, Alvin Langdon, 345 n. 60
Coleridge, Samuel Taylor, 275
Colin, René-Pierre, 342 n. 11
Compagnon, Antoine, 309 n. 9, 345 n. 54
Cousin, Victor, 275
Crawford, Donald W., 314 n. 63
Curtius, Ernst, 318 n. 64, 319 nn. 66, 67, 70
Cyprian (Saint), 323 n. 136

Danto, Arthur, 309 n6, 320 nn. 80, 81, 334 n. 150
Deleuze, Gilles, 334 n. 160
Demachy, Robert, 295
Democritus, 92, 318 n. 59
Denis, Maurice, 277
Derrida, Jacques, 309 n. 1, 313 n. 41, 337 n. 28, 338 nn. 35, 37
Descartes, René, 239, 241
Doesburg, Theo van, 278, 281
Droysen, J. G., 99
Duchamp, Marcel, 48, 289

Eichner, Hans, 48, 289
Empedocles, 212
Engels, Friedrich, 276
Escal, Françoise, 329 n. 87
Euripedes, 126

Ferry, Luc, 4, 309 n. 3, 311 nn. 1, 7, 312 nn. 21, 30
Fichter, Johann Gottlieb, 73–78, 80, 112, 182, 315 n. 9, 316 n. 10
Fink, Eugen, 238, 332 nn. 78, 85, 333 n. 125, 335 nn. 140, 155, 335 n. 170
Fleming, Ian, 294
Frederick the Great, 51

Galassai, Peter, 290, 292
Gaugin, Paul, 277, 278

Index of Concepts

aesthetic doctrine, *see* critical philosophy vs. aesthetic doctrine

aesthetic norm, 29–31, 59–60

aesthetic pleasure, 19–24, 33–34, 298–308. *See also* judgment, aesthetic

aesthetic value, *see* judgment, aesthetic

aesthetics, *see* aesthetic norm; aesthetic pleasure; aesthetic predicates; autonomy of the judgment of taste; common sense; constitutive vs. regulative; critical philosophy vs. aesthetic doctrine; finality without specific end; harmony of the faculties; imagination; judgment, aesthetic; judgment, reflective vs. determinative; meta-aesthetics

antiquity vs. modern age, 118–20, 121–29, 132–34

art: compensatory function, 8–10, 91–92, 96, 140, 203–12, 242; ecstatic knowledge, 6–7, 80–81, 139–40, 190–92, 208, 219–20, 254–55; fiction, 209, 230–36; illusion, 220–21, 225–26, 232; ontological revelation, 69–71, 104, 117, 138–41, 190–92, 204–6, 210–22, 246–52; organon of philosophy, 136, 213, 234 (*see also* philosophy: organon of Art); philosophy, 9–12, 70–71, 78, 90–91, 135–38, 139, 146–51, 153–54, 188–89, 202–8, 229, 244–46 (*see also* poetry: and philosophy); reality (*see*: art: compensatory function; illusion); redemption, 203–12; religion, 141–43, 147–51, 154–55, 160–61, 229 (*see also* poetry: and religion)

attentional vs. intentional (aesthetic system), 295–97

autonomy of art, 114–15, 149–50

autonomy of the judgment of taste, 20, 29, 35–37, 53–54

autoteleology, historical, 281–82, 287–88

autotelic nature of the work of art, 39, 54–55, 87–89

avant-gardes, *see* modernism

beauty, natural vs. artificial, 23, 30, 32–40, 46–48, 49–50, 54, 62–63. *See also* genius

Common Sense, 30–31

constitutive vs. conditional (aesthetic functioning), 293–94

constitutive and regulative (principle), 30

crisis of philosophy, 8–9, 68–69

critical philosophy vs. aesthetic doctrine, 12–18, 55–61, 63–64

critical philosophy vs. metaphysical doctrine, 9–10, 77–78

death of art, 17, 151–52, 227–28

decisive moment, 127–28, 210–11, 241–42

definition, descriptive vs. evaluative, 60, 64, 107–8, 113–14, 284–87

definition, persuasive, 286

definition of essence, *see* essentialism

empirical vs. transcendental (foundation), 29–31

essentialism, 6, 13, 106–7, 152, 153, 166, 186, 280–81

evaluation, *see* definition, descriptive vs. evaluative

evolutionism, *see* historicism

ecstatic, *see* art: ecstatic knowledge

finality without specific end, 22–23, 26–27, 36–40, 54; and the work of art, 40, 48

finality, specific, 33–35, 37–40, 42, 43–44, 46

genius (theory of), 40–49, 194–95, 227–28

genres, literary (theory of), 118, 129–34, 174–81

harmony of the faculties (Kant), 24–28

hermeneutics of Art, 4, 138, 146, 154, 169, 171

hierarchy of the arts, 49, 166–67, 174–75, 179–80, 195–96, 200, 216–17

history vs. theory, 107–14, 114–15, 131–32, 150–51, 152–58, 165

history, internal, *see* autoteleology, historical

historicism, 5, 71–72, 97–102, 109–14, 155–56, 165, 172, 184–85, 252–54, 287–92; vs. rejection of history, 184–85

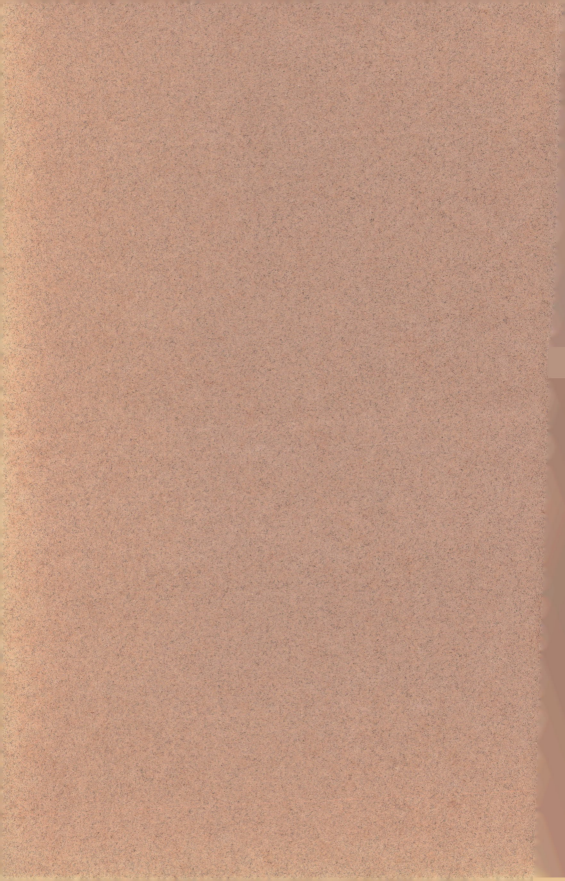